EXCLUSIVE
SAFARI LODGES

of South Africa

EXCLUSIVE
SAFARI LODGES

of South Africa

Celebrating the ultimate wildlife experience

PHOTOGRAPHY AND EXPERIENCES IN THE AFRICAN BUSHVELD
BY GERALD HOBERMAN

WITH LODGE TEXT BY CARRIE HAMPTON

THE GERALD & MARC HOBERMAN COLLECTION
CAPE TOWN · LONDON · NEW YORK

Concept, design and production control: Gerald & Marc Hoberman
Photography: Gerald Hoberman
Reproduction: Marc Hoberman
Text: Carrie Hampton (Lodges)
Text: Gerald Hoberman (Experiences in the African bush)
Managing editor: Roelien Theron
Layout: Gerald Hoberman, Melanie Kriel
Indexer: Ethleen Lastovica
Proofreader: Sean Fraser
Cartographer: Peter Slingsby

www.hobermancollection.com

ISBN 1-919939-37-7 / 978-1-919939-37-7

Exclusive Safari Lodges of South Africa is published by The Gerald & Marc Hoberman Collection (Pty) Ltd
Reg. No. 99/00167/07. PO Box 60044, Victoria Junction, 8005, Cape Town, South Africa
Telephone: +27 (0)21 419 6657/419 2210 Fax: +27 (0)21 425 4410 e-mail: office@hobermancollection.com

International marketing, corporate sales and picture library

United Kingdom, Republic of Ireland, Europe
Hoberman Collection UK
250 Kings Road, London, SW3 5UE
Telephone: 0207 352 1315 Fax: 0207 681 0064
e-mail: uksales@hobermancollection.com

United States of America, Canada, Asia
Hoberman Collection USA, Inc. / Una Press, Inc.
PO Box 880206, Boca Raton, FL 33488, USA
Telephone: (561) 542 1141
e-mail: hobcolus@bellsouth.net

**For copies of this book printed with your company's logo and corporate message contact
The Gerald & Marc Hoberman Collection. For international requests contact Hoberman Collection UK.**

Other titles in this series by The Gerald & Marc Hoberman Collection

ENGLISH			GERMAN	FRENCH	SPANISH	ITALIAN
Cape Town	*KwaZulu-Natal*	*South Africa*	*Afrikas Wildnis*	*L'Afrique du Sud*	*Ciudad del Cabo*	*Namibia*
England	*London*	*Teddy Bears*	*Die Tierwelt*	*La Faune Africaine*	*Sudáfrica*	
Franschhoek &	*Namibia*	*V&A Waterfront*	*Kapstadt*	*Le Cap*		
Rickety Bridge	*Napa Valley*	*Washington, D.C.*	*London*	*Londres*	**JAPANESE**	
D'vine Restaurant	*New York*	*Wildlife*	*Namibia*	*Namibie*	*London*	
– The Cookbook	*Salt Lake City*	*Wildlife of Africa*	*Südafrika*			
Ireland	*San Francisco*					

Agents and distributors

Namibia	*South Africa*	*United Kingdom*	*United States of America, Canada*
Projects & Promotions cc	Hoberman Collection	DJ Segrue Ltd	Perseus Distribution
PO Box 96102	6 Victoria Junction	7c Bourne Road	387 Park Avenue South
Windhoek	Prestwich Street, Green Point	Bushey, Hertfordshire	New York
Tel: +264 64 571 376	Tel: +27 (0)21 419 6657	WD23 3NH	NY 10016
Fax: +264 64 571 379	Fax: +27 (0)21 425 4410	Tel: (0)7976 273 225	Tel: (212) 340 8100
e-mail: proprom@iafrica.com.na	e-mail: office@hobermancollection.com	Fax: (0)20 8421 9577	Fax: (212) 340 8195
		e-mail: sales@djsegrue.co.uk	

Printed in Singapore

For Hazel,
Richard, Ilse,
Joanne, Laurence,
Leah, Noah,
Marc and Sarah

I never knew of a morning in Africa
when I woke that I was not happy.

Ernest Hemingway (1899-1961)

Contents

Acknowledgements

Special thanks go to the owners of the extraordinary safari lodges and camps featured in this book, for their commitment, dedication and important contribution to the continuity of Africa's wild outdoors. It is through their efforts and the sustainable management of the land and facilities in their care that people from far and wide can come to Africa to experience its wonders.

They provide visitors with luxurious comfort, style and safety, coupled with excellent service, while also supporting the development of local communities. Lodge managers, game rangers, trackers, chefs, waiters and chambermaids are all part of the equation. Without the special hospitality, friendliness and assistance of the management and staff of all the lodges featured in this book, it would not have been possible to produce it in its present form.

I would also like to thank the many wonderful guests from all over the world whom I have been privileged to meet, including an American astronaut, a Russian cosmonaut, famous film stars and celebrities. I am honoured to have enjoyed their friendship and good company, and appreciate their interest in my work.

To Magda Bosch, Jacqueline van Zyl, Marschelle September, Melanie Kriel and all our staff, as well as those mentioned below, thank you.

AQUILA PRIVATE GAME RESERVE: ROMEO MULLER
CAMP JABULANI: BRENDON CREMER, MICHELLE DINNIE, ILANA OTTO, LENTE ROODE, RUDOLPH VAN DER BERG
CC AFRICA: WILNA BEUKES, LISA CAREY, VALERI SENEKAL
CHITWA CHITWA PRIVATE GAME LODGE: THERESA PIETERSE
CLIFFTOP EXCLUSIVE SAFARI HIDEAWAY: KIK GRIGAT, PETER HARRISON, CHRISTO JACOBS, TANIA JACOBS, WALTER RALPH JUBBER, DAVID KONING, BRENDA MUNRO, DAVE PECKAM, DEBBIE PECKAM, DAVID SMITH
DEPARTMENT OF ZOOLOGY, UNIVERSITY OF CAPE TOWN: DR GARY BRONNER (SMALL MAMMAL RESEARCH UNIT), DR MICHAEL PICKER
DONALD GREIG SCULPTURE: DONALD GREIG
ELEPHANT PLAINS GAME LODGE: ETIENNE SWART
GARONGA SAFARI CAMP: KÓREN LEIGH AUTEF, MUSA MAYINDI, BERNARDO SMITH, TISH STUART
HAYWARD'S LUXURY SAFARIS: LEYLA HAYWARD, PETER HAYWARD, VICTORIA HAYWARD
IDUBE PRIVATE GAME RESERVE: RICHARD KELLY, LOUIS MARAIS
IMPODIMO GAME LODGE: THATOENG MOGAPI, PATRICK NDLOVU, MMABATHO RALETLAPANE, SEBATI SEBUENYANE, DEBBIE TUCKER, STEVE TUCKER, SEBASTIAN WILSON
INTSOMI FOREST LODGE: HELEN FICK
ITAGA LUXURY PRIVATE GAME LODGE: DANIEL BRANDAO, NICK CROUCH, WILLIE KRUGER, MELINDA MATHEWS
IVORY TREE GAME LODGE: JACQUES LE GRANGE, SIPHO MACHABE, PATRICK MATHIKGE, SAM MOLATLHEGI, CHRISTINA MONYATSI, LEON ROUSSOUW
JACI'S SAFARI LODGE AND TREE LODGE: STUART HUNTER, ANDREW READ, JACI VAN HETEREN
JOCK SAFARI LODGE: IGNUS LE ROUX, LEONIE HERSELMAN

JUST AFRICA: ASHRAF CASSIM
KAPAMA LODGE, KAPAMA RIVER LODGE AND KAPAMA BUFFALO CAMP: PAUL DANIEL, ROBERT MAHAKUKE, JOHAN MANGANE, LINDIWE MKHARI, EMMANUEL MULAUDZI, BERNARD NKOVANA, RHANDZU NXUMALO, BERNARD ROODE, JOHAN VAN EEDEN
KINGS CAMP PRIVATE GAME RESERVE: HIMLER DORFLING, LISHA MOORE, WARREN MOORE, CHRISTEL SCHOEMAN
KIRKMAN'S KAMP: NIALL ANDERSON, SONYA CALDECOTT
KRUGER MPUMALANGA INTERNATIONAL AIRPORT: ROWAN TORR
KUNAME RIVER LODGE: SUE GALLAGHER, CARMEN GRAMANN, TSAKANI IGNATUIS MALULEKE, SEAN MATTHEWSON
KWANDWE ECCA LODGE, GREAT FISH RIVER LODGE AND UPLANDS HOMESTEAD: TIM CARR, DEBBIE GODFREY, ROBBIE GRANT, SIMONE MULLER
LEADWOOD LODGE: KELLY RYDER
LEOPARD HILLS PRIVATE GAME RESERVE: NIKI HOPKINS, DUNCAN RODGERS, LOUISE RODGERS, JOHAN SCHOLTZ, KELLY WHITFIELD
LION SANDS IVORY LODGE AND RIVER LODGE: NIKKI HERBST, LUCKY MABASO, OLIVER RICHTER, PETER JOHN SCOTT
LONDOLOZI GAME RESERVE: CHRIS KANE, BRONWYN MAY VARTY
LUKIMBI SAFARI LODGE: LEONARDO BURCKARD, CRAIG GEBHARDT, NONHLANHLA MAGAGULA, LOUIS MARAIS
MADIKWE HILLS PRIVATE GAME LODGE: ADRIËNNE DE CLERK, HENNIE DE CLERK, RIAAN FOURIE, MAX LETSHAVITI, PERTUNIA NKUNA, NICKY TAYLOR
MADIKWE SAFARI LODGE: WILNA BEUKES, BRIAN DE GRUCHY, MAVIS NKGOTHOE, CLIVE SELOMANE, VALERI SENEKAL, LEONIE STOKKER, SHAUN STRYDOM, STEVEN WOODALL

MAKANYANE SAFARI LODGE: GARTH KEW

MAKWETI SAFARI LODGE: HELEN WILSON

MATEYA SAFARI LODGE: SUSAN W MATHIS, JANE BAFSHOE, INNOCENT CHIMENYA, SHAI GOODMAN, ANNA MAETLA, ELLEN MATLAPENG, GARY OPPERMAN, OLEFILE PANANA, KK THETHE

NEDILE LODGE: HENNIE KRIEL

NGALA SAFARI LODGE AND TENTED CAMP: JANE BAKER, JONATHAN BRAACK

NKORHO BUSH LODGE: DIRK BECKER, JACQUI BECKER

NOTTEN'S BUSH CAMP: DALE GOLDSCHMIDT, GRANT NOTTEN, BAMBI NOTTEN, GILLY NOTTEN

PERCY FITZPATRICK INSTITUTE OF AFRICAN ORNITHOLOGY, UNIVERSITY OF CAPE TOWN: HILARY BUCHANAN, IAN TCHAGRA LITTLE, MICHAEL MILLS

PHINDA FOREST LODGE, MOUNTAIN LODGE, ROCK LODGE, VLEI LODGE, ZUKA LODGE, GETTY HOUSE AND WALKING SAFARIS CAMP: HENDRIK FEHSENFELD, SIFISO ANDRIES MADONSELA, CLAIRE POTGIETER, VALERI SENEKAL

RHULANI SAFARI LODGE: NATALIE LAPPEMAN, JACOB MAKOLA, GRANT MARCUS, DAVE SUTHERLAND, SEAN VAN DER MERWE

RIVER LODGE: ANDREW SCHOEMAN, NICOLENE SCHOEMAN

ROYAL MALEWANE: PHIL BIDEN, LIZ BIDEN, LORNA KLEIDMAN, GRAIG MCFARLANE

SABI SABI EARTH LODGE: STEPHAN KRITZINGER, PATRICK SHORTEN, ROD WYNDHAM

SANBONA WILDLIFE RESERVE: IGNUS LE ROUX

SAVANNA PRIVATE GAME RESERVE: PADDY HAGELTHORN, IRENE MABUZA, STANLEY MABUZA, THEMBINKOSI NDLOVU, LYBON NKUNA, IAN WHYTE, NATASHA WHYTE, NIEL WHYTE, PRECIOUS ZWANE

SEASONS IN AFRICA: SAMANTHA GARRATT

SEDIBA LETLAPA LODGE AND LETLAPALA LODGE: HAPPYNESS NKOSIE, VICTOR NKOSIE, SARA NKU, DAISY SANGWENI, ANNAH SEHLARE

SHAMWARI BAYETHE TENTED LODGE, EAGLES CRAG LODGE AND LOBENGULA LODGE: JASON GOLDSMITH, IGNUS LE ROUX, DAVID OLSEN

SHIBULA LODGE: FRANCOIS KLOMP

SIMBAMBILI GAME LODGE: DOCTOR MBHANYISI, MARK VAN SCHALKWIJK

SINGITA BOULDERS LODGE, EBONY LODGE, LEBOMBO LODGE AND SWENI LODGE: JUSTICIA BEST BOYS, SEAN BISSETT, NKUNA GEORGE, SEAN INGLES, FRANK LOUW, KERRYN MUDIE, THEMBA NDLOVU

TANDA TULA SAFARI CAMP: ALISON ROBIN MOORE

TAU GAME LODGE: BENJAMIN MOLOTSI, RENATE OOSTHUIZEN

THANDA PRIVATE GAME RESERVE: EPHRAIM MATHE, SIMA NDLELA, RICHARD PHIRI, BIANCA SHAW, MARTIN SIBANYONI, VICTORIA SMITH

TINGA LEGENDS LODGE AND NARINA LODGE: SEAN BRADLEY, NELEK CHAUKE, PAULA KEEN, FRANCOIS LIEBENBERG

TSWALU KALAHARI RESERVE: WILLIAM DE REUK, BLESSING DLAMINI, THERESA FEHRSEN, MURRY LETCHER, TAKKUNI MOTI, BRENDON ROUSSEAU, SHARON STAINTHROPE, LYRENE ZIMMERMAN

TUNINGI SAFARI LODGE: KATE NAUGHTON

ULUSABA PRIVATE GAME RESERVE: SIR RICHARD BRANSON, NICOLA FUHRI, DAVID KHOZA, ILANÉ LANGDON, KARL LANGDON, CHRIS SCHOOMBE

The organisation of transfers between seventy-two lodges and safari camps in often very remote locations in the wild was quite a challenge. I am especially grateful to Ian and Lee-Ann Williams, Laurance Buric, Ruette Roberts, Adam Mosima and Richard Swanervelder of Waterberg Transfers; Bettie Bester, Lucky Kgohloane, Johan Scoltz and Anelle Vermeulen of Eastgate Safaris; Keith Benjamin of Kab Tours and Transfers; Karen Schultz of SquareRoute Corporate Transfers; and Seela Moodley of Umhlanga Explorer for their assistance, generosity, professionalism and friendship. Their sterling service is personally recommended. Being driven to your destination in comfort after a domestic or long international flight serves as a perfect introduction to the scenic splendour of Africa's great outdoors. Choosing this option allows you to sit back, relax and enjoy the commentary provided by your expert guide, while you sip a complimentary bottle of chilled mineral water and admire the scenery.

REGIONAL TRANSFER COMPANIES

KWAZULU-NATAL	KWAZULU-NATAL	LIMPOPO	MPUMALANGA
SQUAREROUTE CORPORATE TRANSFERS	UMHLANGA EXPLORER	WATERBERG TRANSFERS	EASTGATE SAFARIS

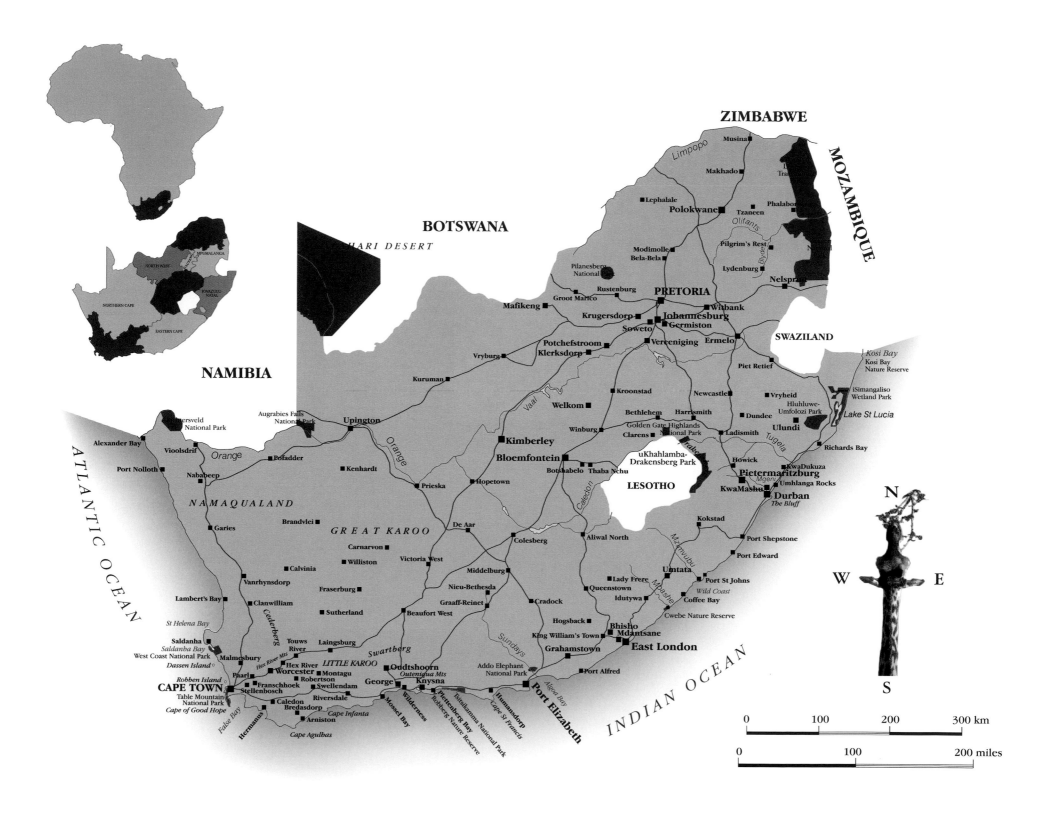

ZIMBABWE

MOZAMBIQUE

BOTSWANA

KALAHARI DESERT

NAMIBIA

SWAZILAND

LESOTHO

ATLANTIC OCEAN

INDIAN OCEAN

Limpopo

Musina

Makhado

Lephalale

Polokwane

Tzaneen

Phalaborwa

Modimolle
Bela-Bela

Pilgrim's Rest

Olifants

Pilanesberg
National

Lydenburg

Blyde

Nelspruit

Rustenburg

Groot Marico

PRETORIA

Witbank

Mafikeng

Krugersdorp

Johannesburg
Germiston

Soweto

Potchefstroom

Vereeniging

Ermelo

Vryburg

Klerksdorp

Piet Retief

Kosi Bay
Kosi Bay
Nature Reserve

Kuruman

Kroonstad

Newcastle

Vryheid

iSimangaliso
Wetland Park

Welkom

Bethlehem

Harrismith

Dundee

Hluhluwe-
Umfolozi Park

Lake St Lucia

Winburg

Golden Gate Highlands
National Park

Ladismith

Ulundi

Augrabies Falls
National Park

Upington

Vaal

Clarens

Richards Bay

Namersveld
National Park

Alexander Bay

Vioolsdrif

Orange

Pofadder

Kimberley

Bloemfontein

Botshabelo Thaba Nchu

uKhahlamba-
Drakensberg Park

Howick

KwaDukuza

Pietermaritzburg

Umhlanga Rocks

Port Nolloth

Nababeep

Kenhardt

KwaMashu

Durban
The Bluff

Prieska

Hopetown

LESOTHO

NAMAQUALAND

Mgeni

Kokstad

Garies

Brandvlei

GREAT KAROO

De Aar

Port Shepstone

Carnarvon

Colesberg

Aliwal North

Mzimvubu

Port Edward

Calvinia

Williston

Victoria West

Umtata

Port St Johns

Vanrhynsdorp

Lady Frere

Queenstown

Wild Coast

Fraserburg

Middelburg

Nieu-Bethesda

Idutywa

Coffee Bay

Lambert's Bay

Clanwilliam

Sutherland

Graaff-Reinet

Cradock

Cwebe Nature Reserve

St Helena Bay

Cederberg

Beaufort West

Hogsback

Bhisho

Mdantsane

King William's Town

Saldanha
Saldanha Bay
West Coast National Park
Dassen Island

Touws
River

Laingsburg

Grahamstown

East London

Malmesbury

Hex River Mts

Swartberg

Sundays

Paarl

Hex River

LITTLE KAROO

Oudtshoorn

Addo Elephant
National Park

Port Alfred

Robben Island

Worcester

Montagu

Outeniqua Mts

Knysna

Algoa Bay

CAPE TOWN

Franschhoek

Robertson

George

Port Elizabeth

Table Mountain
National Park

Stellenbosch

Swellendam

Riversdale

Wilderness

Pietenberg Bay

Cape of Good Hope

Caledon
Bredasdorp

Cape Infanta

Mossel Bay

Robberg Nature Reserve

Humansdorp

False Bay

Hermanus

Arniston

Tsitsikamma National Park

Cape St Francis

Cape Agulhas

N

W E

S

0 100 200 300 km

0 100 200 miles

Introduction

Imagine a life-altering adventure holiday beyond all expectations in the wilds of Africa. Your safari lodge is an oasis of unbridled luxury, contemporary decor and attentive, well-trained staff. The atmosphere exudes freedom, charm and hospitality, and your every desire is catered for – from health spa treatments to fine cuisine to exotic cocktails at the swimming pool. From your lodge, you have unimpeded views of one of the most spectacular natural environments on earth, pristine and little changed since the dawn of time.

Imagine the sheer exhilaration of a game drive, setting off at first light with a dedicated ranger and an expert tracker in an open-roof, off-road vehicle to see nocturnal animals 'coming off night shift'. The sun rises spectacularly and the lush veld is bathed in a golden glow, illuminating the terrain with an alluring countenance that photographers dream of. It is a time when dew drops glisten on spiderwebs, leaves sparkle in the sunlight of a new day, and the pungent, herbaceous scent of early morning fills the air.

Imagine the thrill of the chase as you track Africa's Big Five – lion, elephant, African buffalo, rhinoceros and leopard – and the many smaller creatures that make for wonderful game viewing.

Imagine a gourmet breakfast taken leisurely on a terrace overlooking a river or a long, lazy lunch followed by a siesta. At around 4 p.m., tea and biscuits are served on the terrace before you head off on safari. Sundowners are taken in the bush, just as the setting sun casts long, photogenic shadows across the landscape. Then it is time to head back to camp, all the while observing wild creatures caught in the searchlights. Upon your return, you are treated to fresh drinks, hot towels and a rejuvenating bath. This is followed by a sojourn to the well-stocked bar where experiences of the day are shared before enjoying an unforgettable culinary feast. Then fall asleep to a chorus of crickets and frogs, roaring lions and laughing hyaenas.

Imagine.

Gerald Hoberman

GERALD HOBERMAN

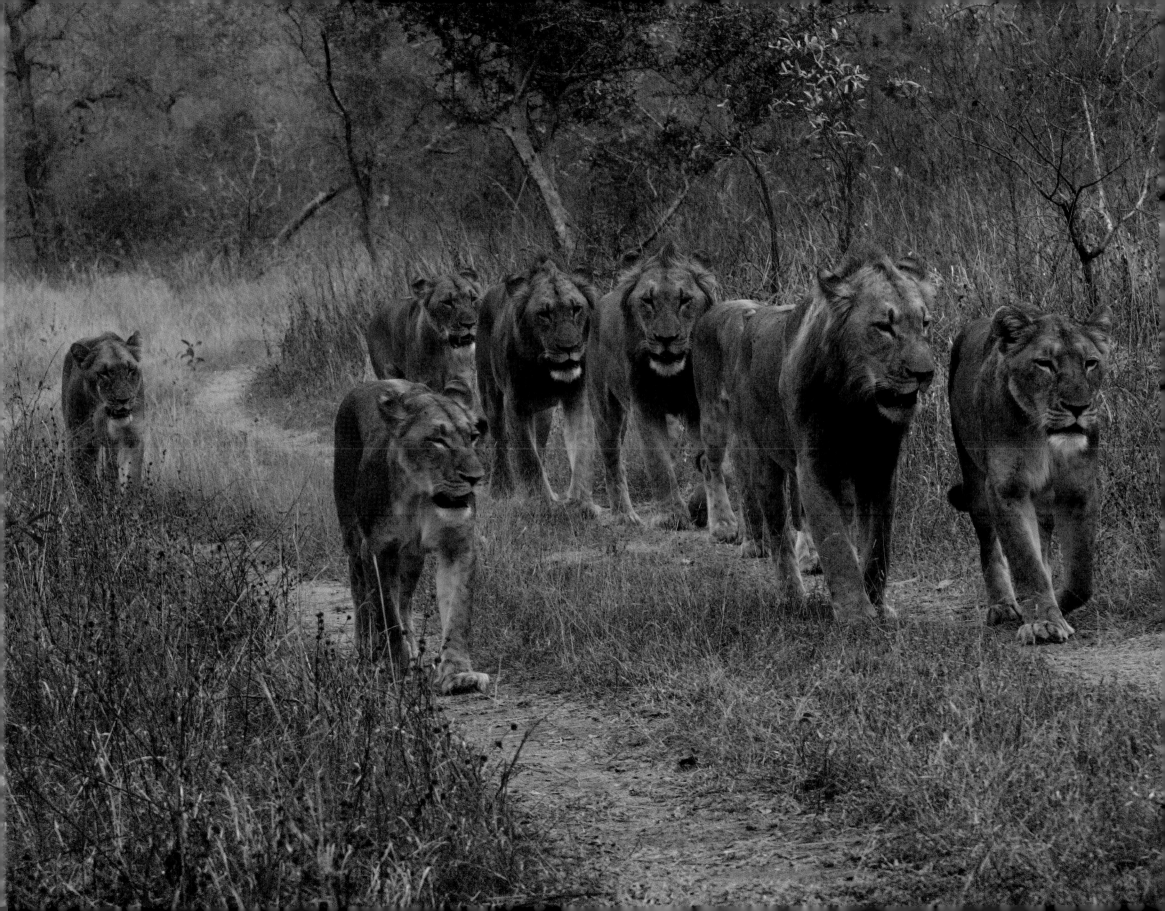

Kwandwe

ECCA LODGE & UPLANDS HOMESTEAD

Fun, flamboyant and fabulous are words that spring to mind when describing the lodges in the expansive Kwandwe Private Game Reserve in the Eastern Cape. Here visitors have a choice of four lodges – Ecca Lodge, Uplands Homestead, Melton Manor and Great Fish River Lodge – all situated within range of the Great Fish River, which flows through the reserve.

The interior design of Ecca Lodge (this and opposite page) combines clean, contemporary furnishings with venerable, old collectibles from the area, giving an unconventional twist to the traditional. The six suites are airy and open with barely a barrier between the indoors and the surrounding veld. Rooms are spacious with ample places to sit and admire the views across the rolling hills.

Clean, contemporary chic does not mean children are not welcome at Kwandwe. The reserve has an interpretive centre with plenty of activities to entertain both young and old. Twice-daily game drives, night drives and guided river walks and hikes provide an opportunity to see a variety of animals in the wild. This is a game-rich area where, unusually, both black and white rhino are found, as well as a range of predators including cheetah, wild dog, lion and leopard. Add to this elephant and buffalo and you have your Big Five and more.

At the entrance to the reserve is the reception building, known as Heatherton Towers. Complete with two gun turrets at either end of the fortified building, the former homestead dates from the Frontier War era, during which, in the eighteenth and nineteenth centuries, a series of wars and battles over land were waged between the Khoisan, Xhosa, trekboers and British settlers.

To the south-west of Ecca Lodge is Uplands Homestead (overleaf). Set in a remote valley, this beautifully restored 1905 farmhouse offers home comforts perfect for the sole use of a family or group of up to six. Antiques and memorabilia blend comfortably with contemporary finishes. Outside, the ultimate modern addition is a swimming pool, set apart from the house.

Part of the Conservation Corporation Africa (CC Africa) stable of lodges and reserves, Kwandwe Private Game Reserve is not far from historic Grahamstown and is a good final destination on a Garden Route tour.

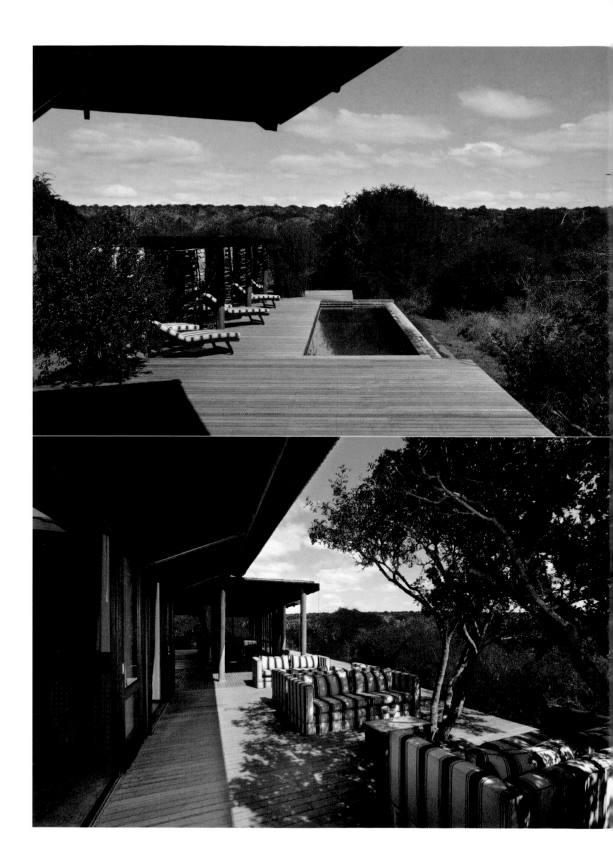

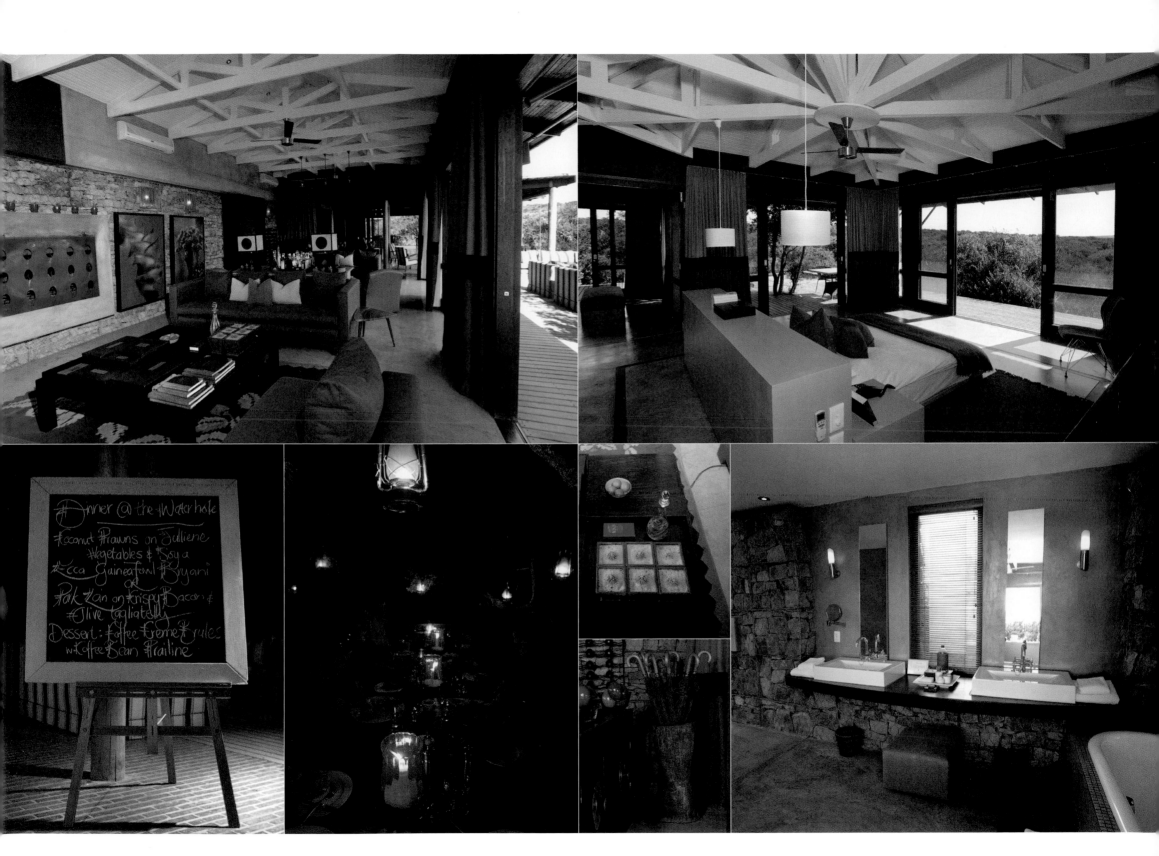

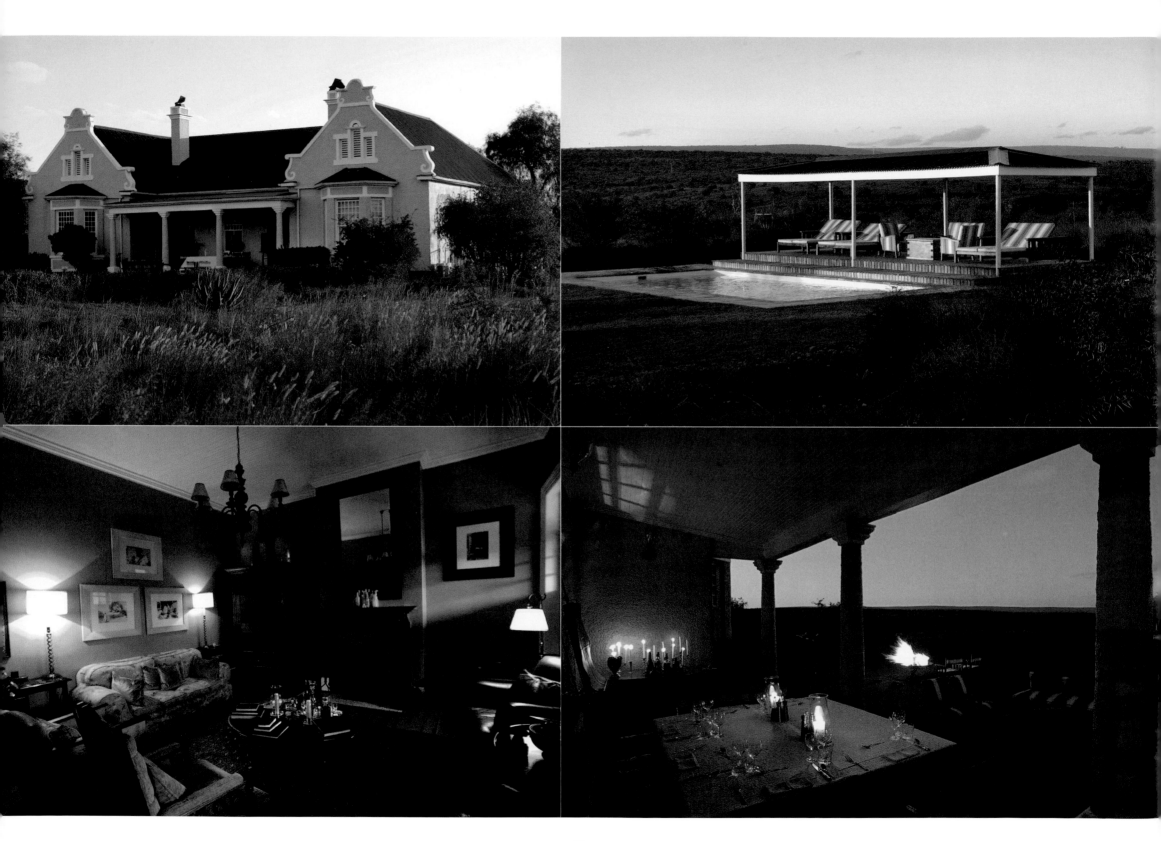

Kwandwe

GREAT FISH RIVER LODGE

The Great Fish River meanders through the Kwandwe Private Game Reserve. In a deep horseshoe bow in the river nestles the Great Fish River Lodge.

Taking its cue from the history of this part of the Eastern Cape, CC Africa's Great Fish River Lodge is furnished in 'frontier settler' style. Early-settler antique china, pewter and silver are combined with African artefacts in a rich palette of earthy tones and crisp greys. The architecture of the guest area is ranch-style, with indigenous timber logs supporting a soaring thatch roof. A cosy fireplace and massive stone chimney dominate the central lounge.

The nine suites are designed to make the best use of the extravagant views across the river and the surrounding wilderness. Floor-to-ceiling glass doors fold back to provide uninterrupted vistas. Added to this are private plunge pools and decks overlooking the water. Although temperatures can get up to 36°C in summer – when a cool pool is just what is needed – this part of the Eastern Cape has an enviously mild climate throughout most of the year.

Settlers surely never had the kind of cuisine you are served at Great Fish River Lodge. The chef's pan-African menu is created with an international palate and the accompaniment of fine wines in mind. Eating meals by candlelight in the dining room or by firelight in the boma may be reminiscent of bygone days, but nothing can top Kwandwe's bush banquet by lantern light deep in the backwoods.

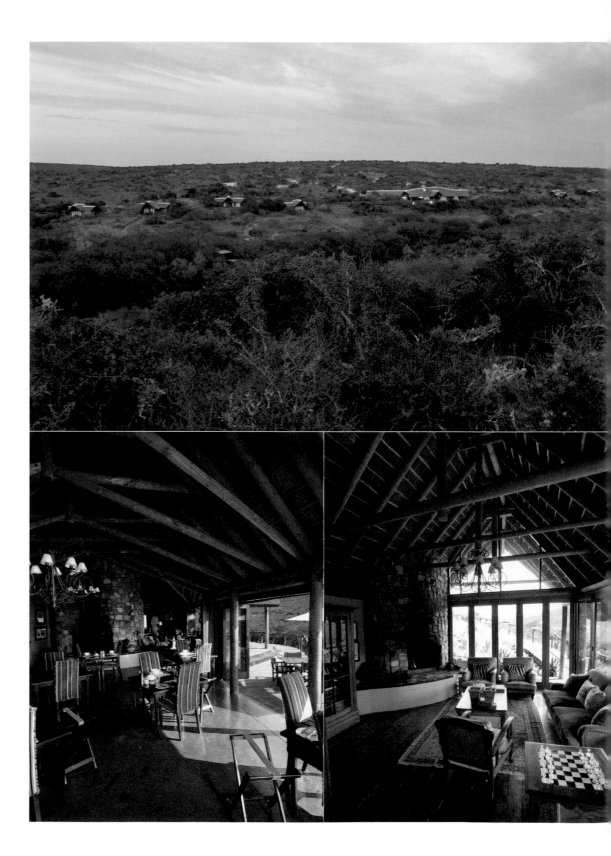

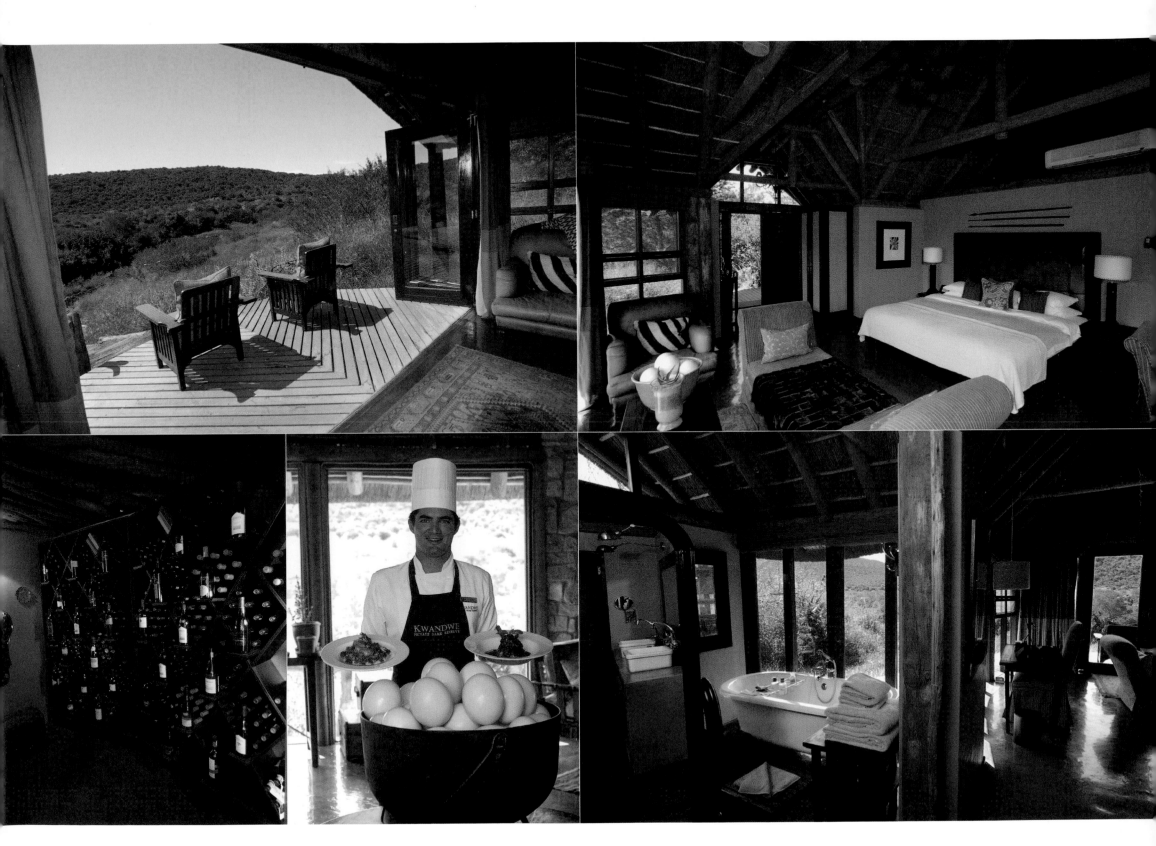

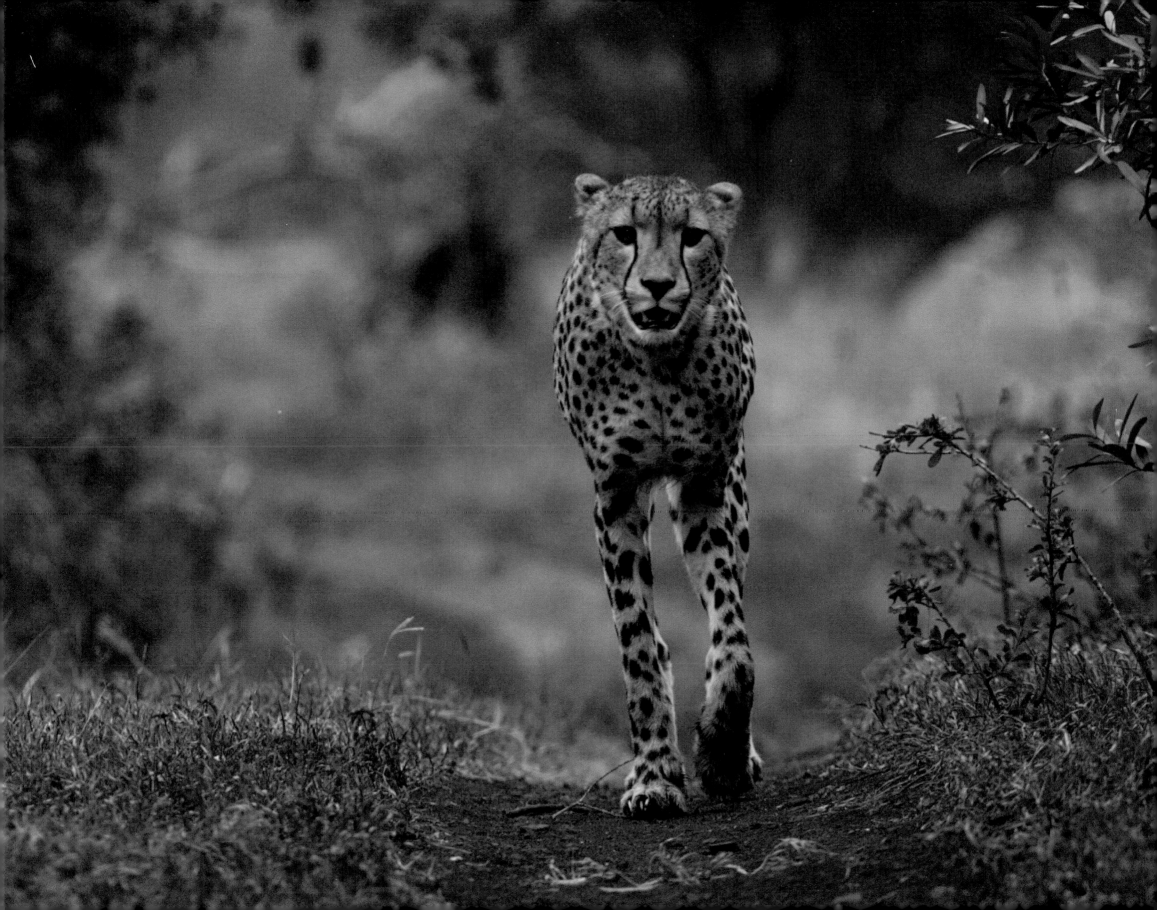

Shamwari
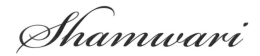

EAGLES CRAG LODGE

The name 'Shamwari' is synonymous with African safaris. This prestigious game reserve in the Eastern Cape has a high international profile, and the constant stream of glamorous visitors who choose to stay in its lodges keeps it firmly in the limelight. It is understandable then that its name is never far from the lips of potential visitors when they decide which game reserve to visit in South Africa.

But it was not always so. In 1990, the land that now constitutes the 20 000-hectare Shamwari Game Reserve was little more than an eroded dust bowl of overgrazed farmland. It was a far cry from its original wild state, described in the nineteenth century as one of the richest wildlife regions in Africa. The new owner of the land, Adrian Gardiner, had a dream of returning the area to its former glory, with buffalo, rhino, leopard, lion and elephant roaming the wooded hills and bushy valleys. In short, he wanted to bring the Big Five back to the Eastern Cape. In 2000, his dream came to fruition when the first lion to range free on this land since 1870 was released into the wild.

Today, Shamwari has been returned to its rightful owners: the flora and fauna of the region. Visitors who come from all over the world to share in this extraordinary success story can choose from an array of accommodation styles, with Eagles Crag topping the bill. Described as the ultimate in luxury, Eagles Crag has been the choice of local and international visitors.

Thatch and stone in part give way to sliding glass doors, providing guests with breathtaking views of rolling hills and gorges, clad with riverine thicket and aloes that glow a flaming orange in winter. Add a private deck with a pool, indoor and outdoor showers, original artworks and a four-poster bed to the equation and you have maximum privacy and superior luxury.

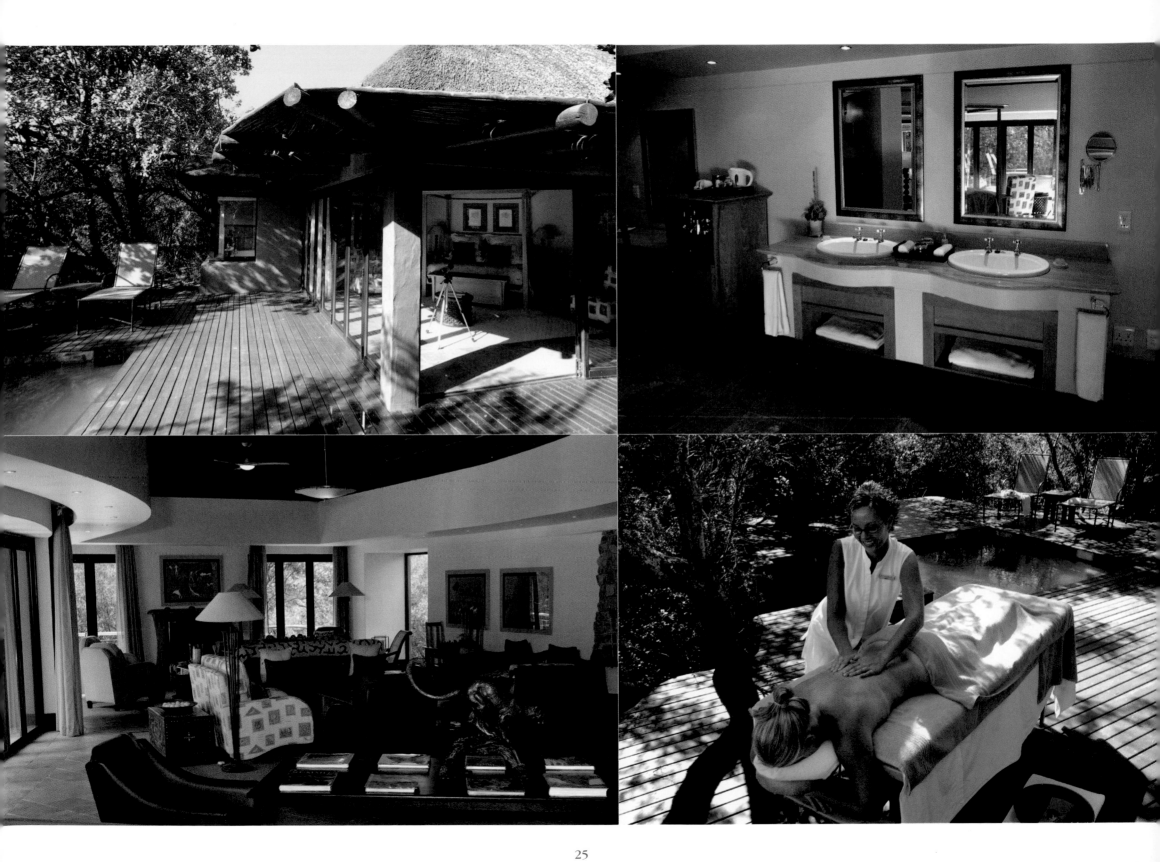

(left)

"The mating lion stopped and charged in our direction."

(below, right)

"These lions had severed the tendons of the gemsbok's hind legs. However, the antelope managed to drag itself in front of a large, impenetrable thorn bush, thus preventing attack from behind. Nevertheless, the lions attempted to stalk the gemsbok through the thorn bush, which proved somewhat painful for the big cats. The gemsbok's formidable rapier-like horns protected it from a frontal attack by the lions. The pride waited until nightfall when, with the aid of their superior night vision, they managed to reach their weakened quarry."

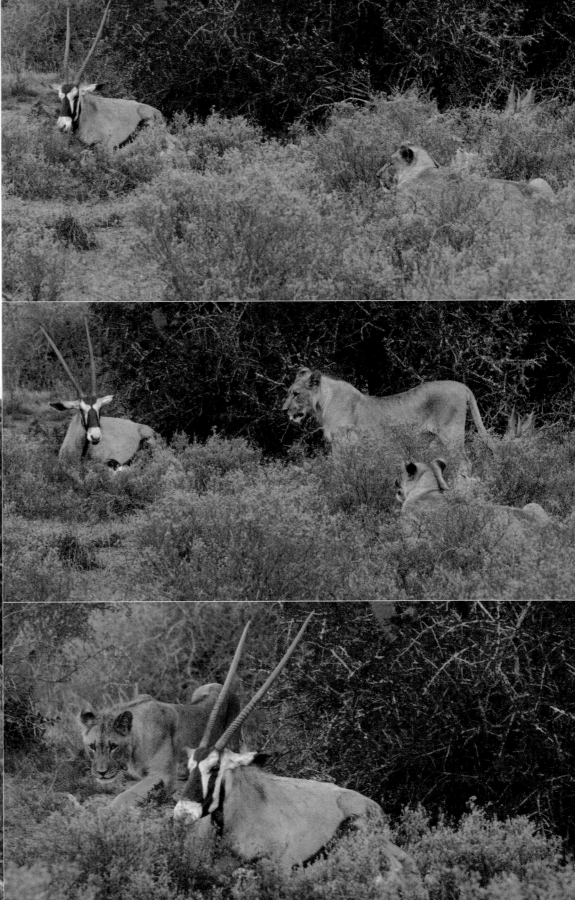

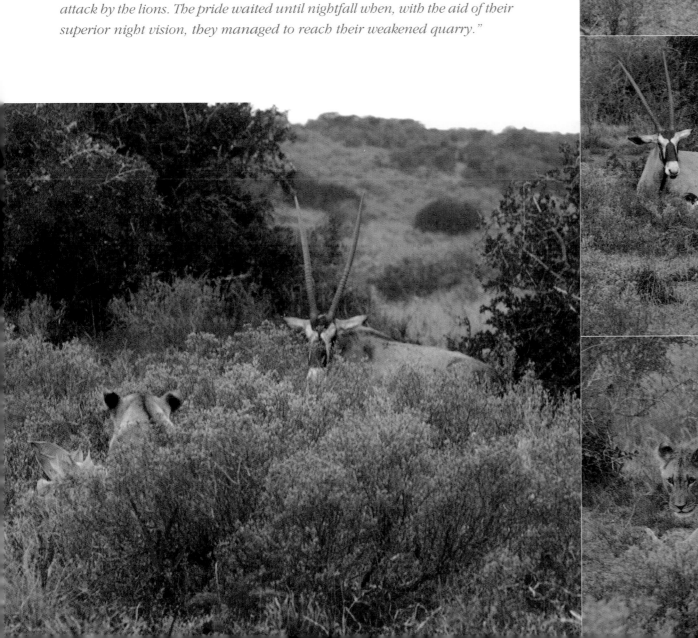

Shamwari

LOBENGULA LODGE

Set amidst the dense bush of an Eastern Cape valley, Lobengula Lodge, in the famous Shamwari Game Reserve, guarantees a quintessentially African experience. The rich palette of earthy colours, the woven textures of the fabrics, and the colourful artworks all reassure you that you are most definitely in Africa.

But it is not only the decor for which people come to Shamwari; it is the malaria-free safari experience in the heart of the Eastern Cape that draws most visitors to the reserve. Animals roam across great swathes of land – just over an hour away by car from the coastal city of Port Elizabeth. This part of the world is known as the Sunshine Coast and it lives up to its name with an average of seven hours of sunshine per day and daytime temperatures ranging from 16°C to 28°C in summer and from 7°C to 20°C in winter.

For those who might find the temperature a tad hot, there is sufficient water at Lobengula in which to cool off. Guests can make use of the large communal swimming pool, conveniently situated right next to the bar, or take a dip in the exclusive plunge pool that comes with their luxury suite. Others might prefer to cool down by dozing on the bed in an air-conditioned room.

There is definitely a need for an afternoon siesta, if for no other reason than to digest the copious quantities of delicious food. Breakfast is served before the morning game drive in winter and after it in summer. Then lunch – a feast of soups, salads, fish, quiches and more – is served from midday till 3 p.m. Do not leave lunch too late or it will merge into afternoon high tea, with delectable cakes and irresistible tarts on offer. Be sure to save some room for the four-course dinner or the evening barbecue in the fire-lit boma. If all this seems like far too much work for one chef, you would be right. There are four chefs, all for a maximum of twelve guests.

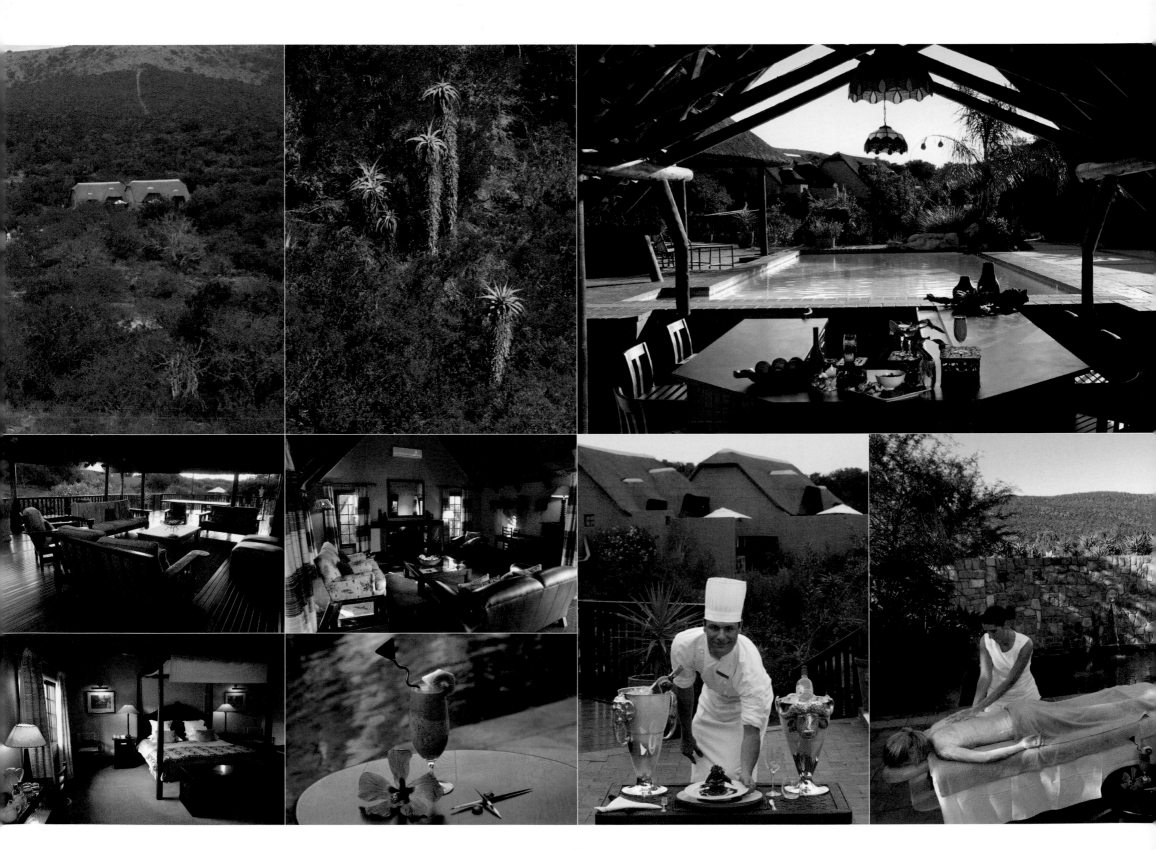

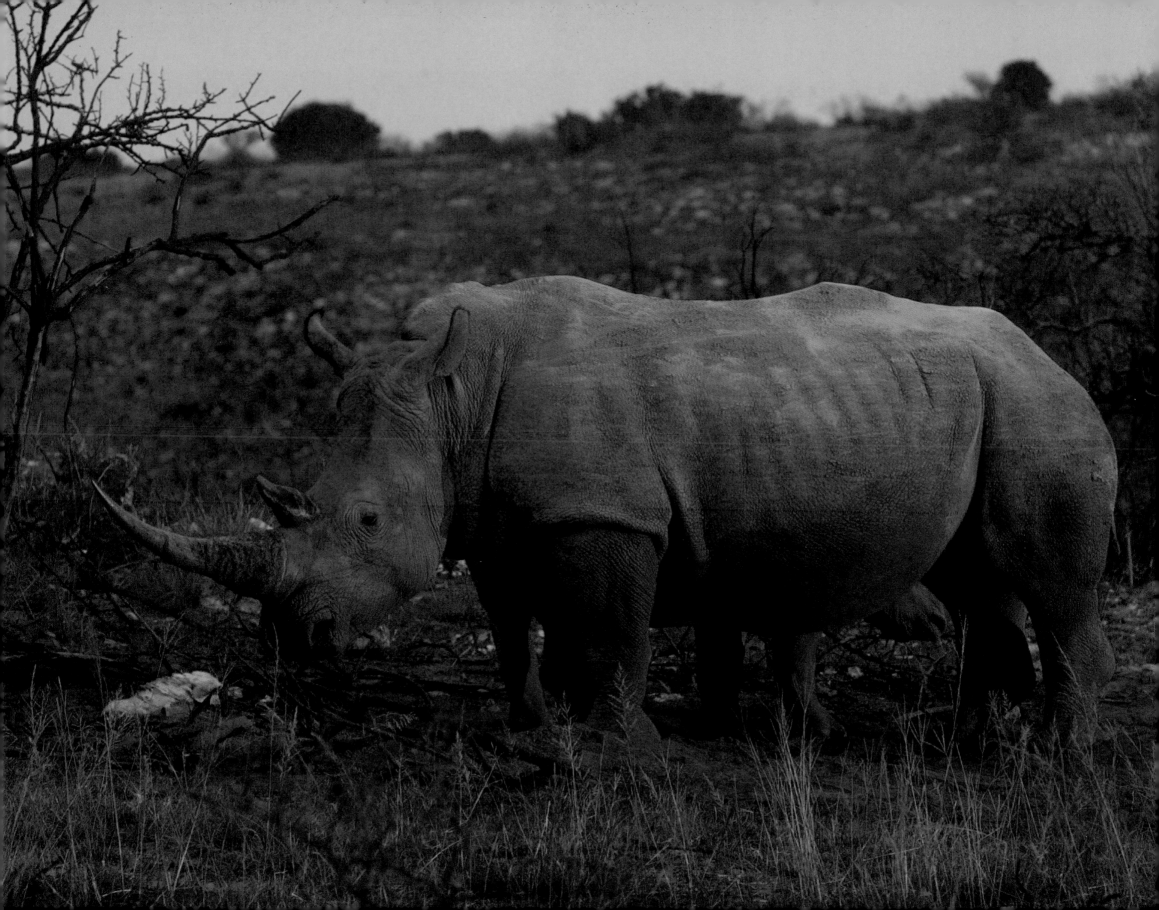

Shamwari

BAYETHE TENTED LODGE

Bayethe nkosi, the salutation given to a chief, is translated from isiXhosa as 'I salute you, honoured one'. This is the origin of the name of Shamwari Game Reserve's luxury tented lodge, Bayethe, where guests are welcomed with the same warmth and respect reserved for the most venerable.

The pulse of Africa is strong here in the Eastern Cape, the heartland of the amaXhosa people, whose language is characterised by a series of distinctive clicks. And while you are likely to be entranced by the sounds of one of South Africa's eleven official languages, you will not be expected to get the hang of it during your stay at Shamwari.

What you might get the hang of is telling one antelope from another and even distinguishing between the spoor of different animals. Herds of impala, waterbuck, nyala, springbok, bushbuck and other antelope flourish in the dense bush that covers the hills and valleys of the reserve. You will also get to know the difference between the endangered black rhino and the more common white rhino. Both species were reintroduced to this wilderness during the 1990s and have bred successfully. Other wild animals that have been reintroduced here include lion, elephant, leopard, buffalo and hyaena. The reserve is also a sanctuary for birds.

Shamwari has chosen the most comfortable of game-viewing vehicles – open Land Rovers, which give you a close-to-nature experience from the safety of an elevated position. The Shamwari rangers, who accompany you on early-morning and evening game drives, nature walks and birdwatching expeditions, are always eager to share their knowledge with you.

What makes Bayethe special and different from Shamwari's other lodges is that each of the nine plush tents is made of canvas walls and a thatched roof. Tented accommodation has never been this classy: your room not only has wooden floors and an en-suite, slate-tiled bathroom, but your elevated wooden terrace has its own plunge pool sunk into the deck. From the comfort of your viewing deck, in the shade of the surrounding trees, you can watch game pass by and eagles soar in the crisp, blue sky.

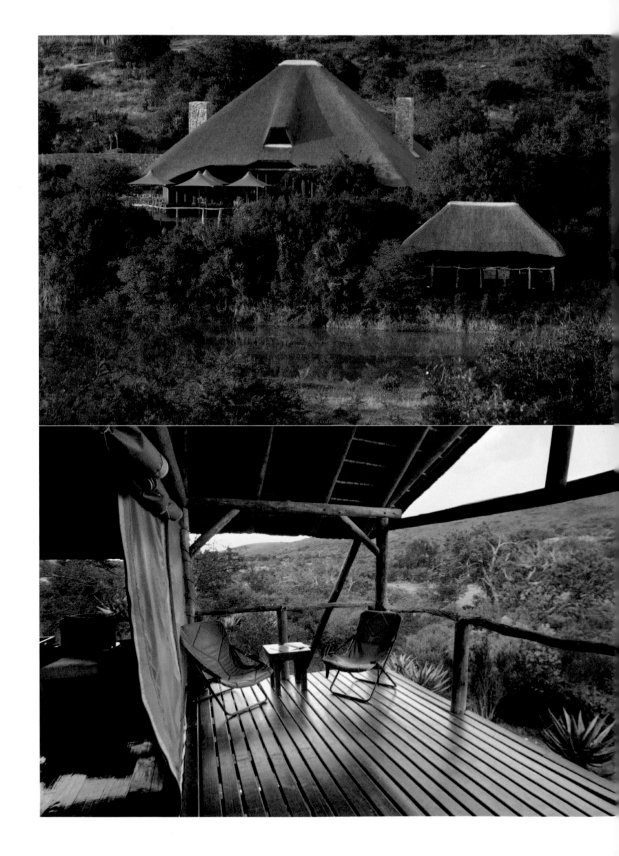

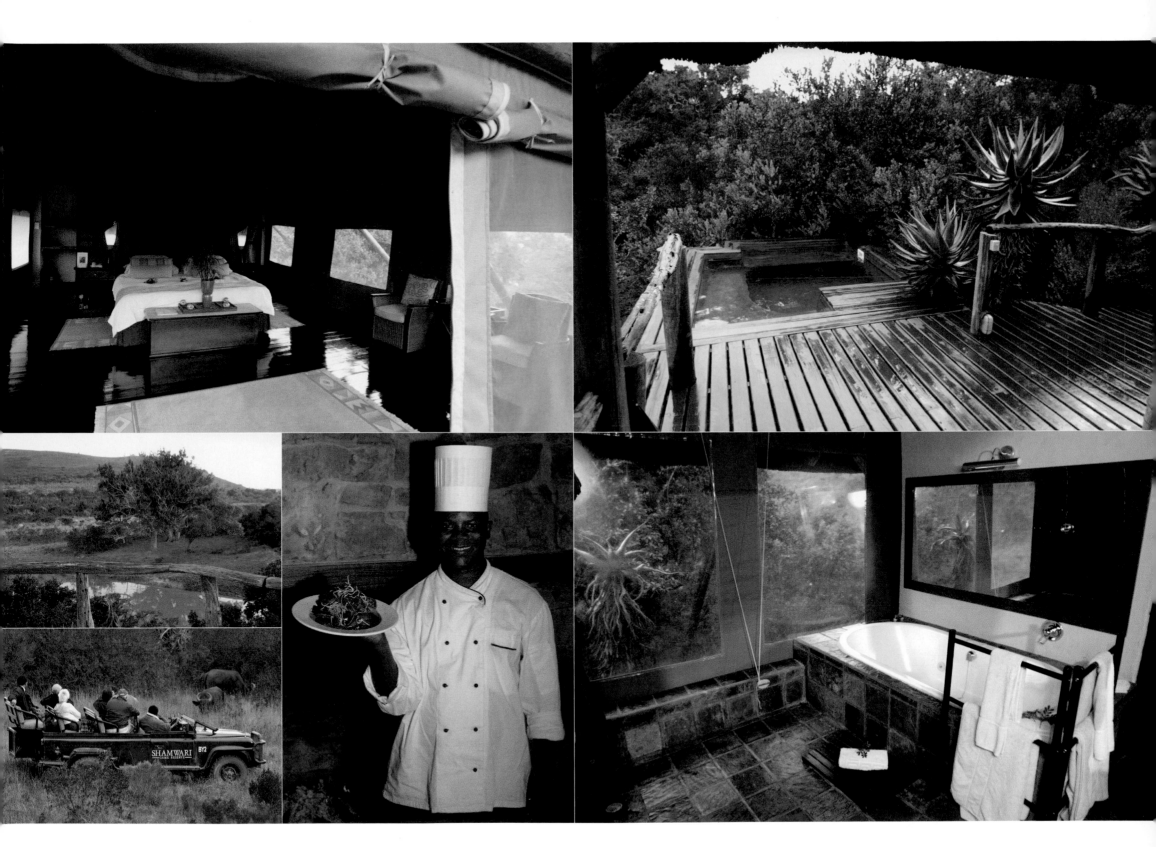

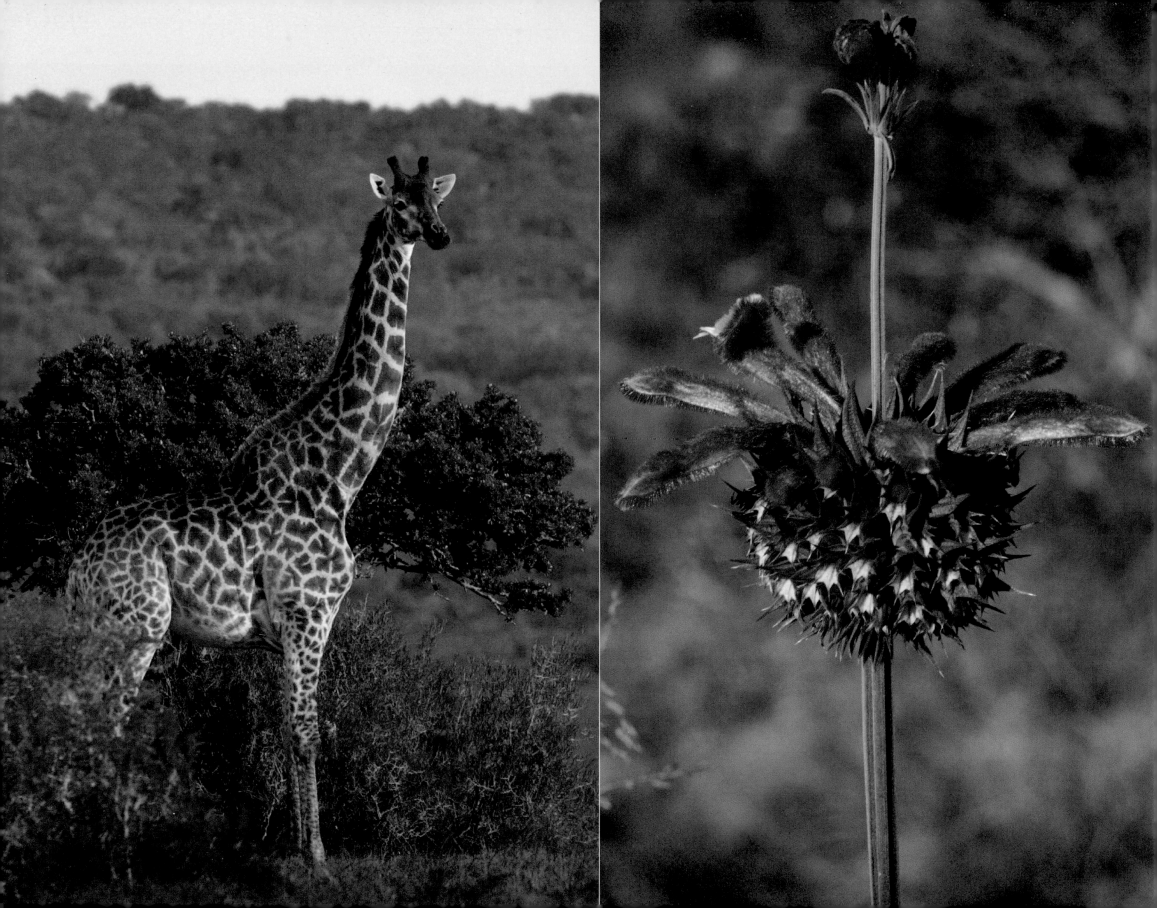

Intsomi

FOREST LODGE

Intsomi Forest Lodge in the Addo Elephant National Park in the Eastern Cape is a breath of fresh air because, although it shares similarities with traditional safari lodges, it departs from the norm with clean lines, uncluttered open spaces and light woods. Its eight suites are surrounded by a forest of huge old trees, including yellowwood, wild chestnut, stinkwood and coral. Three walls of each suite open up entirely to allow the outside and inside worlds to merge, and it becomes easy to imagine that you are in your own forest, full of birds and monkeys calling and chattering their way into your life.

Intsomi is the kind of place where you can slow down and enjoy all that nature has to offer. The 1 000 hectares of land on which the lodge is situated are home to indigenous game and fantastic bird and butterfly populations. Animals like eland, red hartebeest, zebra and buffalo can be found here, as well as the endangered oribi dwarf antelope. Horse trails will take you through the forest and over shifting dunefields along the coast, where ancient Khoisan middens can be visited.

If, at times, game drives, hikes or horse rides do not appeal, you could always relax at the swimming pool or have the wellness centre therapist massage away the stresses of life.

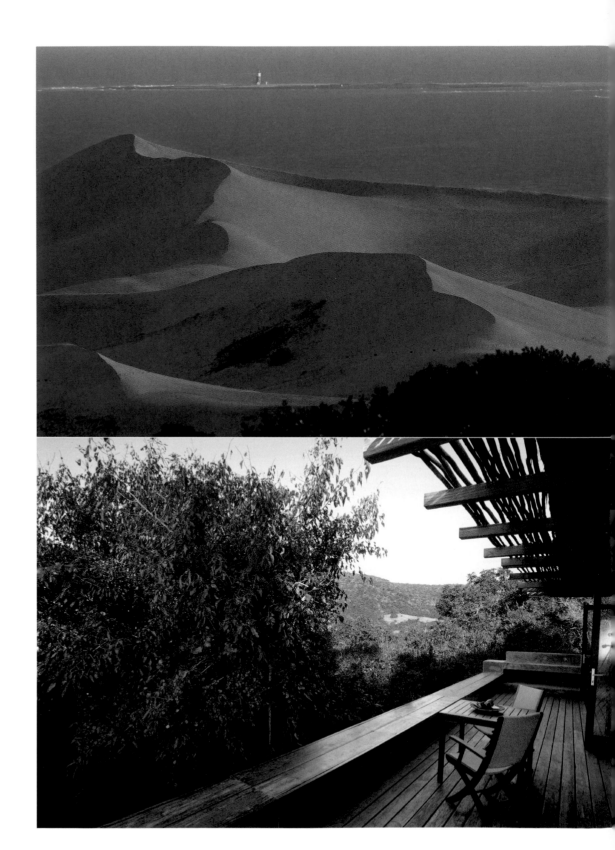

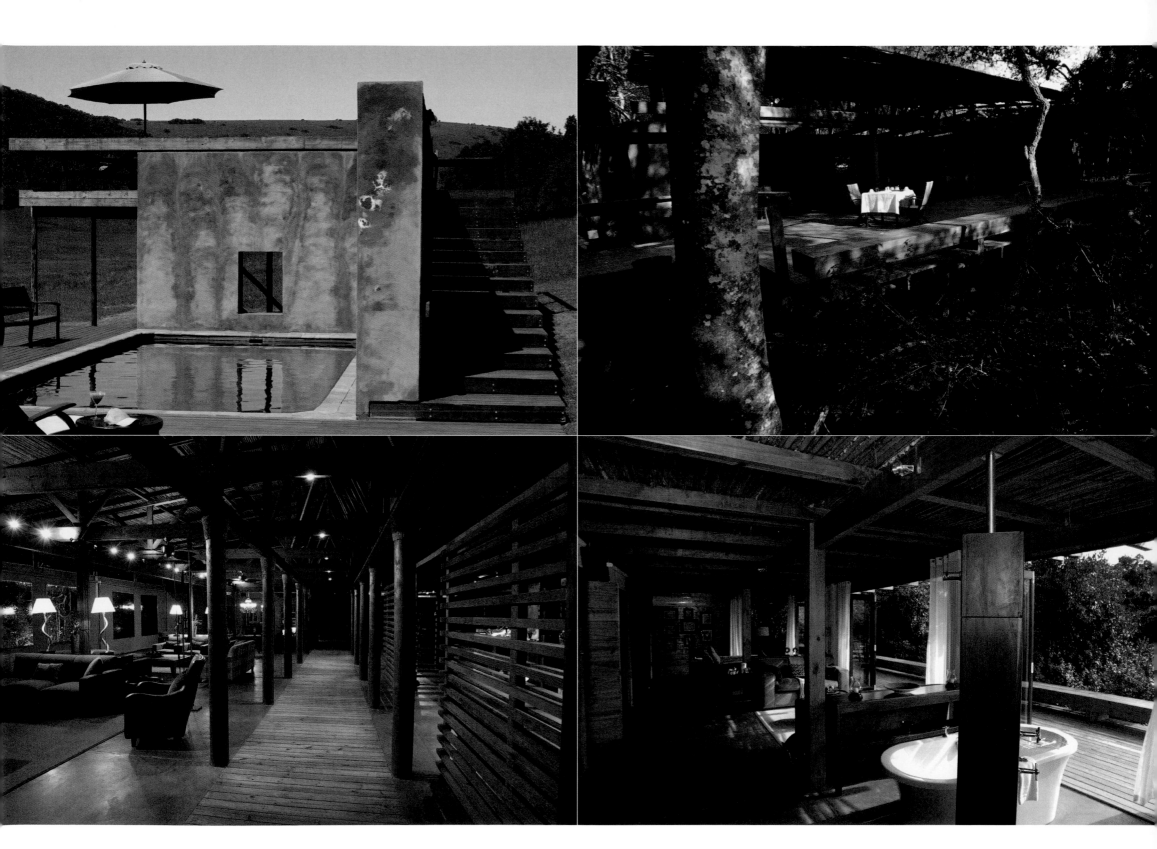

Hayward's
LUXURY SAFARIS

Peter Hayward is a pioneer with a vision. He does not only imagine a world of grand opulence; he creates it with his unique mobile safari operation. Stepping into Hayward's world is like lifting the flap on the past and entering a bygone era of luxury tented safaris in the grandest style, with waiters in white, silver-service dining, and a touch of Bedouin to spice things up.

World leaders and VIPs from the most prestigious corporations have been served by gloved waiters at events staged by Hayward's. A Hayward's safari is for any discerning group of 40 to 120 people, who want to experience, even only fleetingly, a touch of high-society safari life.

Hayward's camp is mobile and its portability means that its collection of tent poles and billowing white drapes can be positioned in extraordinary places. The camp has been seen in the Cradle of Humankind World Heritage Site near Johannesburg, the iSimangaliso Wetland Park, a World Heritage Site in KwaZulu-Natal, the West Coast National Park near Cape Town, the Pilanesberg National Park in North West province, the Kruger National Park in north-eastern South Africa, and the oldest desert in the world, the Namib Desert in Namibia.

Accommodation is in safari tents with en-suite bathrooms. The sturdy camp beds are covered in cream linens and soft pillows, allowing for maximum comfort. Before settling into bed, there is much wining and dining to be enjoyed. Culinary showpieces, complemented by fine wines, are served in the Gin Tent. Dinners can be themed 'Classical White Nights', 'Ethnic African Trader' or 'Out of Africa'. No more far-fetched is the option of having a massage in a large tent in the middle of the wilds of Africa. Afterwards, peruse some old African literary works in the library or examine collectibles in the Trader's Store.

The team at Hayward's Luxury Safaris has given the meaning of safari a whole new dimension. For them, nothing is impossible.

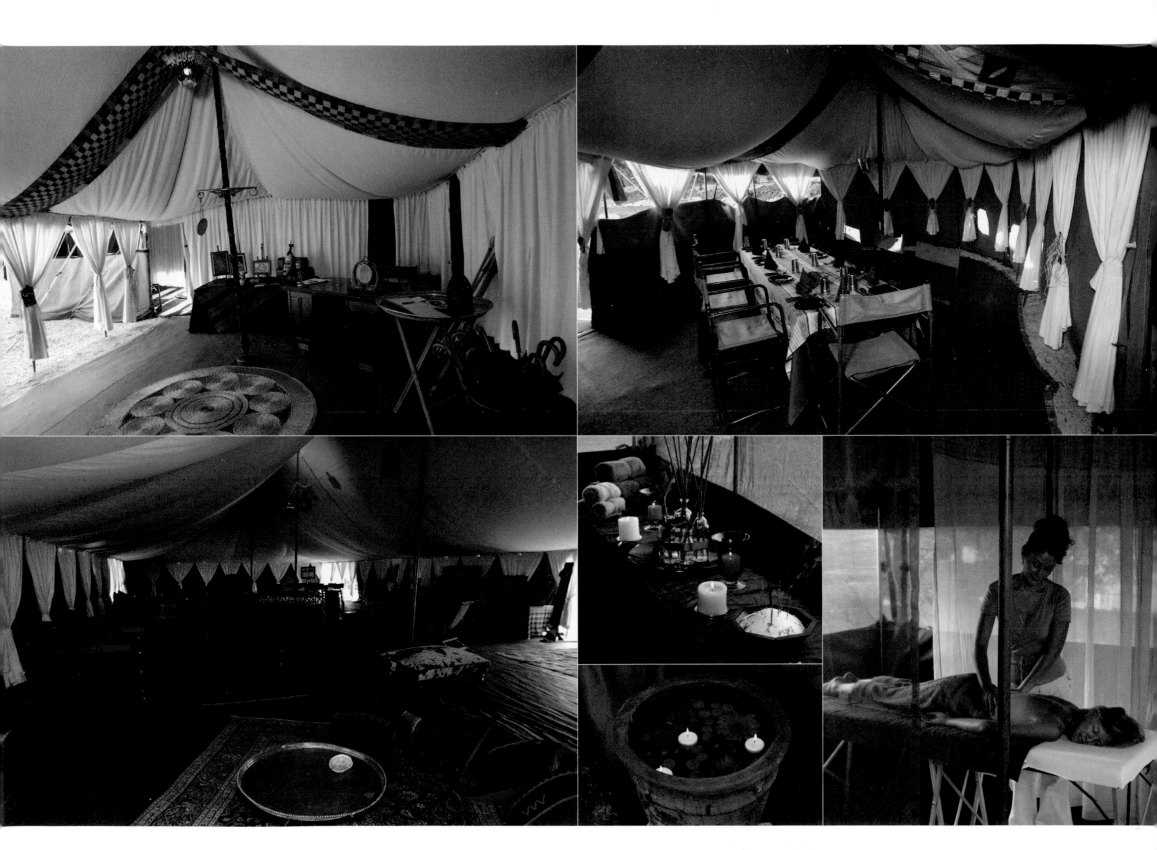

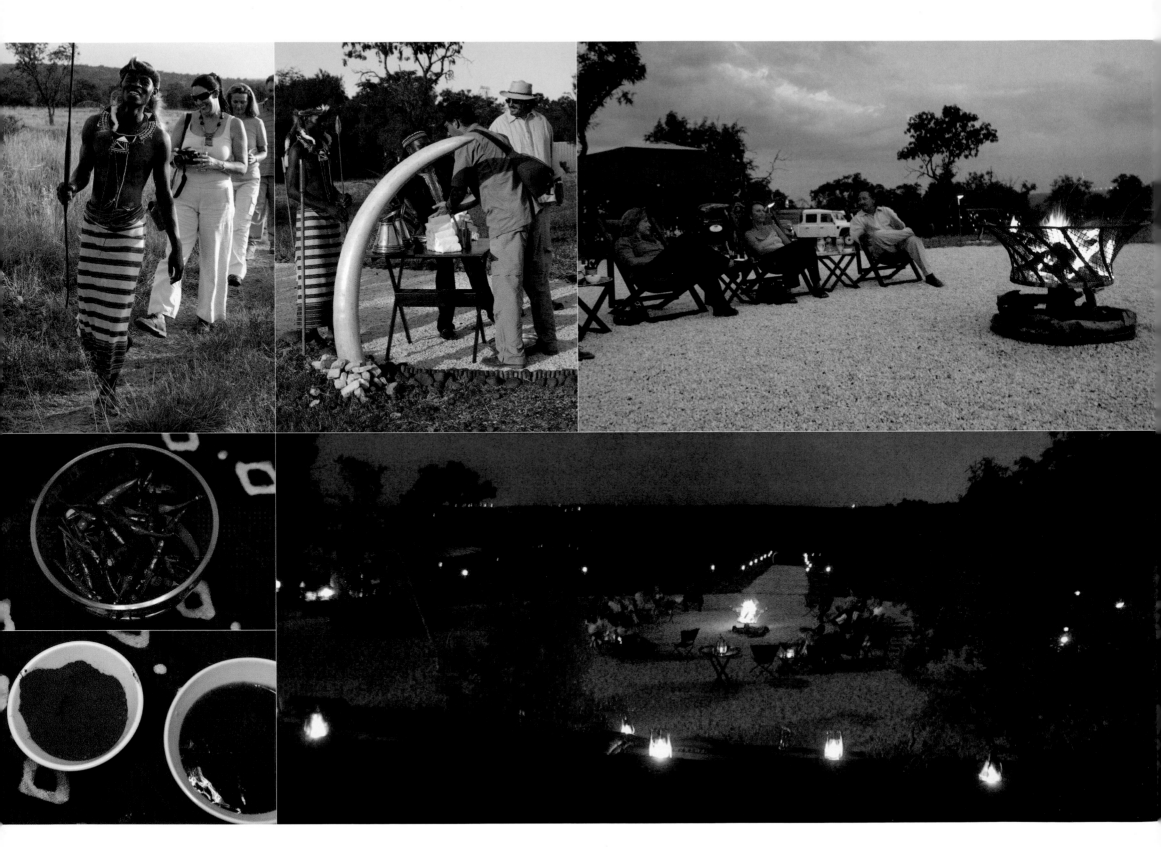

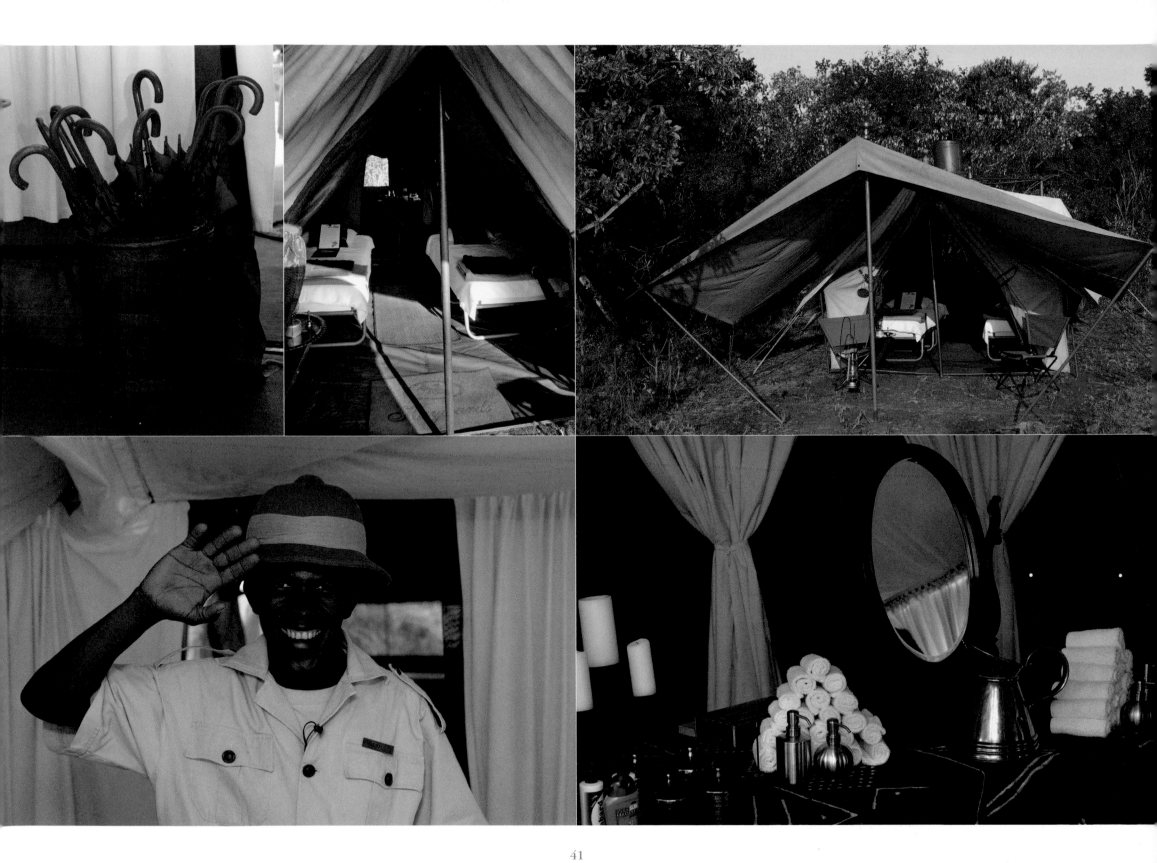

Phinda

MOUNTAIN LODGE & ROCK LODGE

Encompassing 22 000 hectares of pristine wilderness, the Phinda Private Game Reserve in KwaZulu-Natal, with six lodges and one tented camp, is the flagship operation of CC Africa. Phinda's establishment in 1991 saw the transformation of thousands of hectares of depleted farmland into pristine wilderness and the introduction of a variety of wild animals in the biggest game relocation project undertaken by a private reserve in the world at the time.

Mountain Lodge (this page) is Phinda's largest safari lodge. Its twenty split-level suites are dramatically perched on the crest of a mountain in the Ubombo range. Wrap-around views are such that you need not move from your private veranda to be impressed.

Shades of reds, browns and creams dominate the interior of the lodge, where avant-garde meets ethnic with a modern edge.

This bold fusion of contemporary and tribal applies to the food too. The pan-African cuisine served here combines the best of traditional Africa with the adventurous tastes appreciated by a modern palate. Meals are served in a walled boma illuminated by dozens of candles and lanterns or in a clearing under a star-studded sky. Phinda is famous for its bush banquets in unexpected settings, and guests are literally and metaphorically kept in the dark until they are asked to follow a lantern-lit path to tables that have been exquisitely laid for dinner.

Rock Lodge (opposite page) is set into a rugged cliff, permitting spectacular views of the surrounding mountains. Its eclectic design and decor hint at Malian and Spanish influences, with stone and adobe walls and wooden shutters creating a rustic feel. Each of the suites has a private plunge pool, which appears to be suspended over the deep valley so that you feel like you are floating not just in water but in air too.

At Phinda the rangers are adept at sharing their encyclopaedic knowledge in an inspiring way, especially on game drives during which guests learn about small animals as much as they do about big ones, like elephant, rhino, lion and cheetah.

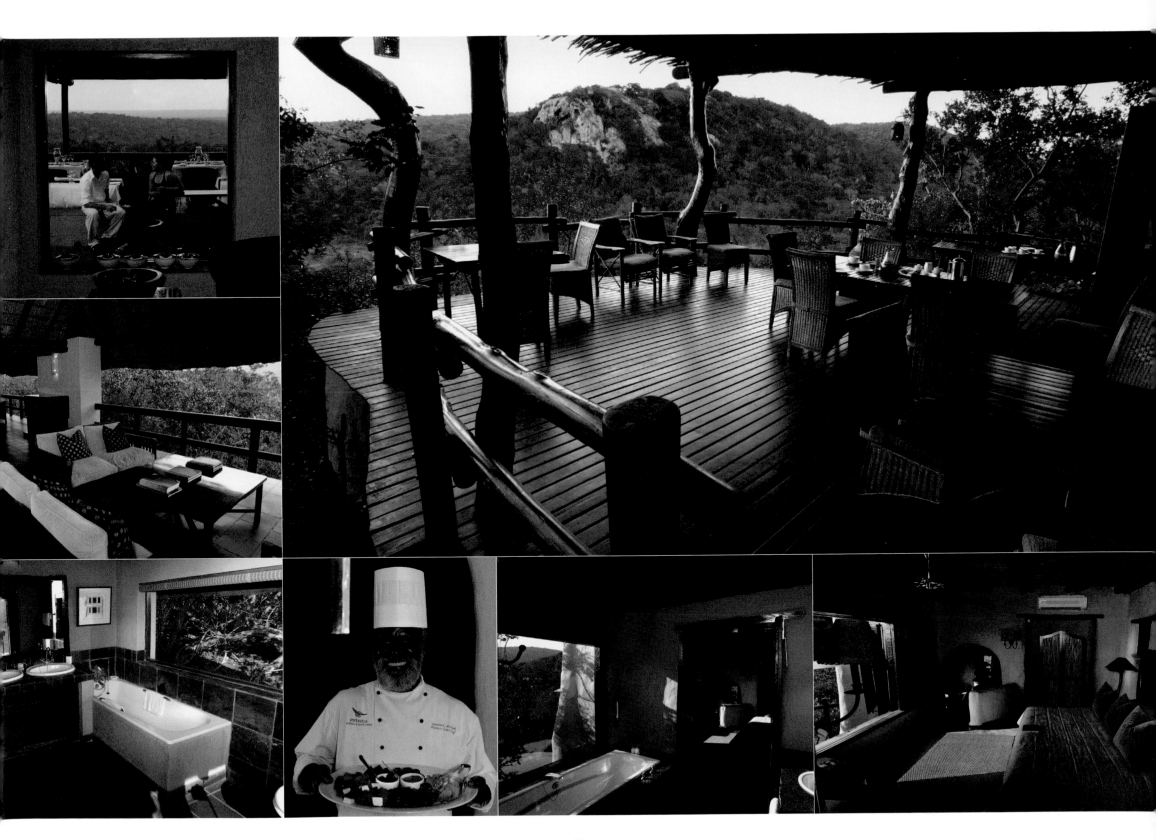

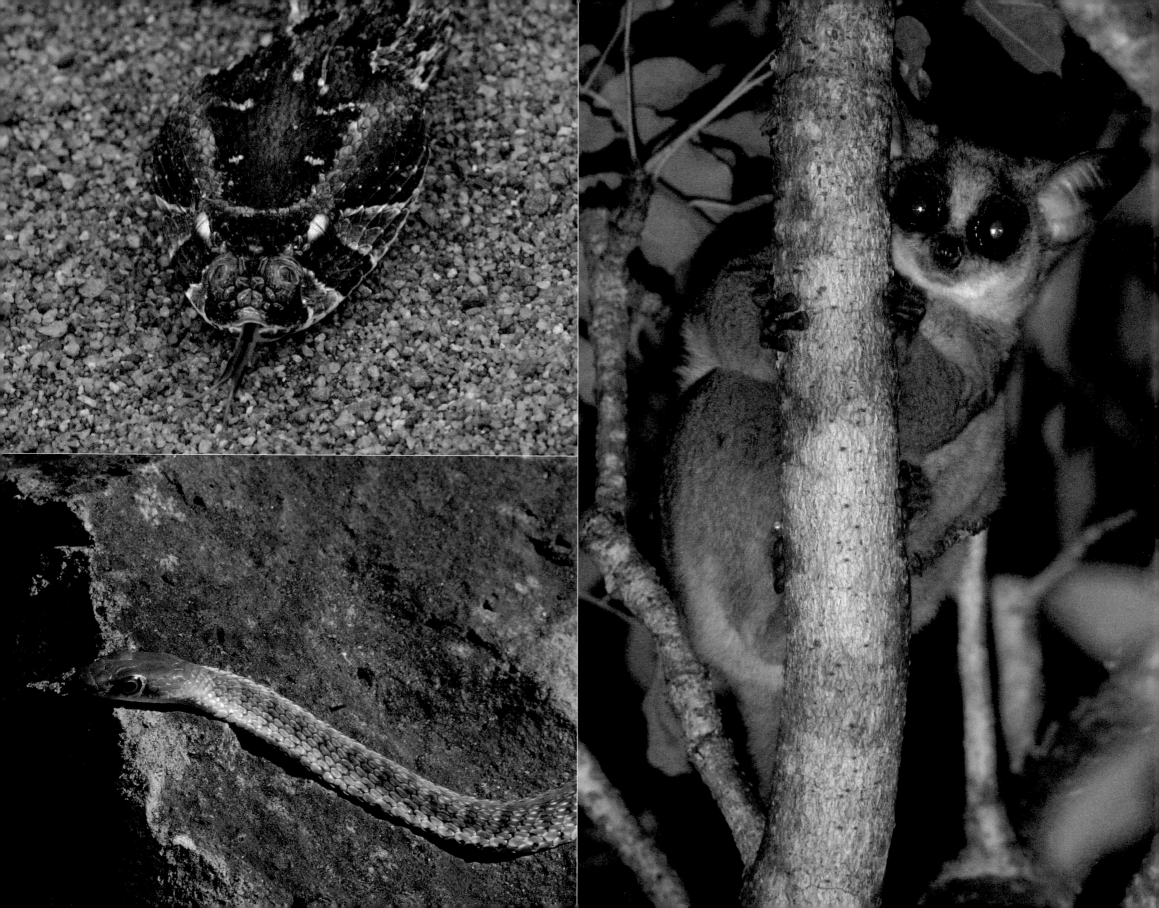

Phinda

FOREST LODGE, VLEI LODGE & WALKING SAFARIS CAMP

Lemonade spiked with ginger proffered with a warm smile is how guests are greeted at Phinda Forest Lodge (this page). This air of affectionate friendliness characterises a stay here in the rare, dry sand forests of KwaZulu-Natal.

The unique terrain – with trees like Zulu podberry, Africa's only cactus species, *Rhipsalis*, and epiphytic orchids – and the nearby wetland system make CC Africa's Phinda Private Game Reserve very different from other game reserves. Activities are designed to showcase the best of the reserve's diversity. Game drives, interpretive bush walks, white rhino tracking on foot, canoe trips and sunset cruises on the Mzinene River all offer opportunities to get to know the environment more intimately.

The game reserve is close to the Indian Ocean and a fifteen-minute flight in a light aircraft can get you to the coast for scuba-diving along the reefs of Sodwana Bay, deep-sea fishing or horse riding along a soft, sandy beach.

The sixteen stilted suites at Forest Lodge are a fusion of innovative architectural design and conservation ethics, resulting in eco-sensitive buildings that did not require a single tree to be felled during construction. Suites are encased in glass and minimally decorated with richly tactile fabrics and crimson Zulu artefacts. The effect is worthy of the invention of a new decor term, 'Zulu Zen'. Even the Wellington boots slipped onto specially placed pegs at the doorway are stylishly stored.

Vlei Lodge, on the edge of the wetland, is a more traditional African lodge (opposite page). It comprises six thatched suites whose interiors reflect North and West African styles. Here warm oranges and assertive reds dominate.

In addition to these two lodges, the intimate Phinda Walking Safaris Camp is located in the reserve (opposite page, bottom row). With just four spacious tents, this really is Africa in the raw. Hot-water showers are bucket style and food is eaten at lantern-lit tables beside roaring fires.

Phinda Private Game Reserve has all the Big Five animals, including three resident lion prides. It also has a thriving cheetah population, often seen near Forest Lodge and Vlei Lodge. Territorial white rhino favour waterholes and wallows, and visitors to Phinda stand an extremely good chance of seeing them.

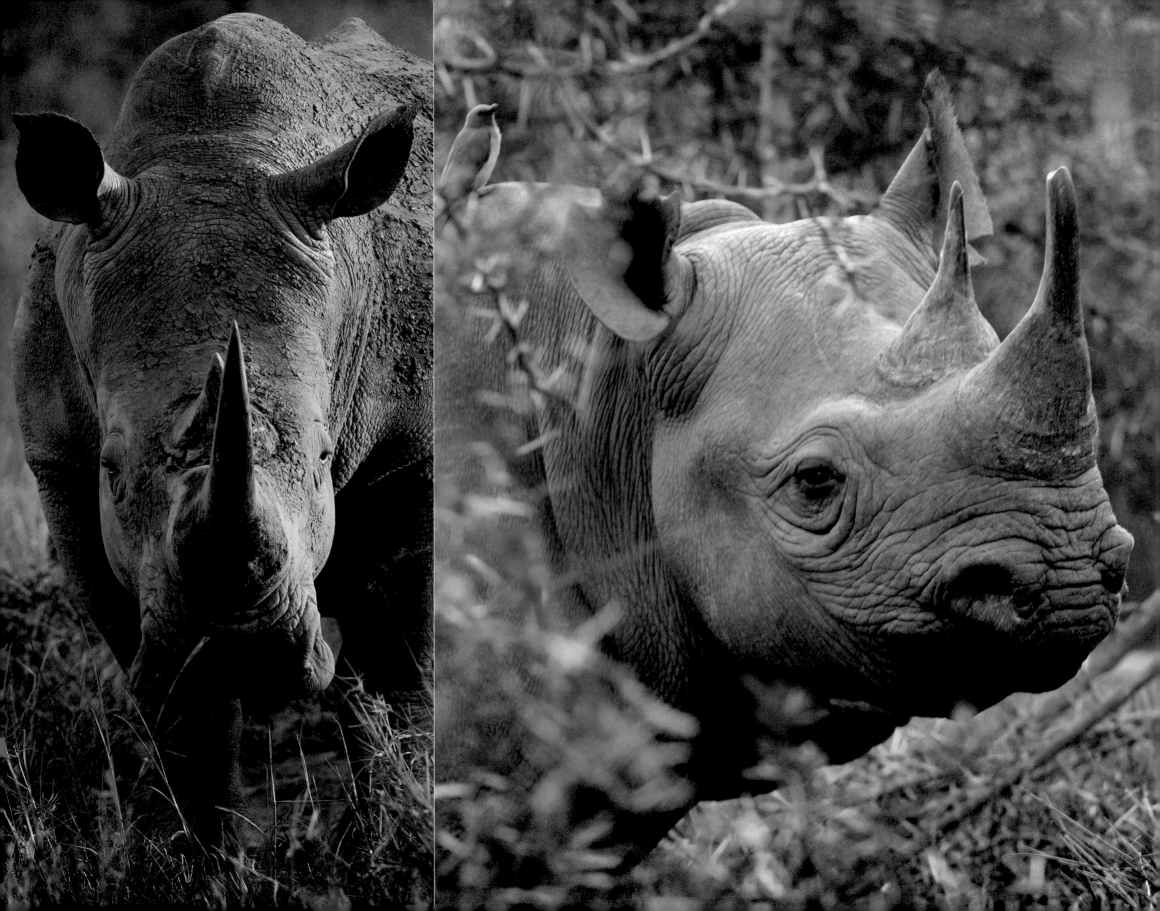

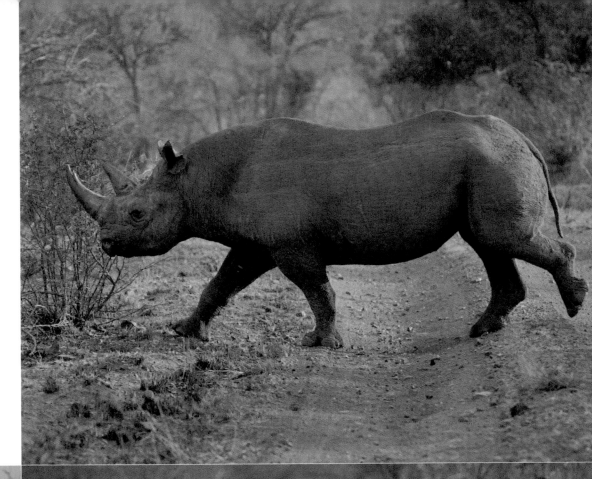

(left)

"It's a colourful story, definitely not black and white. White rhinos (far left) are not white, they are grey. Black rhinos (left) are not black but dark grey. Both like to wallow in variously coloured muddy pools. My favourite rhino mud pack is brick-red mud illuminated by the first or last rays of the sun. At these times of the day the shadows are long and the light has a golden hue, making the rhinos glow the colour of theatrical rouge."

(right)

"Powered by a ton of fury yet displaying extraordinary agility, this black rhino thundered through the savanna woodland and stopped as it reached a path. The animal raised its distinctive head and formidable horn. I raised my camera. The rhino's rounded ears twitched and their tufts bristled. Its beak-like prehensile upper lip, distinctly different to that of its cousin, the square-lipped white rhino, was immediately diagnostic. In the blink of an eye, it ran into the bush and disappeared without a trace."

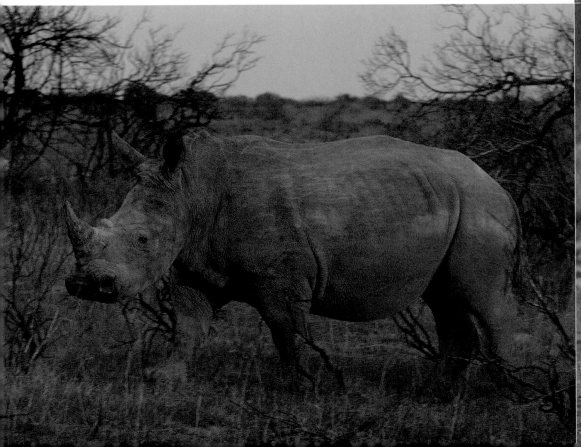

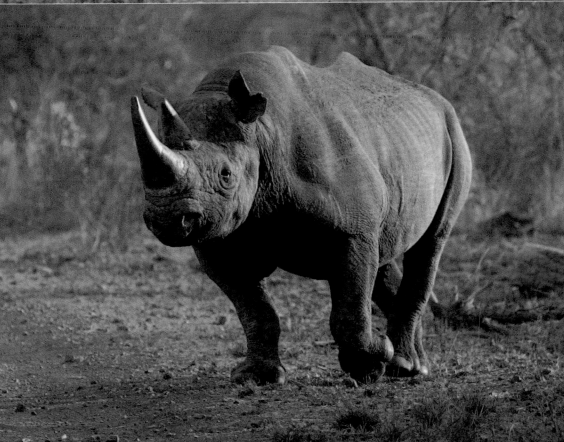

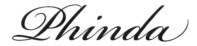

Phinda

GETTY HOUSE & ZUKA LODGE

In the western region of CC Africa's Phinda Private Game Reserve are two exclusive-use lodges for the ultimate private safari: Getty House and Zuka Lodge.

Getty House (this page; opposite page, left, top, centre and bottom) is an eight-guest private residence overlooking an extinct volcano, now covered in lush green vegetation and ringed by gently rolling hills. Designed to be unobtrusive, it incorporates sandstone, thatch, timber and glass. Interiors are elegantly earthy, with airy free-flowing spaces furnished with a mixture of classical and contemporary furniture that feels homely rather than extravagant.

Named by *Condé Nast Traveler* in 2007 as one of the world's 130 top new hotels, and by *Travel + Leisure* as one of the world's 50 most romantic escapes, Getty House attracts an exclusive clientele and is ideal for those who seek total seclusion or who may want a holiday out of the limelight. This is guaranteed, as Getty House comes with its own butler, chef, ranger and tracker, as well as sole use of a private safari vehicle.

Zuka Lodge (opposite page, far right, top and bottom) also has a dedicated team to look after its guests, who are accommodated in four contemporary thatch-and-stone bush cottages surrounded by densely wooded hills and lush valleys. Zuka's interiors are characterised by hues of blue and stone, with a strong accent on shape and texture. The bathrooms were designed for pleasure and feature a curved bathing chamber, twin handbasins and a steamy double shower.

The intimacy at this lodge lends itself to moments of quiet contemplation and reflection in the library or in deep-seat lounging chairs on the private veranda overlooking a well-used waterhole. Social gatherings happen at the swimming pool and in the café-style kitchen where anyone can get involved in creating the feast orchestrated by a white-hatted chef.

An important aspect of both Getty House and Zuka Lodge is the ability to tailor-make each day to suit the desires of its guests. Activities to choose from include game drives, bush walks, riverboat cruises, snorkelling, scuba-diving, fishing and turtle-watching at night.

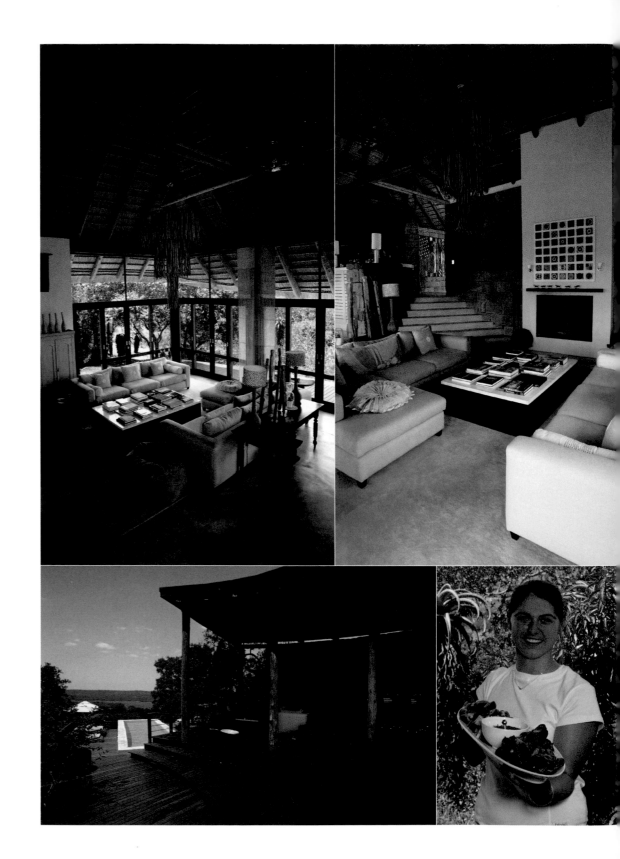

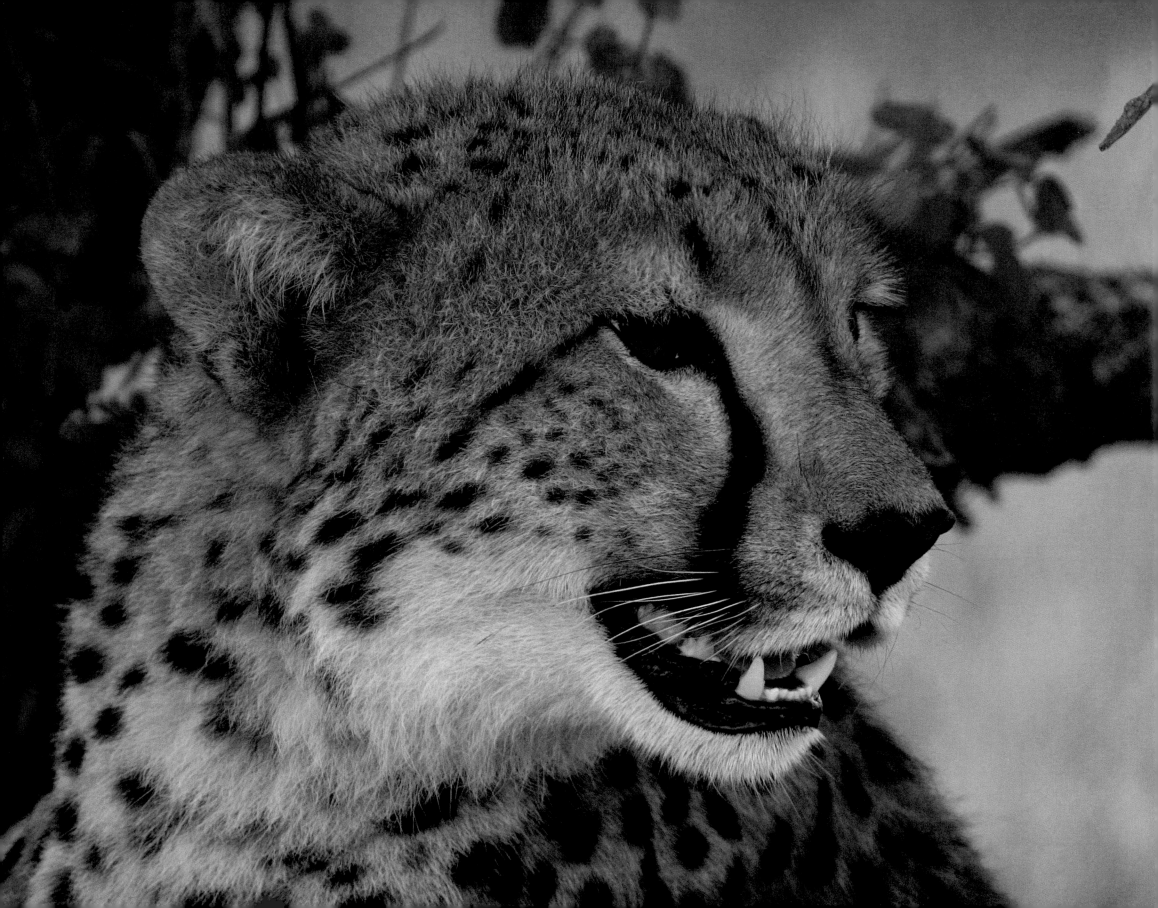

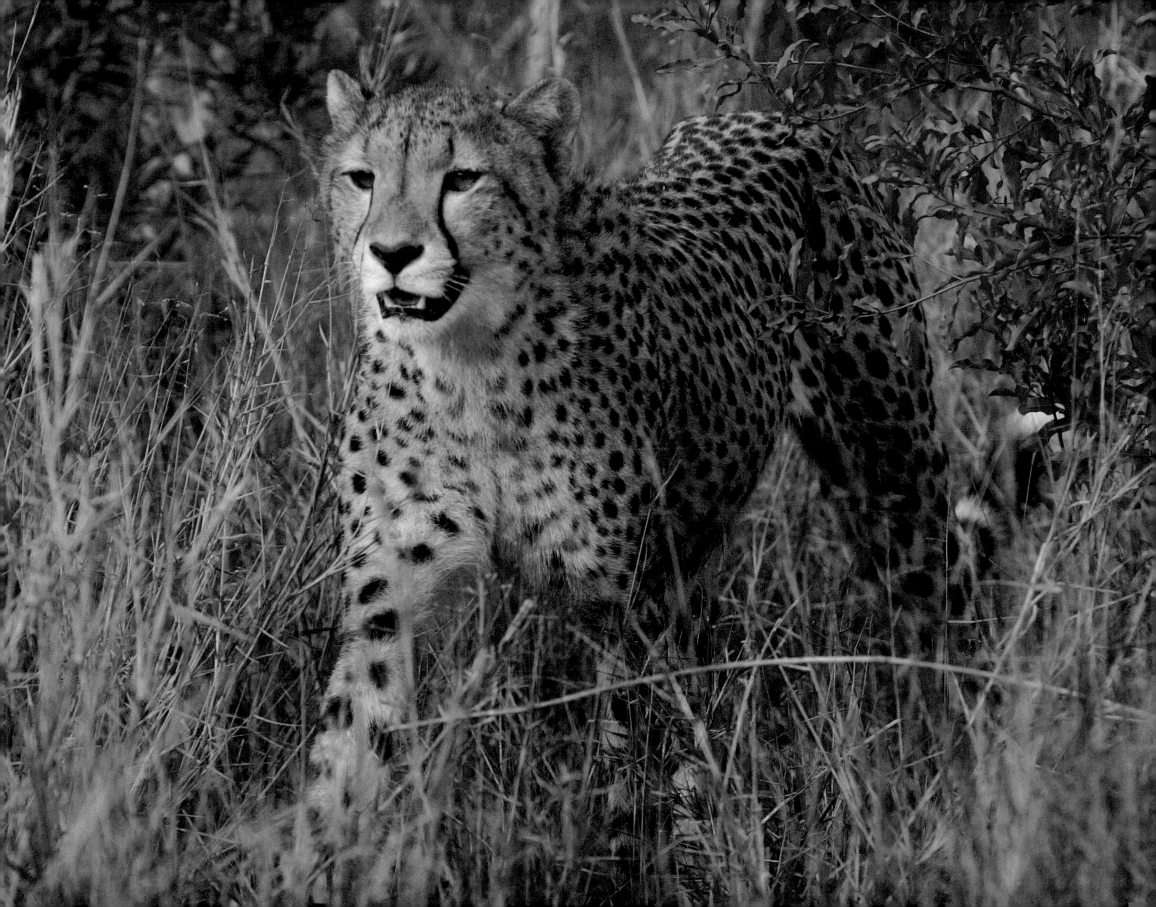

Thanda

PRIVATE GAME RESERVE

The Zulu nation rose to its most triumphant in the nineteenth century, during the reign of Shaka. The word *Zulu* refers to sky, lightning or other heavenly elements, and was the name assumed by the majority of northern Nguni people in south-east Africa following Shaka's rise to power. Thanda Private Game Reserve embraces the charisma and power of Zulu culture, incorporating its elements throughout the lodge to give you a first-hand experience of 'heaven on earth'.

Thanda (meaning 'love' in Zulu) is situated in Zululand, just twenty-three kilometres north of Hluhluwe, in the province of KwaZulu-Natal. It is tucked away in 6 000 hectares of thick bushland, traversed by the illustrious Big Five: lion, rhinoceros, elephant, buffalo and leopard. Currently the only game reserve in the world to hold exclusive membership with The Leading Hotels of the World, Thanda is situated in a low-risk malaria area and has been declared 99% malaria-free by the World Health Organization.

The nine luxury bush villas at the main lodge take pride of place on the rise of a hill against the burning backdrop of the African sun. From a distance they look like self-contained households in the circular structure of a Zulu homestead. Each villa has its own private splash pool, viewing deck and *sala* (thatched outdoor daybed) from where you can admire the lush surroundings.

The non-electrified tented camp is built in colonial safari style, offering an authentic yet luxurious bush experience. The four luxury tents have viewing decks and en-suite canvas bathrooms. Public facilities at the tented camp include a dining tent, a boma area, a splash pool and an 'open-air' lounge with magnificent views of the reserve.

The award-winning wellness centre's treatments draw inspiration from indigenous ingredients and natural approaches to healing. The Signature Treatments have been designed exclusively for Thanda and focus on restoring balance to both body and mind.

Dining at both the tented camp and the main lodge combines the refinement of European cuisine with the flair of African flavours. Where you eat, however, is not restricted to the dining room: Thanda's intimate bush dinners and private dining options provide the perfect opportunity to nurture or rediscover romance.

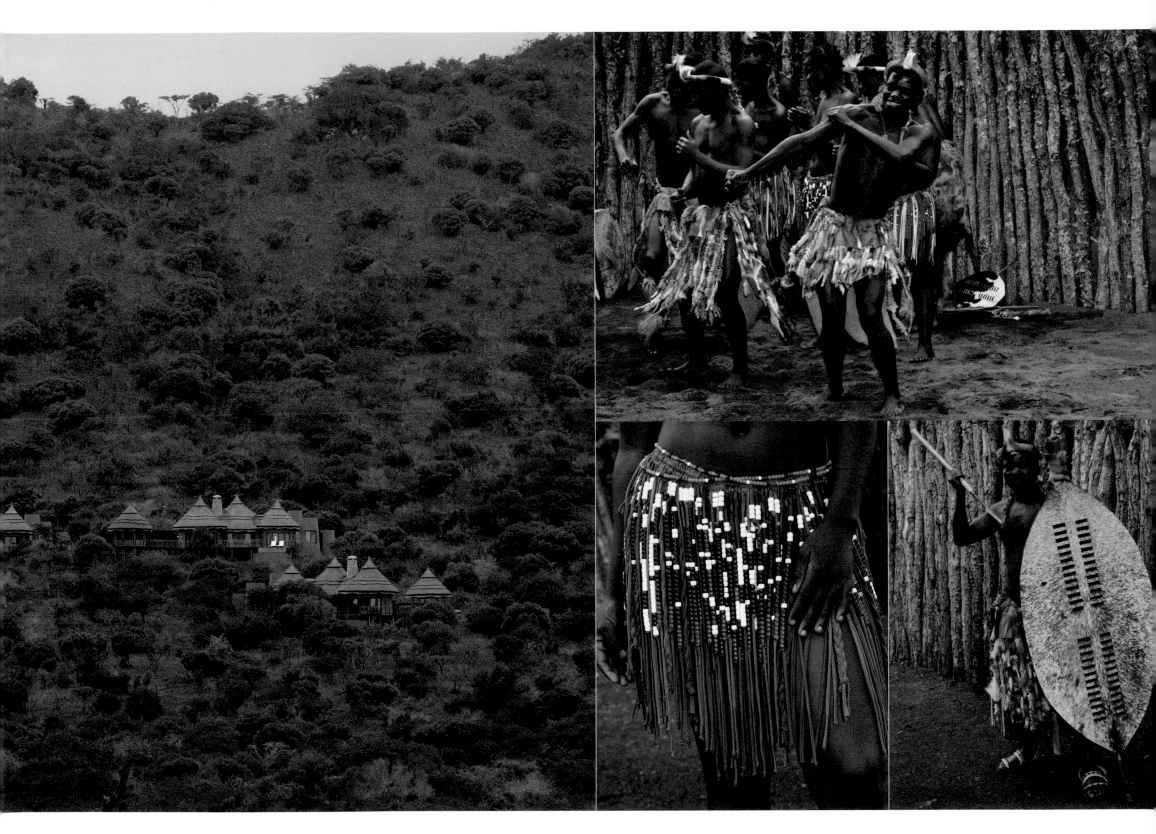

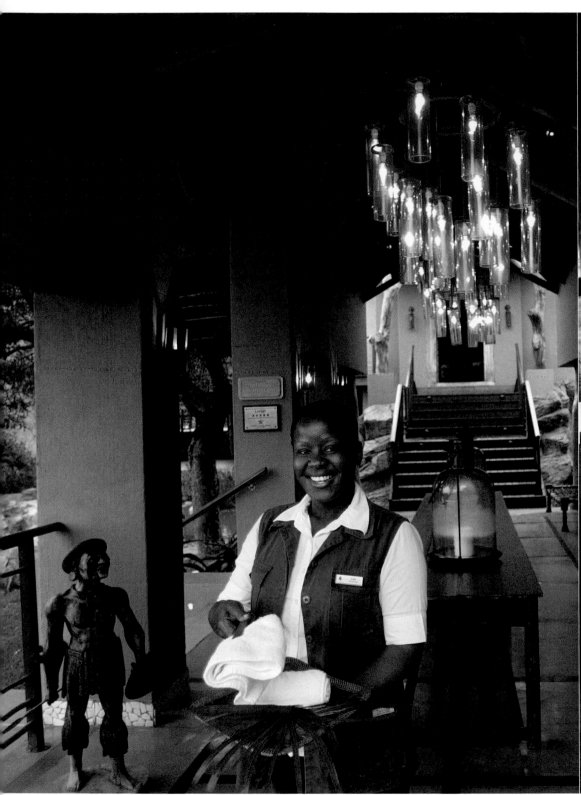
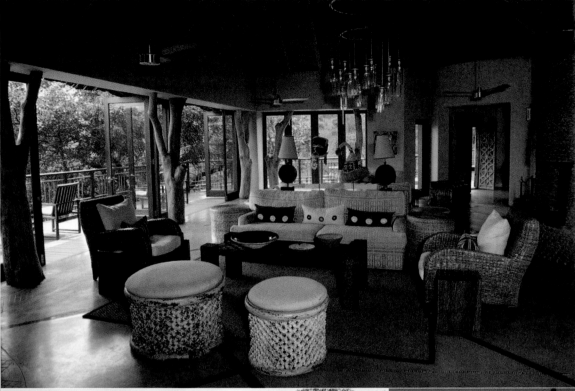

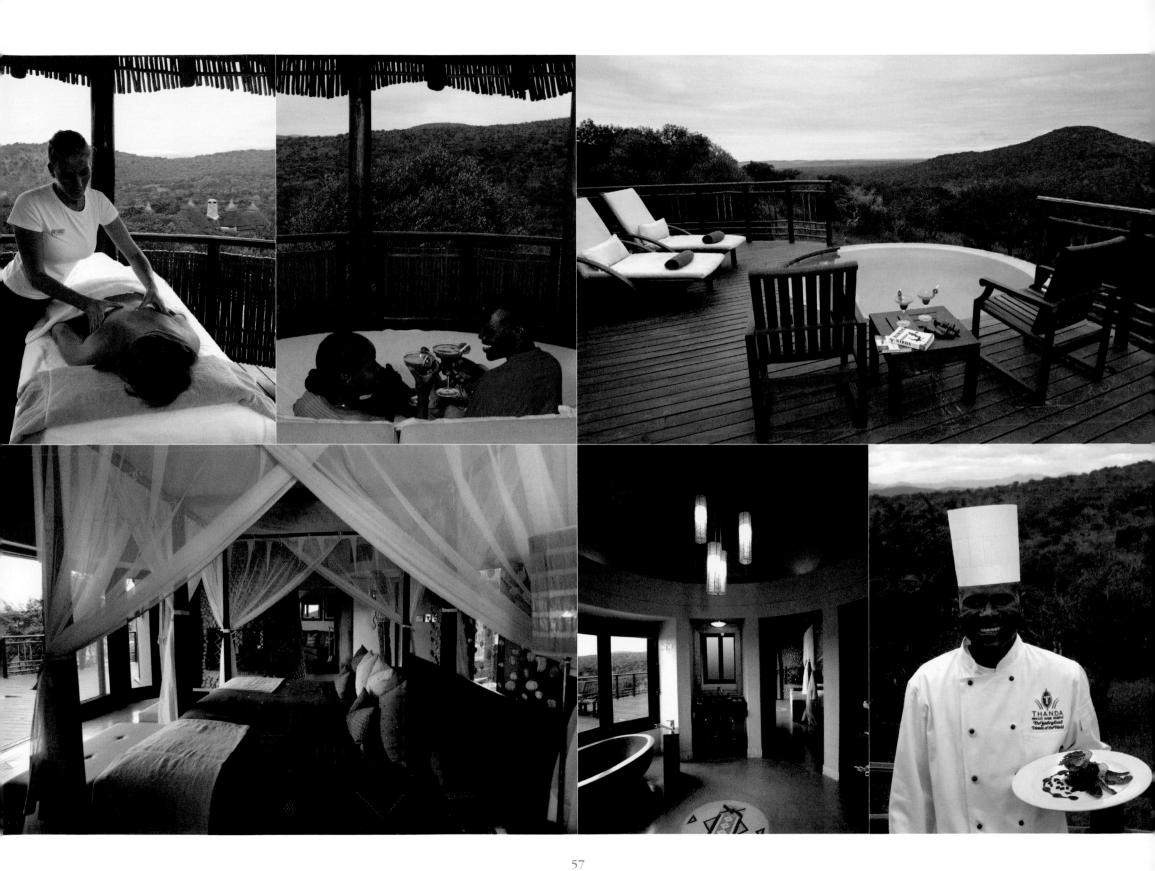

Kings Camp

PRIVATE GAME RESERVE

Those who are familiar with the African bush say that the real king of the jungle is not the lion but the elephant. Kings Camp Private Game Reserve uses the elephant as its logo, as a classic symbol of dignity and strength. Other classic elements, such as supreme style, service and elegance combined with gracious hospitality, are what sets Kings Camp apart from any other game reserve.

Kings Camp's revival of such colonial comforts as leaf tea served in bone china, scented bath salts, decanted wine and softly upholstered sofas adds a further dimension to the refined ambience. Although these touches may evoke an earlier, more genteel era, Kings Camp does not lack for modern comforts: the ten bedrooms are all equipped with air conditioning, tea and coffee facilities, a minibar fridge, as well as sweet-smelling bath and body lotions in the Victorian-style bathroom.

Taming the bush around the camp is not always easy, but there are manicured gardens and lawns into which a swimming pool has been sunk. Beyond this, in the open savanna, a waterhole is clearly visible. Kings Camp is located within the Timbavati Private Game Reserve – a beautiful stretch of land full of African game along the western edge of the Kruger National Park in Limpopo. The monthly Kings Camp wildlife report brings the area to life with its stories: 'Classic', the big elephant bull, named for his beautiful set of tusks, snapped the electric fence with his tusks to come and eat sweet vegetation around the camp; a leopardess hoisted her impala kill into a tree just thirty metres from Room 10, and was seen three times that month taking a relaxed amble through the camp in full view of guests.

Such is life at Kings Camp, and, notwithstanding the odd leopard on the lawn, things carry on. There is food to be prepared and tables to be set. The silver place settings are a fitting match for the artworks presented by the executive chef and his team of culinary artists.

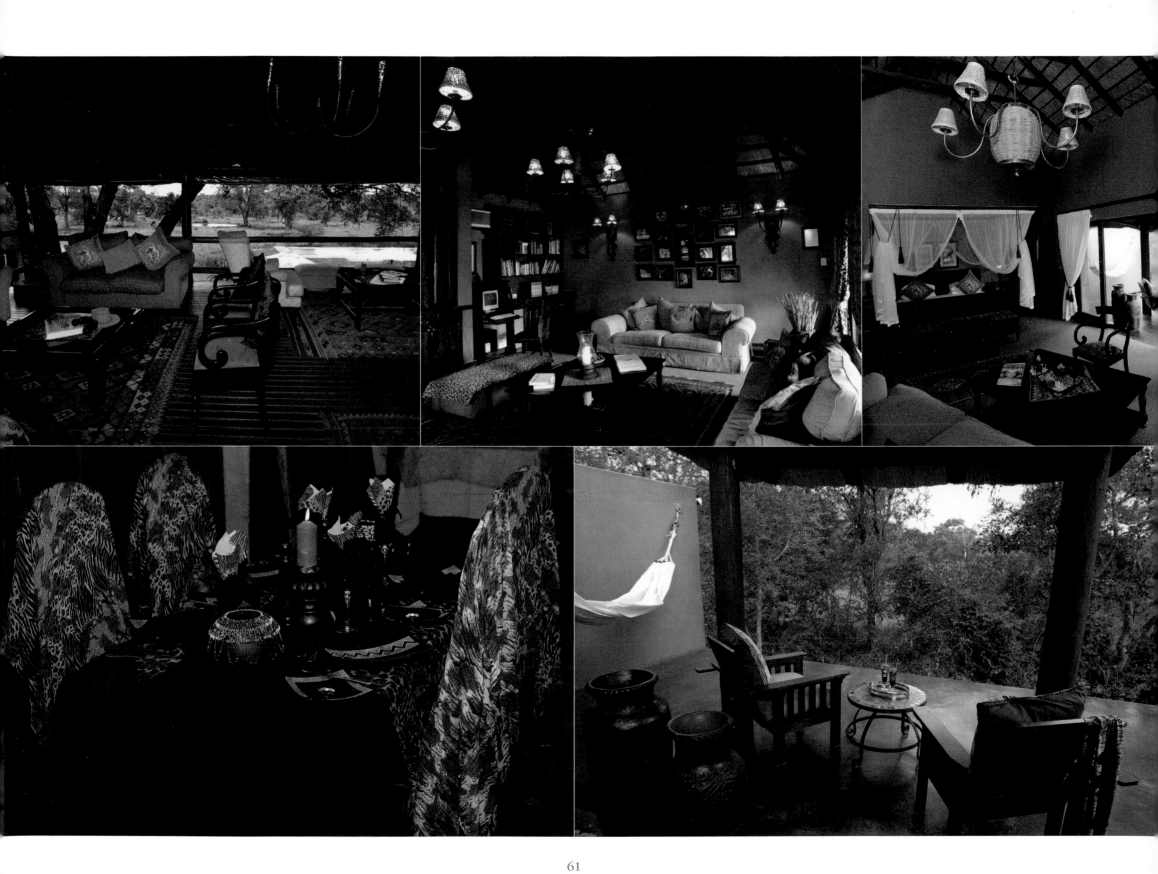

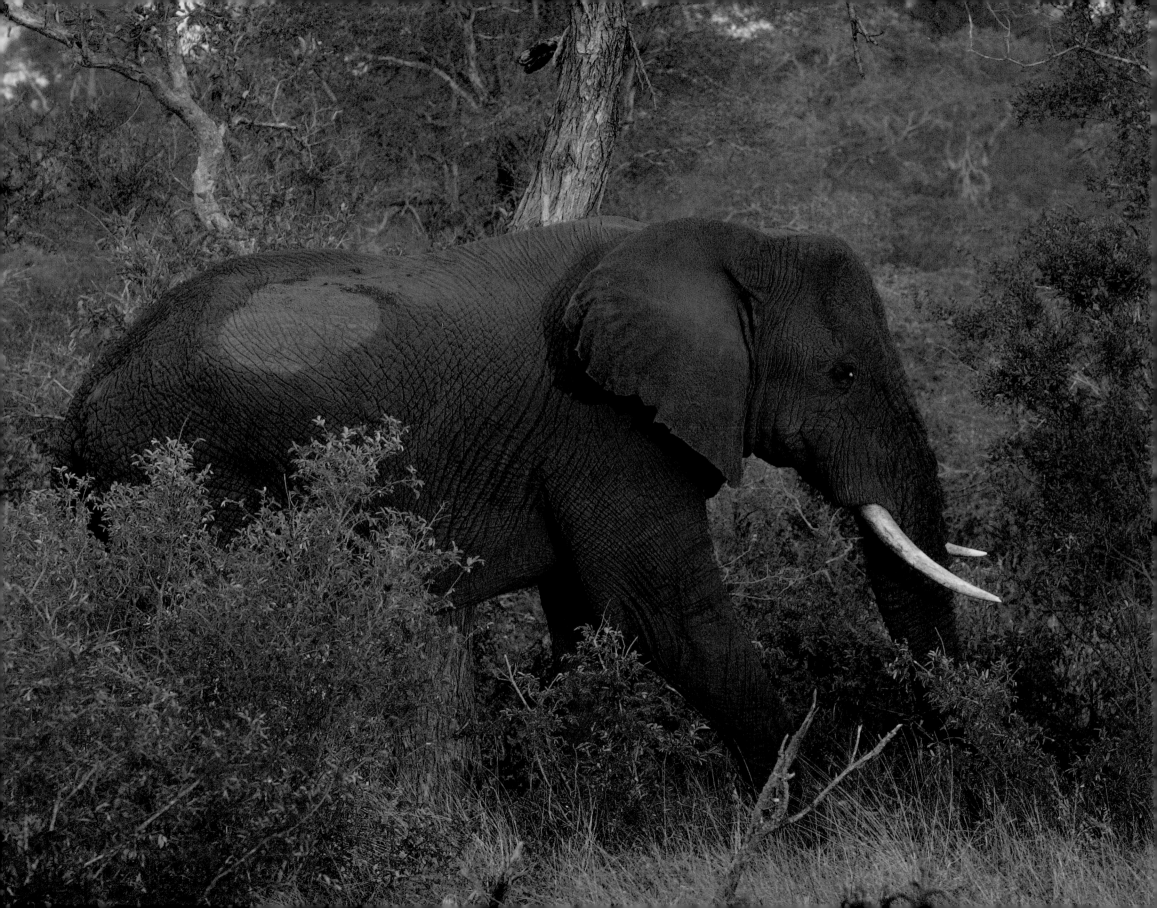

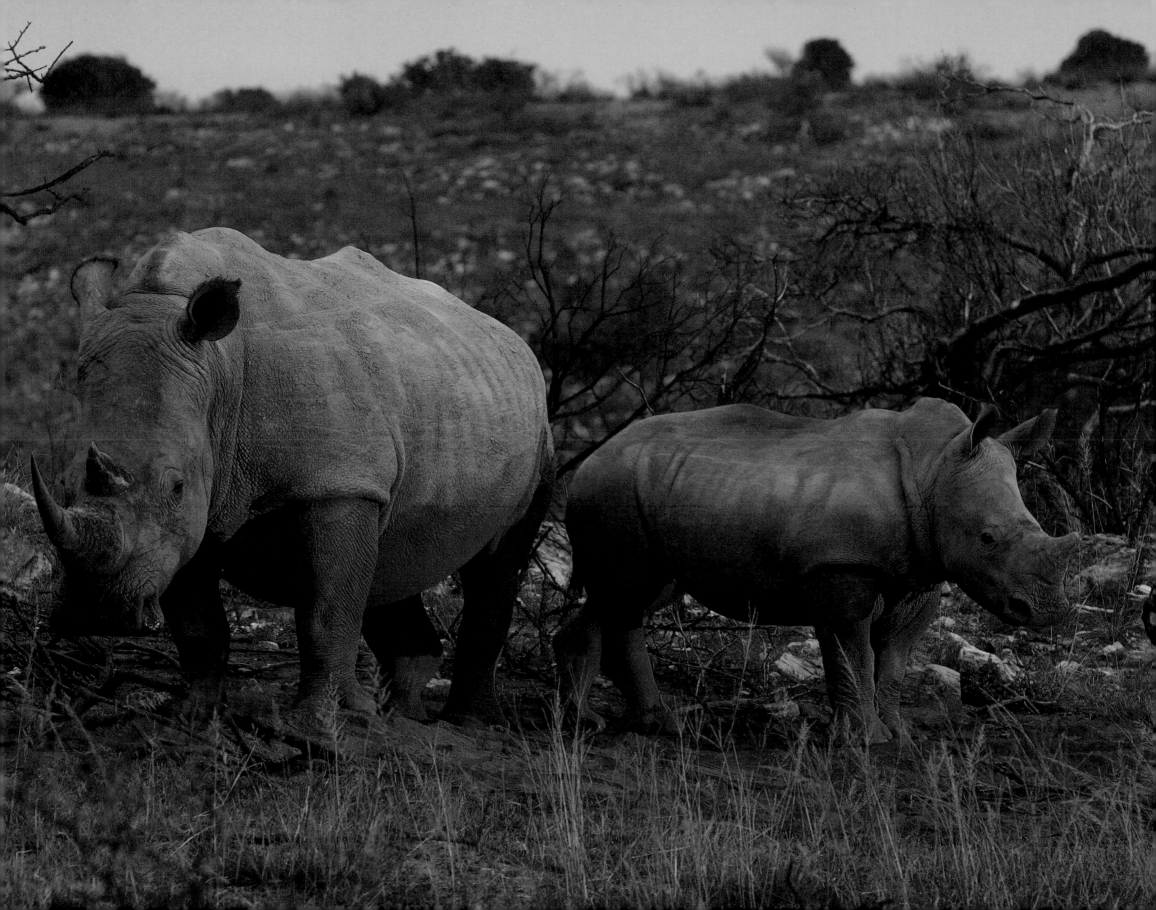

Tanda Tula

SAFARI CAMP

Immerse yourself in a true African wilderness experience at Tanda Tula, an exclusive luxury safari camp in the Timbavati Private Game Reserve in Limpopo. Although you are likely to sight the Big Five here – there are no fences between the reserve and its neighbour, the Kruger National Park – this need not be your ultimate goal. A compelling reason for being at Tanda Tula is to have a heightened gaming experience at the hands of some of the most highly skilled rangers and trackers in South Africa.

One of Tanda Tula's trackers is a senior tracker – one of only fifteen qualified senior trackers in South Africa to date. So highly sought after are his skills that he was invited by the International Professional Tracker Association in the USA to give demonstrations and lectures on the role of trackers in private game reserves and the art of tracking dangerous game.

Tanda Tula's other trackers aspire to follow in his footsteps. But you, too, can follow in this highly acclaimed tracker's footsteps when you join one of Tanda Tula's walking safaris through the bushveld. This is a wonderful way to go from merely being an observer to becoming an active participant on the wonderful stage that is the African savanna.

Tanda Tula does not wish to intrude on that great stage; rather, it prefers to blend into it and the place is so well concealed that you cannot see it until you reach the parking area. There are no manicured lawns or flower beds, just natural bush pulsating with life – from the resident nyala antelopes to old buffalo bulls that hang around the camp and cheeky vervet monkeys looking down from the treetops.

There are elephants too, and scientists based at Tanda Tula are carrying out a long-term research study on elephant movement across an expanse of wilderness that transverses the Kruger National Park and parts of Zimbabwe to the north, Mozambique to the east and South African private game reserves to the west.

The staff at Tanda Tula are the real stars of the show and create such an harmonious atmosphere that all you will remember is smiling faces. Well-crafted food is created by the two Shangaan chefs, winners at the 2005 Bush Banquet Challenge. Producing feasts in the heart of the bush is their speciality and to keep the element of surprise, guests never eat in the same place twice.

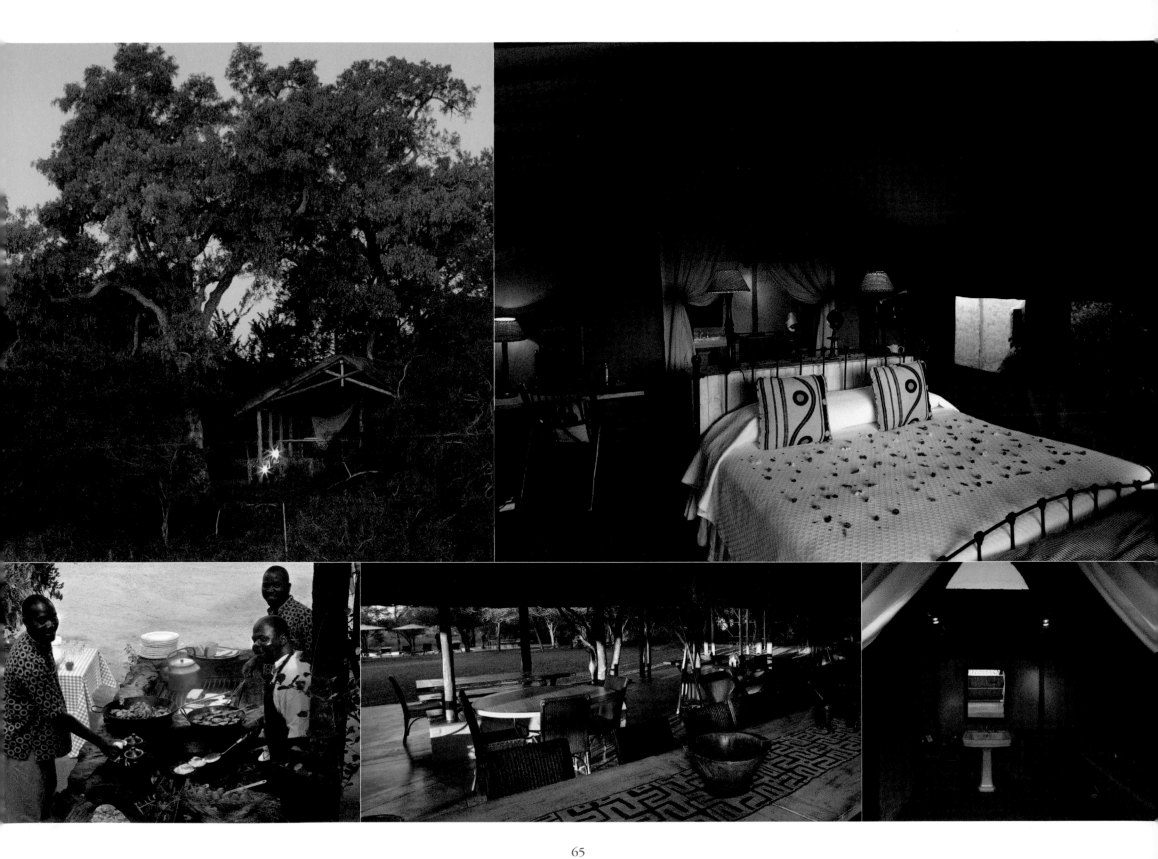

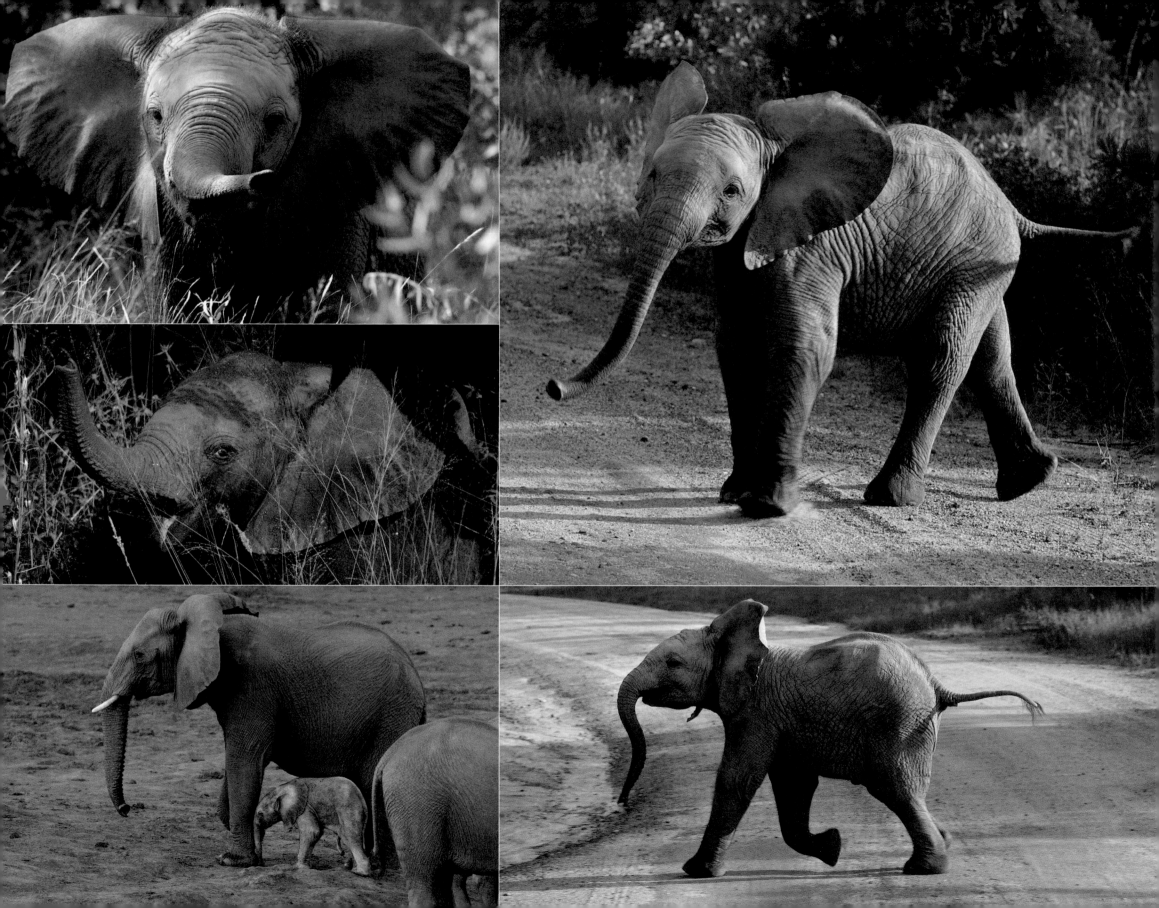

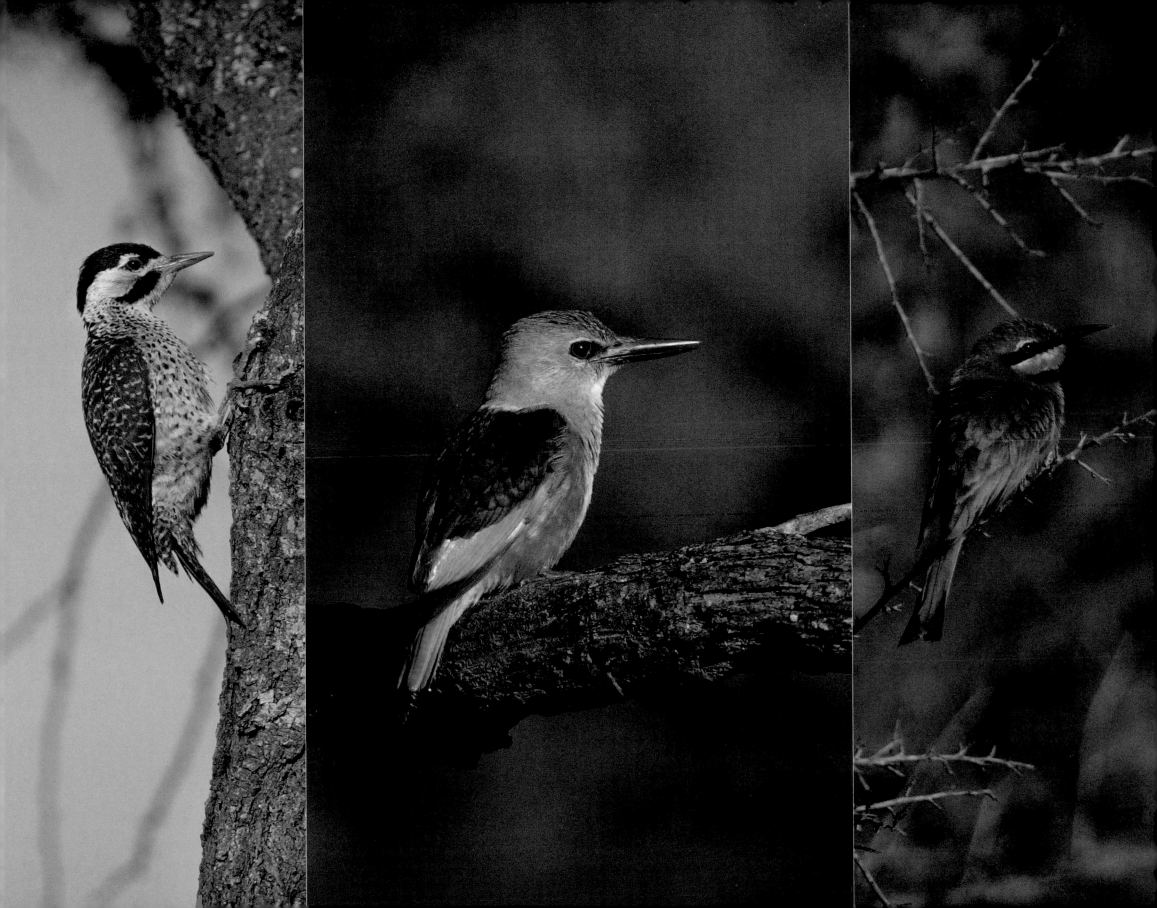

Ngala
SAFARI LODGE

Situated in the exclusive Ngala Private Game Reserve in Limpopo, Ngala Safari Lodge offers classic family safari accommodation in the heart of the game-abundant lowveld of South Africa. The lowveld is one of the richest wildlife regions on the African continent.

Part of the CC Africa group of exclusive game reserves and lodges, Ngala is a 14 700-hectare reserve bordering the western edge of the Kruger National Park. The reserve supports a great diversity of animals, and one species of animal seen daily is the *ngala*, meaning 'lion' in the local Shangaan language. There are several lion prides that patrol this reserve and many of the lions are known by name to the rangers, although this familiarity is not necessarily mutual. Some of the resident female leopards have become quite habituated to visitors and go about their business with their cubs as if they were not being watched. Add to this menagerie great herds of elephant at the waterhole, wild dog roaming across the low-lying land, thundering buffalo, white rhino and nocturnal African wild cat and serval, and you have yourself a safari to entertain any family.

Ngala's twenty thatched cottages hide discreetly under a canopy of mopane and tamboti trees and are decorated in a wistful colonial style. The use of safari memorabilia throughout the lodge reinforces this theme. At night, lanterns and candlelight add a touch of romance, especially in the cosy boma where guests are treated to a pan-African feast around a blazing fire.

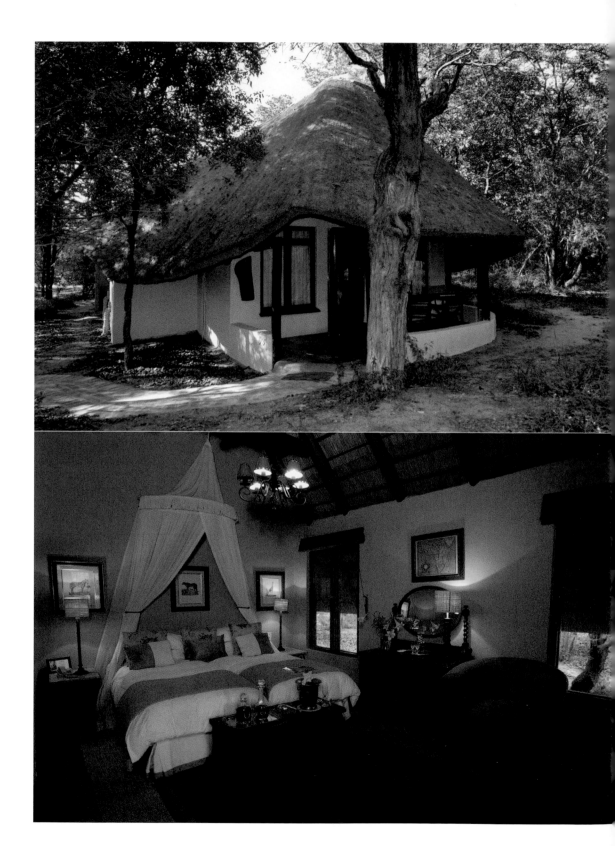

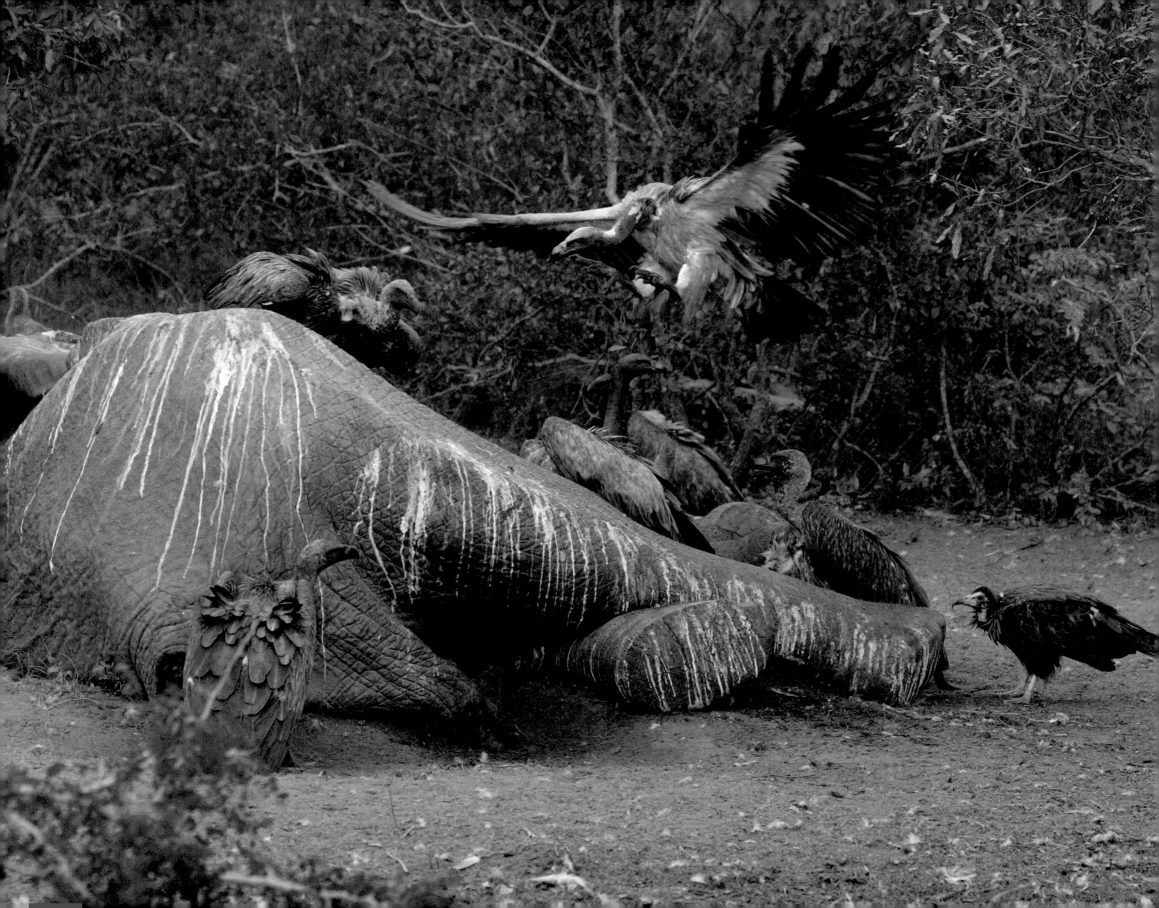

"The branches of the trees hung heavy with vultures. This is usually a clear sign that there is a kill not far away. As anticipated, we came across a carcass lying in a clearing. It was the carcass of an elephant that had died of natural causes, the ranger said. The vultures – often described as the undertakers of the bush – were out in force, hopping about, jockeying for position, squealing, squawking, elevating and displaying their wings and challenging each other. They greedily tore off chunks of flesh and liberally defecated, leaving a mantle of white streaks on the grey elephant carcass. Rows of vultures, led by a marabou stork, waited their turn on the ground in a clearing nearby. The stork reminded me of a priest preaching to his congregation or a politician making a speech.

There was more than enough carrion for all of them, yet they appeared to spend so much energy on territorial posturing – an almost human-like malady, I thought.

Suddenly, large hyaenas appeared and drove off many of the birds. However, the more intrepid vultures and hyaenas tested and contested each other, with both groups achieving a measure of success. Flies and other insects buzzed about unperturbed."

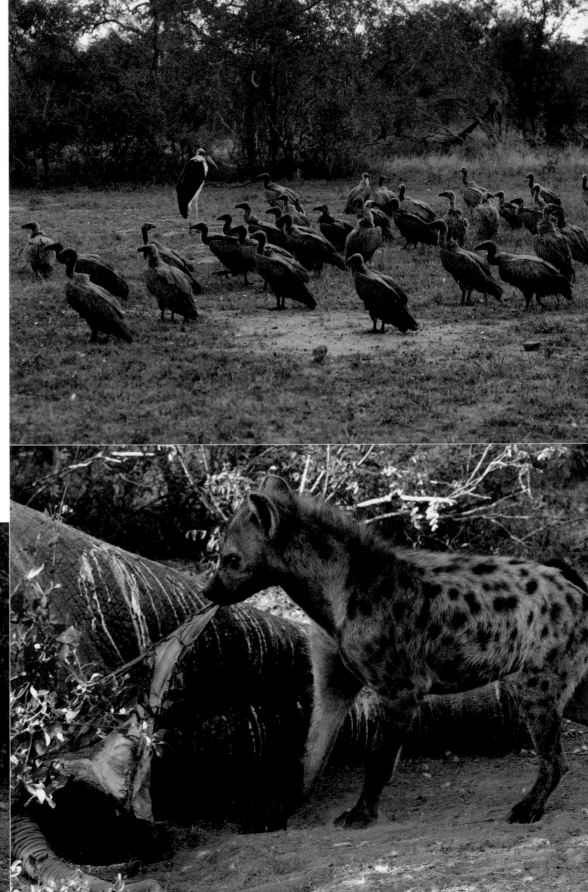

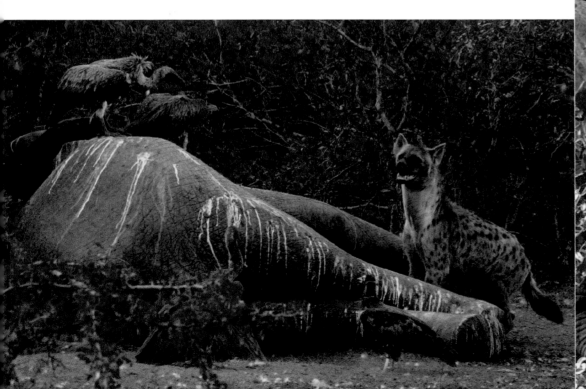

Ngala
TENTED CAMP

Ngala Tented Camp, situated in Ngala Private Game Reserve in Limpopo, is only three kilometres from Orpen Gate – one of the major gateways giving access to the world-famous Kruger National Park. There are no fences separating the game reserve and the park, and wild animals freely traverse these wilderness areas.

In keeping with CC Africa's conservation ethos, Ngala Tented Camp was designed to minimise any negative impact on the environment. Surrounded by savanna bush, the six luxurious tents are built on raised platforms and nestle among indigenous trees.

Like its sister, Ngala Safari Lodge, the camp relies on decor styling from other eras. Here retro pieces from the 1960s and 1970s have been used in contemporary ways. Beautiful timber decks overlook the seasonal Timbavati River. During the dry season, the riverbed is the perfect stage for the camp's unforgettable theatrical alfresco dinners. The lap pool, whose contours follow the shape of the riverbed, is an ideal spot from which to watch game visiting the river.

There is much to entertain guests at Ngala Tented Camp, including morning and evening game drives in open safari vehicles and bush walks. Ngala has also designed several tailored safaris that give guests a deeper insight into the environment and wildlife. Specialist rangers and tracker teams accompany guests on a leopard watch, staying out all night if necessary. Visitors can also learn the art of tracking wildlife on foot and how to identify birds from their calls on a specialist tracking safari – all of which have inspired some to consider becoming rangers themselves.

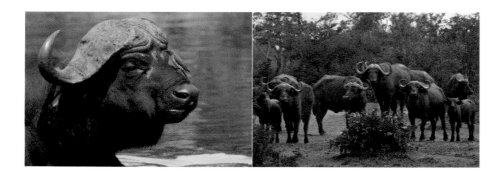

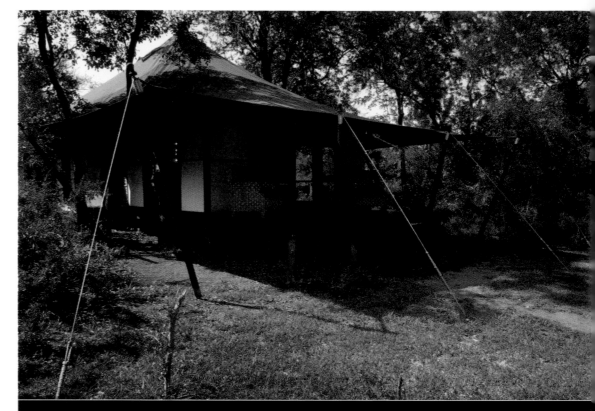

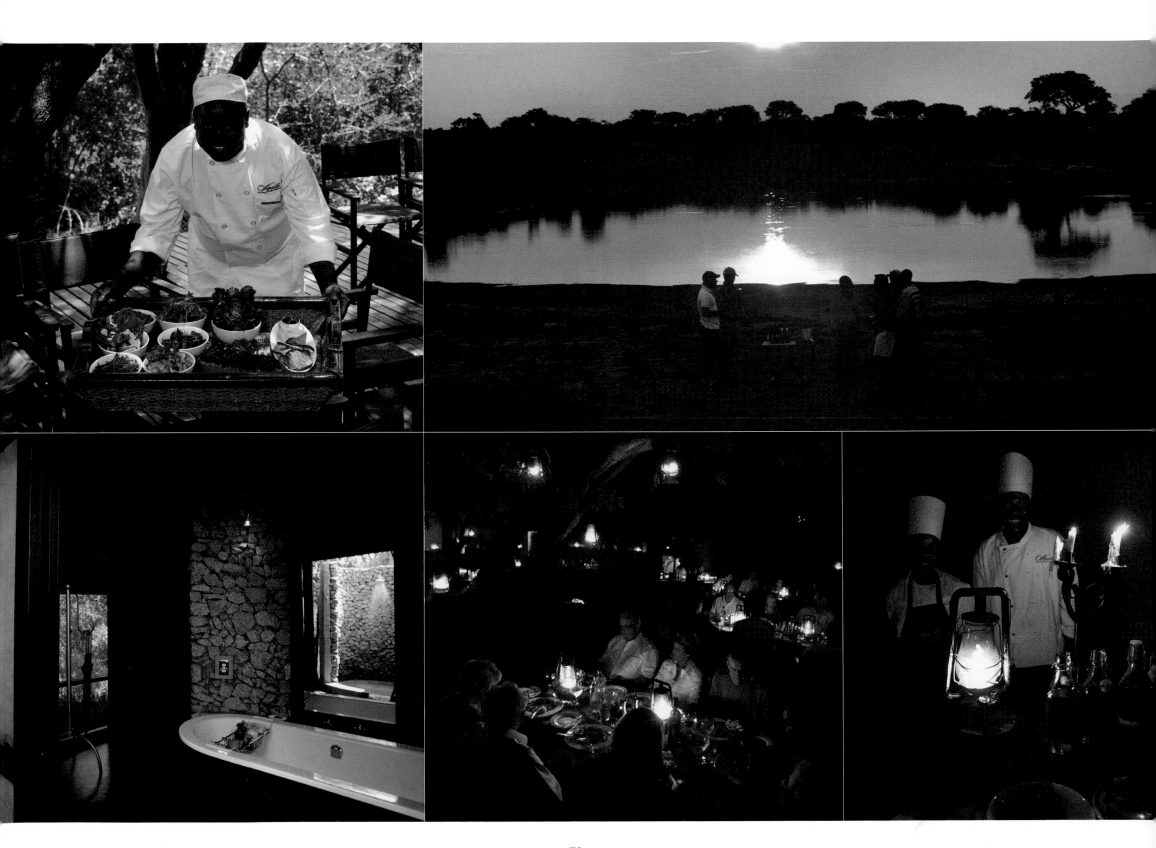

Lukimbi

SAFARI LODGE

In the deep south of Kruger National Park in Mpumalanga is Lukimbi Safari Lodge – a place dominated by African art and legend. The lodge is named after a mythological creature that is half owl and half lion and is said to protect all travellers in the African bush against danger. The full story of this legendary creature is told within a few hours of arriving at Lukimbi.

The staff have a direct interest in the success of Lukimbi, since they own a stake in it. This, of course, means that they want each guest to have the finest experience so that they will tell their friends. So far this approach is working and Lukimibi is thriving.

One thing people certainly talk about is the food, prepared by the characterful head chef, Leonardo Bürckard. His creations require the highest skill and the subtlest of ingredients. He is seen here with one of his signature dishes, Kingklip Sasekane – fish dusted in almond flour, dipped in beaten quail eggs, pan-fried golden brown, and topped with steamed lobster dribbled with creamy chardonnay and a caper dressing infused with saffron. If that does not make your mouth water, nothing will!

At Lukimbi, art does not only come in the form of food. The bold colours and shapes found in African artworks appear everywhere, including the sculpted wood of both functional and decorative objects, textured fabrics with geometric designs and patterns cleverly etched into the plasterwork.

Even the little chapel has been given simple yet effective artistic adornments, adding to the romance and fairy-tale quality of a bush wedding. And once you have said your vows, go no further for the honeymoon, as newlyweds are taken to a mystery venue for a private honeymoon dinner.

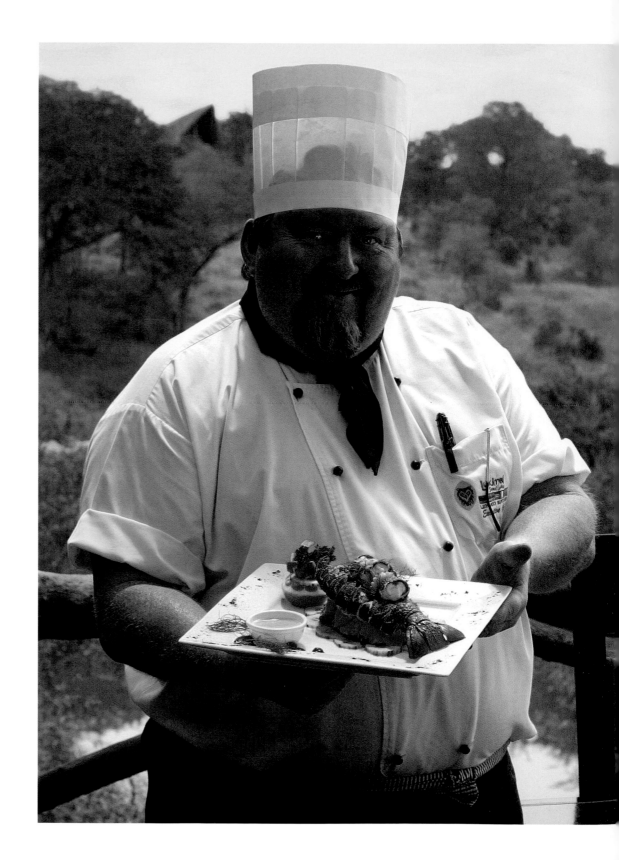

Kapama
RIVER LODGE

The northern Drakensberg mountain range provides a majestic backdrop to Kapama River Lodge, situated within the family-owned Kapama Private Game Reserve in Limpopo. The lodge has a generous capacity of forty-two bedrooms, all of which are a perfect blend of luxury and comfort.

Team-building activities and events for groups are a speciality at River Lodge, and the Kapama 'Amazing Race' is a firm favourite. Teams participating in the race are let loose in 4x4 vehicles with a GPS and some clues to follow to reach a final destination. River Lodge offers a host of other activities too: hot-air ballooning over the game-rich reserve, a gym, beauty treatments, clay-pigeon shooting and elephant-back riding. The most romantic option is without doubt a private sleepout on the lantern-lit 'romance platform', with a bed swathed in mosquito netting.

The bedrooms at River Lodge, situated on two floors, all with views of the leafy-green reserve, are wonderfully comfortable. The lodge's decor is modern yet distinctly African, with clay pots, wooden stools and African artefacts gracing the illuminated recessed alcoves of the main buildings. Chairs are upholstered in reds and golds, and the golden thatched roof reflects a warm light down into all areas of the lodge. Another special feature is the straw-clad walls, helping to seamlessly merge the inside with the outside.

Two fireplaces are positioned in the cavernous L-shaped lounge and bar, which opens up onto a pool deck where a rim-flow swimming pool overlooks the dry, sandy riverbed. It is possible to float in the pool and watch animals drink at the nearby permanent water source.

Meals cannot be said to be inside or outside, as the Rhino Boma offers a bit of both: tables are set under a low thatch and arranged in a horseshoe configuration around an open courtyard whose centrepiece is a roaring fire. Which wine to choose with dinner can be a conundrum, because River Lodge has a perfectly humidified wine cellar where more than 600 bottles are kept. Apart from some French champagne, all the wines are from South Africa's finest Cape vineyards.

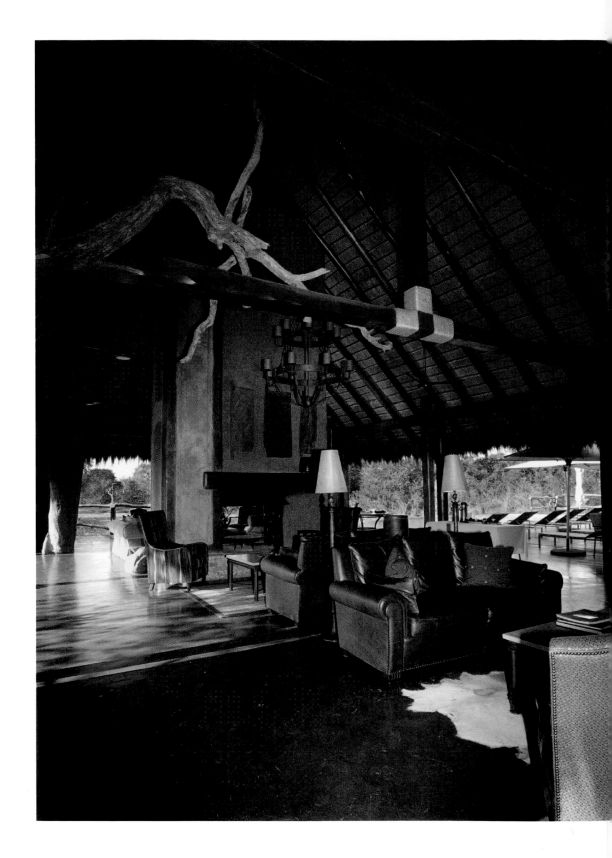

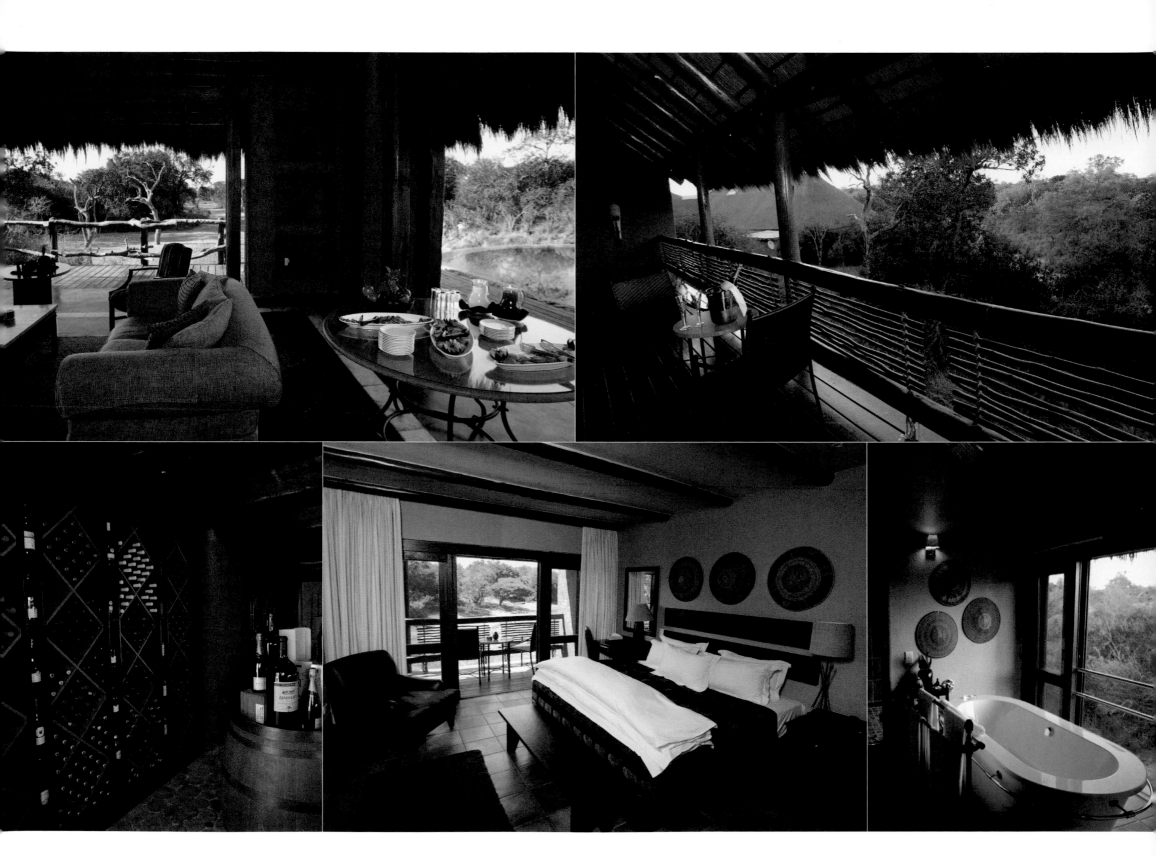

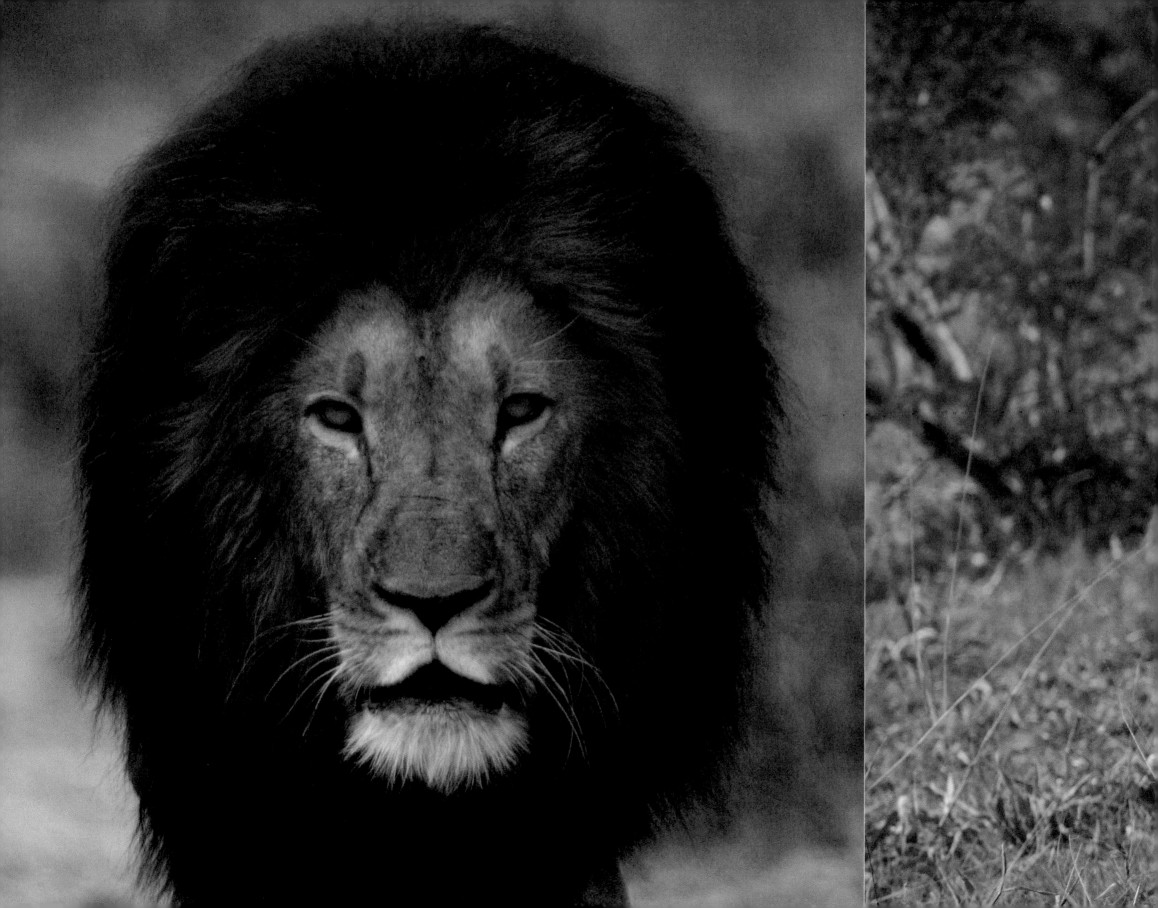

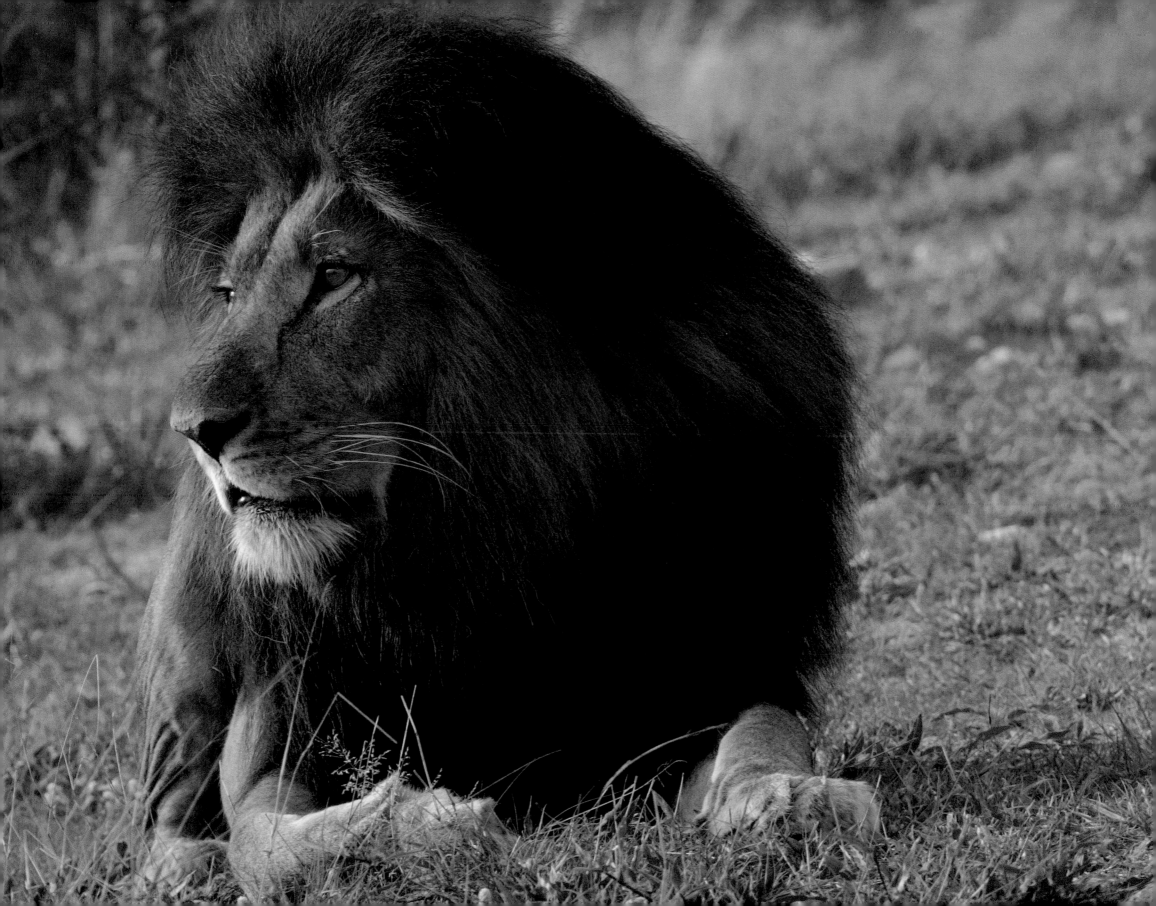

Kapama
LODGE

The rambling natural vegetation surrounding the reed-fringed lake contrasts with the tended gardens and lawns of Kapama Lodge, built right at the water's edge. Some of the viewing decks even have their supporting poles in the water, and if a piece of bread is accidentally dropped from the overhanging balcony the water comes alive with catfish. There are bream, too, and rods are supplied to anyone who wishes to while away some time doing a spot of catch-and-release fishing.

This lakeside setting instills a certain serenity, and sipping cocktails on a balmy evening under the thatched waterside gazebo will seduce you into a blissful state. This is also where afternoon tea occurs, with a range of cakes, meringues and other finger food, which you do not really need because the chef has already filled you up with a slap-up breakfast and a buffet lunch of starters, salad and hot dishes, usually featuring one of the speciality soups made fresh each day. À la carte evening meals include local and international dishes with specialities like tender rack of lamb or gentle curries. These are served in different locations chosen according to whim and weather. You may be eating by lantern light in the outdoor boma, under the moon and stars at a hidden location deep in the bush or in Kapama Lodge's subtly lit main dining room.

Gentle lighting extends to the stone pathways leading through gardens of aloes and fever trees to the twenty thatched cottages. The decor is as eclectic as nature itself, with colours and shapes mirroring the natural world: whole-log door frames, lamps with twisted stems, coir mats and twirly metal-framed furniture. But it is the bed that catches the eye. Fresh white bedding, plump cushions and soft drapes of mosquito netting create a fairy-tale four-poster effect.

But all these comforts mean nothing without the genuine smiling faces of Kapama Lodge staff. From the waiters to the rangers and trackers, it is they who make the difference between a good vacation and a great holiday.

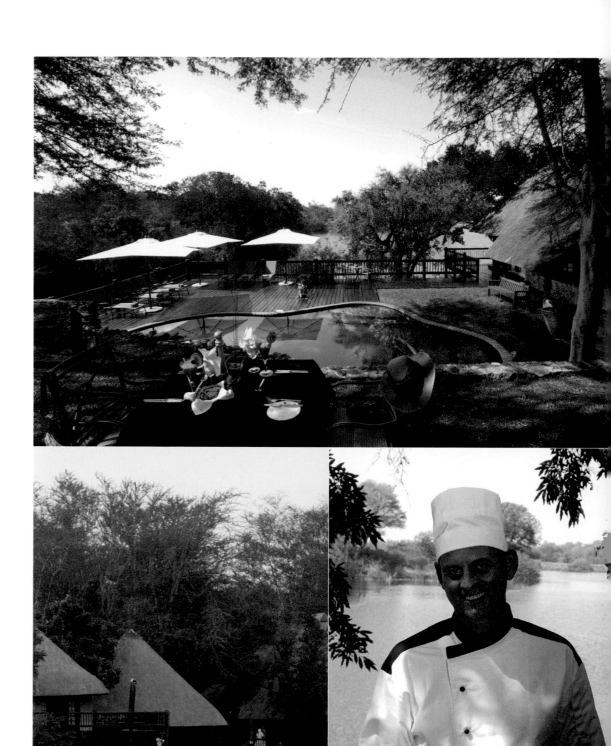

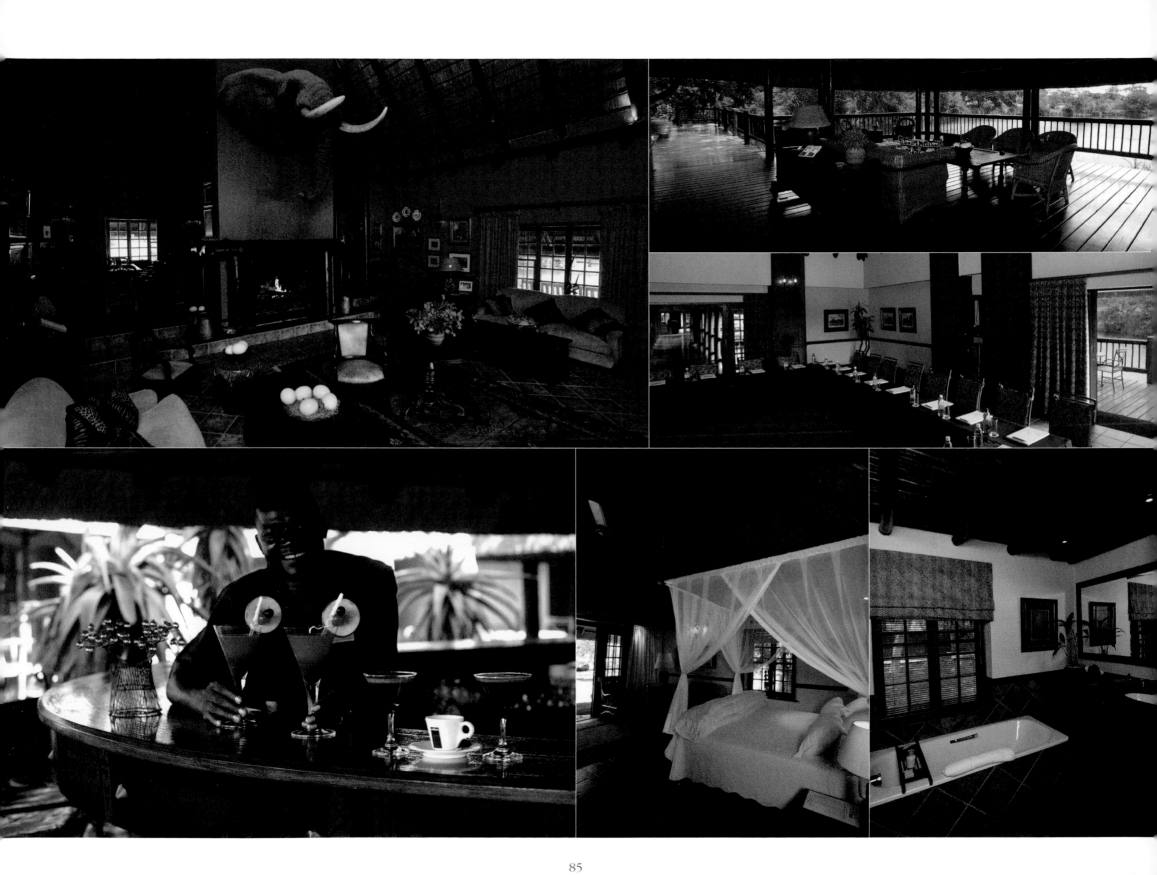

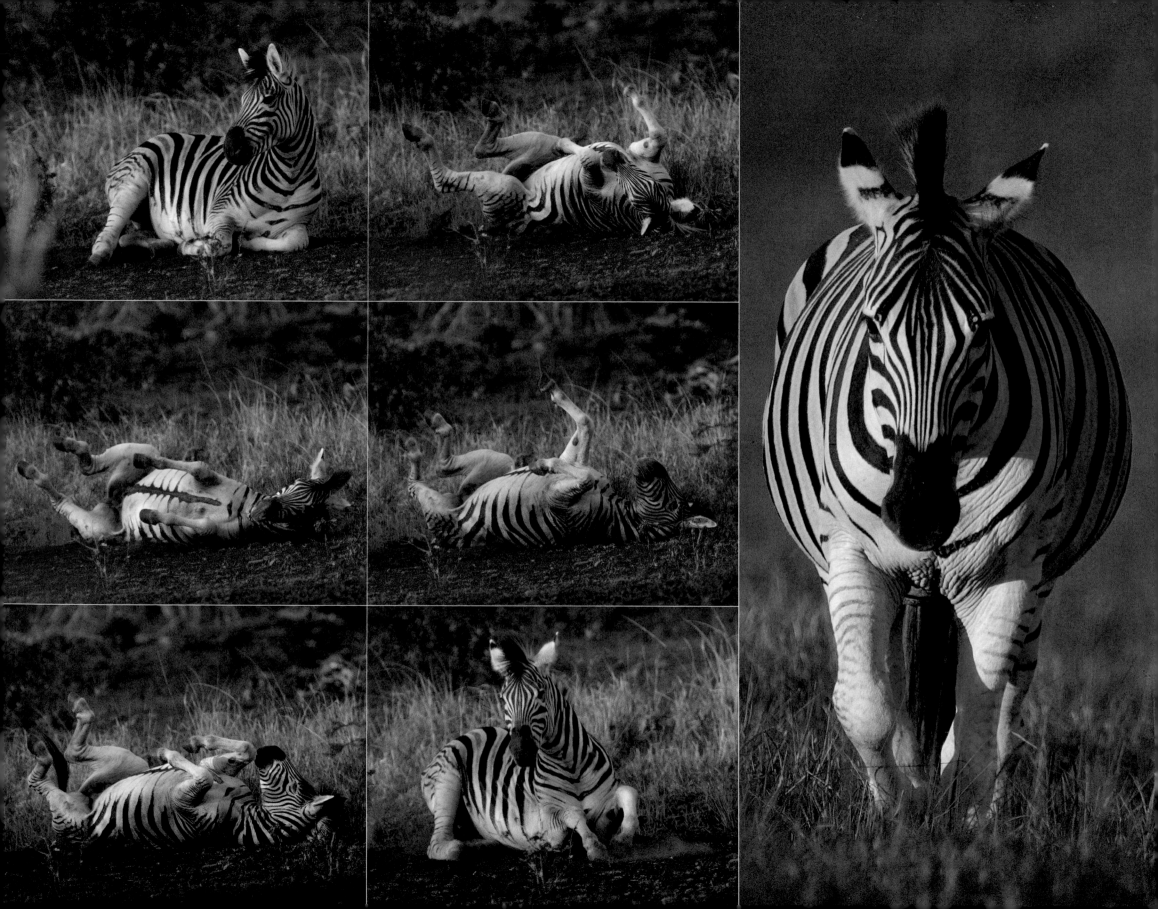

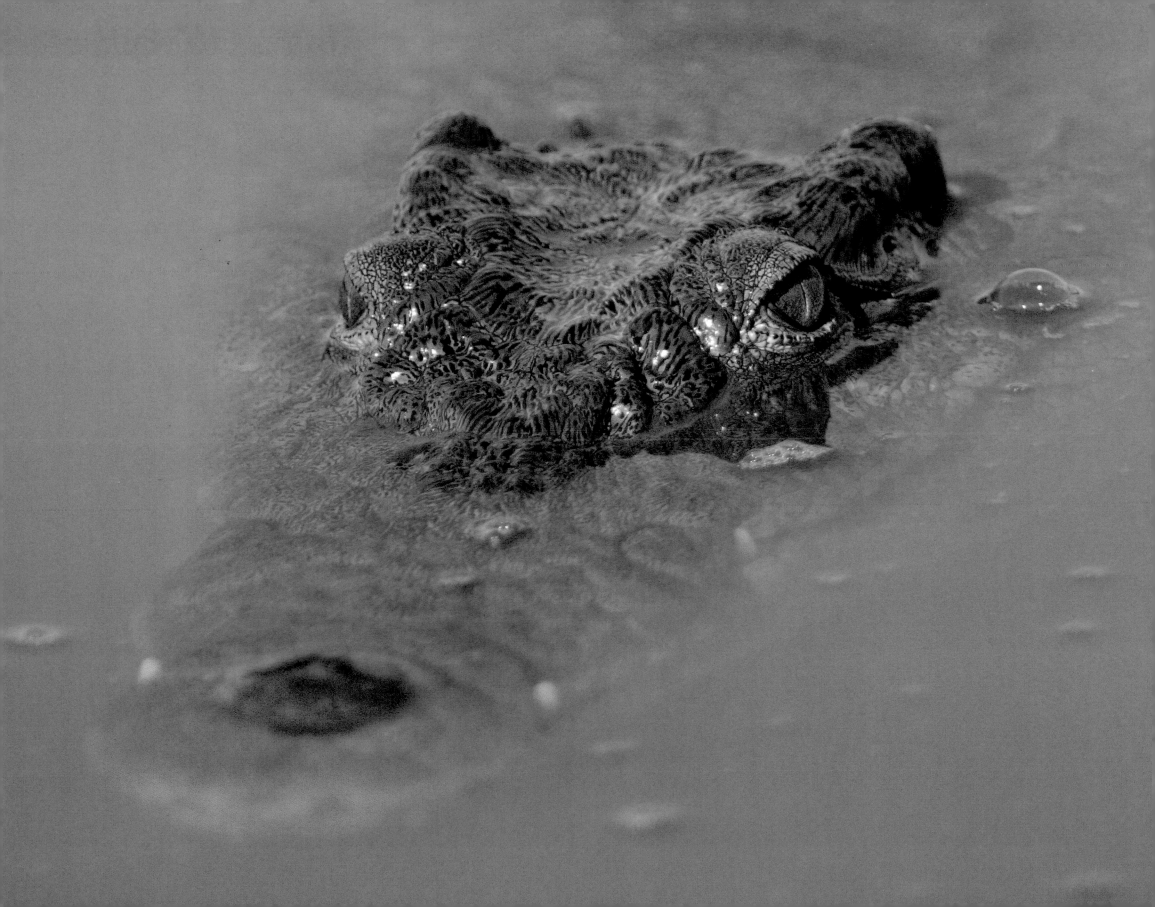

Kapama
BUFFALO CAMP

Kapama Buffalo Camp in the Kapama Private Game Reserve has a sense of timelessness. It is as if its tents were always there, merged with the bush.

Each tented bedroom is set high on stilts in the canopy of the trees lining the steep riverbank. The river below rarely flows, making it easy to spot the dainty footprints left in the sand by antelope. High above, in the branches of the bush willows and leadwood trees that crowd the balconies, birds sing loudly and vervet monkeys stare at you as you sit on a canvas chair in the dappled sunlight. Wooden walkways connect the tented safari rooms and lead back to the riverbank and the main lodge.

There are only eight safari tents, each offering a combination of comfort and style. Steeped in the best traditions associated with luxury bush camps, Buffalo Camp provides for a small number of guests who can get to know each other on the game drives and during the alfresco dinners around the open fire every evening.

Gardens of succulent aloes and euphorbia are tended around the thatched bar, dining room and camp fire, but the thick African bush is just a glance away, trying always to reclaim its terrain.

Lanterns, rather than electric lights, glow at night, creating an intimate ambience particular to Buffalo Camp. This African camp atmosphere is perpetuated at mealtimes with serve-yourself choices presented in heavy African cooking pots over a gentle flame. Hot and cold breakfast and lunch options are spread out across the servery, while dinner is prepared in the kitchen or cooked on the grill and served around an open fire in the circular traditional outdoor boma.

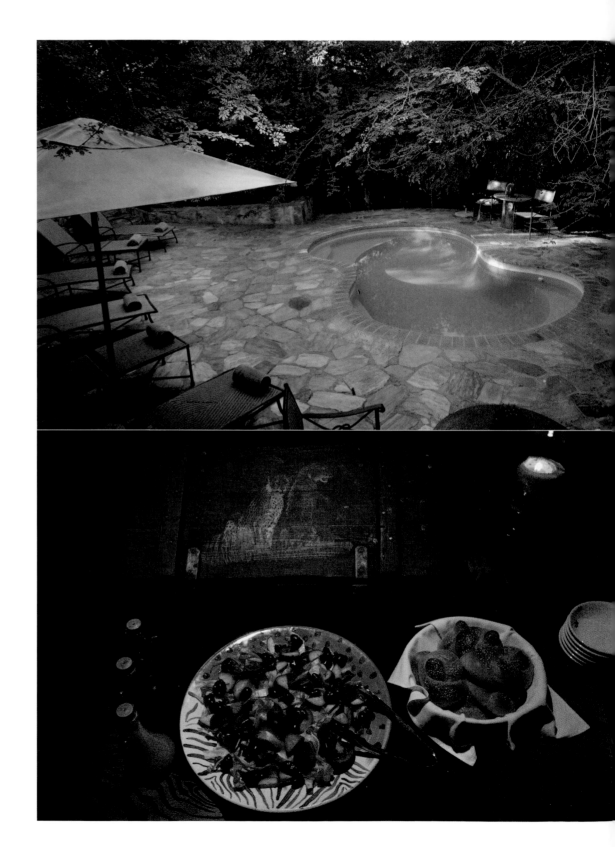

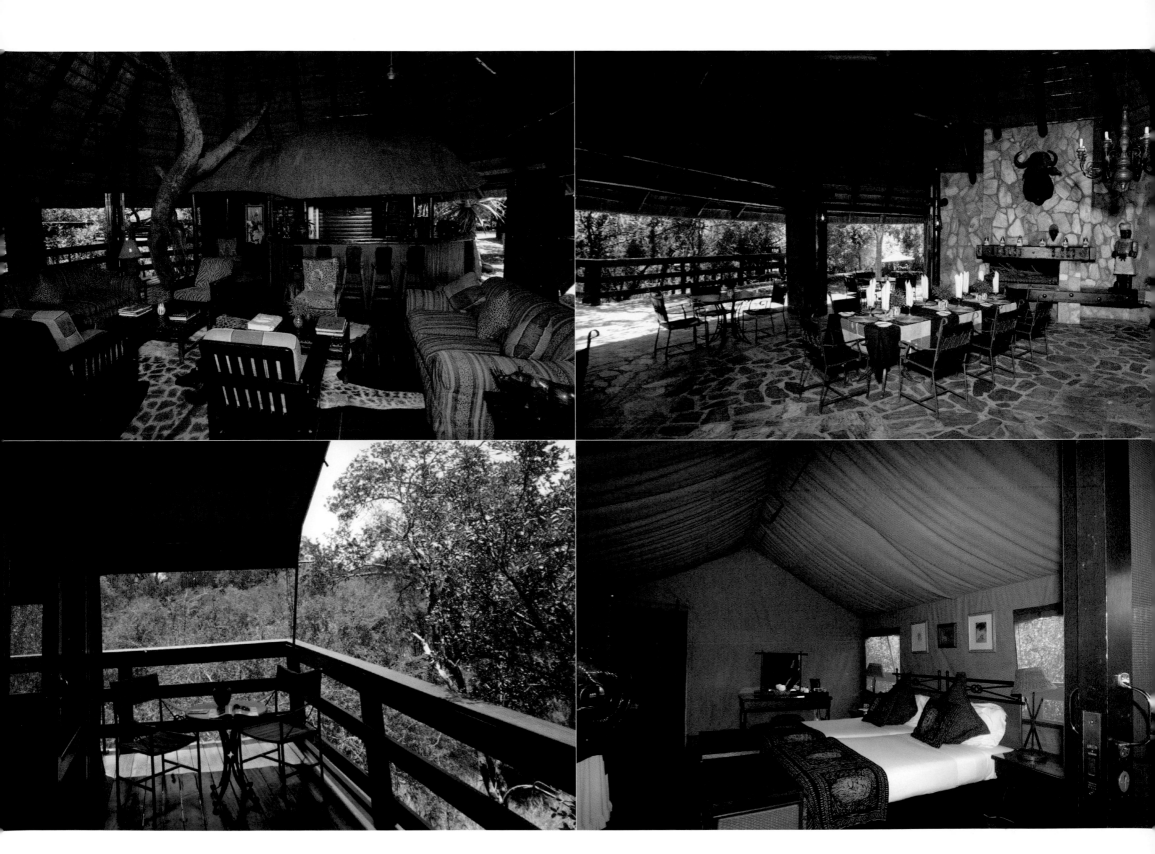

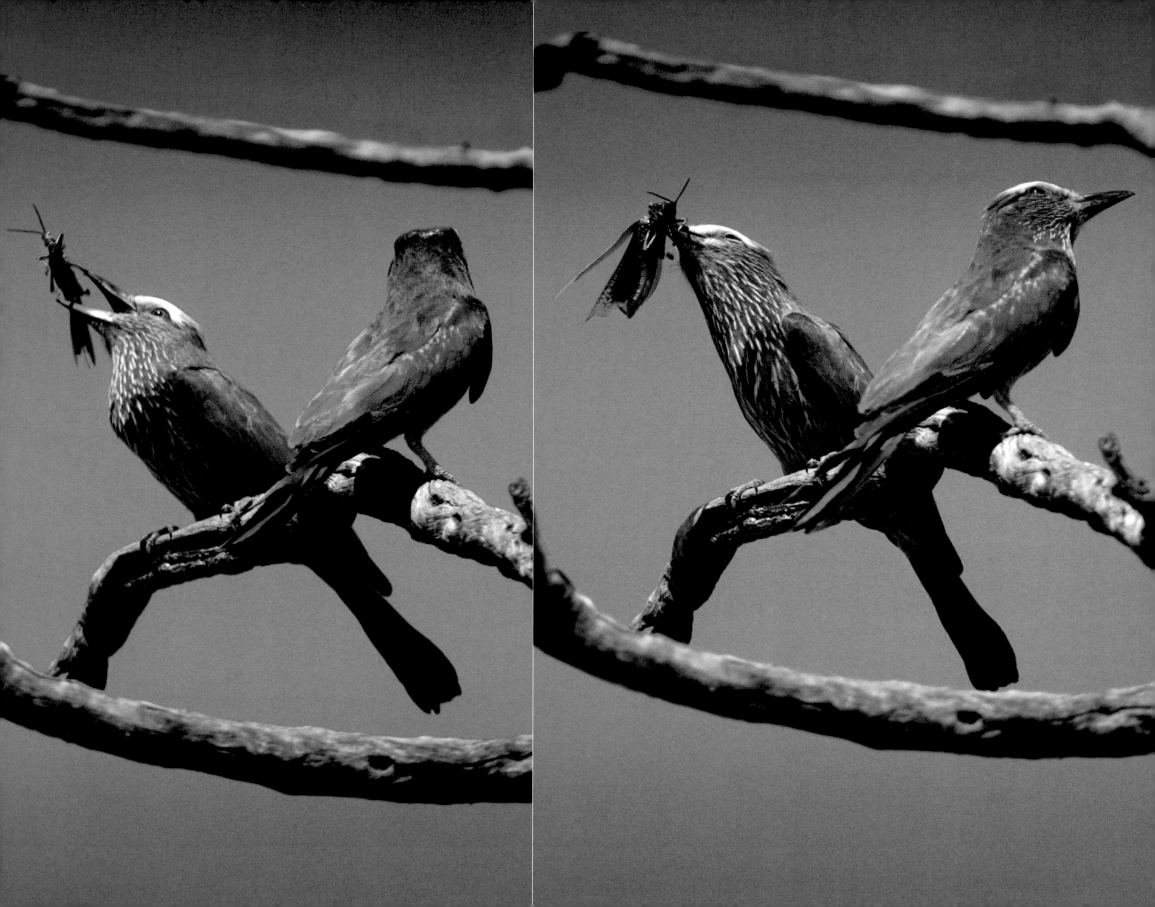

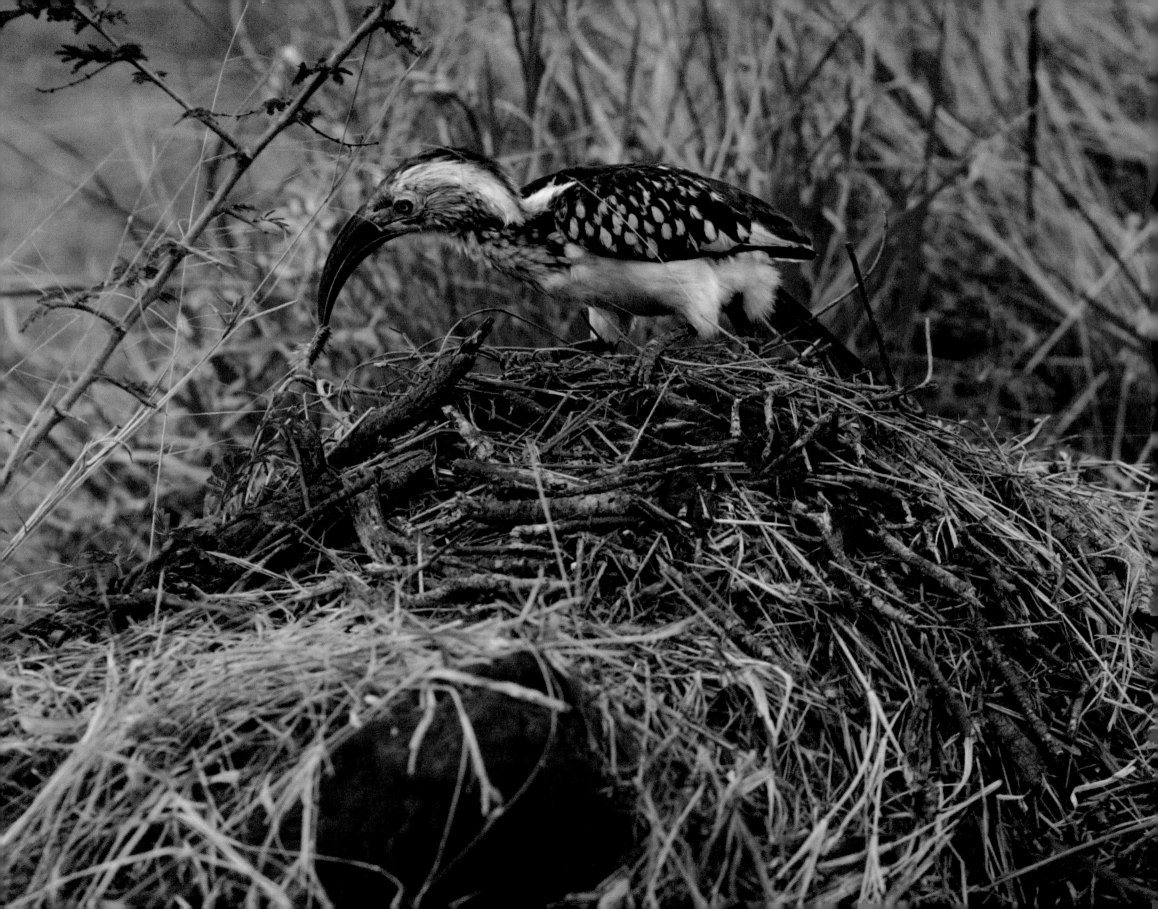

Camp Jabulani

Camp Jabulani leaves you feeling enriched in so many ways; not only will you have been a guest at one of the most comfortable and elegant safari camps in South Africa, but you will have had much closer encounters with African elephant and cheetah than you would have ever thought possible.

Camp Jabulani is named after one special elephant that lodge owner Lente Roode rescued after he was found stuck in mud. This baby elephant was nurtured back to life before attempts were made to reintroduce him to the wild. However, it seemed he preferred human company.

Jabulani needed friends, and when Roode heard that eleven trained elephants were facing an uncertain future in Zimbabwe, she rescued them. Now she owned a whole herd of trained elephants and luckily also a very large game reserve close to the Kruger National Park in Limpopo, namely Kapama Private Game Reserve. Like Jabulani, these elephants were too conditioned to return to the wild, so another plan was hatched, this time to offer elephant-back safaris in the reserve. These safaris give guests the opportunity to ride atop an elephant among the wild animals of the reserve. And just because you are on top, the pachyderms will not necessarily stop tearing off branches to feed on as they go.

Camp Jabulani guests can also get close to cheetahs at the Hoedspruit Endangered Species Centre, a non-profit breeding and research centre established by Roode in the late 1980s.

Back at Camp Jabulani, Roode's passion for animals is evident from the wildlife paintings, bronzes and artefacts found throughout the lodge. Elephant figures are even stamped on leaves decorating the marble-top basin consoles in the suites.

Cuisine at Camp Jabulani meets international gourmet standards and the chef personally introduces the menu at the start of each meal. The signature style is to create perfectly sized portions of the freshest ingredients presented in an exquisite arrangement that will leave you more than satisfied.

The passion that all staff members have for Camp Jabulani is palpable, and sharing this passion is what makes a stay at Camp Jabulani unforgettable.

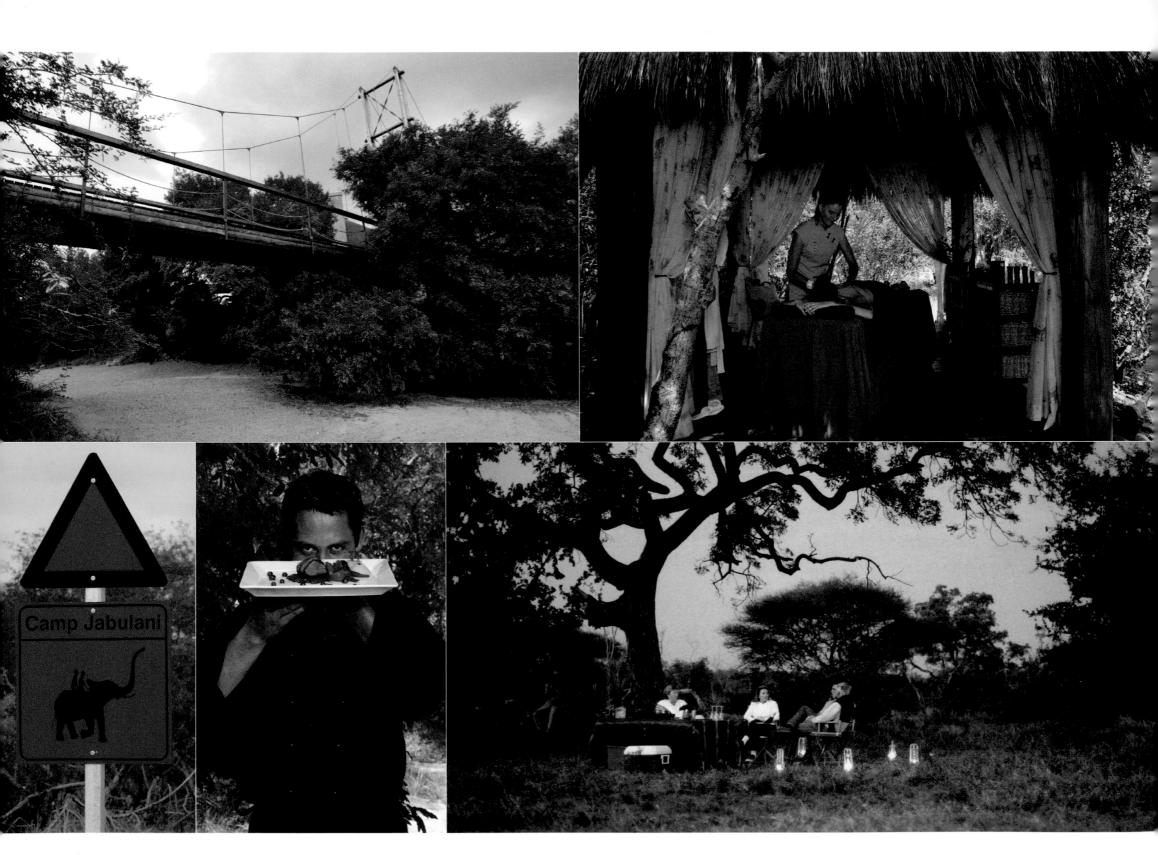

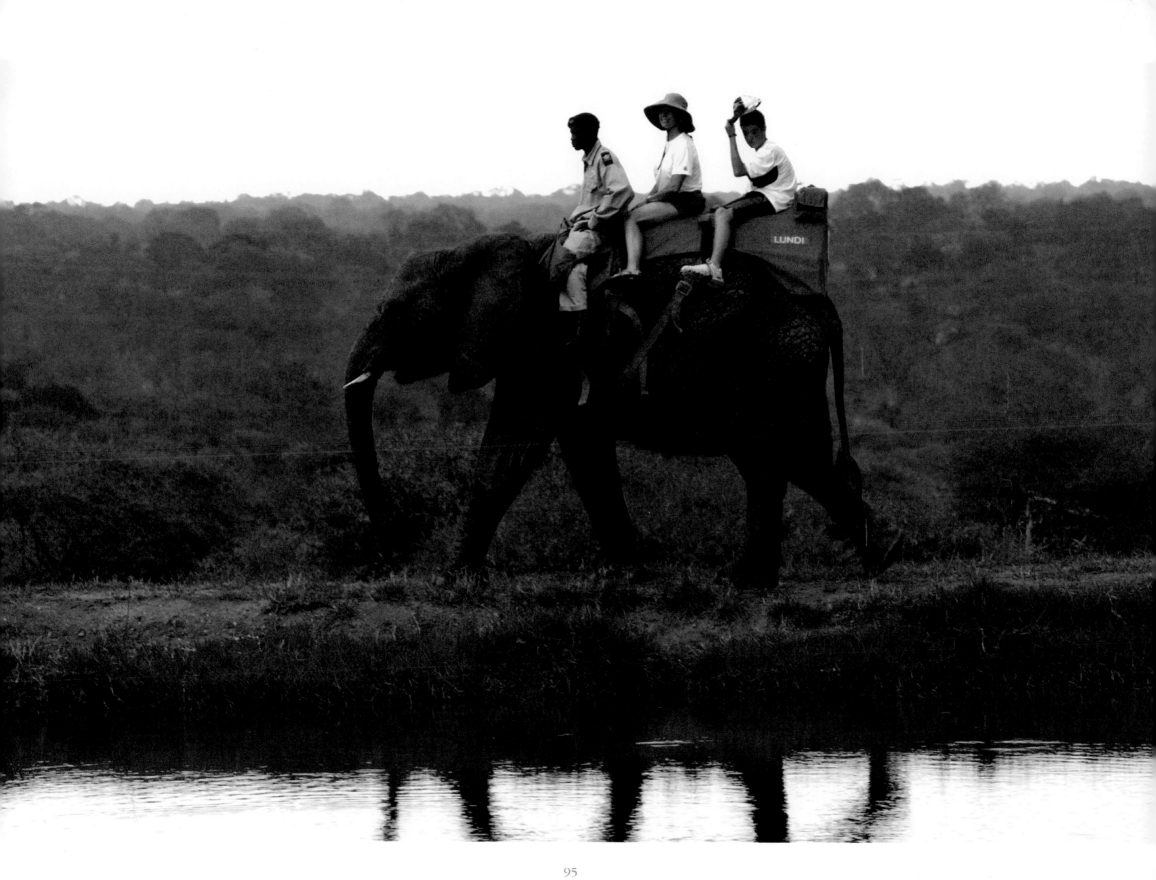

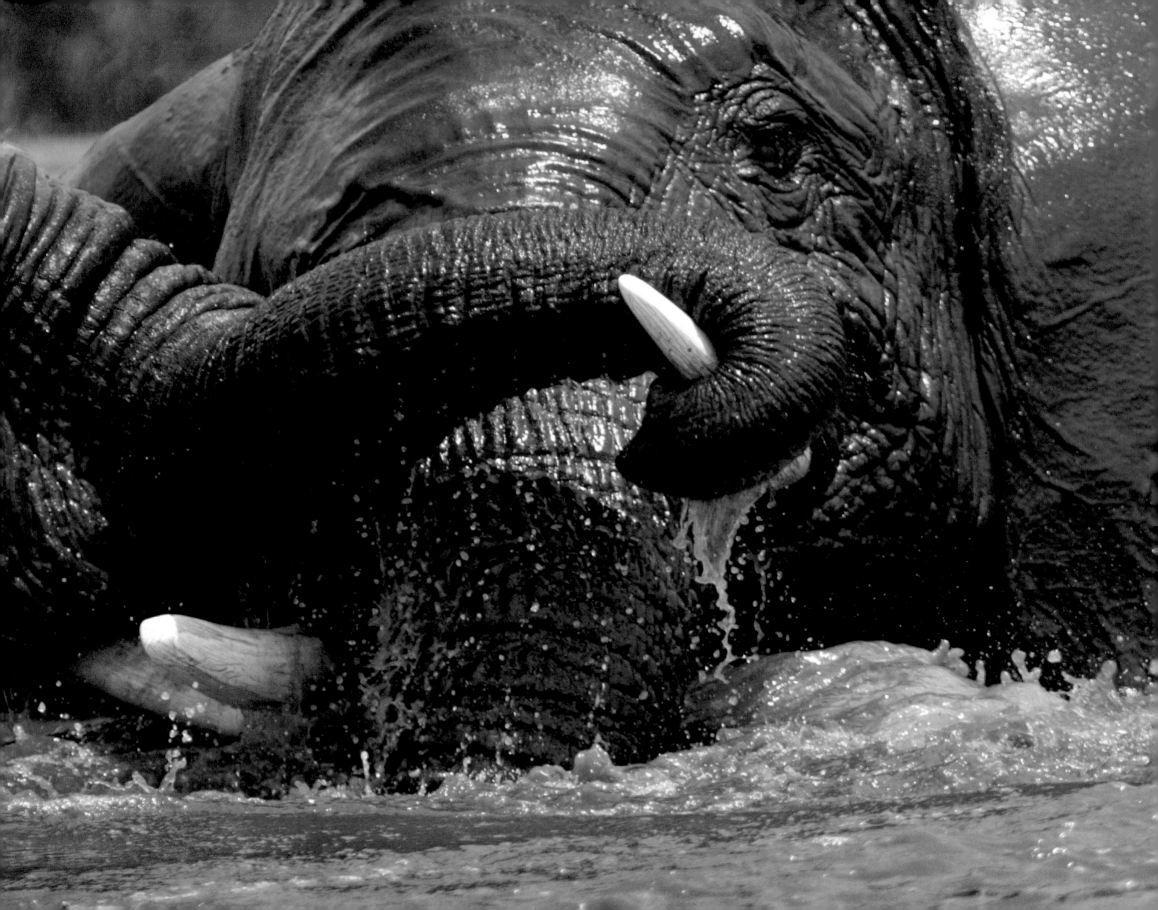

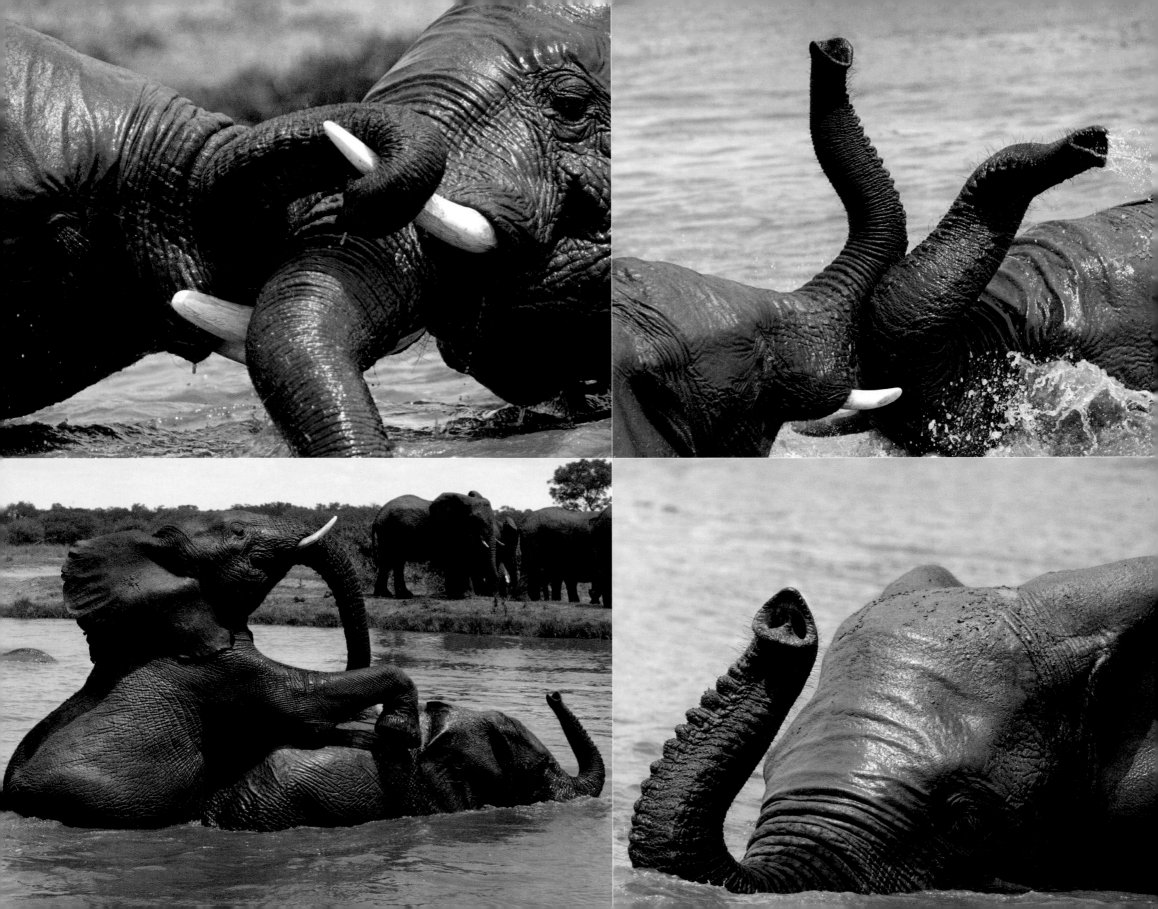

Itaga

LUXURY PRIVATE GAME LODGE

Head for the hills a couple of hours north of Johannesburg and you will cross from Gauteng into the province of Limpopo. It is here, at the foothills of the Waterberg mountains in the greater Mabalingwe Game Reserve, that Itaga Luxury Private Game Lodge is found.

A large thatched roof covers the central complex where guests can recline in deep leather couches and comfortable armchairs. Grass, wood, pottery and woven textiles, along with zebra skins, ostrich eggs and Zulu baskets, create a distinctly African atmosphere throughout the lodge. The fact that you cannot be anywhere other than in the wilds of Africa is confirmed by a glance at the waterhole, where wild animals, including buffalo, elephant, warthog and a variety of antelope, can be seen slaking their thirst.

Itaga's eight en-suite, thatched-roof chalets are the perfect home away from home. Each one is individually styled and has its own pergola-covered patio. Air conditioning will keep you snug in winter and cool during the swelter of hot summer afternoons. Most chalets have an outdoor shower as well; when using it, you will be forgiven for imagining you are in your own private rainforest.

While you are out viewing game or watching birds, the lodge staff get on with their job of making your stay as comfortable and memorable as possible. Itaga's kitchen always seems to be on the go. Mornings are the best time to appreciate the care taken in the preparation of meals, with an enticing display of tropical fruit that greets you like a burst of sunshine. Of course, the breakfast buffet sets the tone for the epicurean masterpieces, complemented by fine wines, that await you at lunch and dinner.

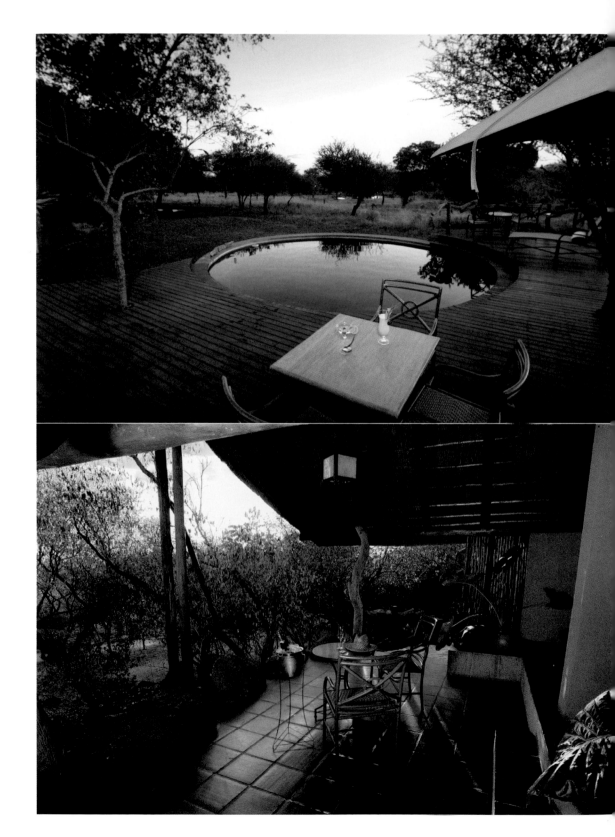

(below)

"This fascinating songololo, also known as a millipede, reminded me of an occasion during my early childhood when my sister Cecile taught me a rhyme about its cousin, the centipede. I recited it to a honeymoon couple on safari. They were so delighted by the rhyme that they asked me to repeat it at dinner and wrote it down in their journal."

<div align="center">

The Centipede was happy quite,
Until the Toad in fun
Said 'Pray, which leg goes after which?'
And worked her mind to such a pitch
She lay, distracted, in the ditch
Consid'ring how to run.

Mrs Edmund Craster (*circa* 1871)

</div>

(right)

"The anatomical complexity of the ant, right down to the fine hairs on its legs, is extraordinary. Ants' habit of stopping to 'greet' each other as they pass is reminiscent of game rangers in their vehicles, who stop to chat when they meet on the road on safari."

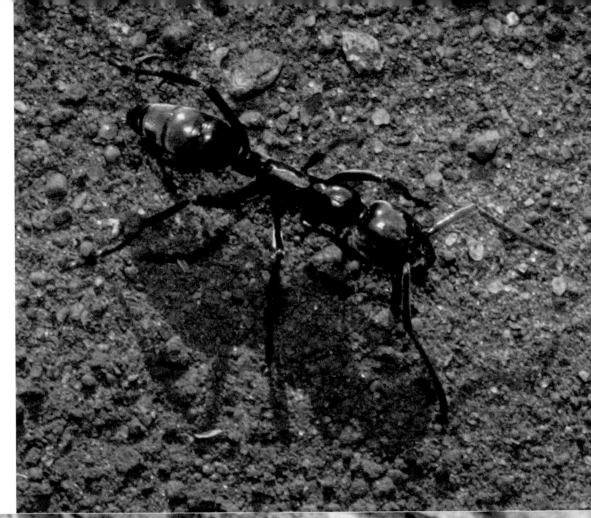

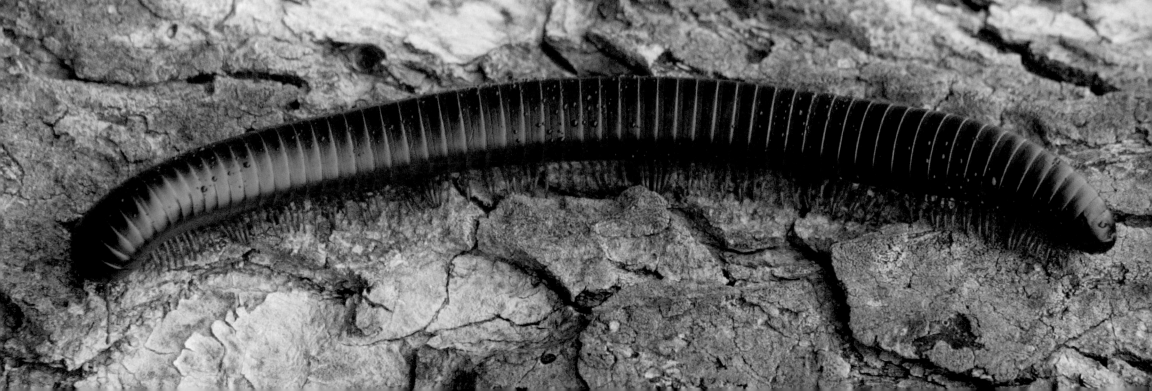

Kuname

RIVER LODGE

Passion is the priceless ingredient that will make a stay at Kuname River Lodge exceed all your expectations. All those associated with Kuname are driven by a passion for the land and the animals, for conservation, for food, and for service. In addition, Kuname demonstrates its passion for the local community by providing educational support for future generations and exposing them to career opportunities. This makes Kuname River Lodge a rather special place.

Set in 9 000 hectares of pristine African bush in the Karongwe Private Game Reserve in Limpopo, Kuname River Lodge is just 45 minutes' drive from the world-famous Kruger National Park. Its holistic attitude to tourism ensures a well-rounded safari experience. Here a bush walk turns out to be a nature expedition, with participants learning about medicinal plants, lesser-known flora and fauna and veld skills passed down from one generation to the next. On the game drives, too, you become a participant rather than simply a spectator of wild animals and birds.

African animals always emulate the colours of the bush, but birds often sport much brighter hues. All these aspects are incorporated into the colour scheme of Kuname River Lodge and its five riverside chalets. The subdued tones of the natural fibres, wood and thatch are enlivened by brilliant flashes of colour, from the bold pink of the poolside towels to the fiery oranges in the soft furnishings. Hand-selected artworks, gathered over time for exact spots in the lodge, complement the African decor and colour palette.

Cuisine is in the expert hands of an innovative chef who uses wild African ingredients to add an authentic and exciting twist to the menus. Basil pesto is made from wild basil collected fresh by the guests on morning excursions, and a coffee infusion for the chocolate mousse is made from the seeds of the weeping boerbean tree.

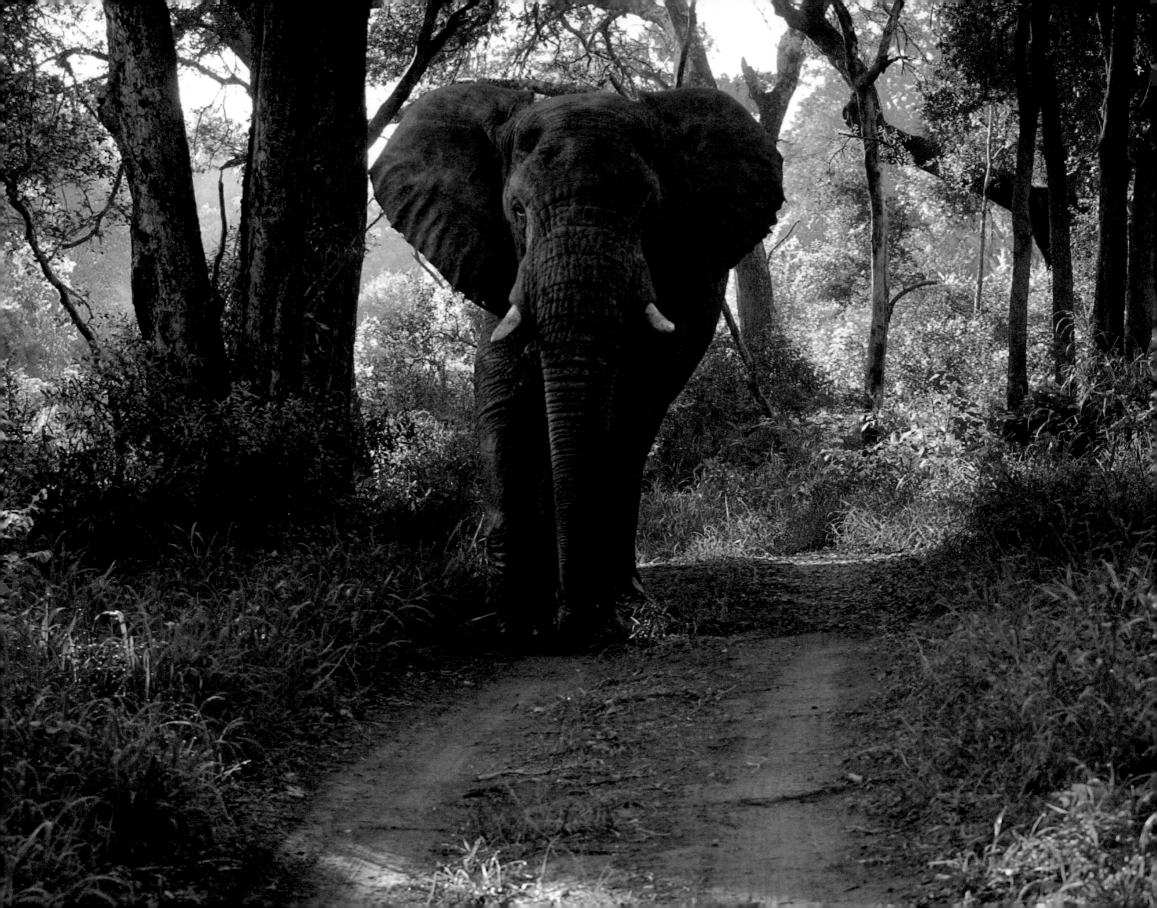

(left)

"The gigantic elephant came down the path between the trees, walked straight towards our vehicle, and then, at the eleventh hour, exited left of centre stage."

(below, right)

"What a wonderful life these two little frogs have. They spend their time perched on metal electric light fittings in the lounge of Kuname River Lodge and feed on insects that buzz around the lights at night. Relatively safe from harm there, they enjoy the heat emitted by the glass bulbs and the affection of the lodge staff."

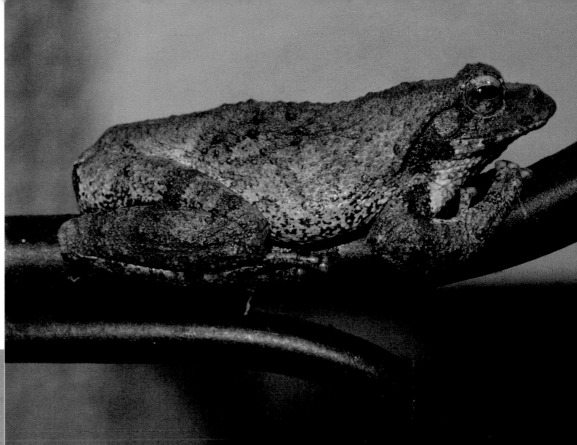

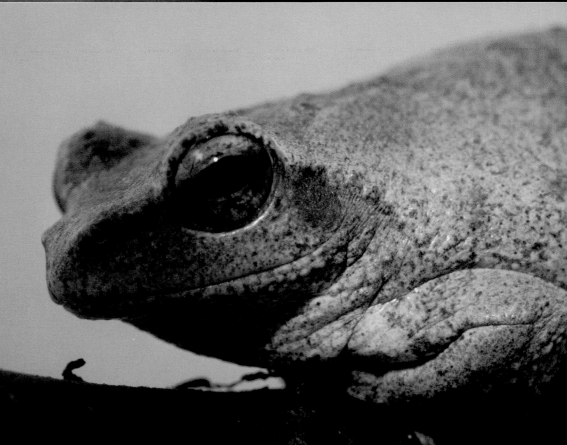

Garonga
SAFARI CAMP

Garonga Safari Camp promises a 'safari for the soul'. There is no rushing around of guests armed with binoculars ticking the names of animals and birds on a must-see list. On the contrary, the place has an aura of tranquillity that soothes the soul. This does not mean, though, that you would not see members of the Big Five in this wilderness in the Makalali Conservancy in Limpopo. On game-viewing drives there is every chance of seeing white rhino, elephant, lion, cheetah, spotted hyaena and even the elusive leopard. Game walks provide a further opportunity to observe the animals – large and small – in the conservancy.

Much of the intimate ambience at Garonga is created by the architecture and interior design of the camp. Colours and styles are borrowed from nature: terracotta tones, curved walls, reed ceilings and mahogany-coloured roof trusses characterise this stylish lodge.

The suites are a dreamy affair. White canvas, soft lighting, fine linen and a four-poster bed combine to create a space for relaxation, reflection and meditation. A private deck, shaded by large ebony trees and hung with a hammock, aids the journey towards enlightenment. For further destressing, you could relax in the pool or enjoy an aromatherapy massage or reflexology or reiki treatments. Alternatively, you could be fed exquisitely tasty morsels around the pool or out in the bush. Sumptuous picnic baskets are a specialty and the wine cellar stocks quality South African wines.

Not to be missed is a stay on the sleepout deck opposite a waterhole. High above the prowling animals of the night, you can spend the night in a real bed under a mosquito net and wonder at the noises of an African night.

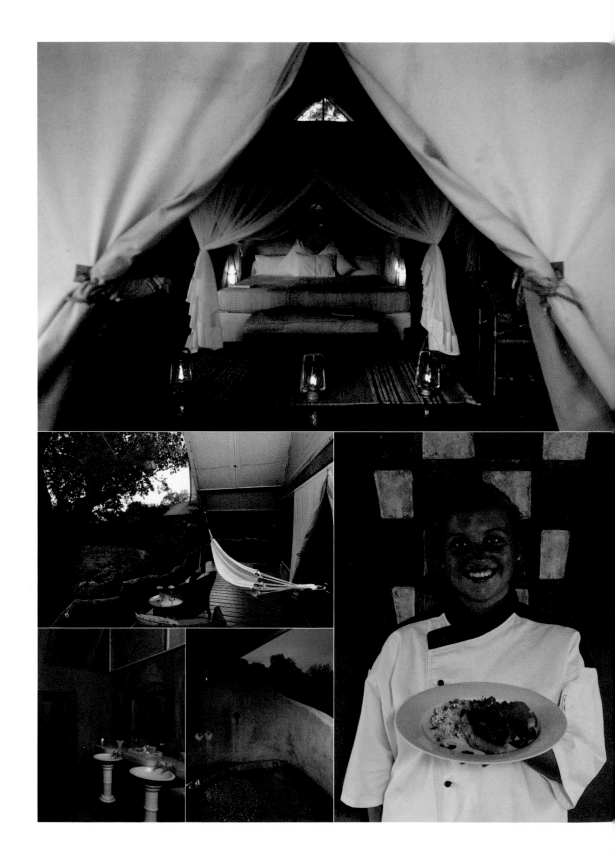

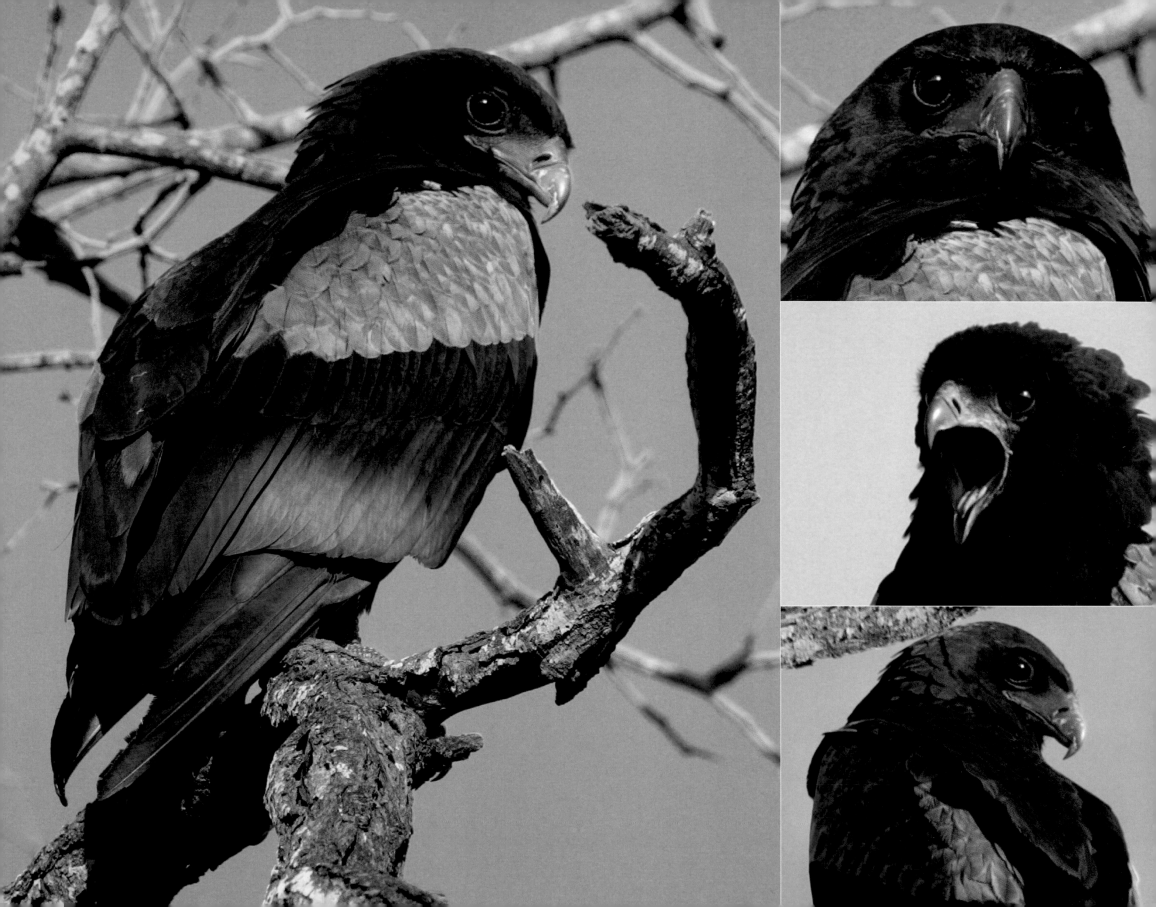

Clifftop

EXCLUSIVE SAFARI HIDEAWAY

It does not take much to work out the kind of position Clifftop Exclusive Safari Hideaway in Limpopo must enjoy. Yes, it is indeed perched on the edge of a cliff of ancient striated sandstone in the Waterberg mountains and every part of it takes advantage of the incredible vista across the valley below.

Clifftop is all about safari with sophistication. At this bushveld hideaway, situated two and a half hours' drive north of Johannesburg in the malaria-free Welgevonden Private Game Reserve, you will find a fusion of modern comfort and untamed wilderness. The lodge's eight luxury suites overlook the Sterkstroom River below, and each suite has its own private deck and plunge pool, affording guests an opportunity to watch the wildlife from the privacy of their suites.

With dramatic views of the surrounding landscape, the main lodge offers a perfect setting for sundowners – on the deck next to the infinity pool. It is also here, and in the bar lounge, that guests can congregate to recount their experiences of the day's game-viewing activities, whether a game drive in an open 4x4 vehicle or a bushwalk in the company of trained field guides.

The new perspectives that watching wild animals at Welgevonden can give may serve to heighten the appreciation of everything Clifftop has to offer, from fine food and prize-winning cellar wines to log fires in almost every room and baths-with-a-view in which to soak away the stresses of city life.

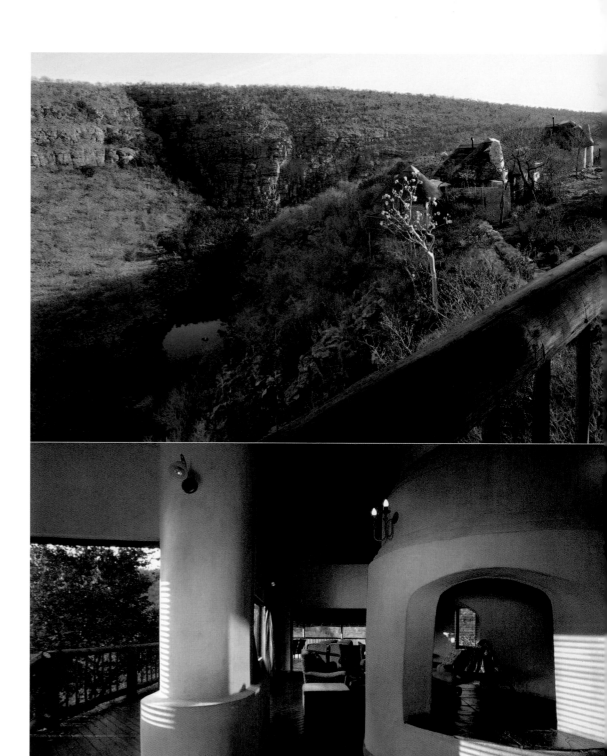

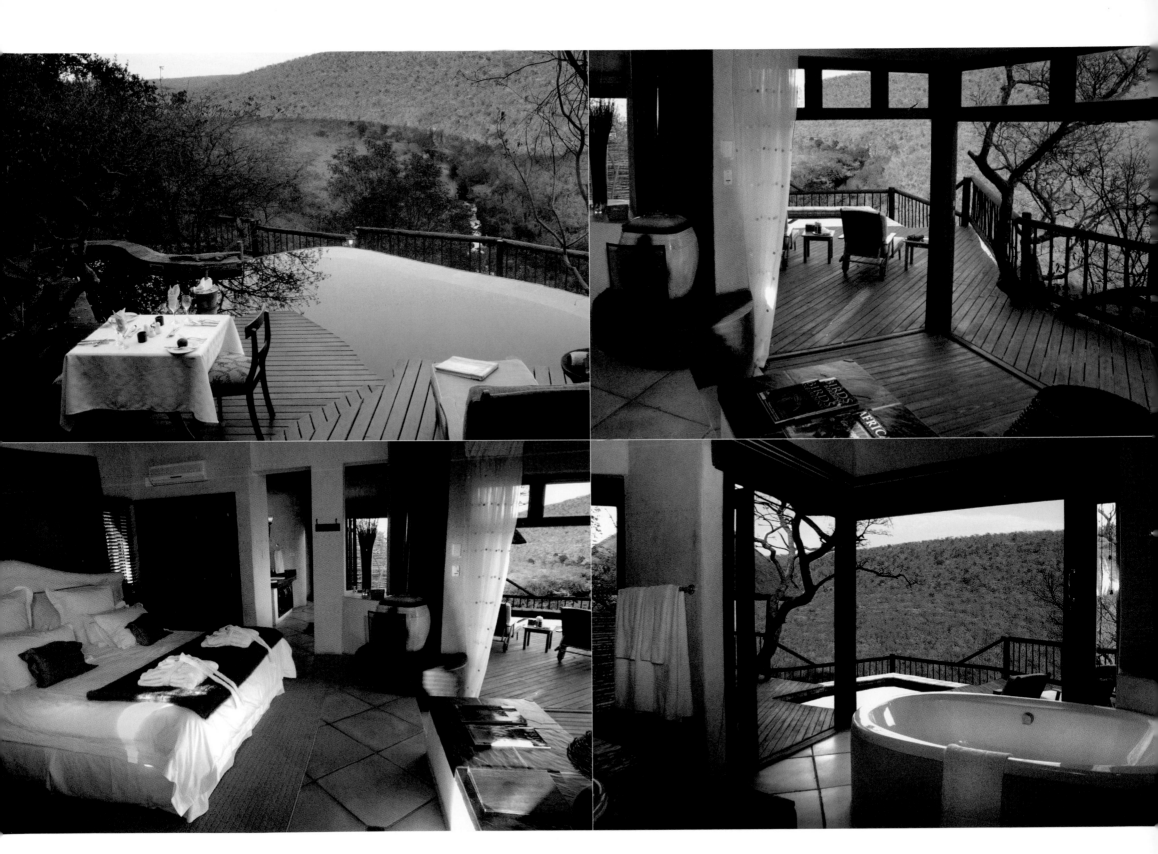

113

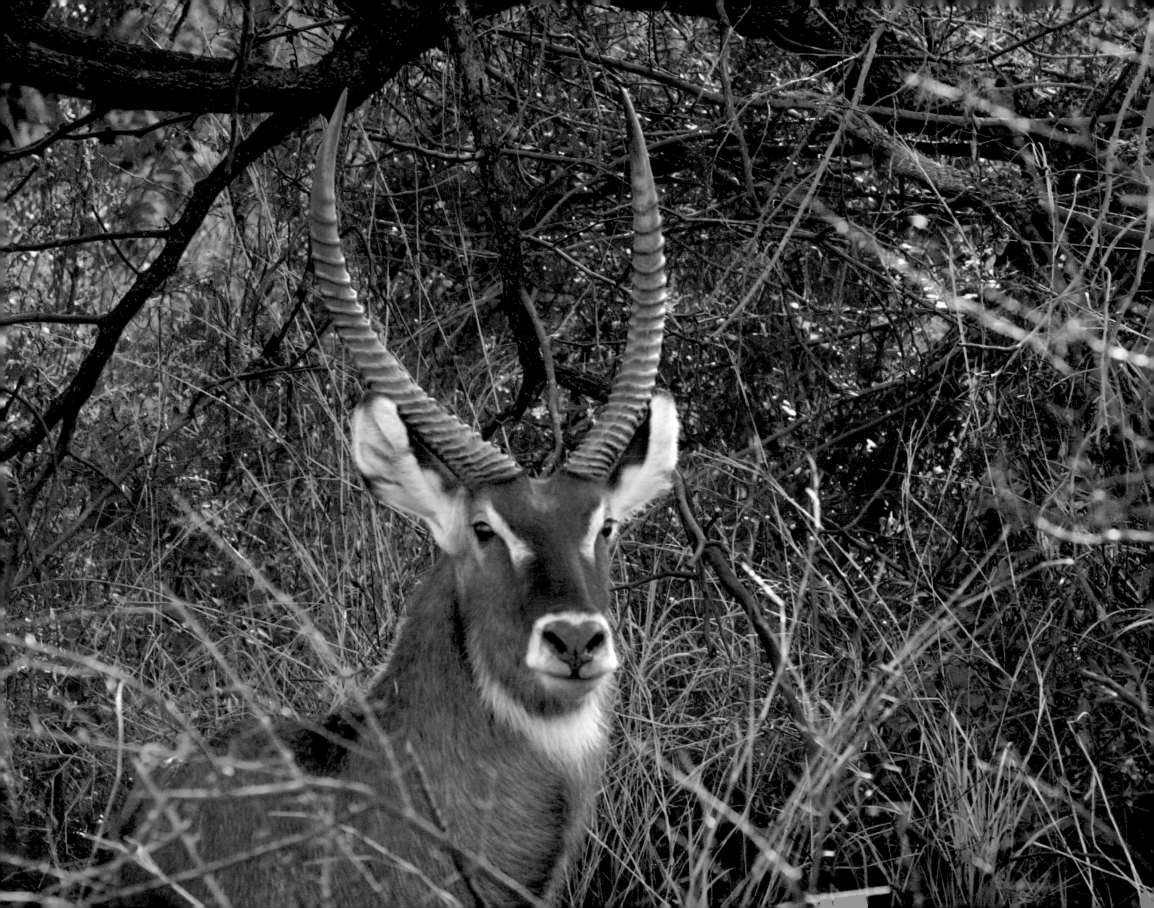

Makweti

SAFARI LODGE

Secluded deep in the Waterberg mountains is Makweti Safari Lodge. Exclusive and stately, it rests comfortably among the rocks and indigenous trees that blanket the hills and valleys in these parts. Giant euphorbia trees lend a surreal, ancient air to this graceful and elegant lodge, situated in the heart of the Welgevonden Private Game Reserve, a 33 000-hectare wilderness in Limpopo in the northern region of South Africa.

The lodge accommodates just ten guests in individually built thatch-and-stone suites. The architectural style is a finely woven synthesis of natural elements and comfort. The Indaba lounge has become a celebrated feature, with stylish African art, khelim rugs, hand-beaded fabric and leather couches adding richness and colour to the traditional mud walls and thatched roof. Makweti's fare offers a fusion of exotic spices and the freshest ingredients. This culinary hallmark has earned the lodge membership of the prestigious Chaîne des Rôtisseurs – the international gastronomic society established in Paris in 1950 and devoted to promoting fine dining and preserving the camaraderie and pleasures of the table. A good wine goes a long way towards these aims, and Makweti's cellar carries a selection from the best wine estates in South Africa.

As seductive as the soft, leather sofas, ancient artworks, fine food and cellar wines are, it is evocative Africa and the magnificent diversity of wildlife found here that are the real drawcards. Makweti is open to the wild and no fences interrupt the natural flow of the game. The diverse habitats of Welgevonden – from rugged gorges, thick with broad-leafed trees, to open plains and grasslands – support a multitude of wild animals like lion, elephant and white rhino, as well as zebra and antelope. Over 300 species of bird and a proliferation of insects occur within its boundaries. The plentiful wildlife can be seen on game drives in open safari vehicles, on guided walking safaris or at the waterhole near the lodge. And, no doubt, the experience of coming face to face with one of Africa's Big Five will reinforce Makweti's philosophy of living in harmony with all that is untamed and untouched.

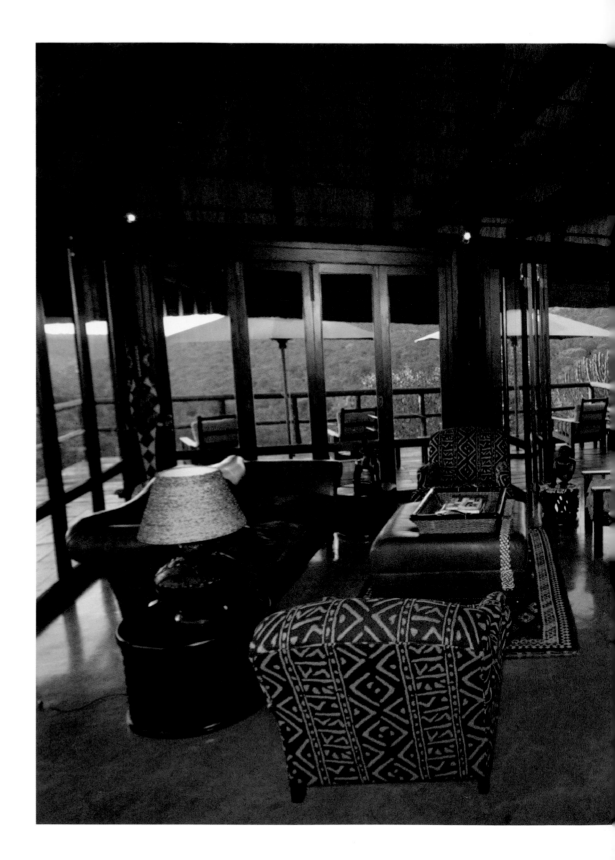

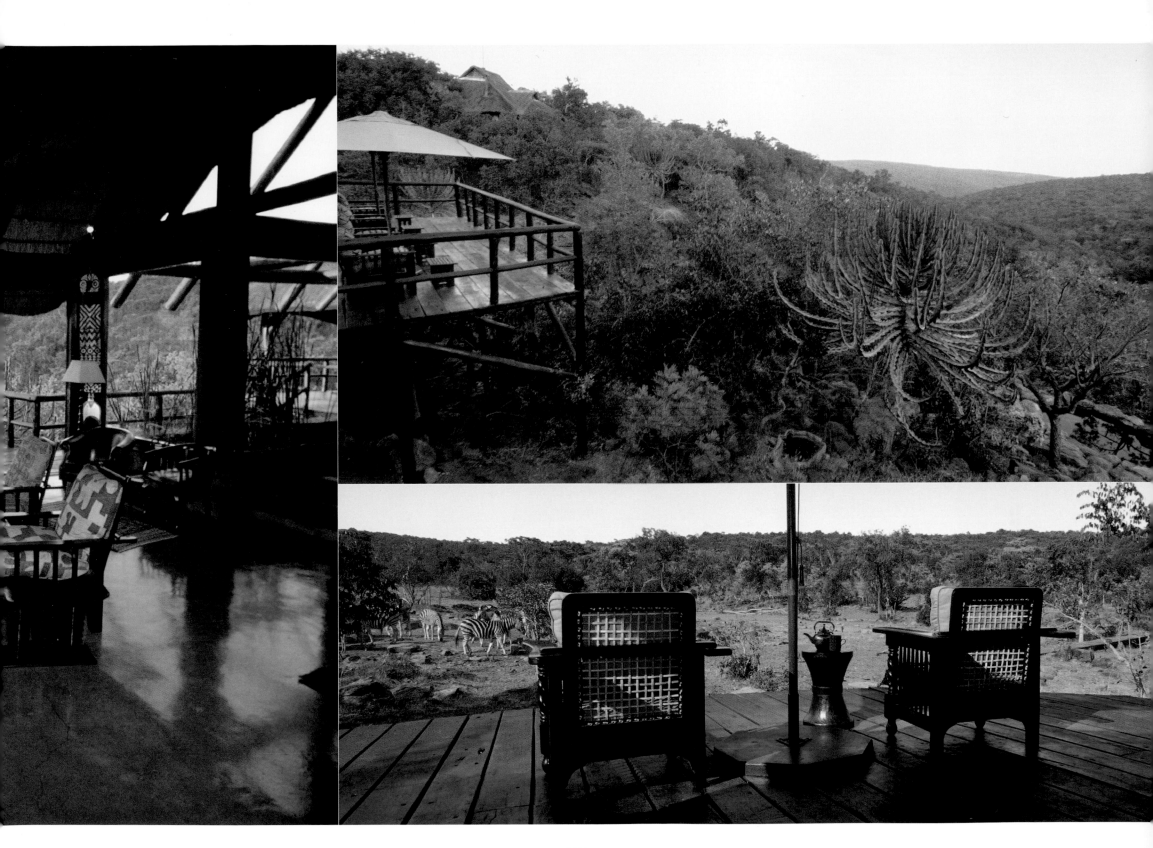

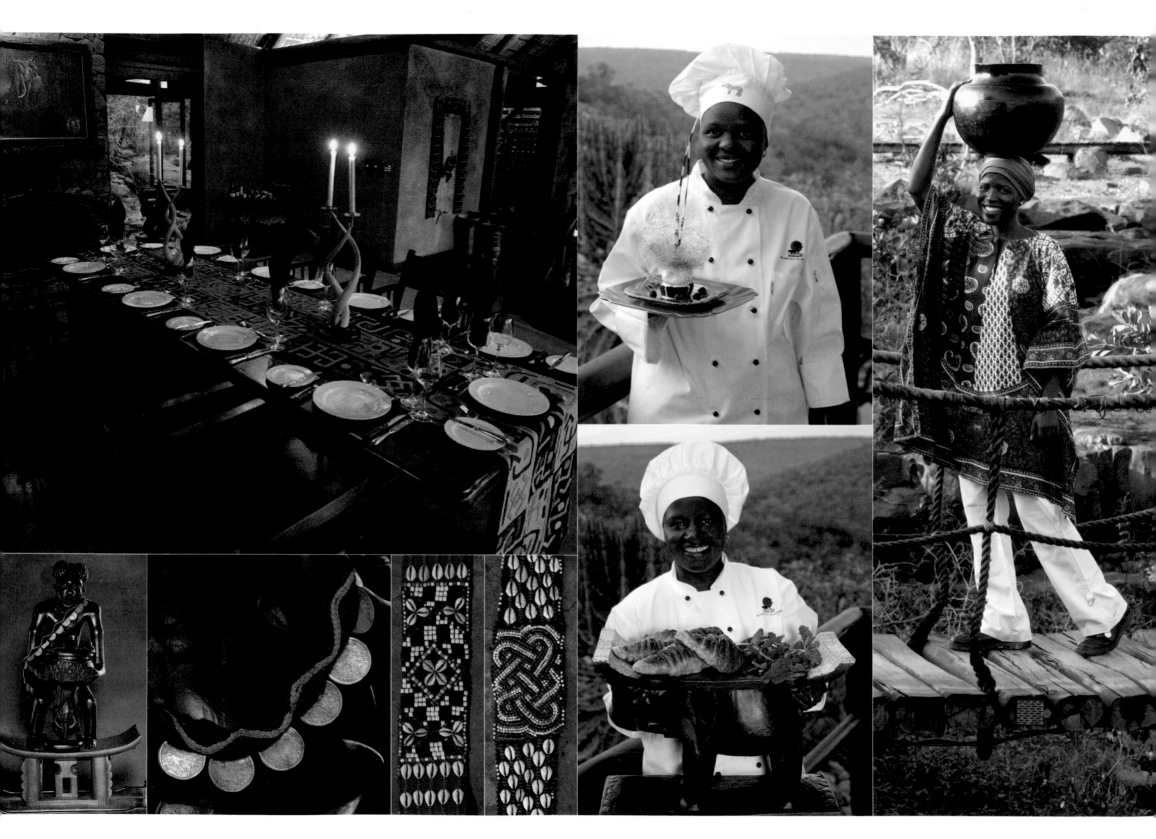

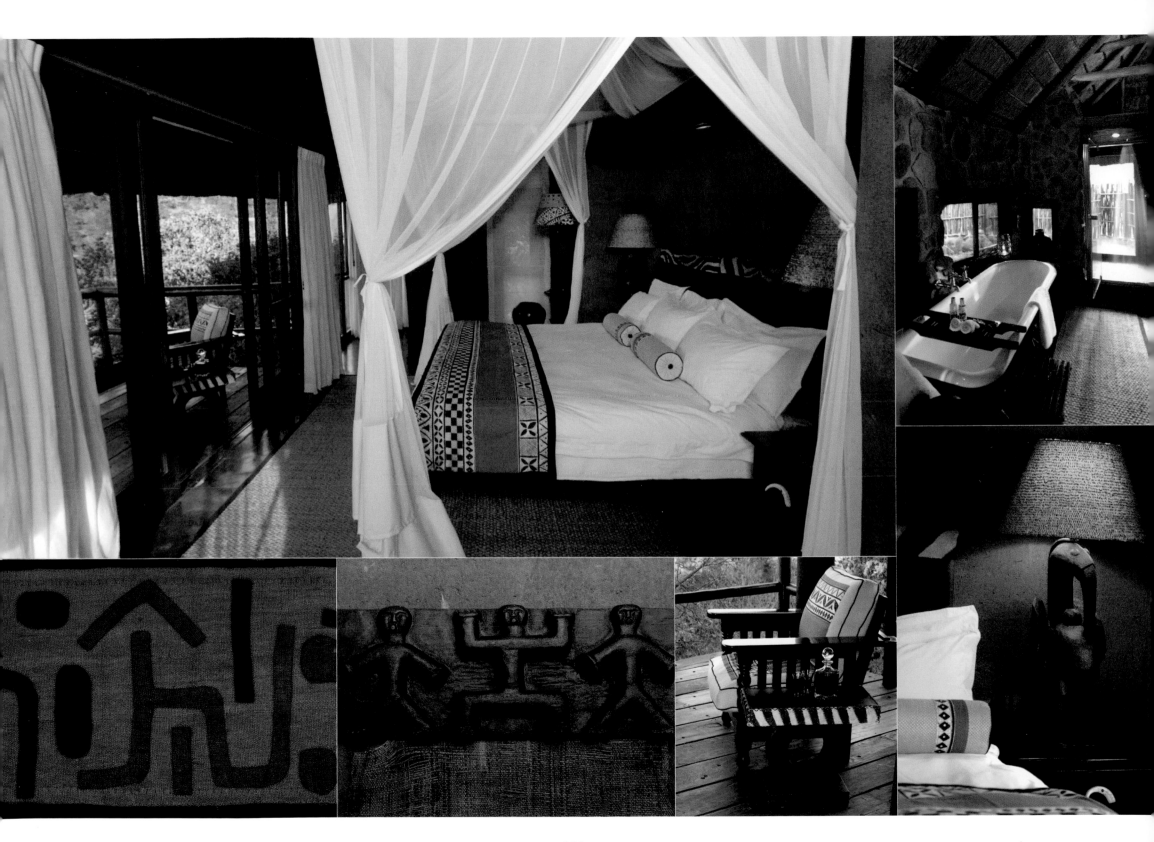

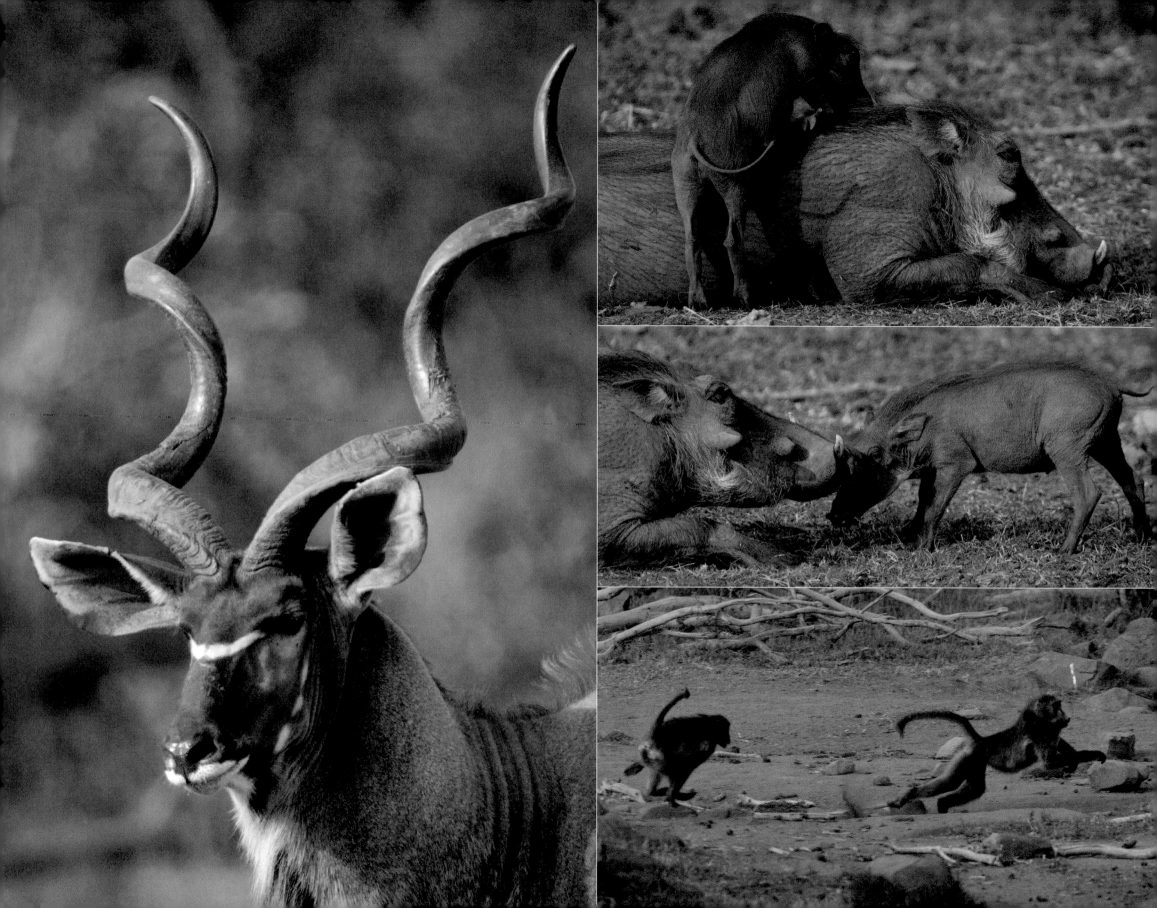

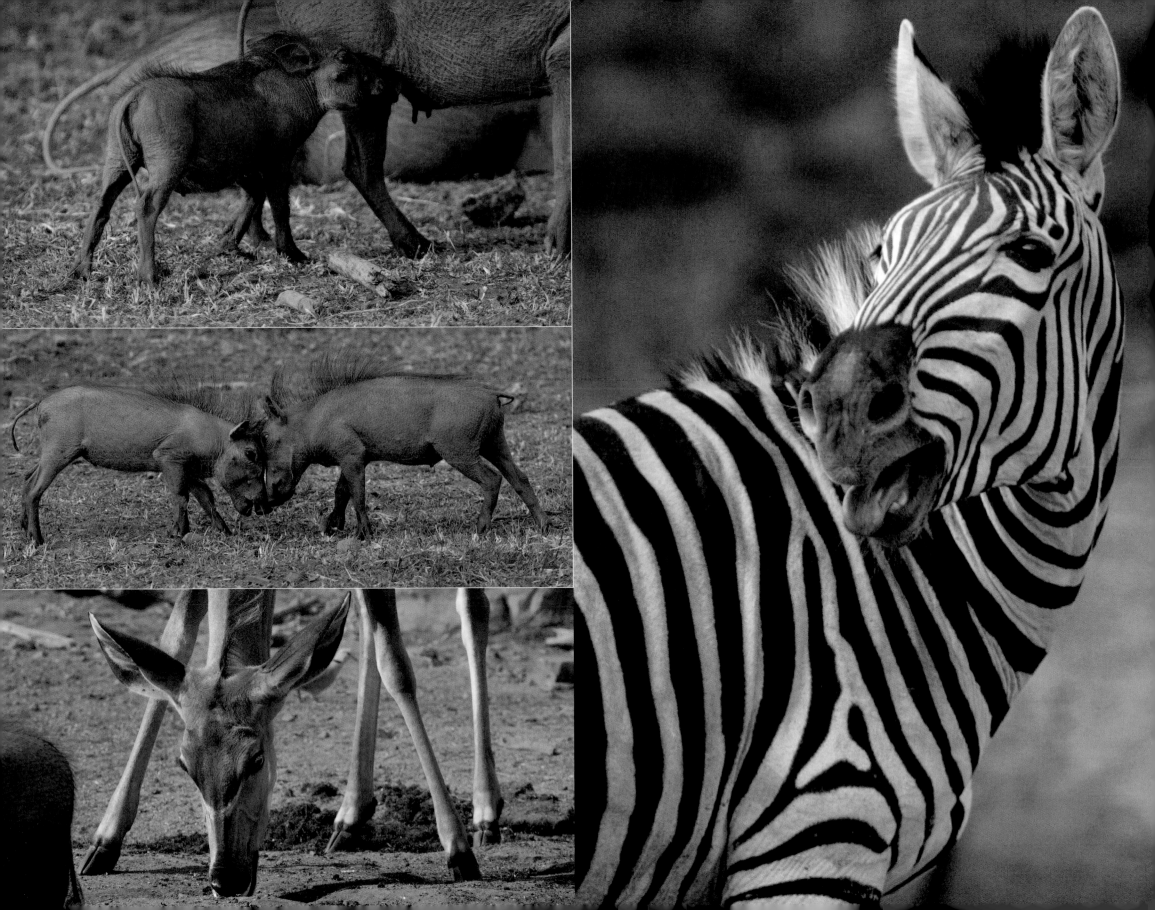

Nedile Lodge

Despite being a mere three hours' drive north of Johannesburg, Nedile Lodge feels like it is a million miles from civilisation. In the dark of night you cannot see any sign of human habitation, even though Nedile, in the Welgevonden Private Game Reserve in Limpopo, is situated on a high ridge in the Waterberg mountains.

Nedile's five suites are carefully positioned between rocky outcrops on a sunny north-facing slope, providing breathtaking views of the surrounding hills. The sense of space you get from anywhere in this lodge is invigorating. One way of getting to know the surrounding environment is to join one of Nedile's game walks, led by a senior field guide whose job it is to ensure that you get the most out of your bush experience. The thick vegetation helps to conceal the many animals, which include one of the largest collections of white rhino on private land. Other species occurring here are elephant, lion, leopard, buffalo, giraffe, zebra, eland and sable. There may even be the odd glimpse of the rarer species like aardvark, brown hyaena or honey badger.

Guests at Nedile do not dash around trying to spot the Big Five in the shortest possible time on a game drive – this terrain is not suited to that style of safari. Nedile is a put-your-feet-up-and-enjoy-the-view kind of place. The decor theme is decidedly African, and hippopotamus sculptures are used as mascots in the lounge, bar and dining area, all of which lead out onto wooden decks. A rock swimming pool adds to the relaxed mood and a boma set among the boulders provides an outside dining area to enjoy meals around a traditional campfire.

There is no need to dress for dinner to appreciate the chef-prepared dishes; it is all very relaxed around here. This is in good part attributed to Nedile's owner, who may appear buzzing above the lodge in his helicopter. He does not live at Nedile, but visits whenever he can to add his inimitable presence and a dose of true South African hospitality to the atmosphere at Nedile.

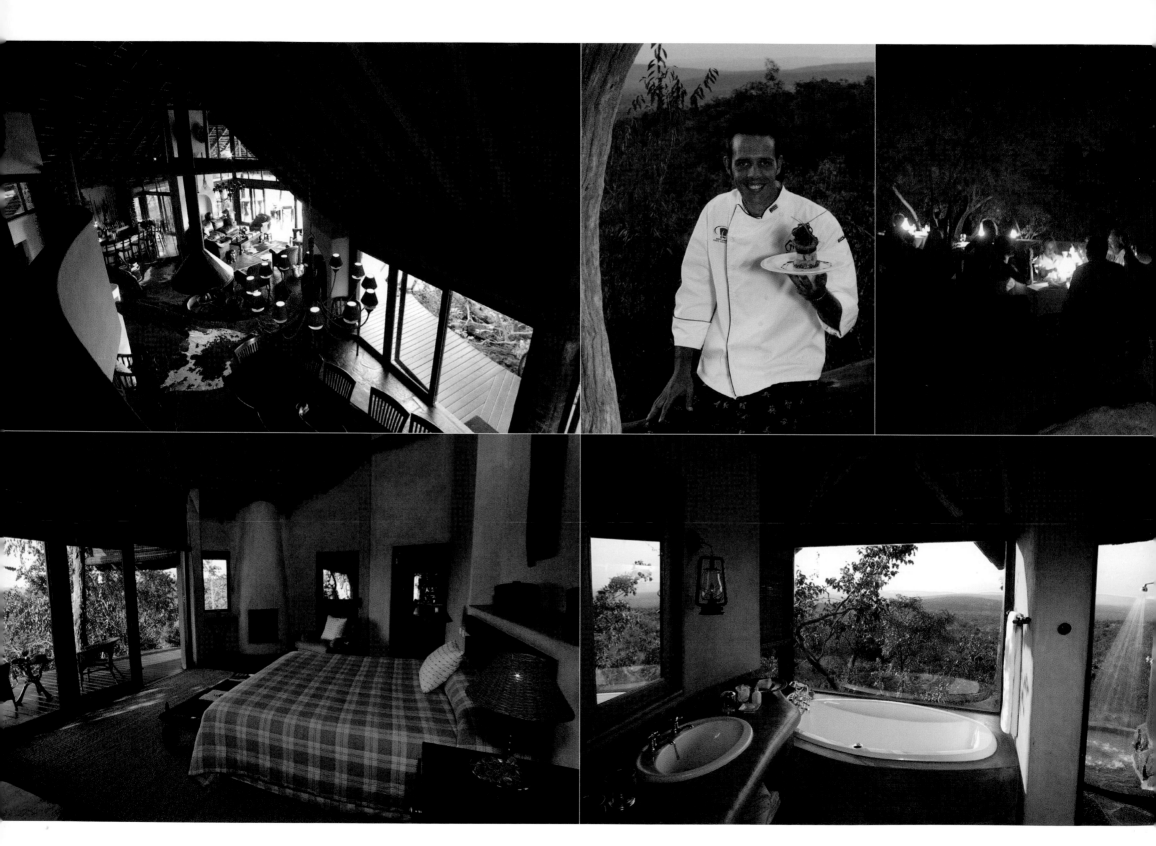

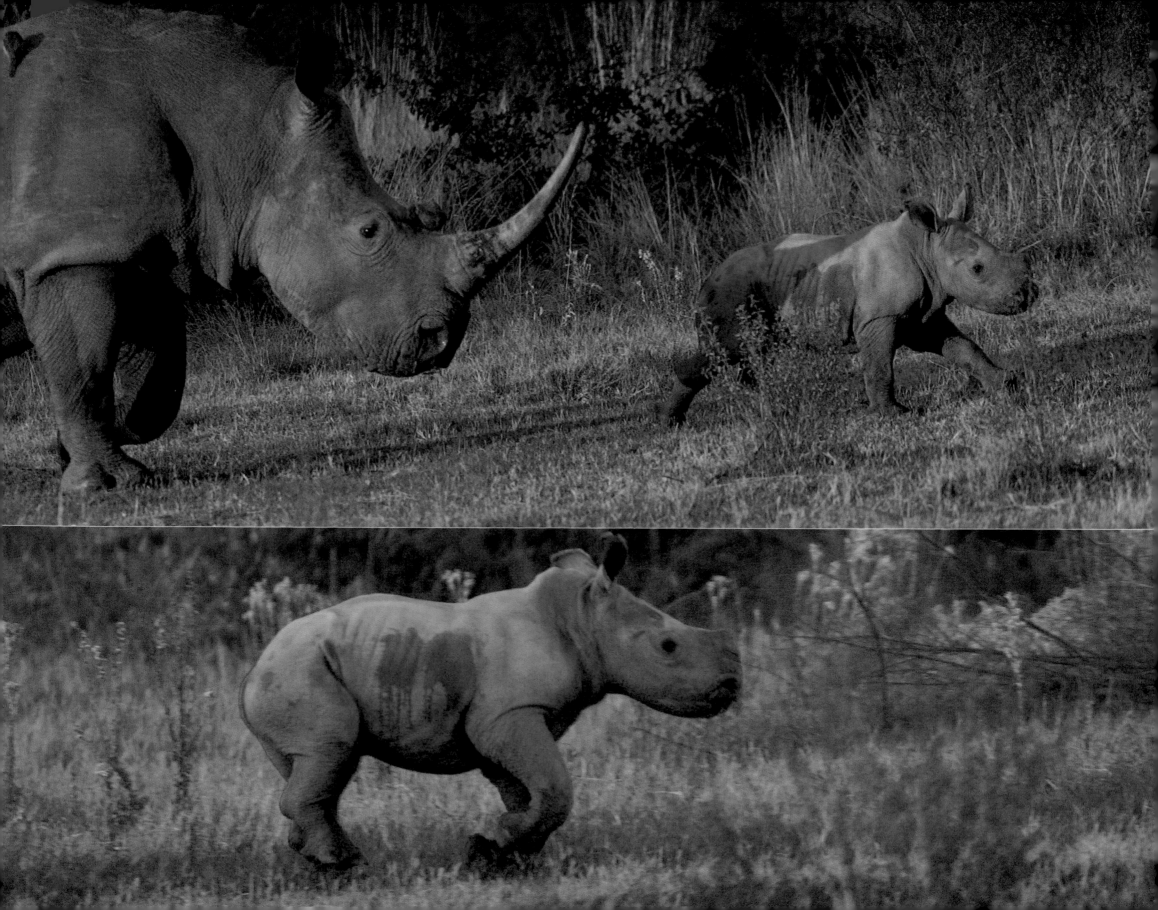

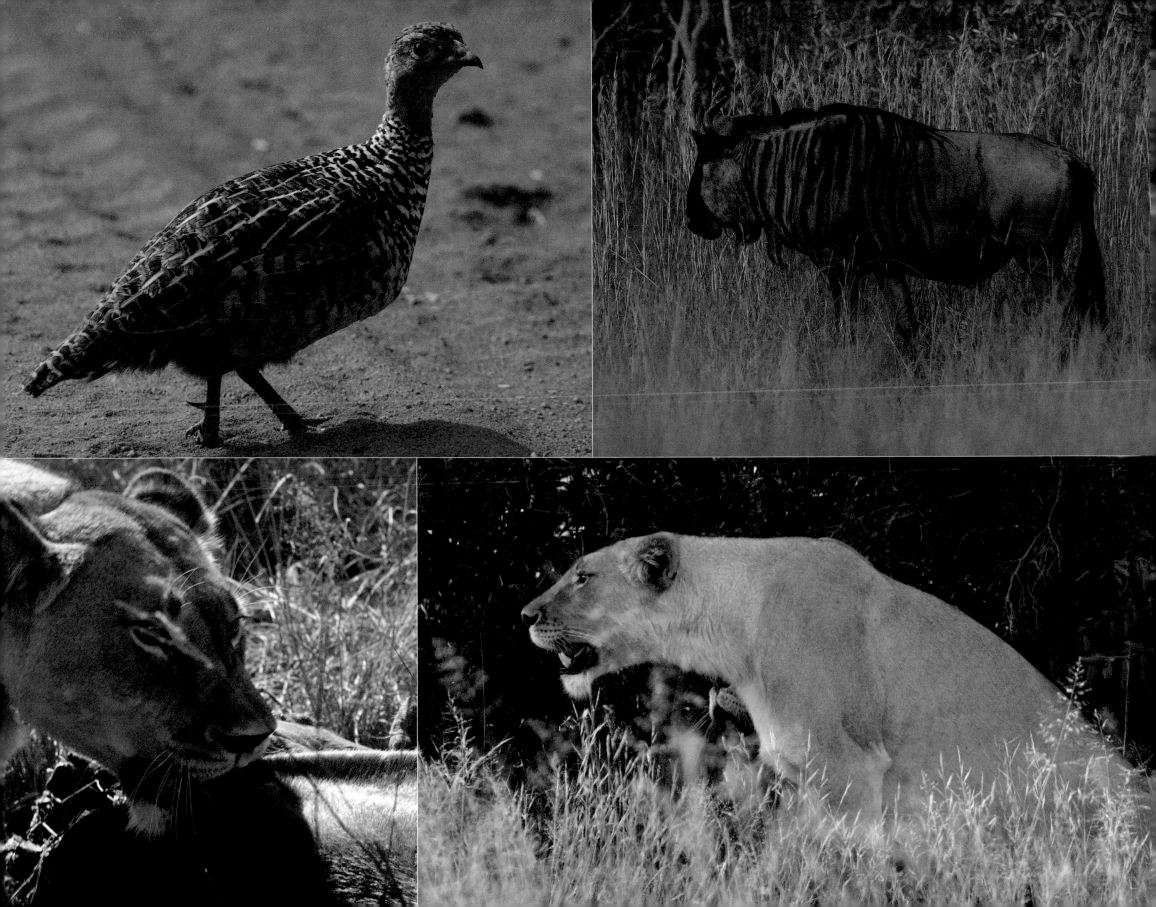

Sediba

LETLAPA LODGE & LETLAPALA LODGE

Sediba Private Game Lodge is located in the Welgevonden Private Game Reserve, one of the largest privately owned reserves in South Africa. It sprawls across 33 000 hectares of pristine bushveld in Limpopo's Waterberg region.

Inhabitants of this terrain include lion, elephant, white rhino, buffalo, leopard and antelope species such as sable, roan and gemsbok. Giraffe, warthog, black-backed jackal and brown hyaena also make an appearance, along with over 270 bird species.

Presiding over this landscape are the two lodges that comprise Sediba Private Game Lodge – Letlapa and Letlapala. Letlapa, meaning 'flat stone' in Northern Sotho, is hidden deep in a valley graced with a perennial spring while Letlapala is situated high up on a ridge overlooking the hilly surrounds.

High, thatched ceilings, open fireplaces, indoor and outdoor showers, private Jacuzzis and king-size beds are found in all fifteen suites at Sediba's lodges.

The sheer power and immensity of this land must have inspired the architecture of Letlapa, as its ten suites are extravagantly large. The suites are linked to each other, and to the main lodge, by boardwalks.

Just a five-minute drive from Letlapa is Sediba's other lodge, Letlapala. It is the more intimate of the two lodges. Every aspect of the lodge's five suites is carefully designed to create a seamless flow between the interior and the exterior. This is best demonstrated by the bathrooms, which have indoor and outdoor bathing options. Freshening up takes on a new meaning when you have to choose between the sunken outdoor Jacuzzi, the indoor copper bath resting on a bed of pebbles or an invigorating outdoor shower.

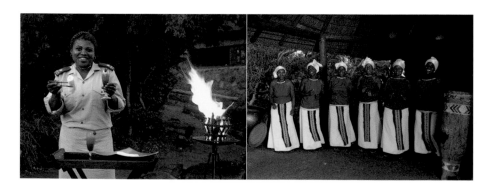

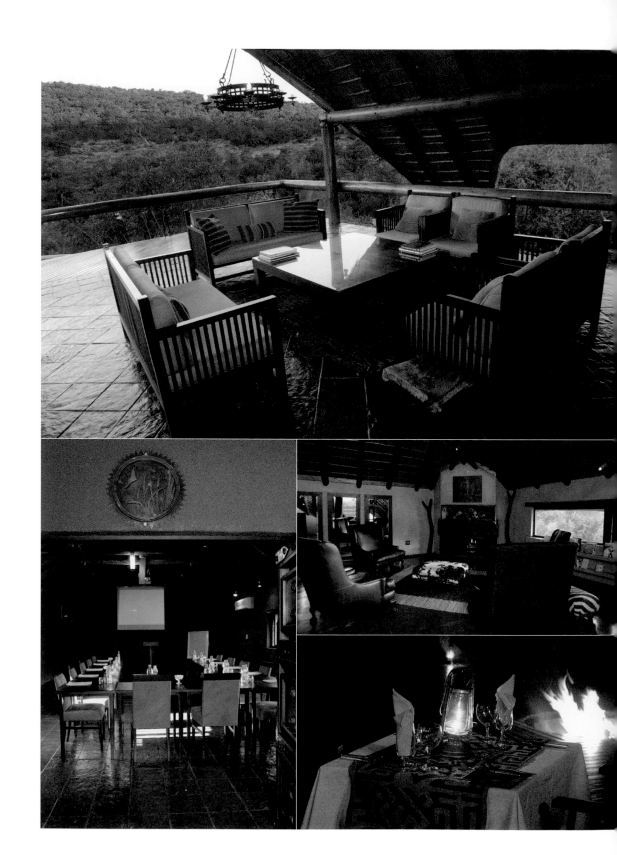

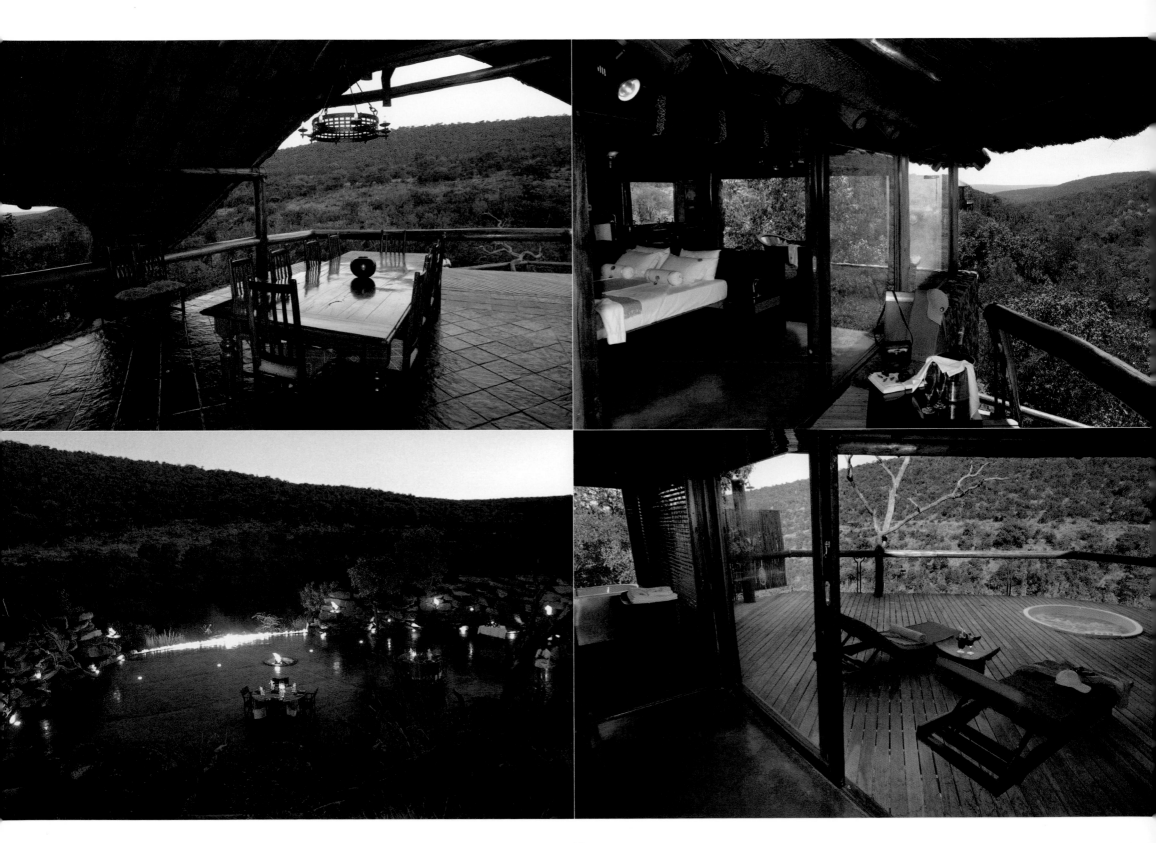

The guest experience at both of Sediba's lodges is enhanced by superlative service. Staff members are always there to greet you with a drink, a scented damp towel and even a song. It is they who create the welcome and their care is evident in a chocolate left on your pillow at night or a plate of tropical fruits offered with a smile.

Sediba has created one of the most dramatic outdoor dining areas: great slabs of stone are arranged in a large circle around the dining tables. When the fire is lit in this boma and the flames light up the mountain in the background, it is indeed a perfect spot to sit with a bottle of full-bodied cellar wine and muse on the meaning of life.

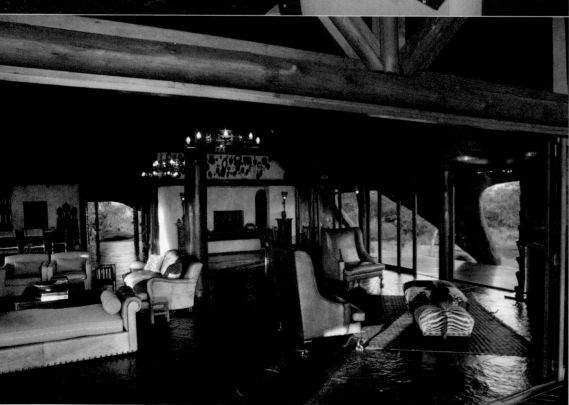

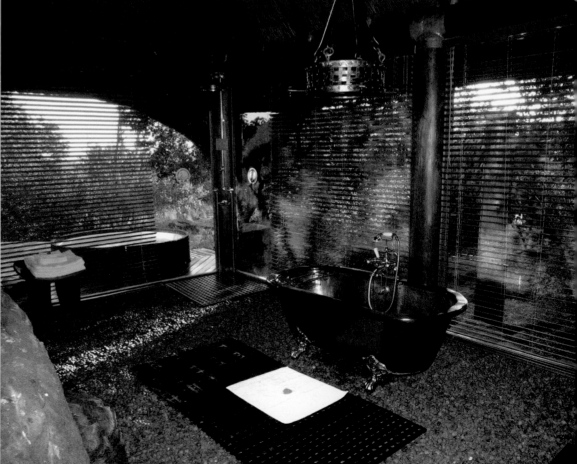

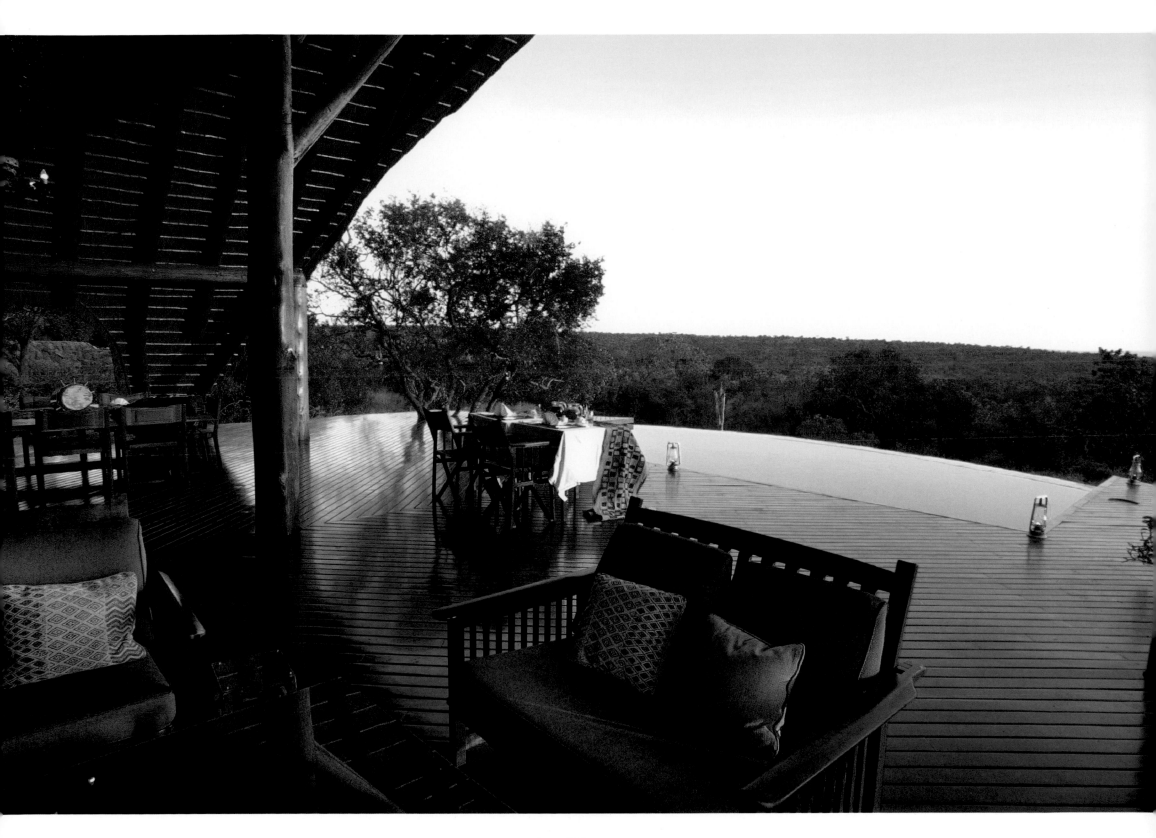

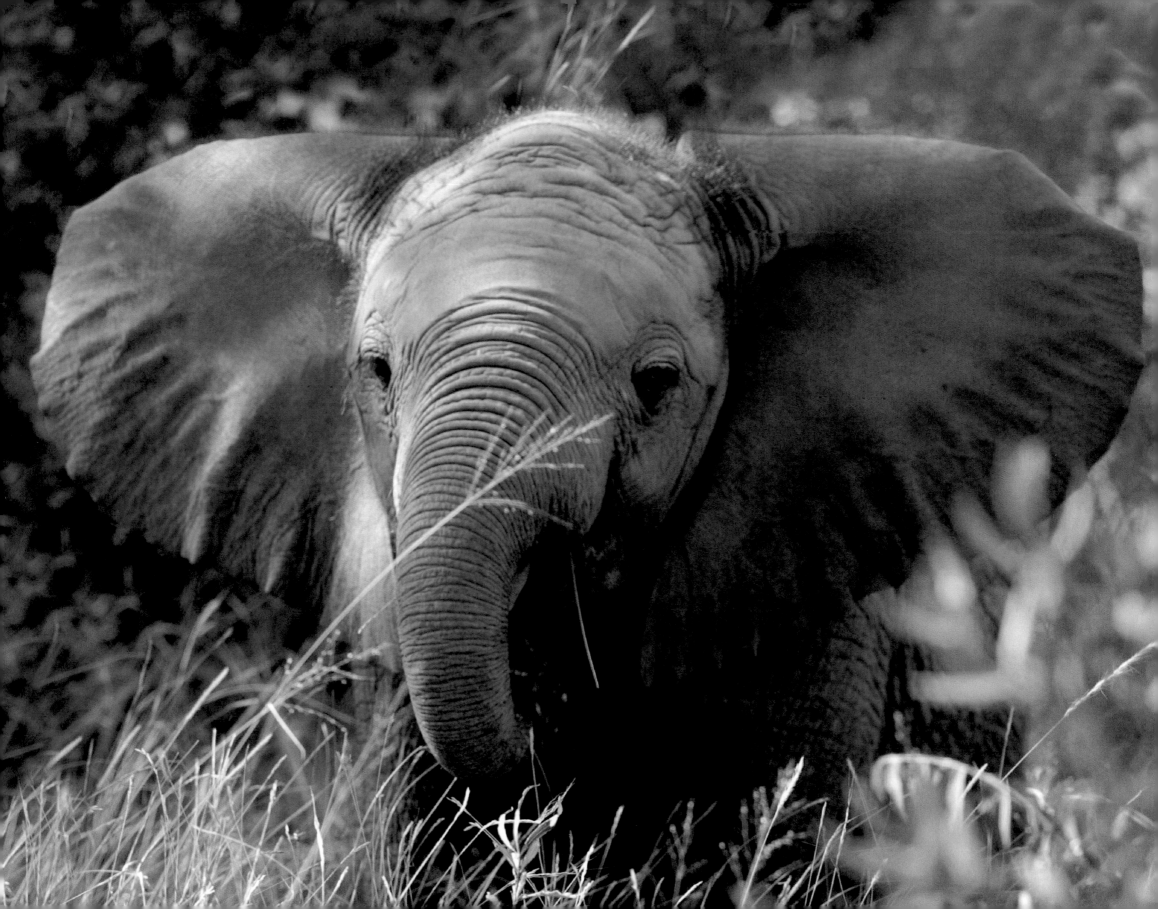

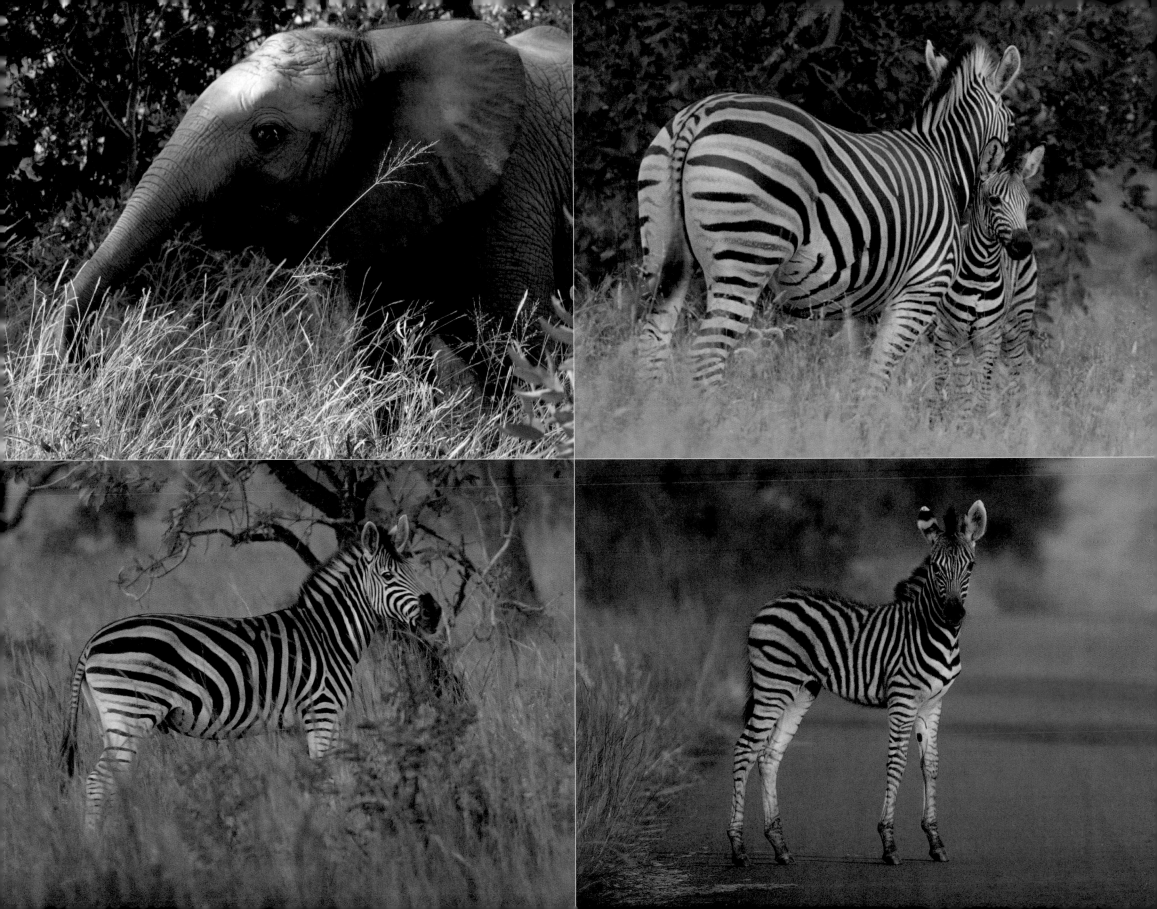

Shibula

LODGE AND BUSH SPA

In the far north-east of South Africa is Limpopo province – an area considered to be quite wild and remote. Limpopo is home to the Welgevonden Private Game Reserve, a wilderness sanctuary north of the metropolis of Johannesburg. The combination of being untamed yet accessible has made Welgevonden a desirable destination for visitors and international tourists alike.

Shibula Lodge and Bush Spa is located along thickly wooded hills in the Welgevonden Private Game Reserve and is situated at an elevation that keeps all mosquitoes at bay.

Shibula is famous for its spa and the many relaxing and rejuvenating treatments available for guests. Its signature massage is the TheraNaka African Wood Massage, which begins with gentle stretching techniques to relax the body. Warm olive and shea butter is then drizzled over the back, legs and chest, and specially designed smooth, wooden dumbbells are used to massage the body. The effect is intense and deeply satisfying. There are other options, too, many of which involve the use of natural materials and ingredients such as basalt stones, rain sticks, baobab extract, rooibos tea and Kalahari watermelon. You emerge almost edible from a Shibula Bush Spa experience.

With such good things going on in the spa, game drives sometimes take second place. This is Big Five territory, although the terrain and thick foliage is such that wild animals can watch you in secret while you search eagerly for them. One of the most satisfying moments of the afternoon game drive is when you stop for sundowner drinks to witness the perfect orange orb of the sun sink below the horizon. Darkness falls quickly in the bush and it is soon time to return to the lodge to see if someone has lit the fire in the boma.

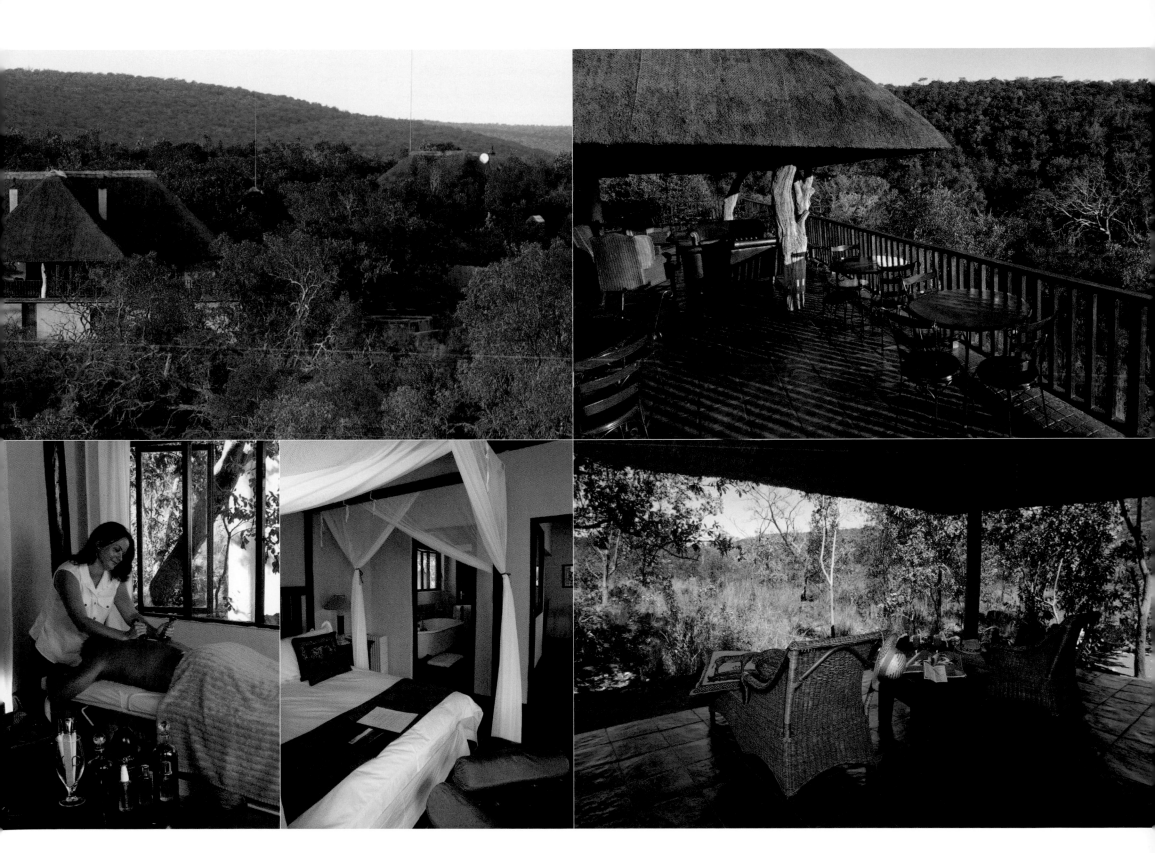

Singita
LEBOMBO LODGE

Lebombo Lodge, one of eight luxury lodges in the Singita stable, is set in one of the most dramatic landscapes in the Kruger National Park in Mpumalanga, offering an abundance of wildlife including the Big Five, antelope, birdlife and a variety of smaller animals.

'Touch the earth lightly' is Singita's motto, so the entire lodge and individual loft rooms are perched on sturdy wooden frames on the slopes of a riverine gorge deep inside the world-famous park near the Lebombo mountains.

White canvases billow in the breeze that flows through the open-plan lounge, which is decorated in tones of white, straw, lime green and grey. Being here is like existing inside a magazine photo shoot. Singita Lebombo's cool, trendy appearance would work well beside a palm beach or even in a sun-blessed city, but here is Singita looking perfectly at ease in the heart of the African bush.

Singita Lebombo offers a style experience as well as an African safari, and the two make an exquisite combination. The fifteen loft suites sit at various levels on the boulder-strewn slopes and inside is a feast of creative design features. A cascade of glass forms a lampshade; grey and white seeds strung together function as a curtain; a charcoal-grey walk-in mosquito net is tied to a square frame, creating an element of order amidst the frivolity.

Many unique decor items can be bought at The Trading Store, which offers experiences to please all your senses. There is even a gym and a treadmill, as jogging in lion country is not recommended. Or just relax around the pool until it is time to go and look for the pride of twenty lions in whose territory you are a guest.

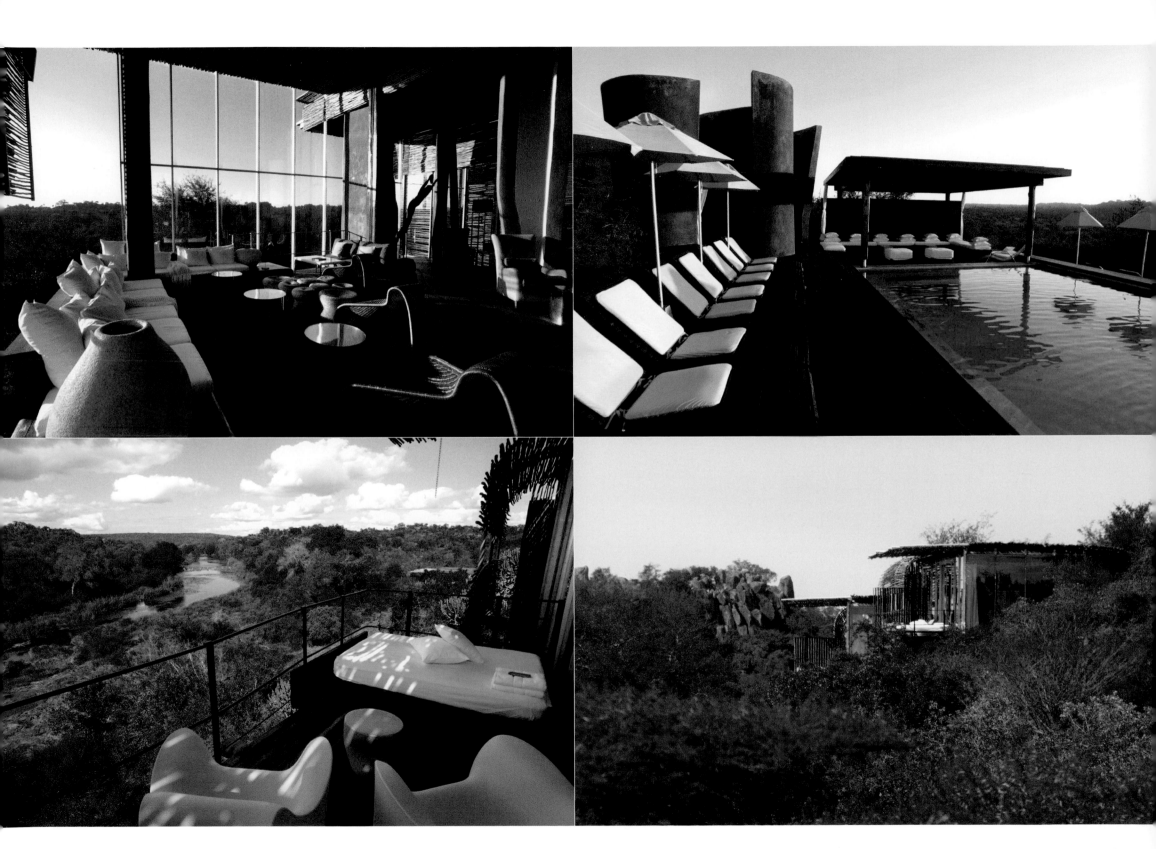

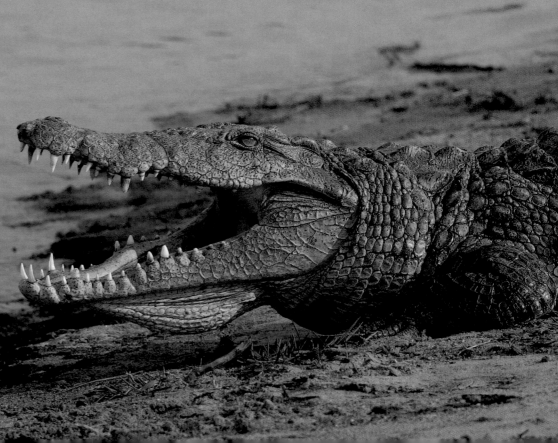

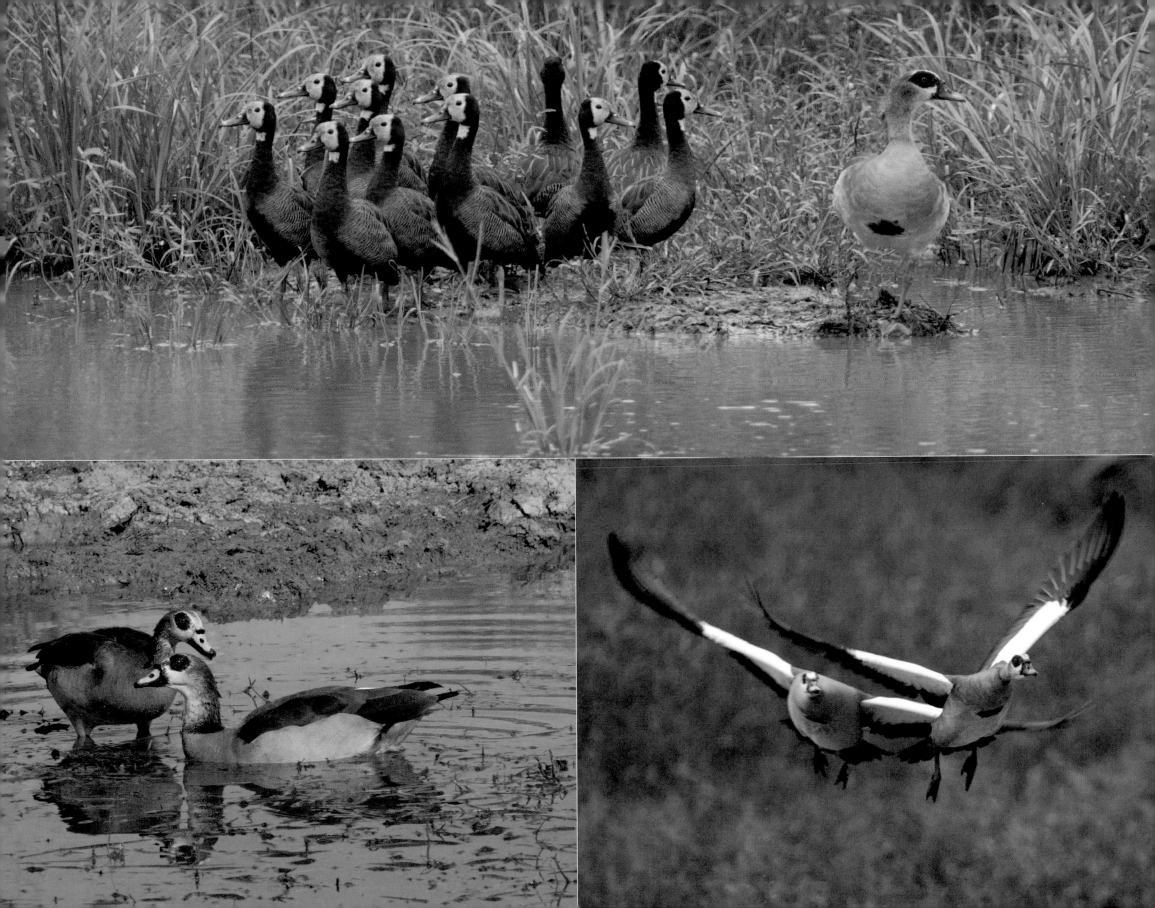

Singita

SWENI LODGE

Like its sister lodge, Singita Lebombo, at the top end of the gorge, Singita Sweni Lodge's six suites are erected on dark timber decks supported by stilts. But, unlike Lebombo, Sweni, nestled in a riverine forest, has a particularly African feel. Khaki browns and olive-green safari colours are present, but their application departs from convention: large comfortable sofas have been covered in utilitarian green tent canvas.

The stark lines of the mosquito nets around the beds are tempered by a cascade of green and grey seeds at the head of each bed and orange lampshades that soften the evening light. Every touch somehow blends with the environment, yet demands attention by its very difference.

Spiky, cactus-like euphorbia trees are a significant feature of the landscape and of Sweni Lodge in particular. Several of these large succulents grow through the wooden decks, creating something of a tropical feel here in the bushy heart of the Kruger National Park. The area has a variety of creamy-golden rocky outcrops, woodlands opening to grassy pastures, deep river valleys and a plateau reaching eastward to the Mozambican border – all of which are home to a multitude of African animals, including a resident pride of twenty lions, which you may well encounter.

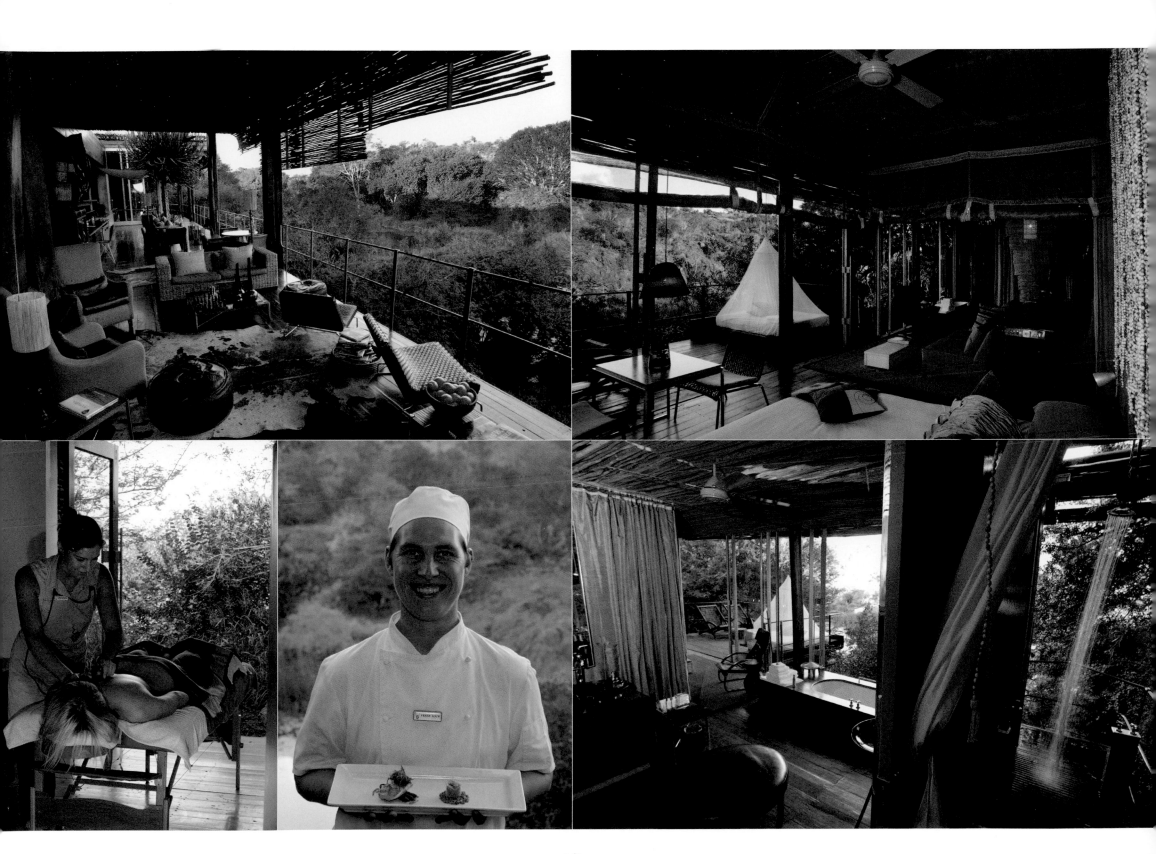

Tinga Narina
LODGE

Tinga Narina Lodge is one of several private safari lodges given the right to operate within South Africa's internationally renowned Kruger National Park in Mpumalanga. Guests of Tinga Narina and its sister lodge, Tinga Legends, may traverse any roads within the park, but only they have access to Tinga's exclusive concession. This means night drives are on offer, and with that comes the added chance of seeing lions on the move.

Similar yet different to Tinga Legends, Tinga Narina has a strong African feel created by overriding colours and textures of browns and beige and wood. Persian carpets and simple chandeliers add a touch of elegance. There are huge fireplaces and high beamed ceilings open to the thatch. Artefacts from all over Africa are displayed or put to more functional uses, such as the masterly carved coffee tables. Even the fruit in the bowl look like works of art.

You come to expect treats at Narina, and the suites offer more than one could even want, including Internet connection and satellite television. Resist the urge to go online or watch television and you will be treated to entertainment African style: hippos grunting their intention to emerge from the Sabi River and munch their way through the night on grasses up to a kilometre or more away from the river.

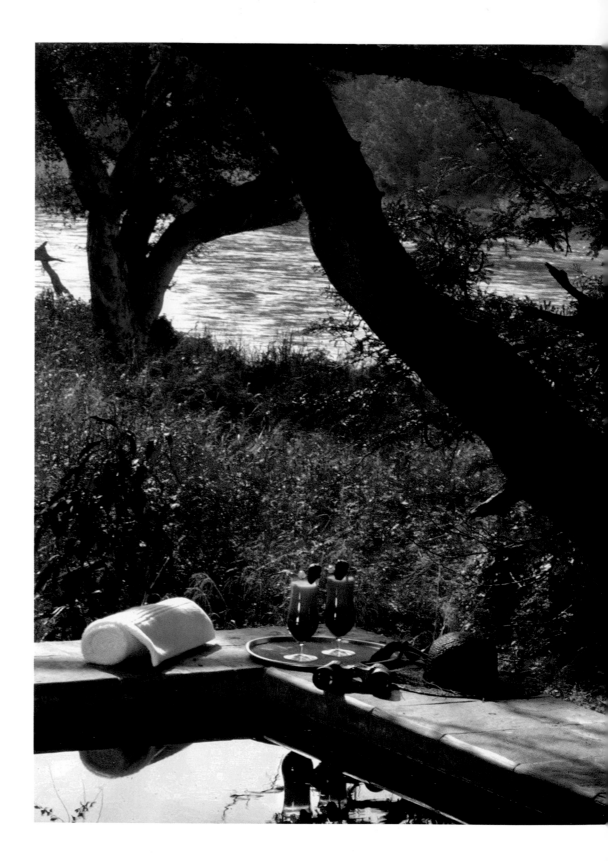

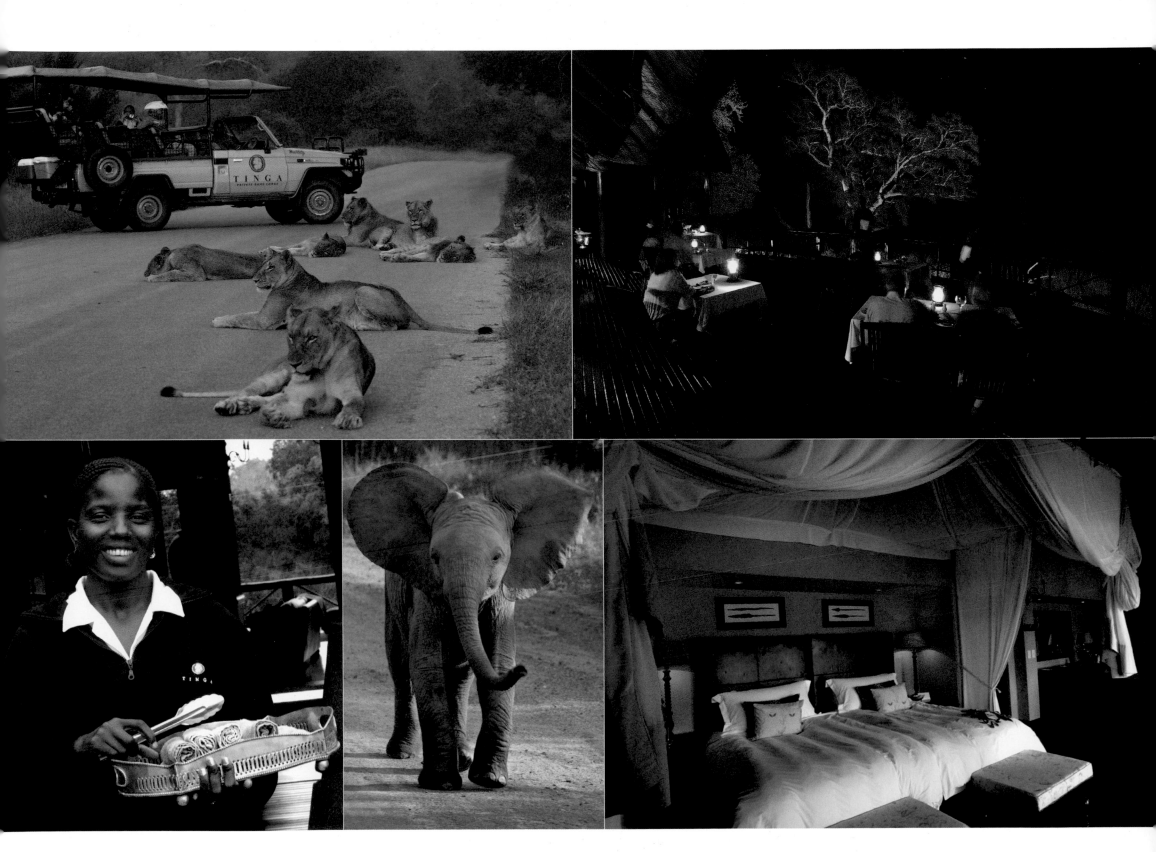

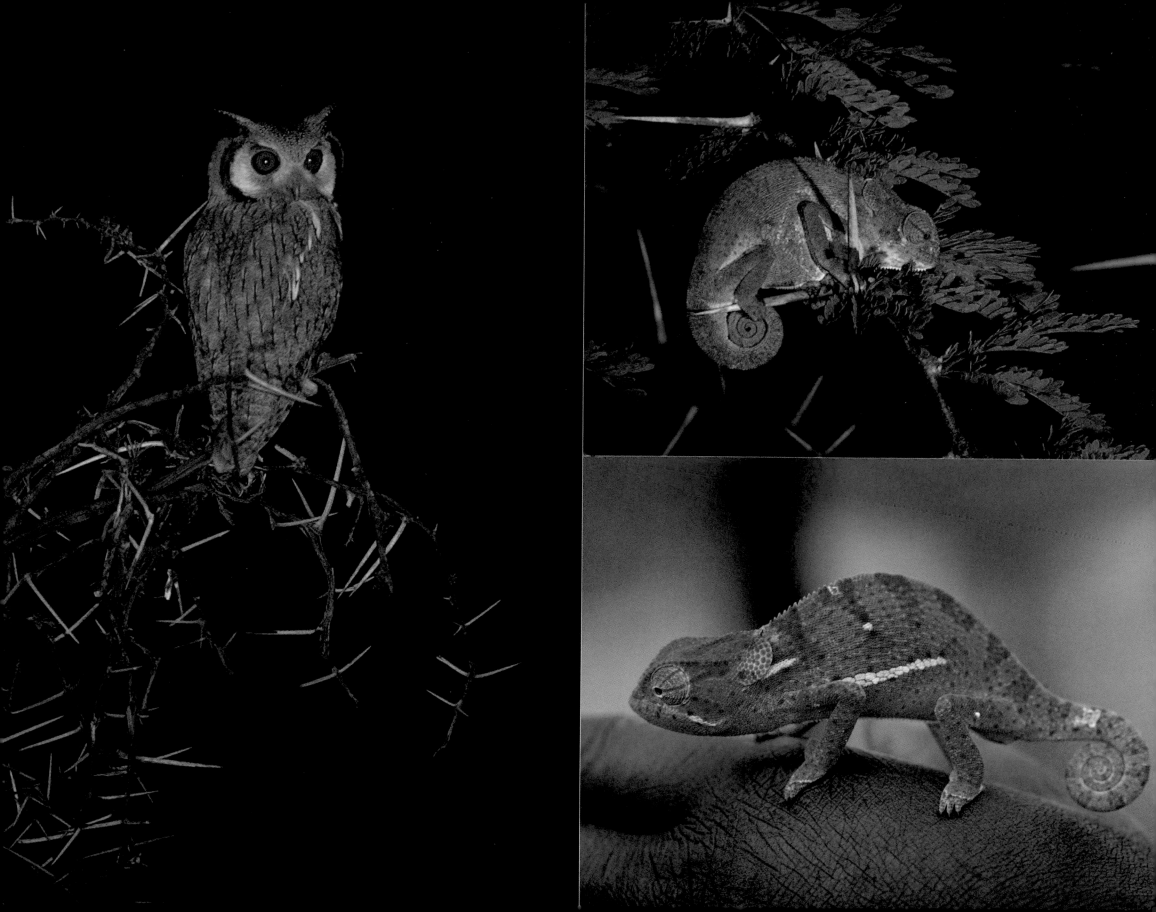

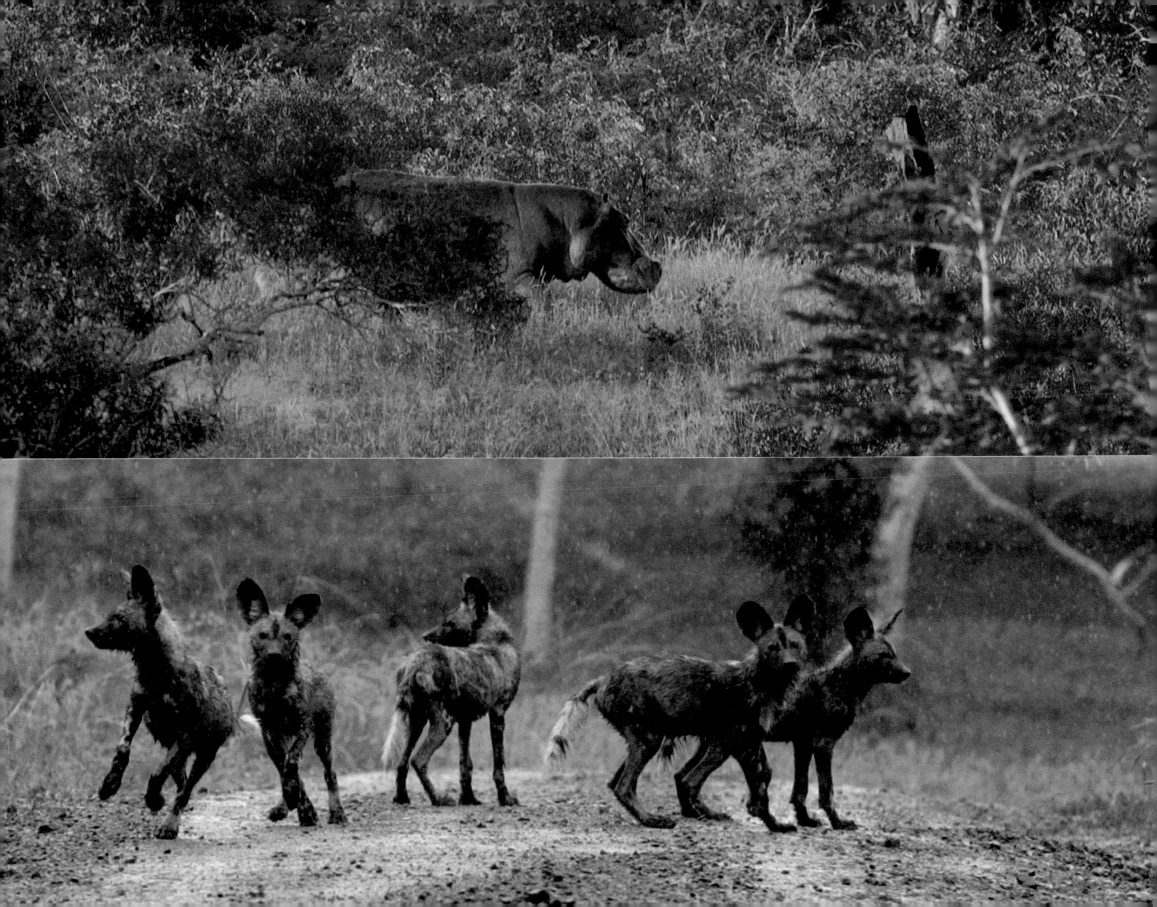

Tinga Legends
LODGE

A thatched cathedral-like entrance greets you at Tinga Legends Lodge, which befits the lodge's grand and sumptuous design mix of Afro-colonial and classic gentleman's club. This is achieved with mounted antelope horns, Persian rugs, fine African antiquities and dark leather sofas contrasting with light, wicker terrace chairs. The whole effect is striking yet understated. Design features are not limited to the interiors: rendered walls around the lodge incorporate African swirls into the plasterwork and a beautiful dry-stone wall surrounds the outdoor dining boma.

Everything seems bigger here – the swimming pool, the wooden dining deck, the suites with king-size beds and private terraces with plunge pools, and the views from every part of the lodge out across the Sabi River and into the Kruger National Park bushveld. Everything has been thought about and then doubled!

With only nine luxury suites, the level of service for the lodge's maximum of eighteen guests is of the highest order. A simple smile from friendly staff starts the day well, but a massage with river stones followed by an exquisitely prepared lunch cannot fail to make your day.

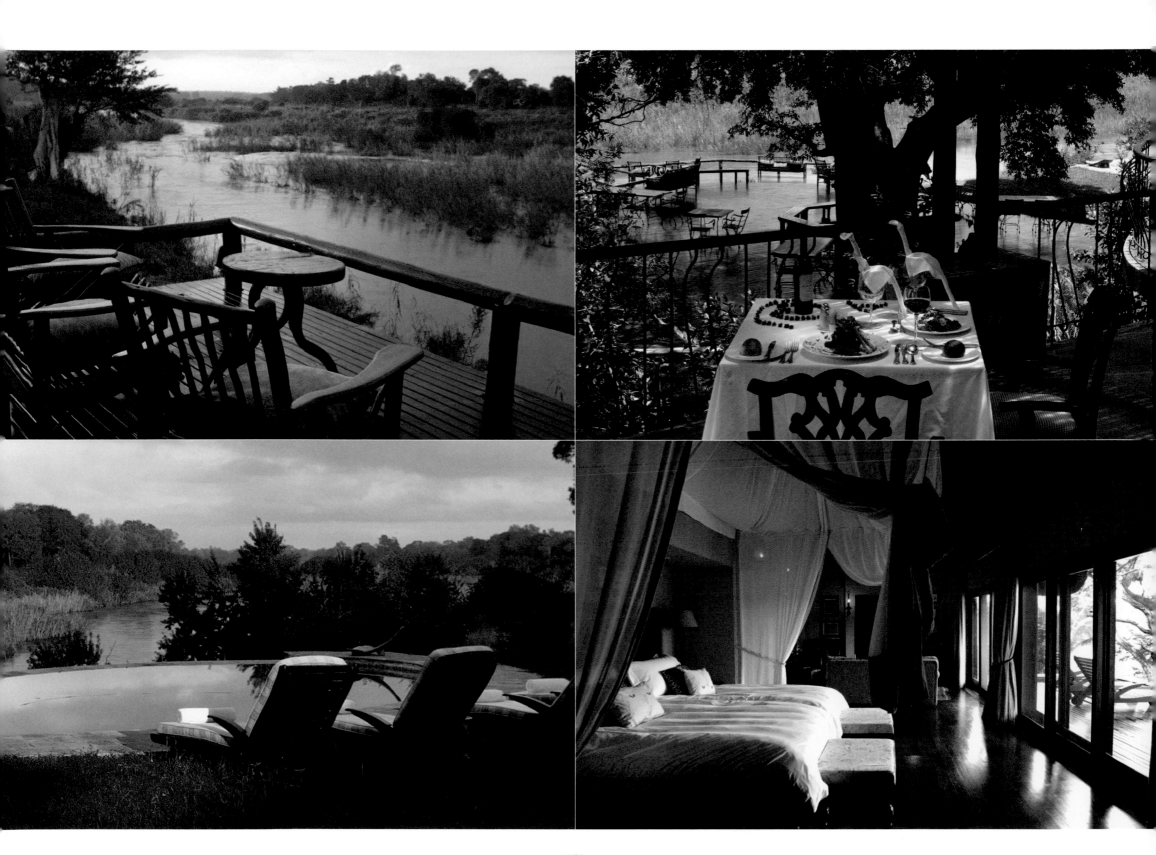

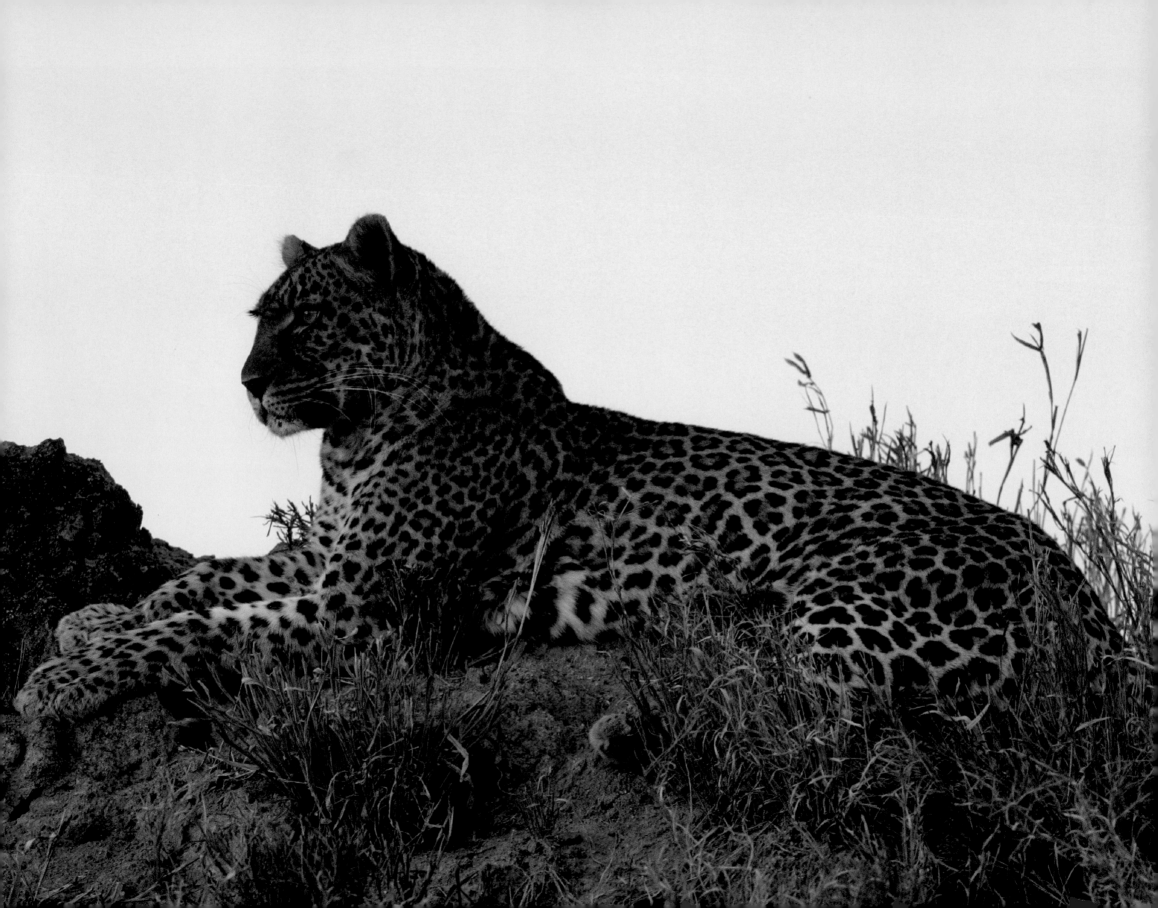

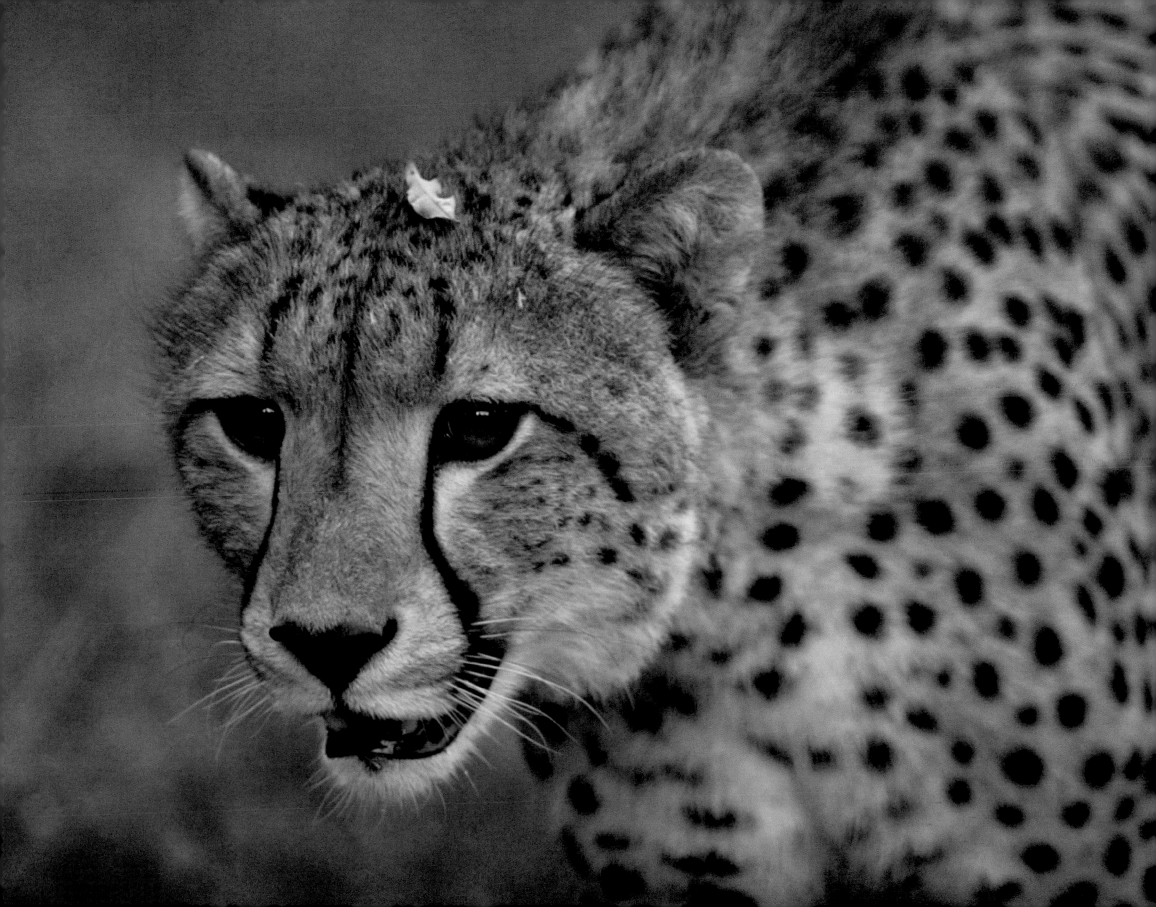

Jock
SAFARI LODGE

Jock Safari Lodge takes its theme from a well-known personality in this southern part of the Kruger National Park: a feisty Staffordshire bull terrier named Jock, the central character in Sir Percy Fitzpatrick's animal classic *Jock of the Bushveld.* He is the South African version of Lassie, with all the same qualities of courage and loyalty to his owner, a store man, prospector's hand, journalist and transport-rider during the gold-rush days of the 1880s. Jock Safari Lodge celebrates this little dog with statues and recreates the old-world atmosphere and romance of the era through memorabilia like ox-wagons, historic black-and-white photographs and lantern-lit walkways.

But there is nothing old world about the comfort and quality at Jock's and your expectations will probably be exceeded. Each suite has a huge bed, surrounded by walk-in mosquito netting, and lounge chairs looking out over the terrace. A stroll down the wooden walkway leads to a private lapa – an elevated secluded balcony screened by bamboo – which looks directly into the animal-filled bushveld. Vervet monkeys play in the branches and elephants often wander through the dry riverbed, disturbing colourful birds hiding in the riverine thickets.

With all the amenities at Jock's there is barely any need to leave the suite, even in the heat of the day, as you have your own private plunge pool and outdoor shower. But it is nice to swap notes with others and talk about the day's game sightings. For this, there is good company to be had around the pool with a view or in the balcony bar of the main lodge, where there is a constant supply of cold drinks.

Privacy, exclusivity and safari-style luxury in the heart of Kruger are what you can expect at Jock's.

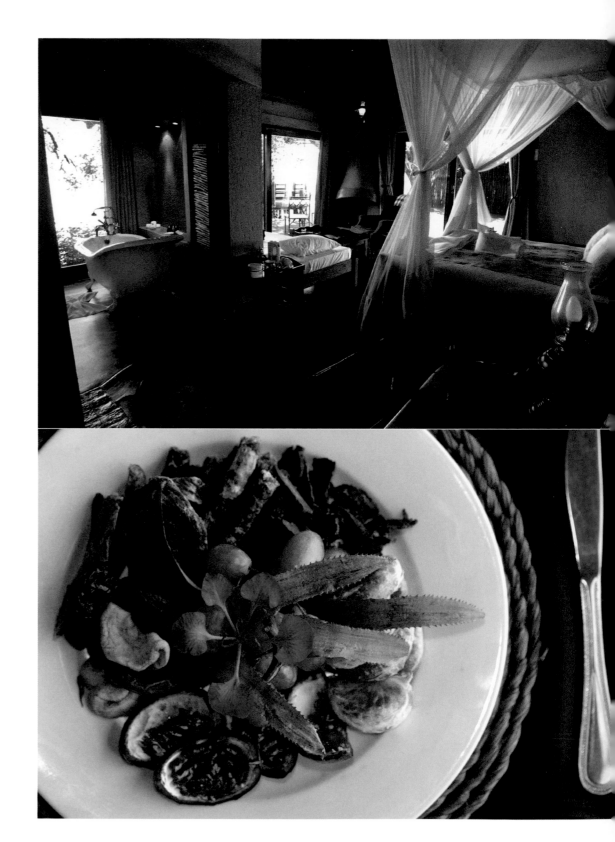

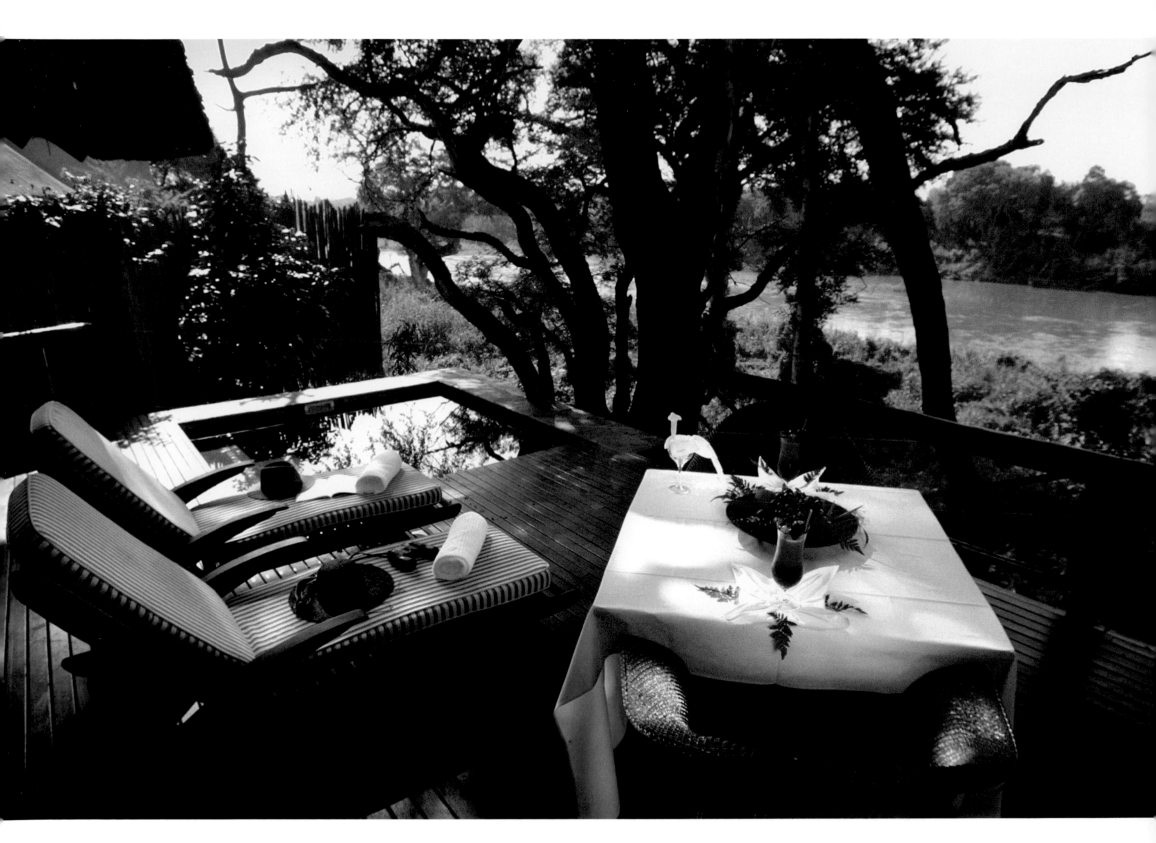

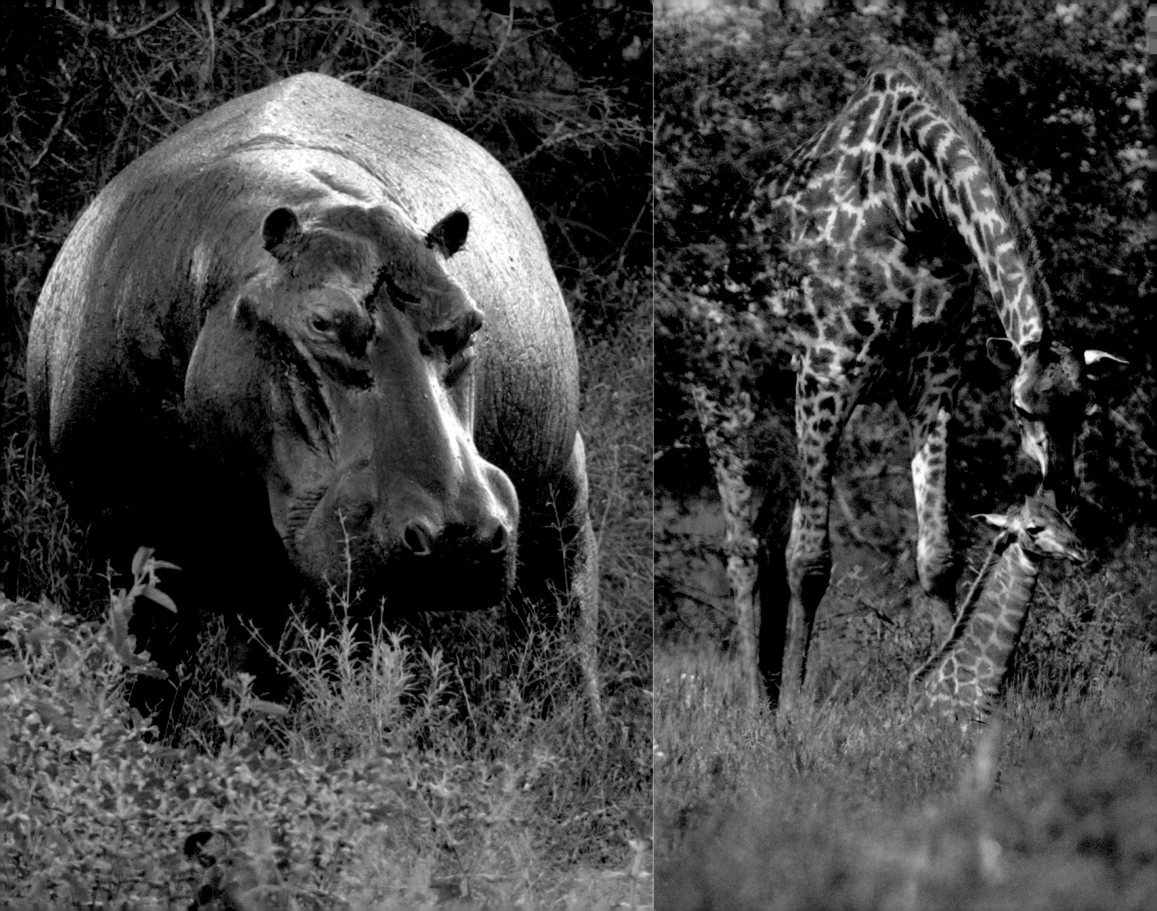

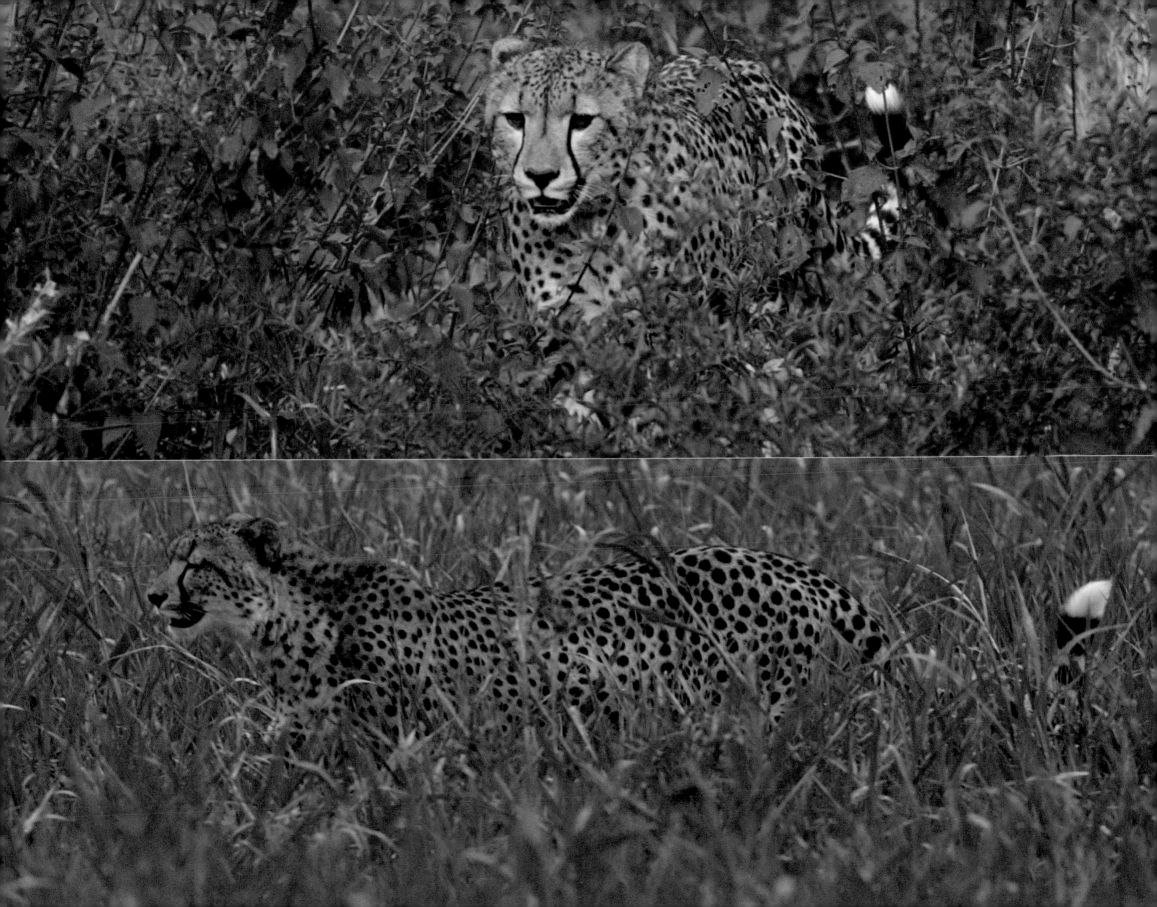

Lion Sands

RIVER LODGE

There is a single word embossed on the cover of the Lion Sands Private Game Reserve brochure: 'rare'. On closer inspection it would seem that it is just the right word to describe everything that goes into making Lion Sands, in the bushveld of Mpumalanga, a perfect safari destination.

It all started close on a century ago when the great-grandfather of current owners, Nicholas and Robert More, purchased land along the Sabie River for use as a private retreat. It is said that the wildlife and pristine condition of the property left such a deep impression on him that he never again took part in any form of hunting in his life. His passion for the wilderness and the need to conserve it has been passed down from generation to generation, and it is this passion that continues to imbue all that happens at Lion Sands. The family's commitment to conservation and the development of the local community reflects a deep sense of responsibility to their 'little jewel on the banks of the Sabie River'.

These principles are also inherent in the experience guests have at River Lodge and its ultra-luxurious sister lodge next door, Ivory Lodge. River Lodge perches above the permanently flowing Sabie River. Here, twenty rooms lie beneath 800-year-old jackalberry trees. Each of the rooms faces east, catching the sun as it rises over the river that marks the boundary between the reserve and the Kruger National Park.

Game is abundant in this area and guests are likely to spot the Big Five during a single game drive. Those who simply want to take it easy can spend time in one of two swimming pools or at the peaceful lounge and bar overlooking the river.

The lodges at Lion Sands are rare for their complement of staff, who are more like family than employees. This includes executive chef Janine Hobbs, whose long association with Lion Sands has not diminished her creativity. Inspired by local and international culinary trends and the availability of only the freshest ingredients, the imaginative chef and her staff produce unexpected and delicious combinations.

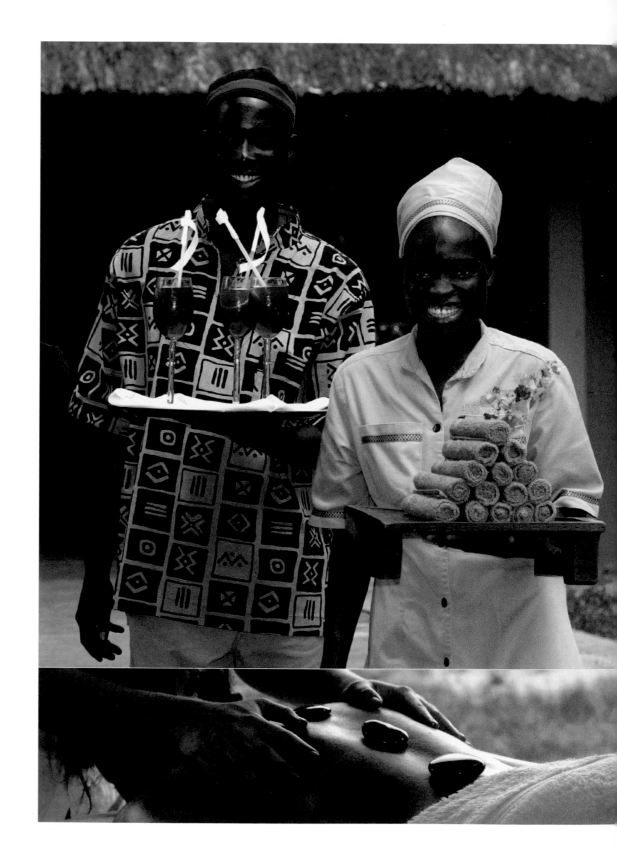

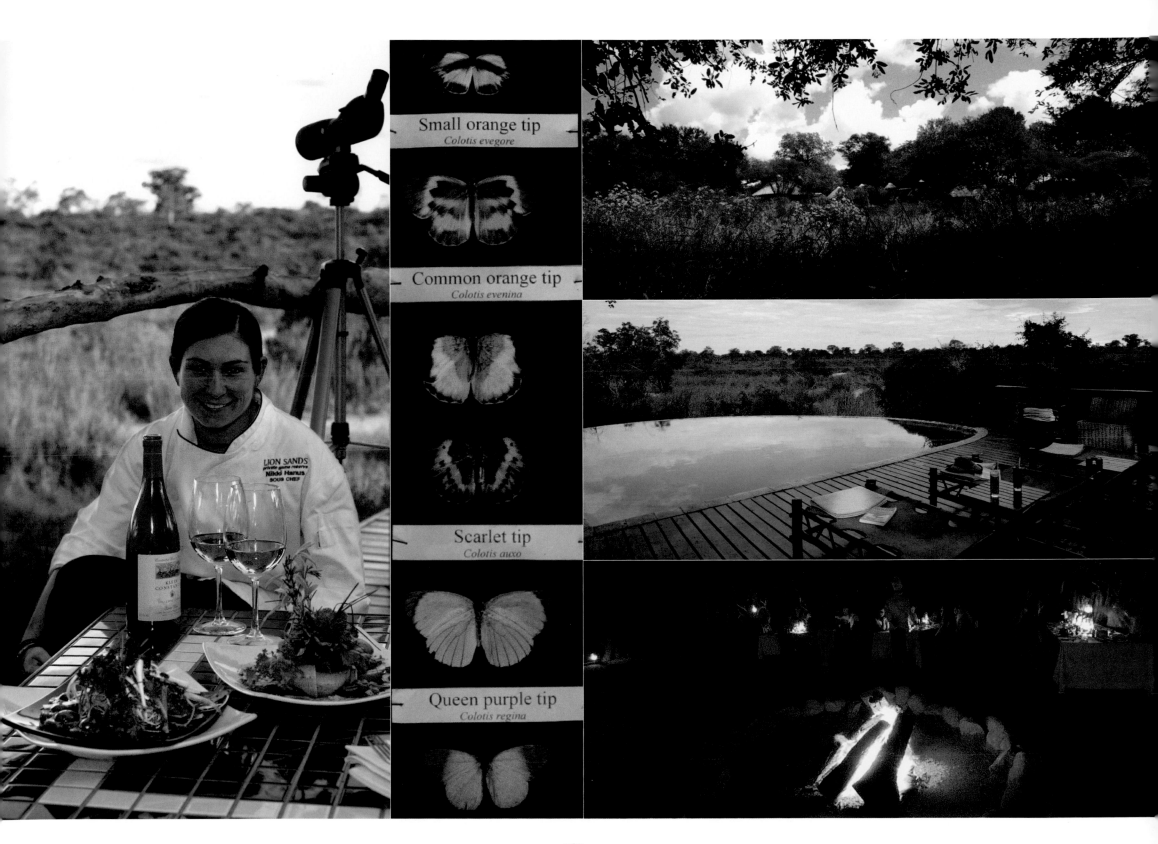

Small orange tip
Colotis evegore

Common orange tip
Colotis evenina

Scarlet tip
Colotis auxo

Queen purple tip
Colotis regina

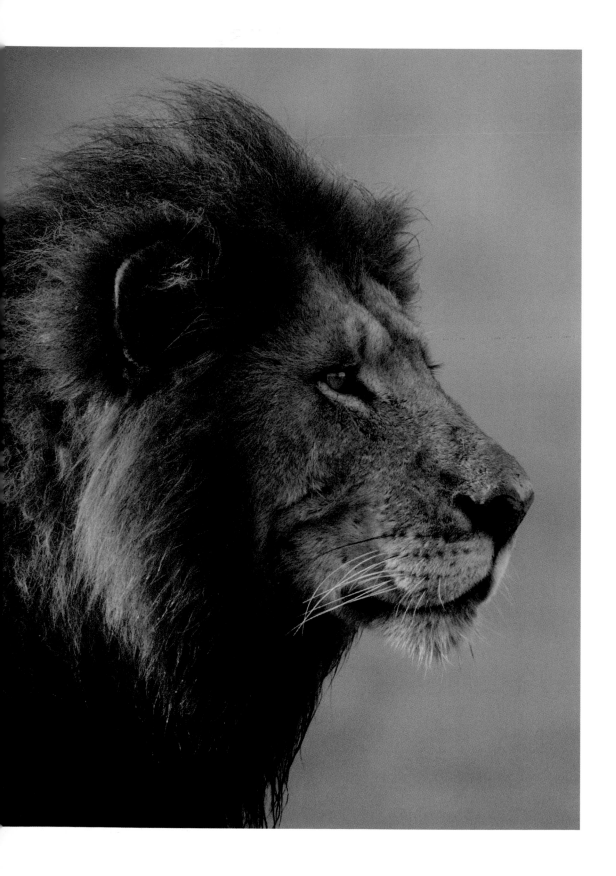

Lion Sands

IVORY LODGE

Lion Sands Ivory Lodge is all creams and deep browns – even the enormous tree whose boughs sprawl over the riverside dining deck is mahogany. Shades of ebony and ivory are the only colours that feature here, and they create a warm and captivating palette for the contemporary Afro-European design and decor of this exclusive lodge in the Lion Sands Private Game Reserve.

There is such a 'wow' factor to the architectural and interior design of Ivory Lodge that the simple act of entering your suite for the first time can render you speechless. Behind huge wooden double doors is the accommodation, all 165 square metres of it. A central courtyard, with a square plunge pool, is flanked by the living room on one side and a tiered open-plan bedroom and bathroom on the other. All rooms have full glass fronts, permitting expansive views across the flowing Sabi River and beyond, into the adjoining Kruger National Park.

The suites alone may give you a good indication of what to expect from your stay, but you will soon learn that style, creativity and unfaltering attention to detail come in many forms at Lion Sands: specialist treatments in the health spa, expert rangers and trackers with only six passengers per specially adapted 4x4 Land Rover, an executive chef who creates food that appears looking like a work of art, and a world-class wine cellar.

Luxury and safari can go hand in hand and need not be separated, as evidenced by the fact that, if you stay long enough on your sunlounger, the wildlife will come to you. But if you have a strong desire to feel the African bush around you and beneath your feet, Lion Sands' highly skilled trackers, rangers and ecologist are at your service. Interestingly, Lion Sands is the only safari estate in this part of Mpumalanga to employ a full-time ecologist, there to ensure the preservation and maintenance of the natural environment.

Being on the ground in big-game country is almost as good as being up a tree, and Lion Sands Private Game Reserve has two tree houses in which you can overnight – a very popular choice if what you are looking for is a night of romance or simply an experience like no other. These freestanding platforms each feature a large bed with mosquito netting swaying in the breeze and a picnic basket containing everything you might want for an extraordinary night under the stars.

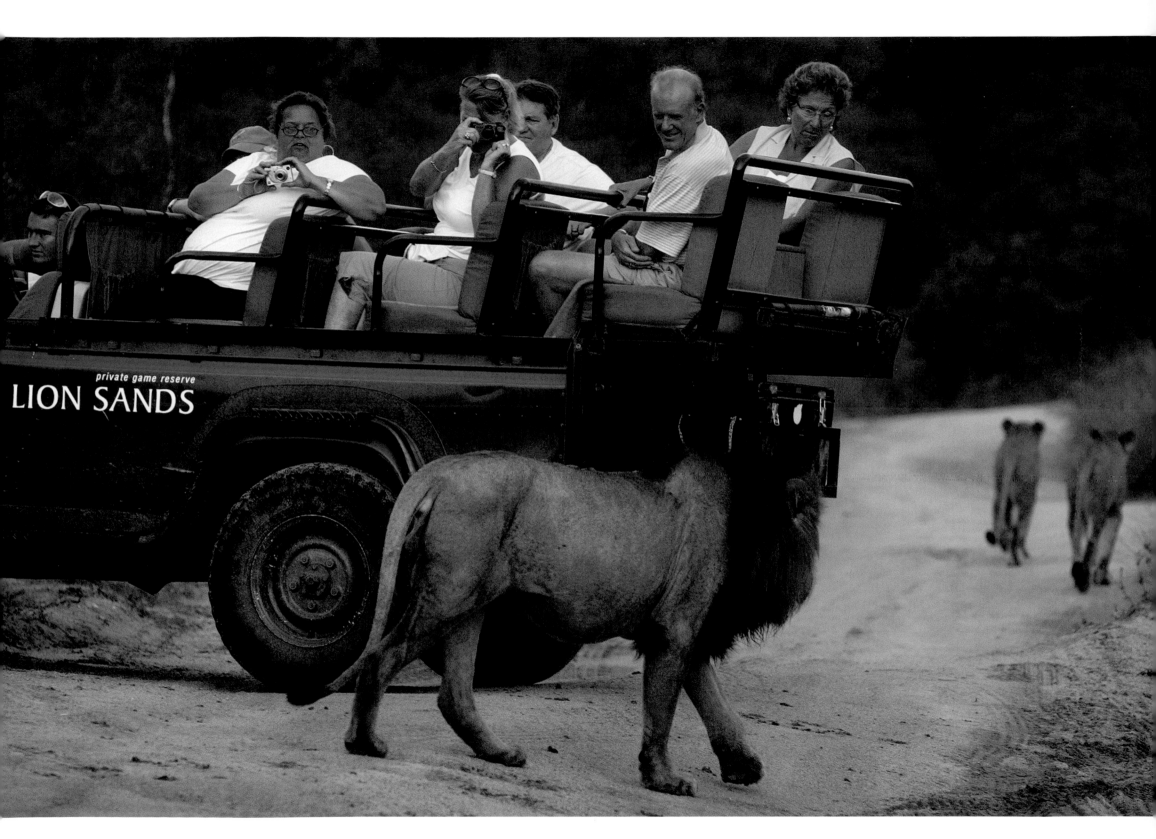

Royal Malewane

People talk about Royal Malewane with the kind of reverence usually reserved for those held in the highest regard. This is because Royal Malewane has reached the pinnacle of taste within the boundaries of timeless, classic elegance. Simply put, it is luxury in its purest form.

Attention to detail and quality are paramount, and such is their seamless integration into the daily operation of the lodge, you may not necessarily notice you are sleeping on designer linen or eating haute cuisine from monogrammed plates, or that your chair (and even your Victorian bath) rests on a Persian carpet.

The concept of solitude is redefined at Royal Malewane. Suites are so self-contained that you can remain cocooned in yours for as long as you wish, unless of course you want to swim in your own slip-water pool or rest under a thatched gazebo. Exclusivity is taken one step further in the extravagantly proportioned Royal and Malewane suites, which come with a private chef, private game drives and up to four massages per suite per day.

Royal Malewane is situated in the Thornybush Reserve, along the western boundary of the Kruger National Park. As there are no fences separating the reserve and the park, animals can move freely between the two wilderness areas. This makes for good game watching, and it is possible to see the Big Five here.

The quality and experience of rangers and trackers can make all the difference to the enjoyment of a game drive, and Royal Malewane hires only the best, including master tracker Wilson Masiya. And although Royal Malewane can boast that its rangers and trackers have reached the highest levels of proficiency, it refrains from doing so. This is because the guests' responses are evidence enough that they have got it right.

It is advisable to spend some of your time at the Royal Malewane Spa. The spa provides the improbable: a serene courtyard surrounded by treatment rooms, a long lap-pool and an air of opulent peacefulness. Massage therapists wash your feet in a calming ritual that precedes each treatment. The whole atmosphere exudes harmony and luxury in a way that only Royal Malewane knows how to create.

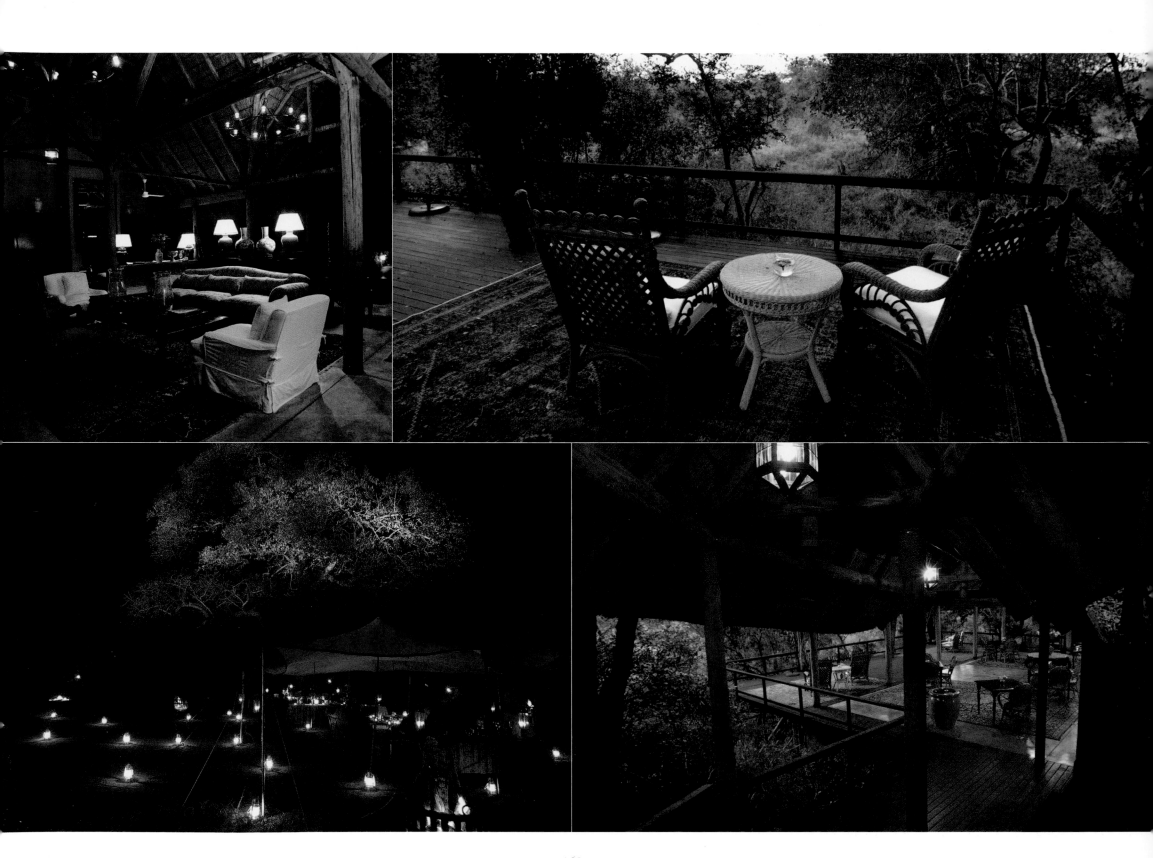

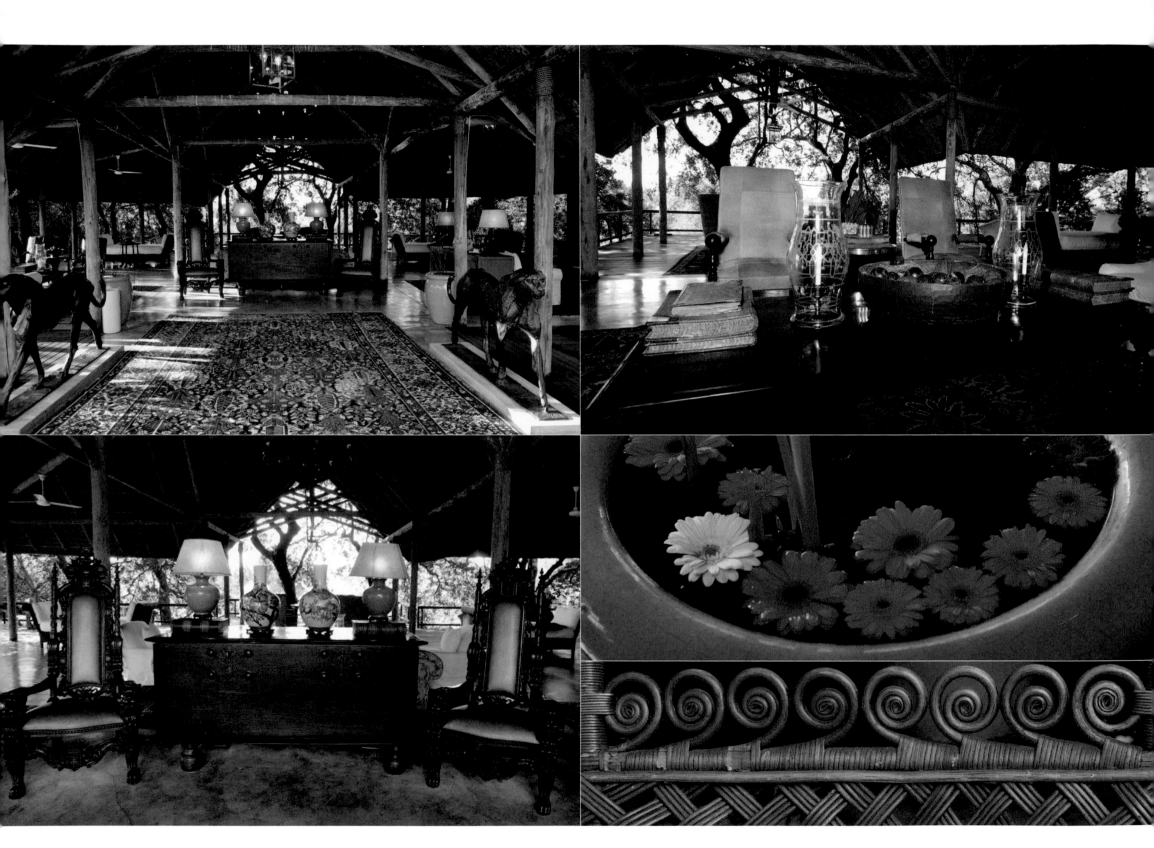

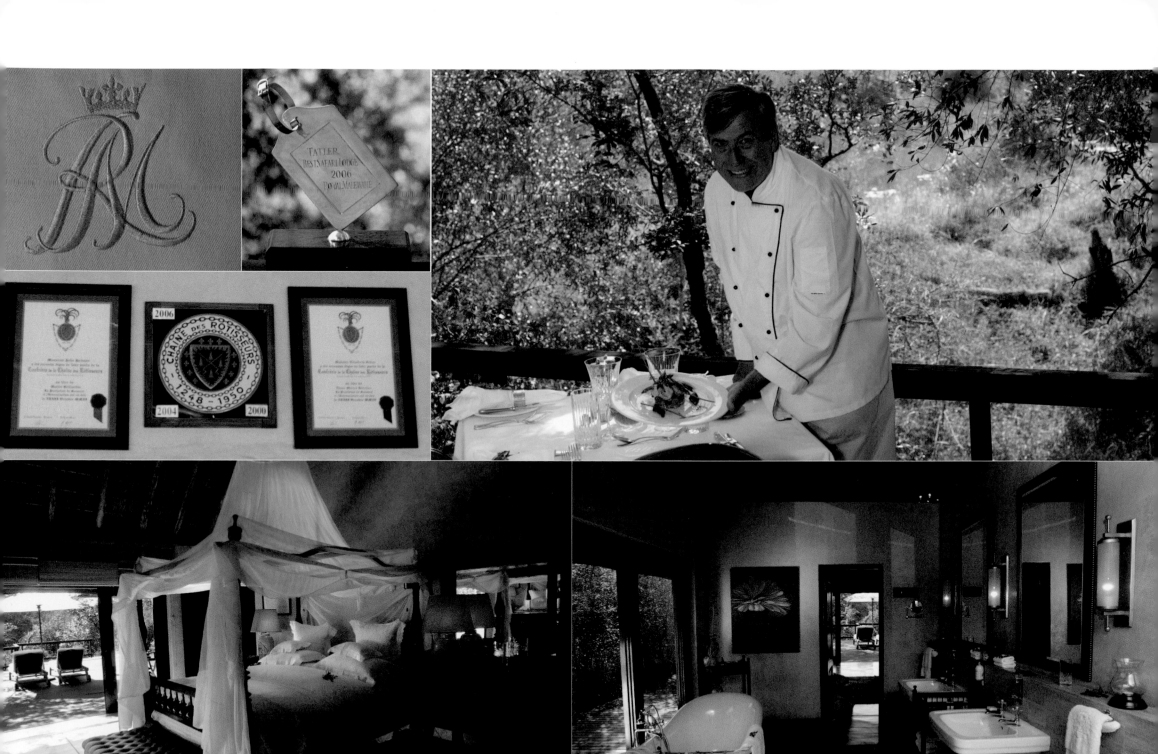

171

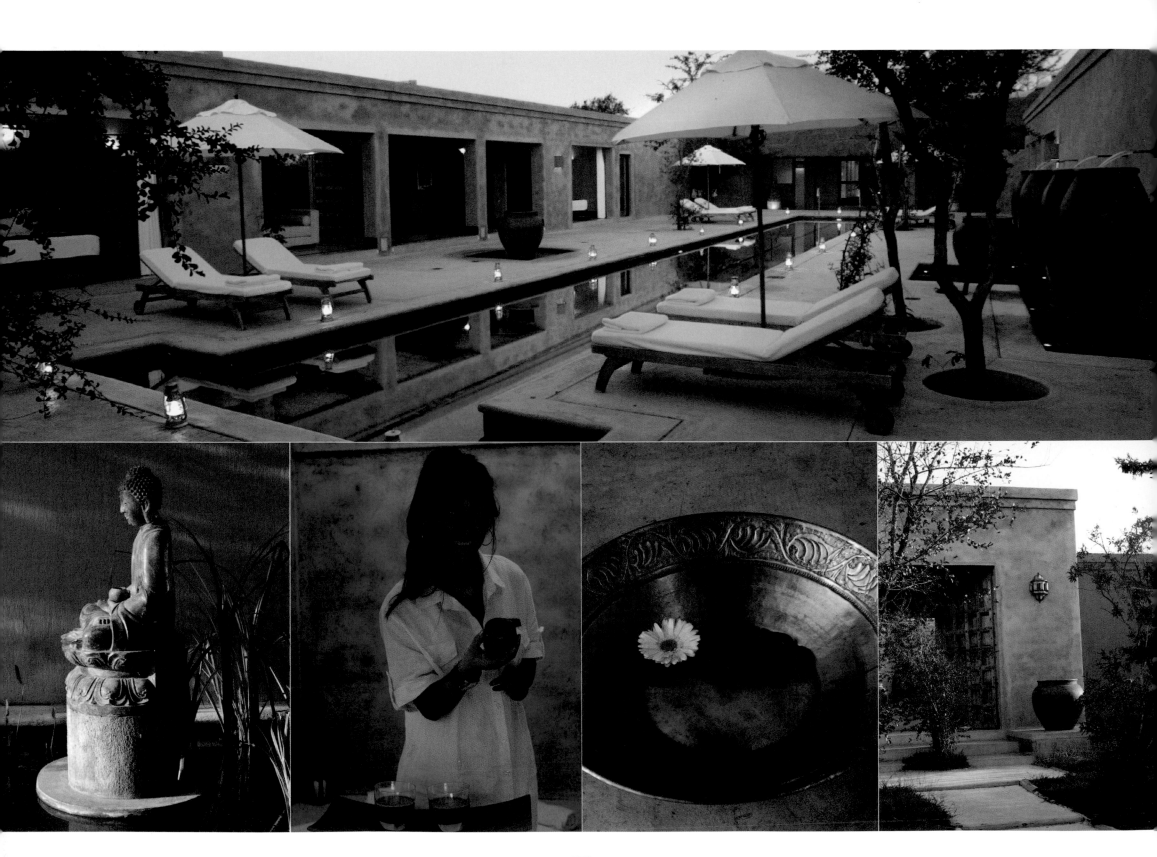

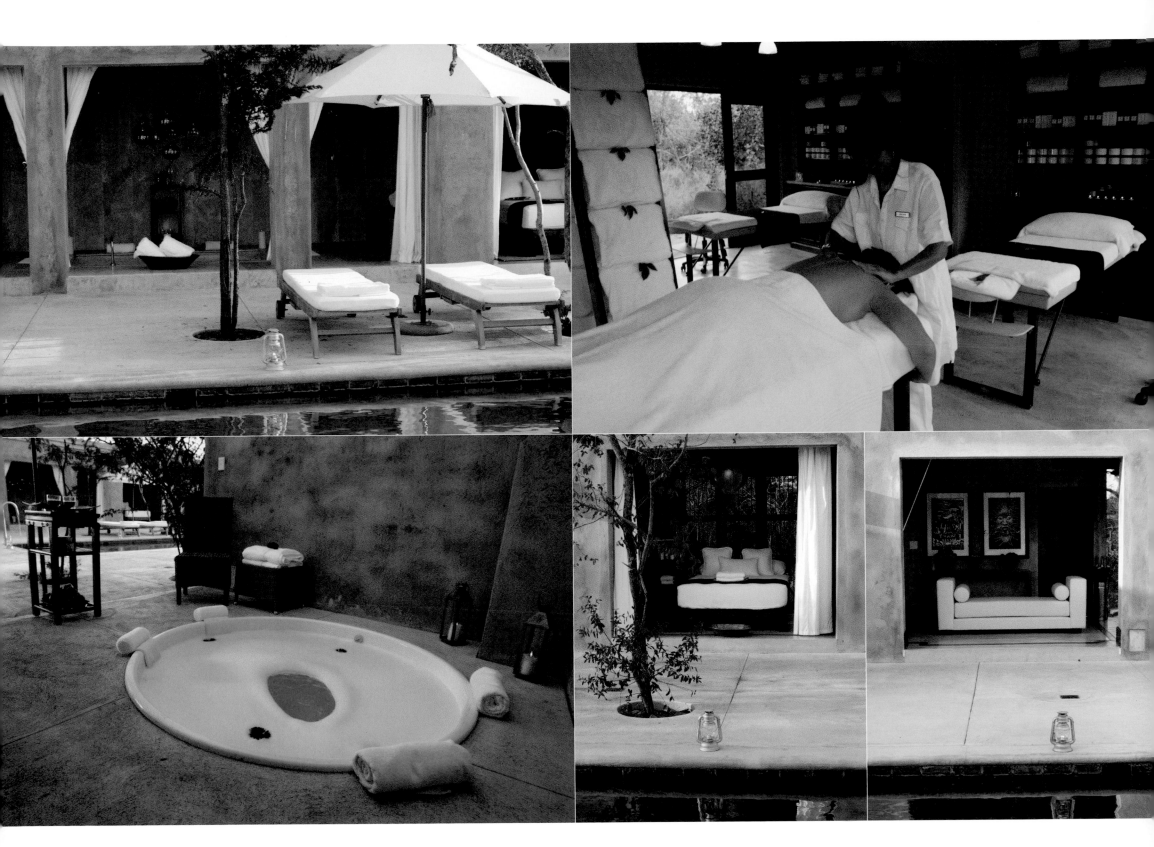

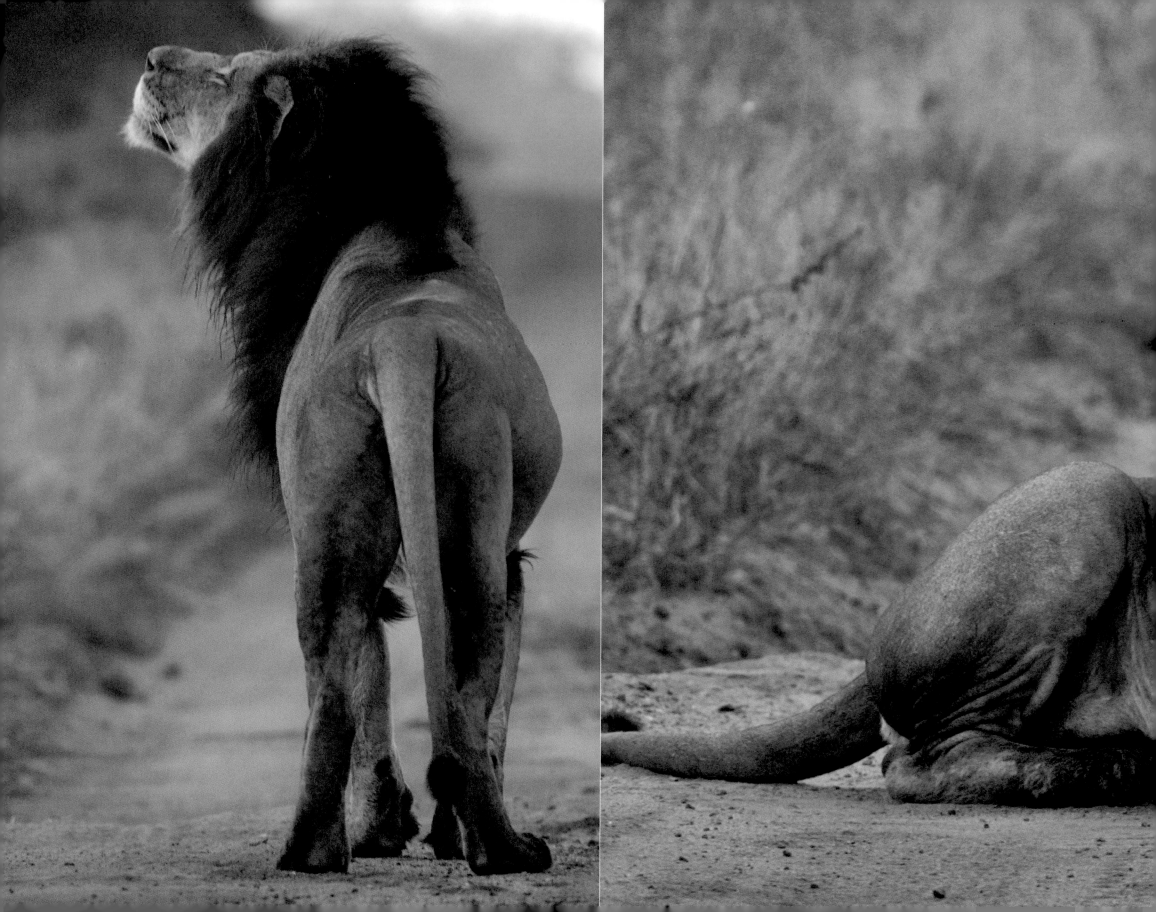

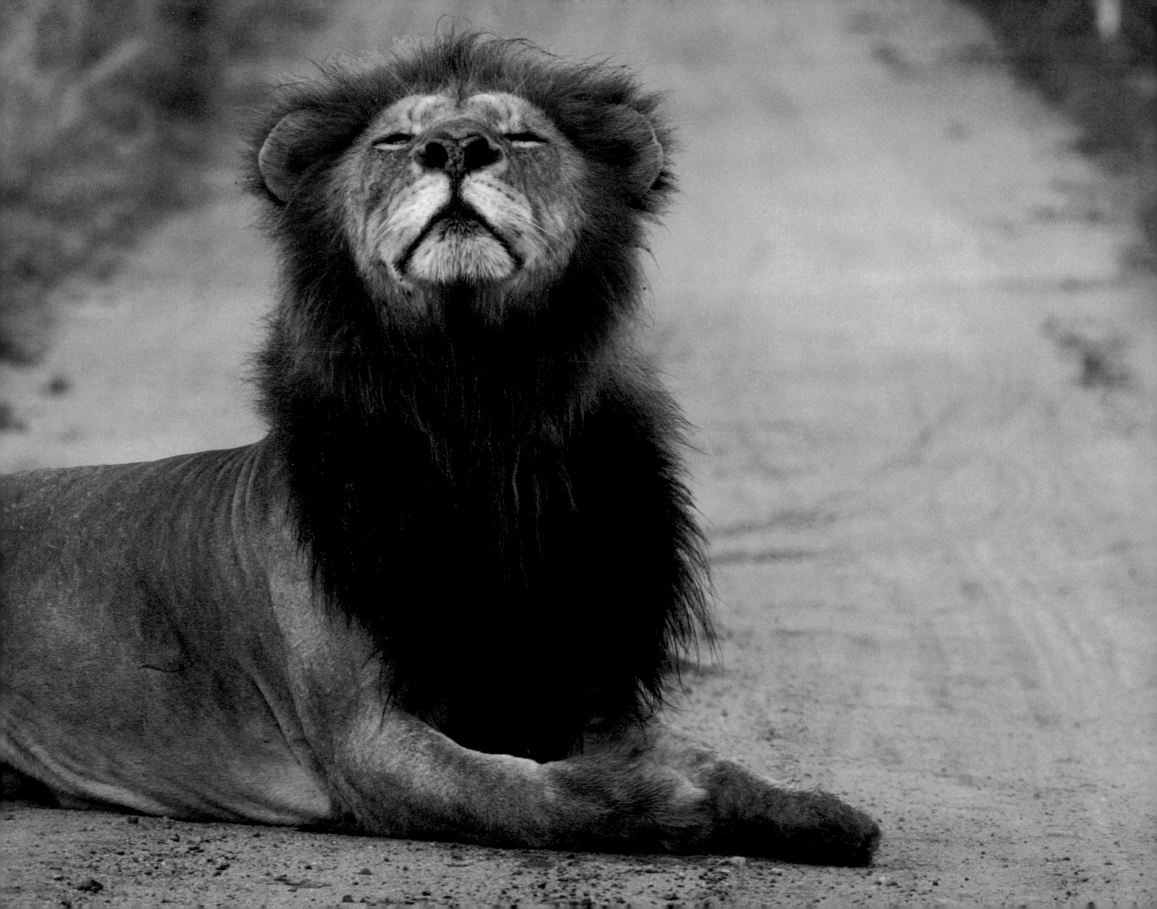

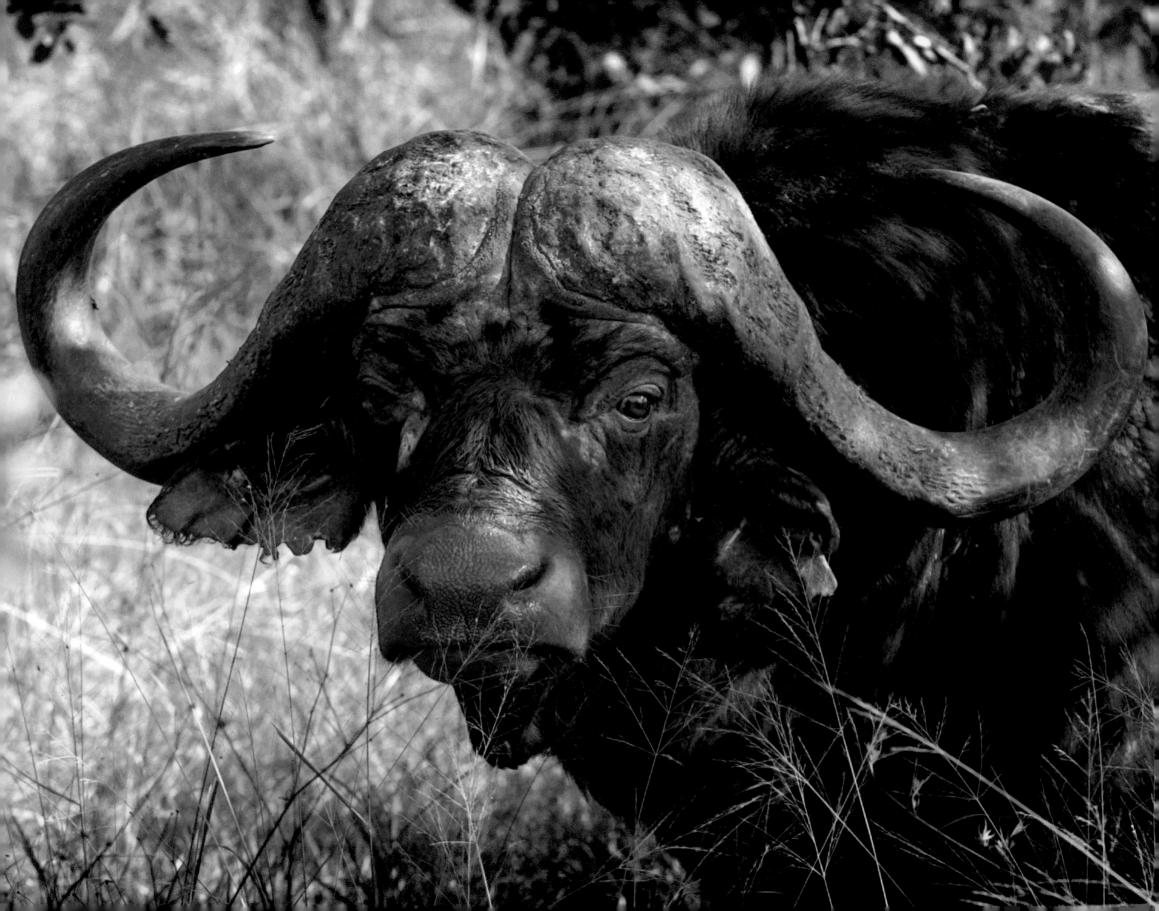

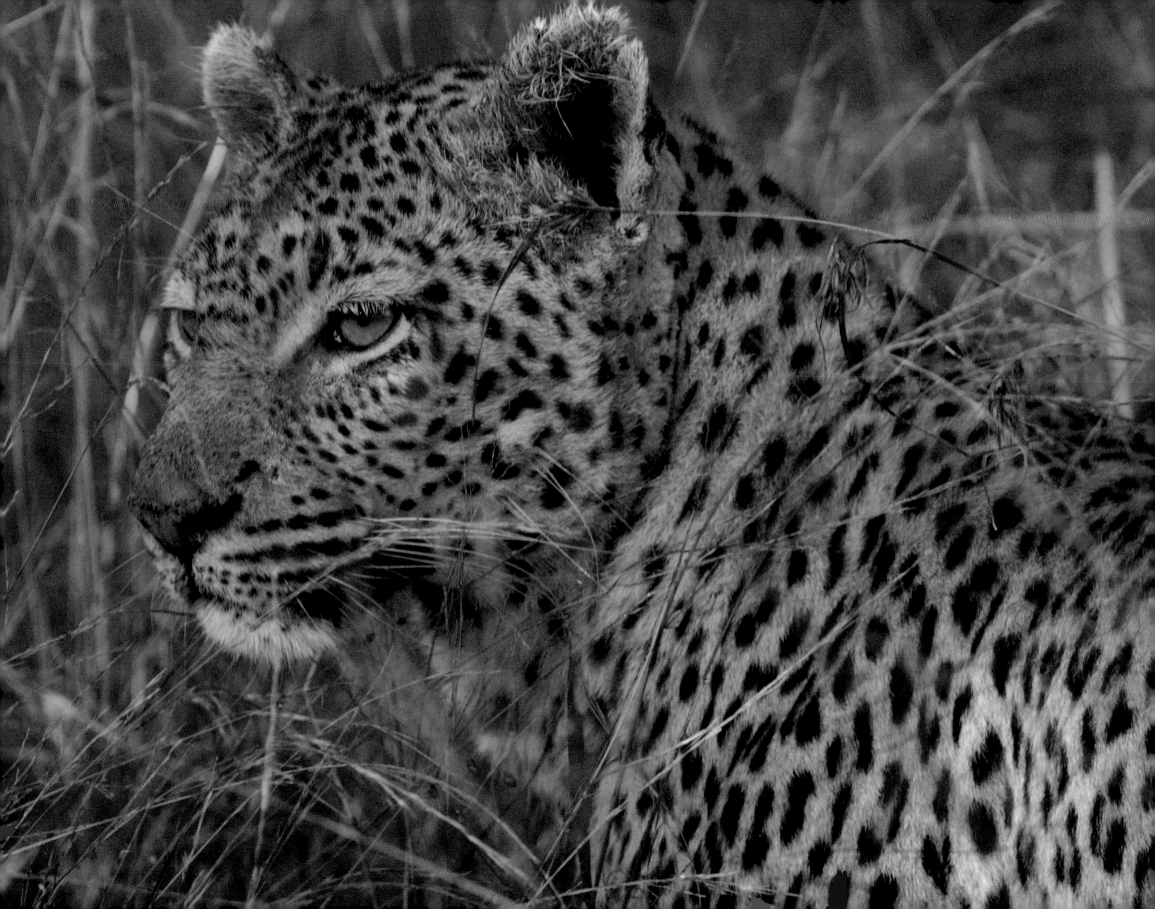

Singita
BOULDERS LODGE

To many, the name Singita is synonymous with style and quality. Renowned as being one of the top safari establishments in the industry, it has reaped an enviable collection of awards and accolades internationally. Singita does not need to blow its own trumpet, as other people do that for it, like the readers of *Travel + Leisure* magazine, who voted Singita the World's Best Hotel, Best Small Hotel and Best Hotel in Africa and the Middle East for 2006.

Singita Boulders Lodge is one of two luxury safari lodges in Singita Private Game Reserve, a pristine wilderness area in the world-renowned Sabi Sand Game Reserve in north-eastern South Africa. Here in Sabi Sand, Singita Boulders sets a trend from the outset with its glass-fronted suites, which enable you to watch game from your bed or bath. Bold in its design, the lodge towers over the landscape, while at the same time blending seamlessly into its rocky surroundings. Throughout the lodge, curved thatch and coarse stone contrast with fine linen, leather and gleaming floors.

Singita is never short on innovation when it comes to development projects. When Boulders Lodge waiter Zamani Mathebula was repeatedly asked by guests about his background, he suggested that tours to his home village, Justicia, be offered. Singita promptly made him a guide. This tour now allows guests to share in the culture and history of the Shangaan people and see the community projects initiated by Singita. They also get to meet some of the village's brightest stars, the members of the Justicia Best Boys Choir, seen performing around the fire. Their gentle harmonies are enough to fill guests with the spirit of Africa, which is said to get into your blood and keeps you coming back. Deny it if you can, but Singita's repeat business figures confirm that your first Singita experience is unlikely to be your last.

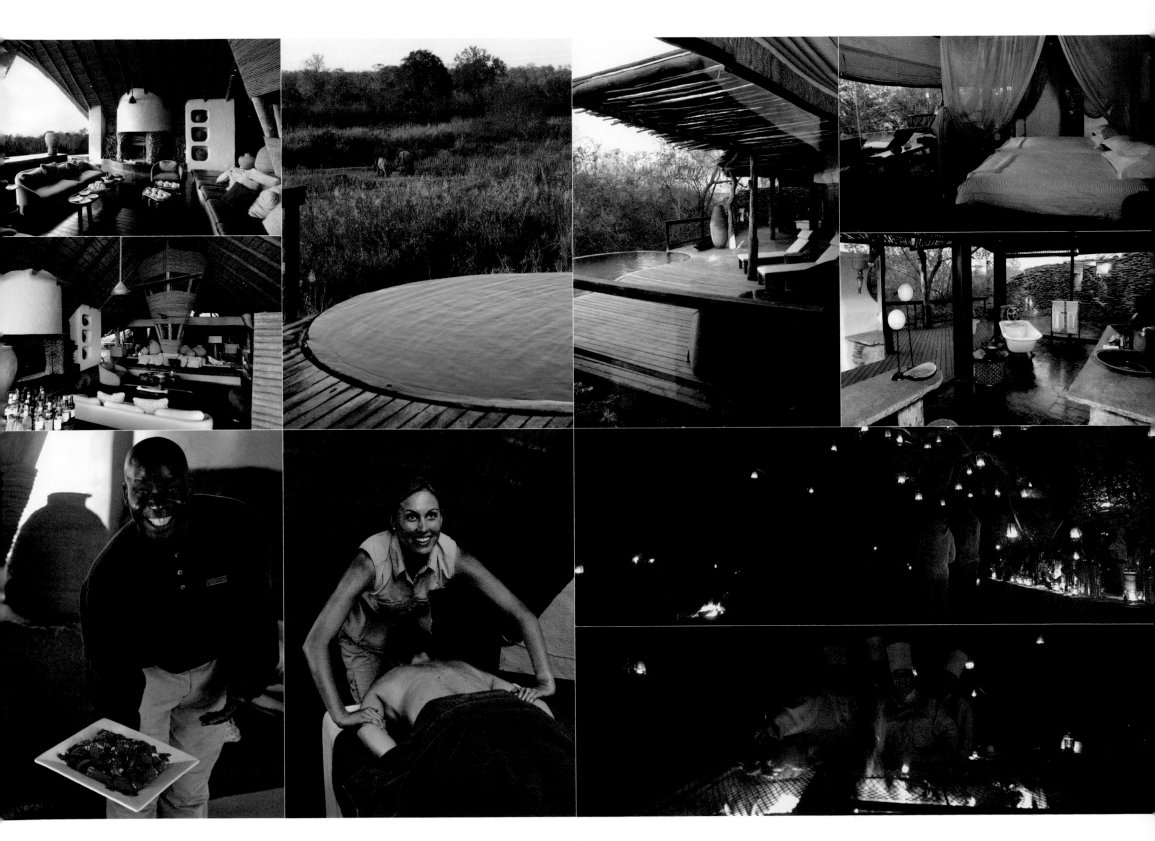

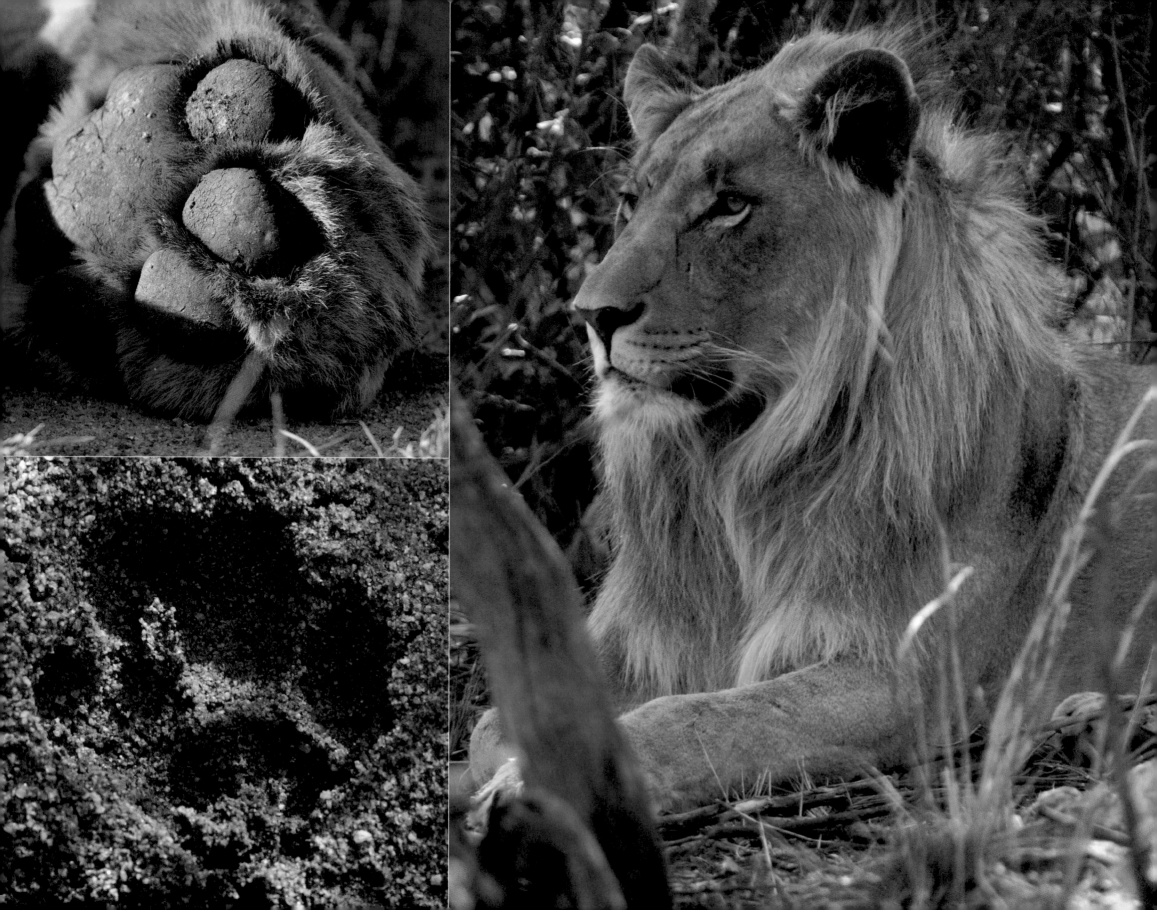

"The leopard's rosette-studded pelage assists in camouflaging it in the dappled light of the undergrowth, providing the perfect cover to advance undetected and make its stalk-and-pounce hunting technique as efficient as possible."

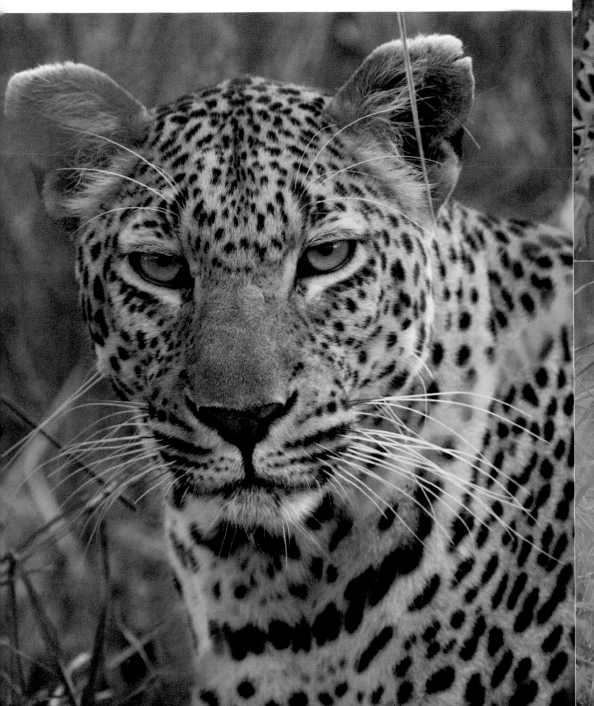

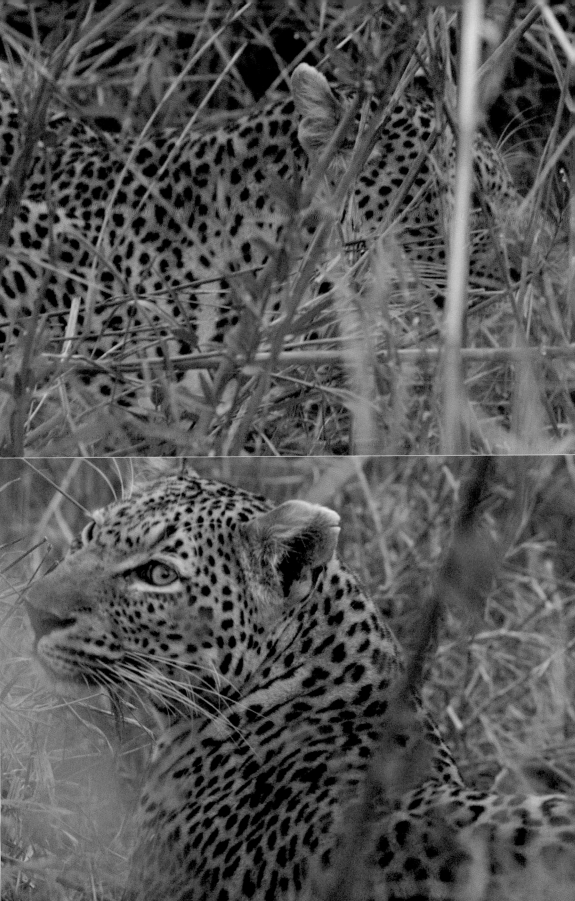

Singita

EBONY LODGE

The more earthy African tones and feel of Singita Boulders Lodge are replaced here at Singita Ebony Lodge with colonial chic and an audacious splash of colour. Checks and tartans in reds and oranges are thrown over well-padded sofas and chairs of similar hues. Added to this mix are Persian rugs and zebra skins, antique furniture and wall displays of antelope horns, resulting in a truly unique yet traditional safari interior.

Singita's interior designers have devised a distinctive style for each of its four lodges – Ebony and Boulders in the Sabi Sand Game Reserve and Lebombo and Sweni in the south-east corner of the Kruger National Park. At Ebony Lodge they have used classic comforts – oversized beds, crisp white cottons, thick pillows, shady spaces and individual terrace pools – to make each suite a place of refuge.

There are also ample outdoor viewing decks from which to watch animals as they come down to the Sabi River to drink. Game viewing is paramount to the Singita experience and since you are in Sabi Sand Big Five country, the chances of seeing lion, leopard, elephant, rhino and buffalo are good.

Food is central to a Singita safari, and fresh ingredients are so creatively used that a buffet salad lunch turns into a sumptuous midday feast. Dinner is as innovative and the table is laid to accommodate you and your ranger, who is dedicated to your wellbeing for the duration of your stay. To say you are well looked after at Singita is an understatement.

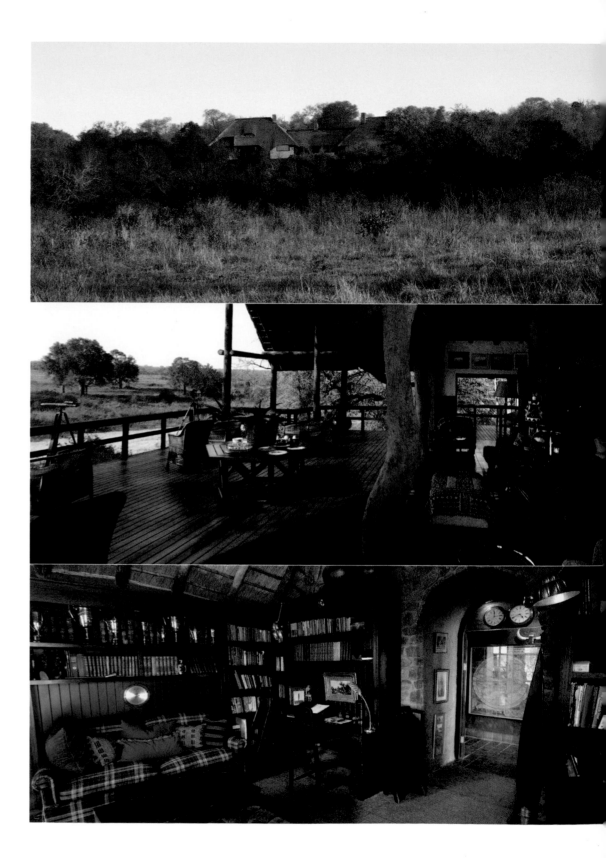

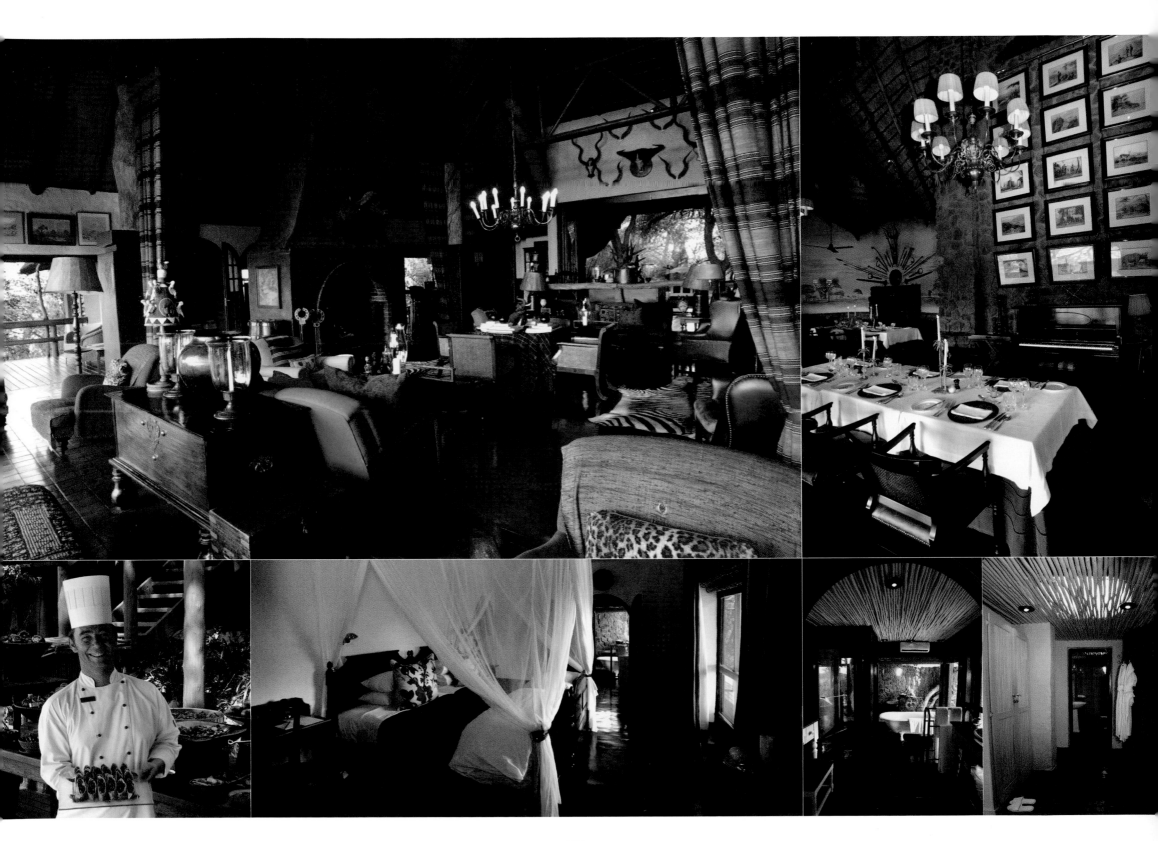

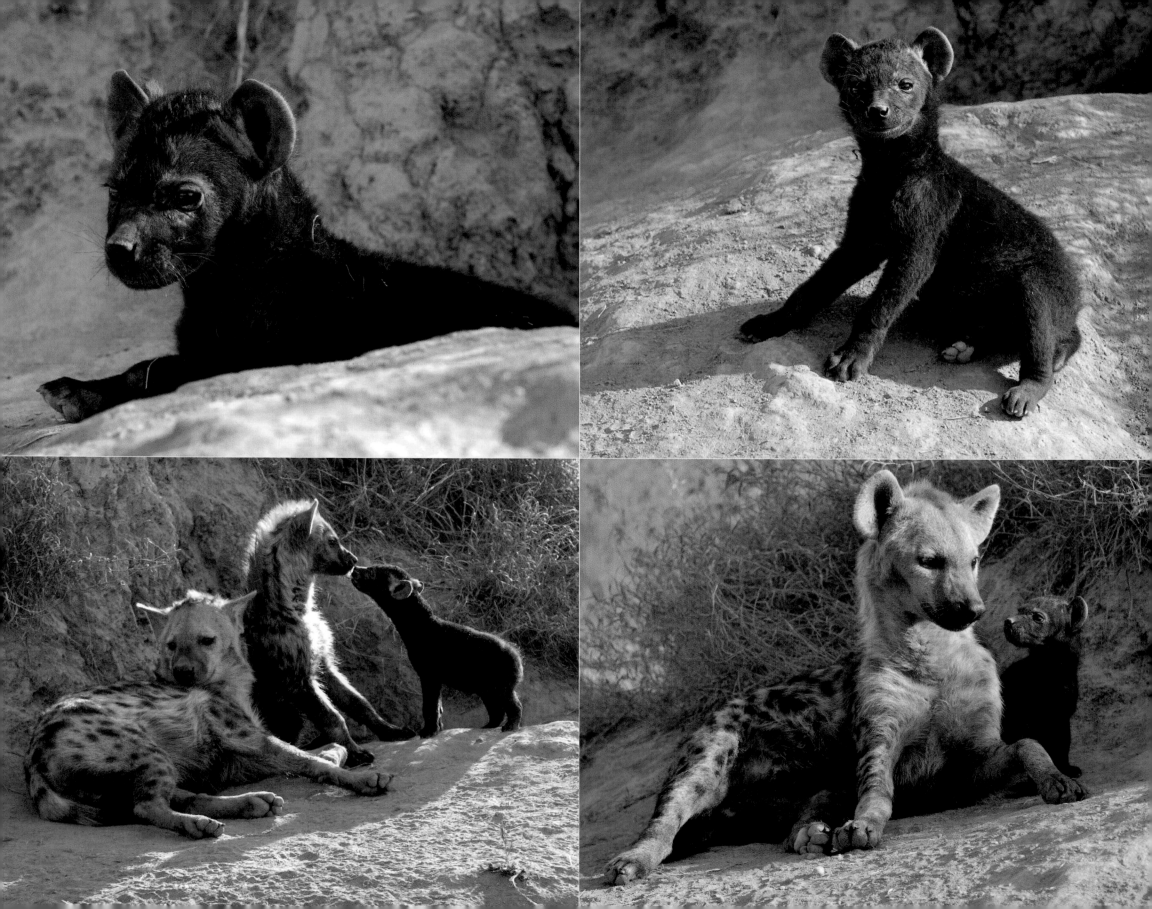

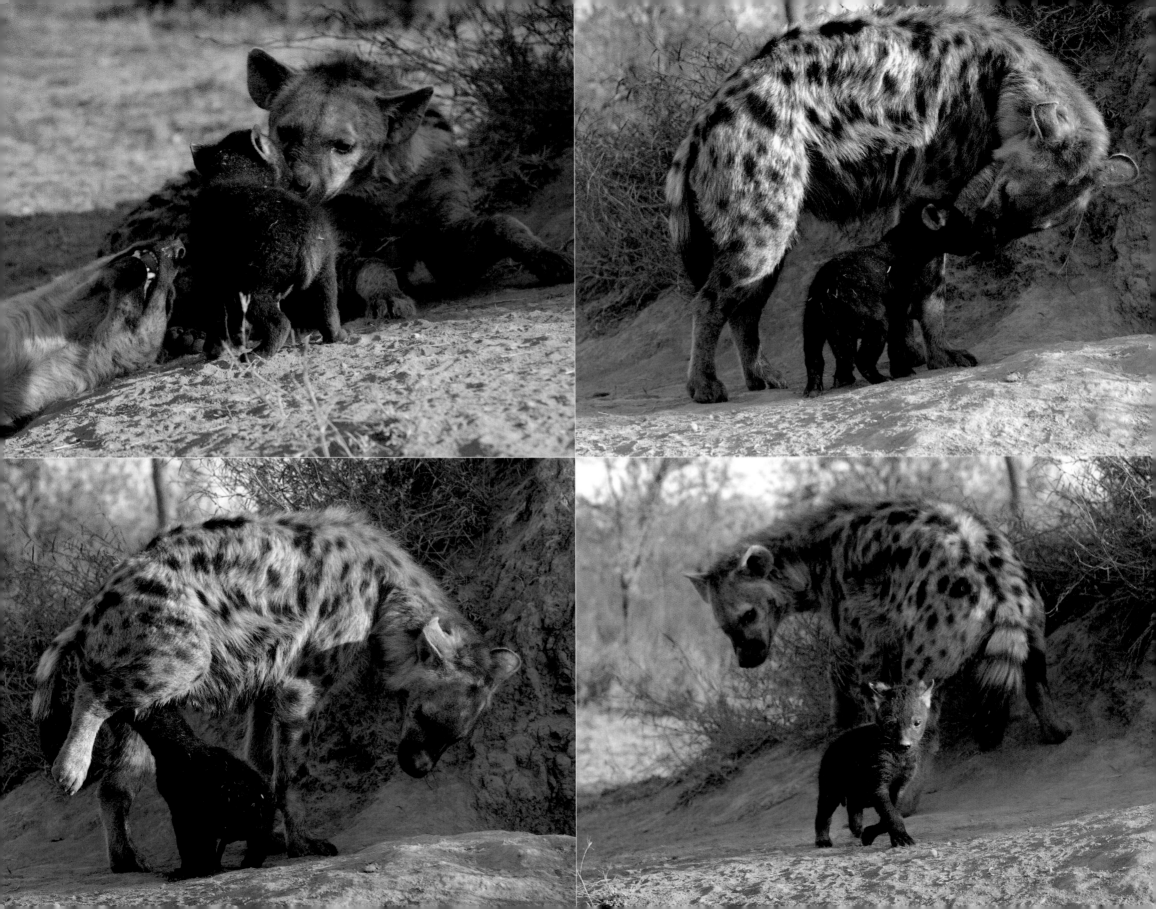

Sabi Sabi

EARTH LODGE

Sabi Sabi Earth Lodge in the Sabi Sand Game Reserve in Mpumalanga is unlike any other safari lodge. Tucked into a slope of grassland and hidden in the earth, the lodge is concealed, even from elephants, who often venture so close that guests get an encounter they had not bargained for.

Earth Lodge takes inspiration from raw nature on one hand and innovative modern trends on the other. Highly contemporary furniture pieces emulate the shapes found in nature. In contrast are the roughly plastered walls incorporating straw, stone and pigment for a realistic elephant-dung effect. Add to this mix gnarled trunks of wild olive trees used to striking decorative effect and a perfectly raked Zen courtyard, and you have some idea of the unique combination of styles that makes Earth Lodge so very different.

The intention at Earth Lodge is to give guests the chance to be at one with the natural world while still having every comfort at their fingertips. Unexpected extras come in the form of personal butlers, private plunge pools at each suite, outdoor showers and exquisite en-suite bathrooms that look out over uninterrupted bush.

This part of the Sabi Sand Game Reserve is well known for lion, leopard, buffalo, elephant and rhino sightings, and a stay at Earth Lodge will usually reveal them all without guests having to travel too far from the lodge.

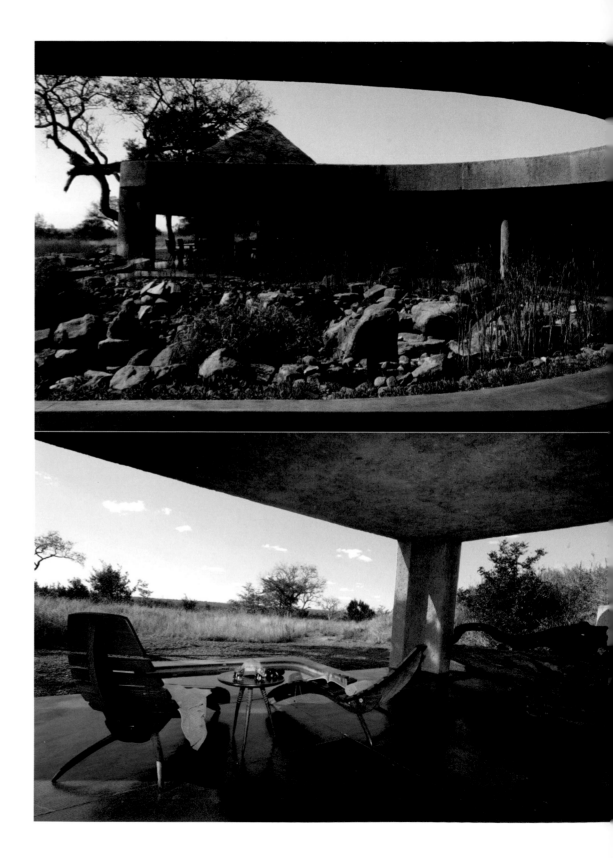

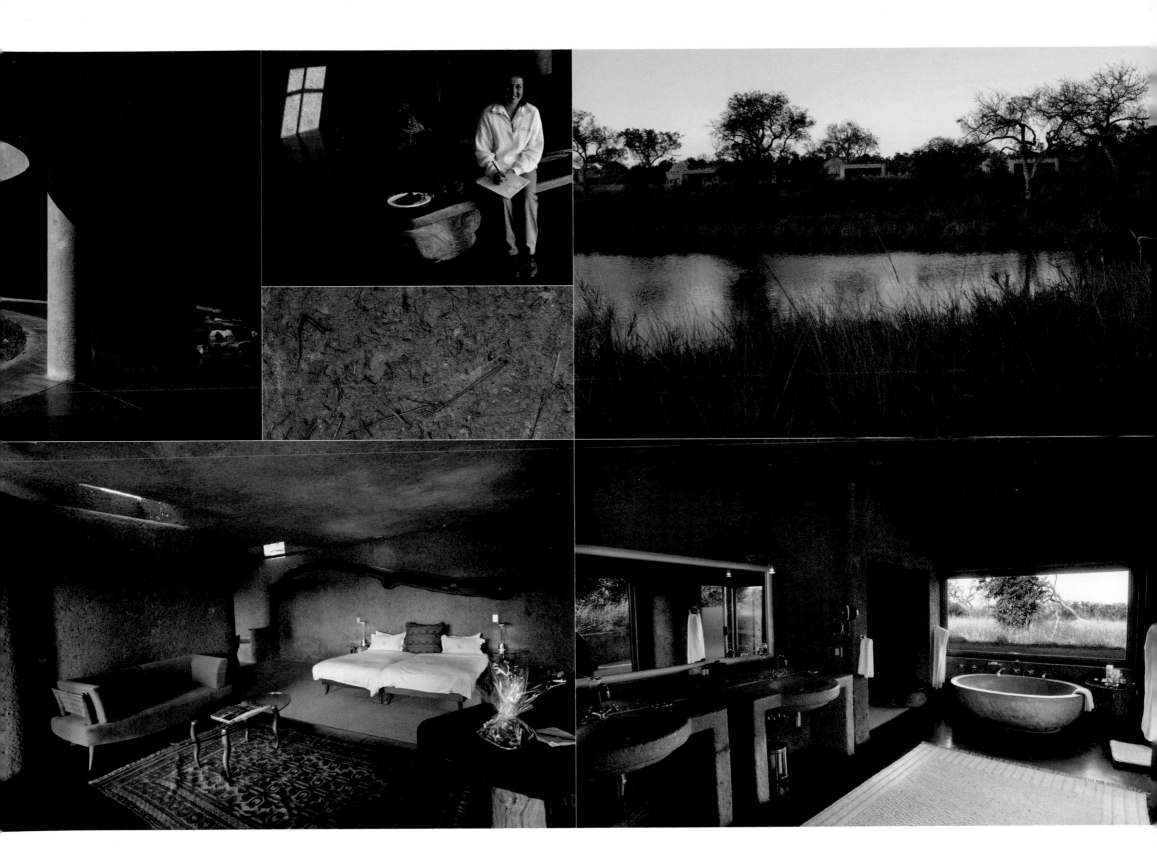

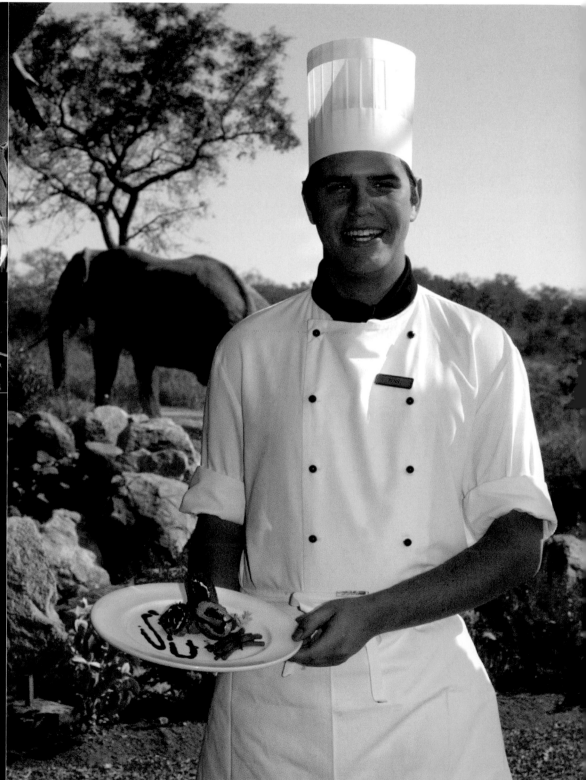

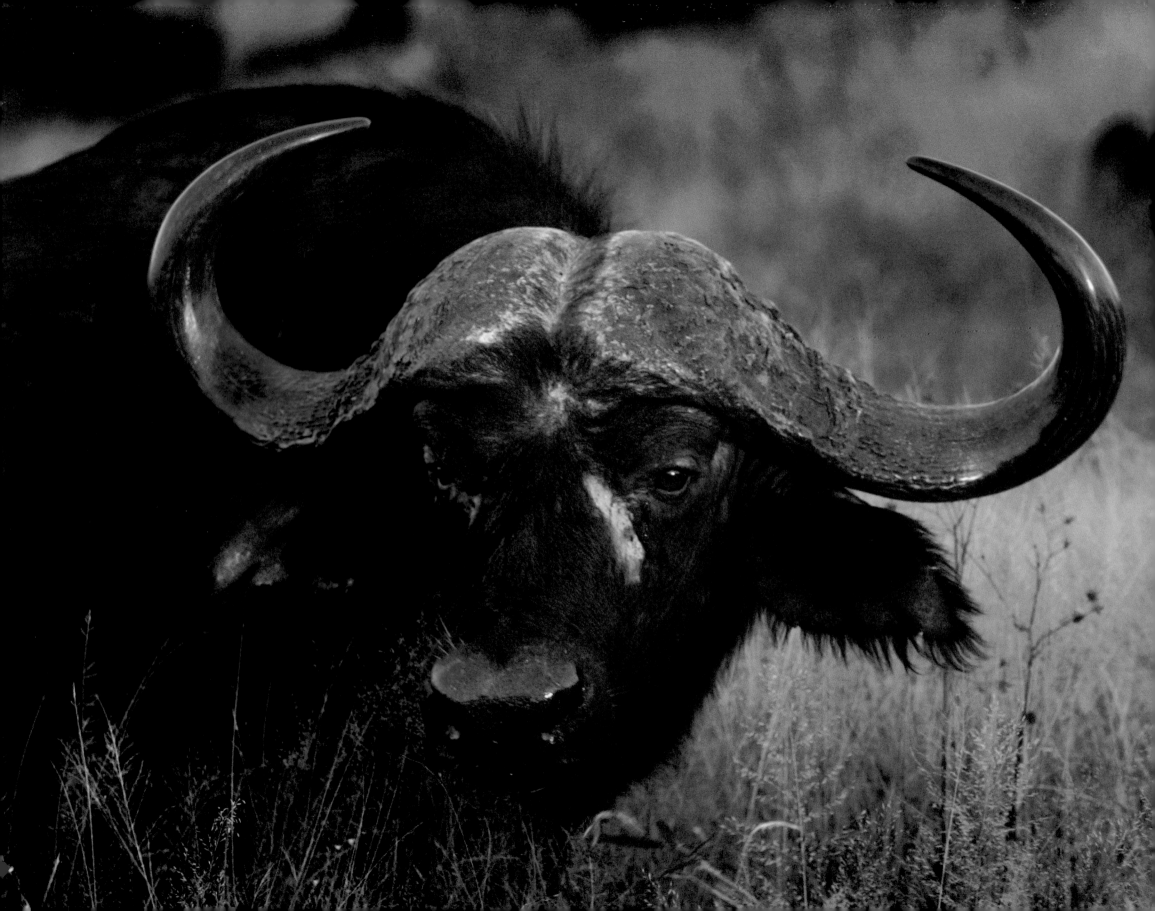

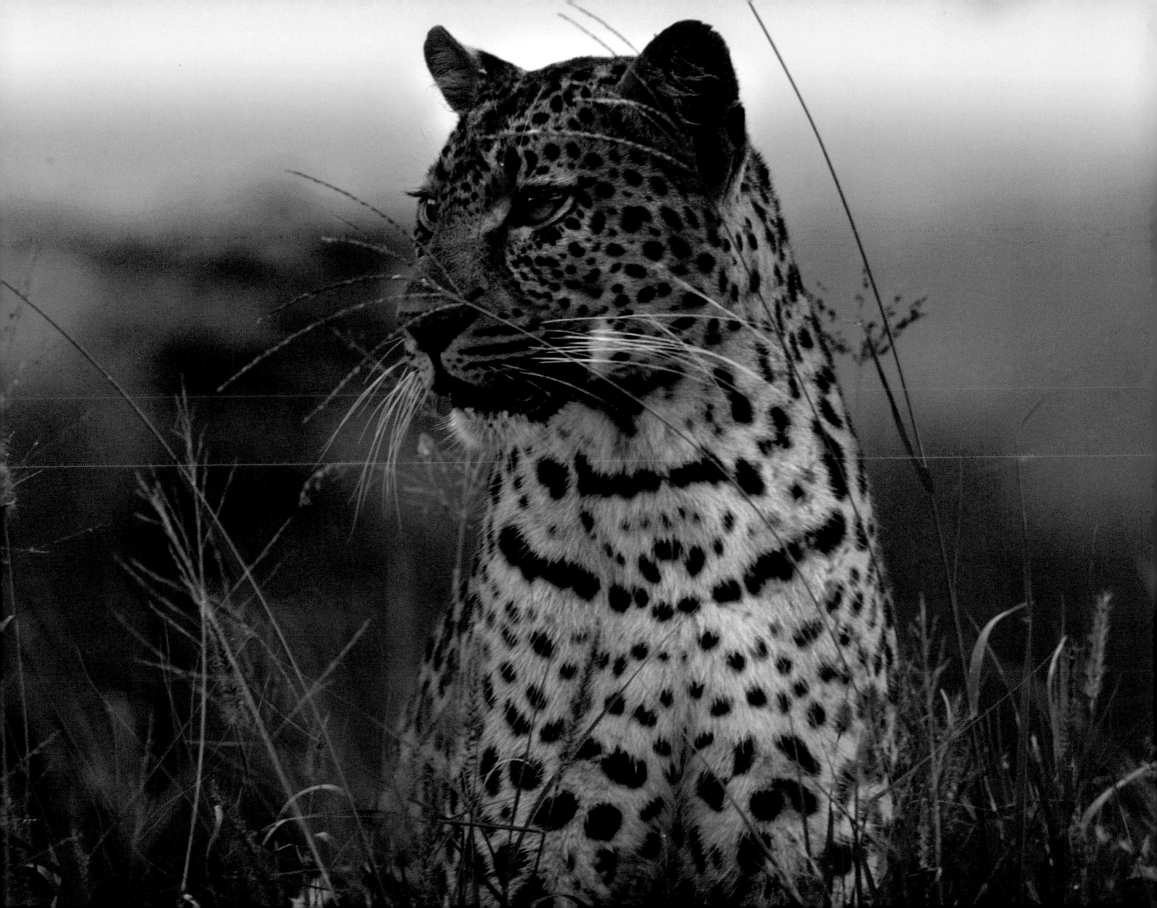

Chitwa Chitwa

PRIVATE GAME LODGE

Standing sentry over one of the largest lakes in the Sabi Sand Game Reserve in Mpumalanga is Chitwa Chitwa Private Game Lodge. Floating in the lodge's infinity pool, you can almost imagine you are swimming in the lake, as the two merge seamlessly into one another, fooling the eye into seeing just one body of water.

This fluid transition from being in the lodge to being in the bush works, because the one meets the other without resistance. Buffalo thorn trees grow right through the wooden outer decking without hindrance and the thatched bar and lounge just about melt into the rich foliage. Ten cottages are found among the trees and their cool-toned interiors and eclectic European design influences tie the African touches together in a soft genteel style.

Softness can be found in the animal kingdom, but it is tempered by the need to survive in the bush. Sabi Sand Game Reserve is Big Five country and guests staying two or three nights usually get to see the five most dangerous animals of Africa: lion, leopard, rhino, elephant and buffalo. In addition, this game reserve, which shares a fenceless border with the Kruger National Park, records regular sightings of cheetah, hyaena and wild dog. Sights such as this should not be taken for granted, as this variety of predators in one place is like hitting the wildlife jackpot.

The jackpot at Chitwa Chitwa would be to reside in the Boulders Suite, which is the most extravagant of the game lodge's chalets and eminently suitable for honeymooners.

The boma, used for alfresco meals, has a feeling of being far away from civilisation. Here you get to savour an intriguing combination of African and Mediterranean dishes in a very social atmosphere. Getting to know fellow guests is a feature of Chitwa Chitwa and makes a safari here a satisfyingly social event.

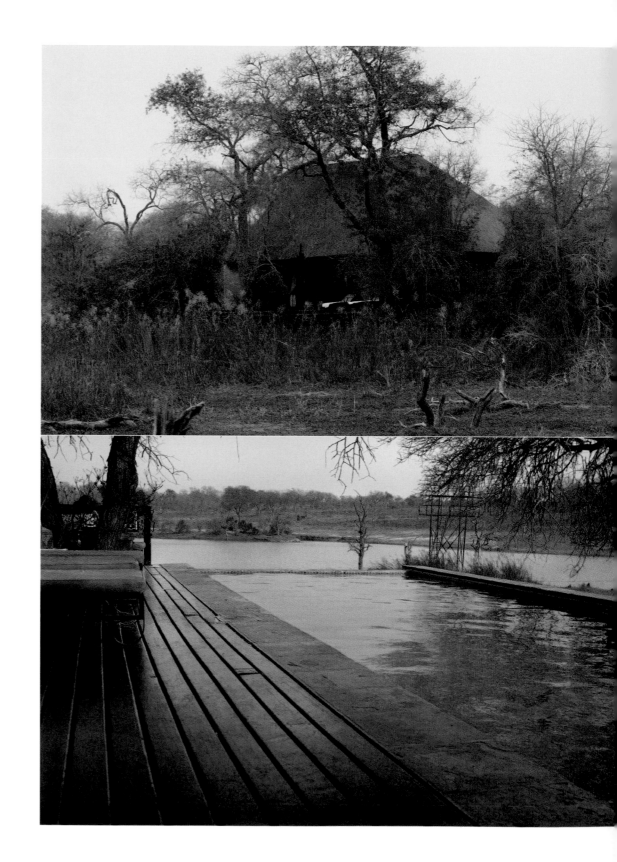

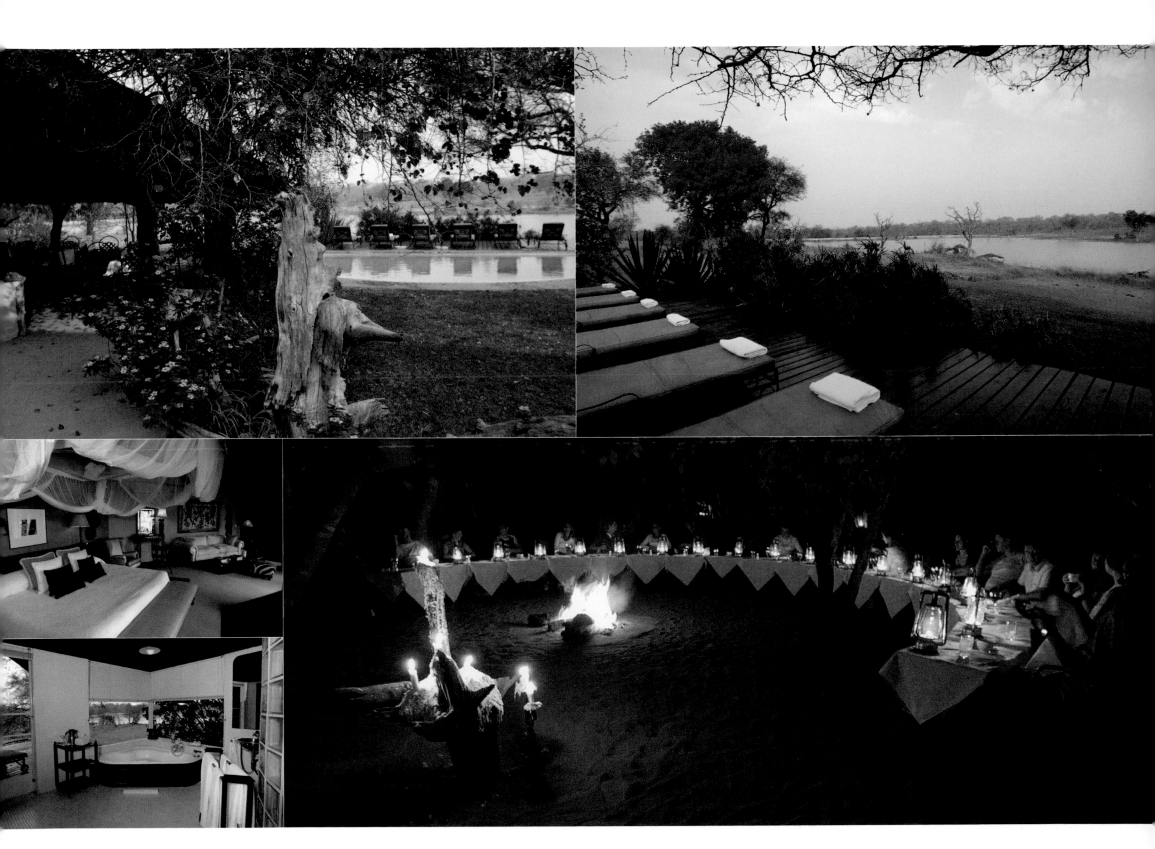

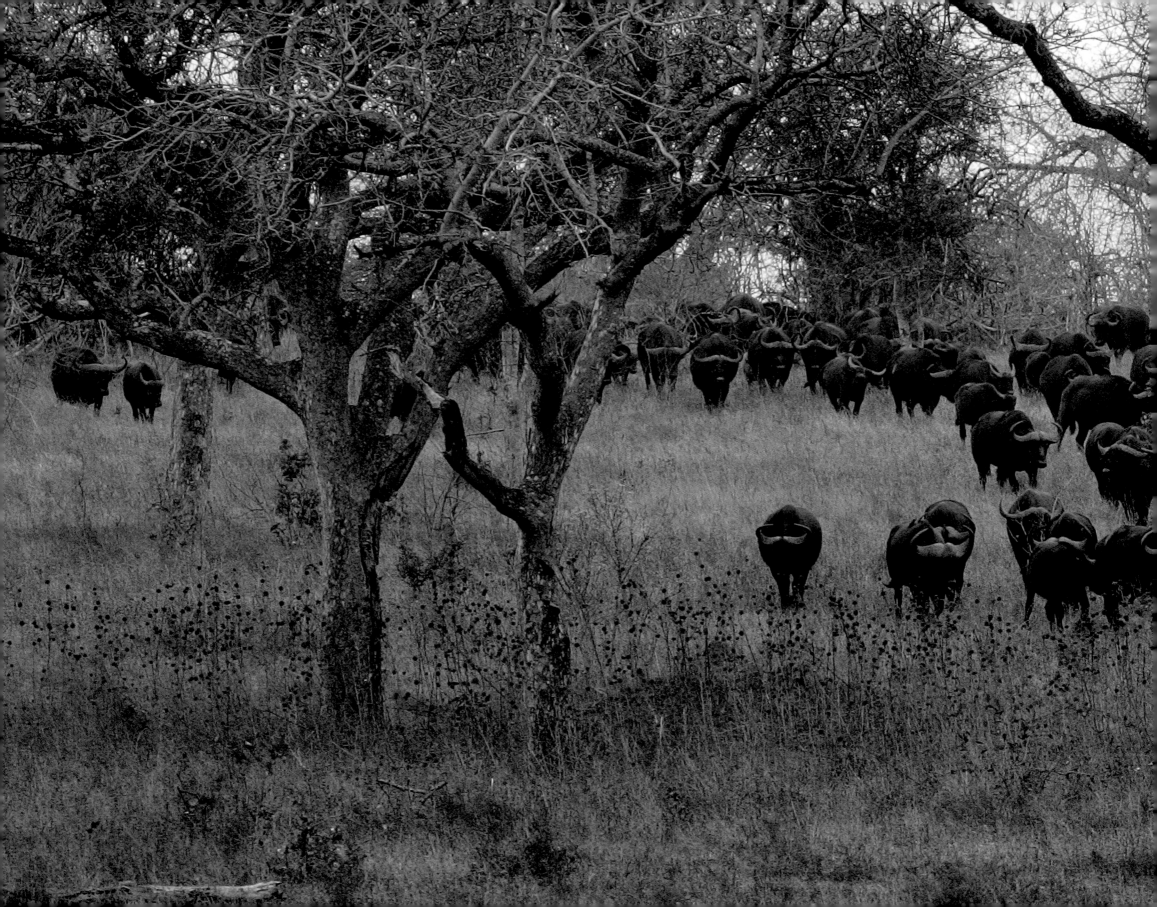

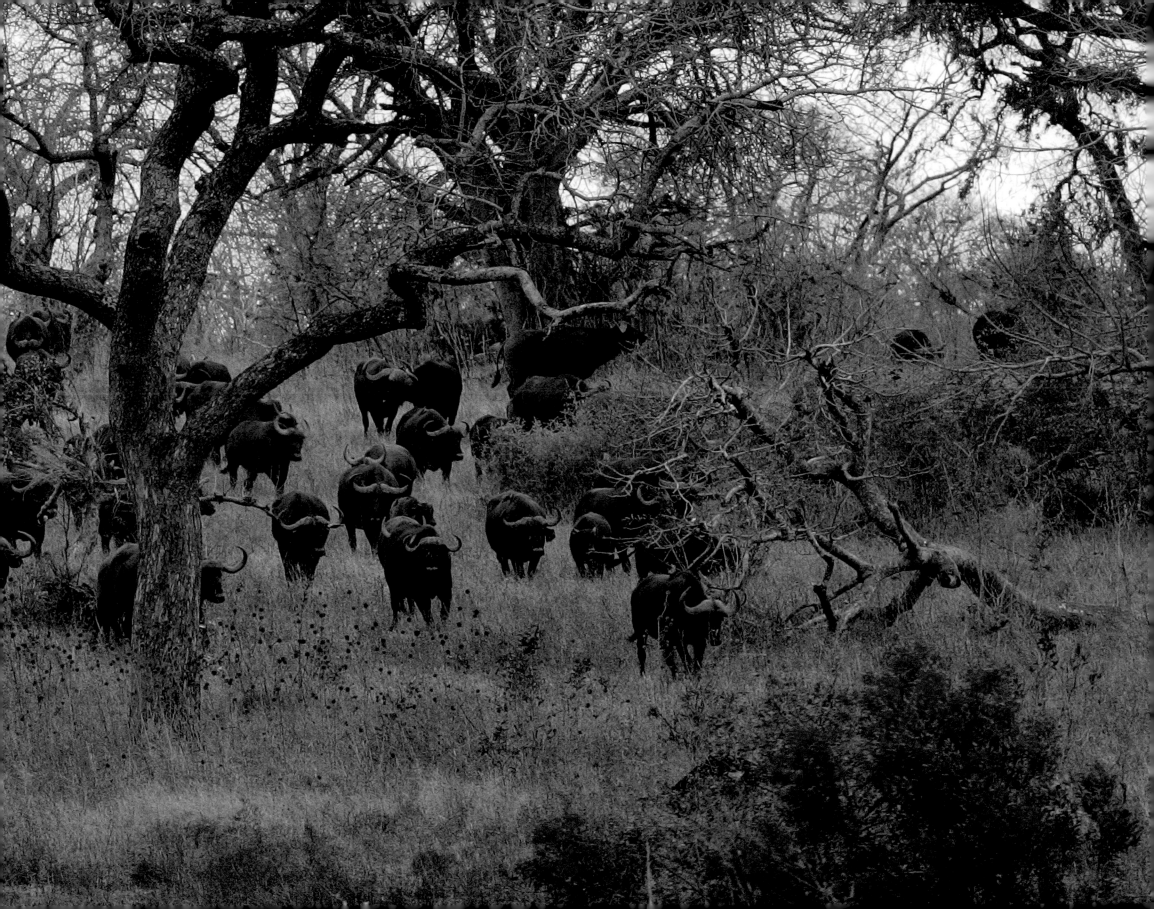

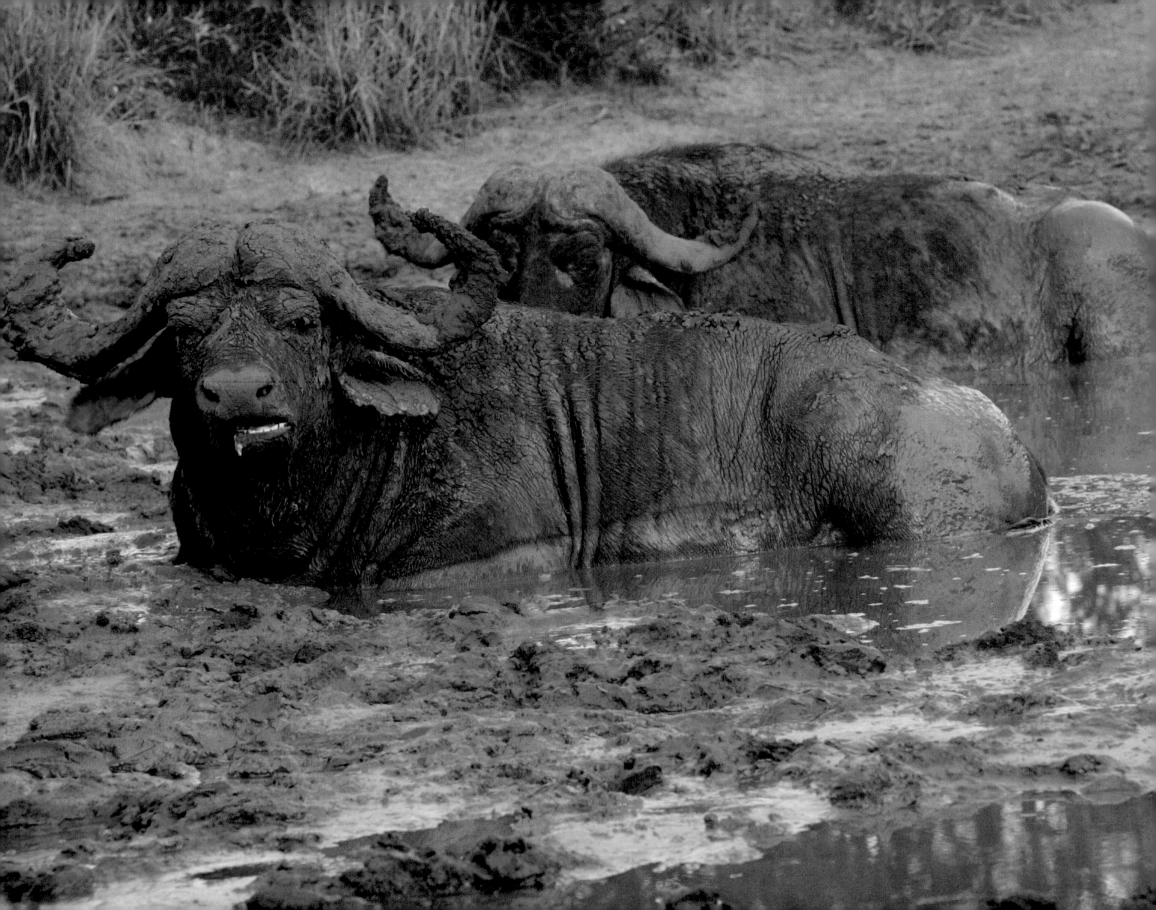

(left)

"Squish, squelch, wallow, bellow! I was a privileged spectator at a waterhole 'health spa'. A buffalo – one of Africa's Big Five – seemed to delight in a mud pack (an effective antiparasitic). It was, at least for a while, unaware of my presence."

(below, right)

"The rhino lay submerged in the mud, totally relaxed. When it saw our vehicle it got up and took off at speed, causing mud waves underfoot."

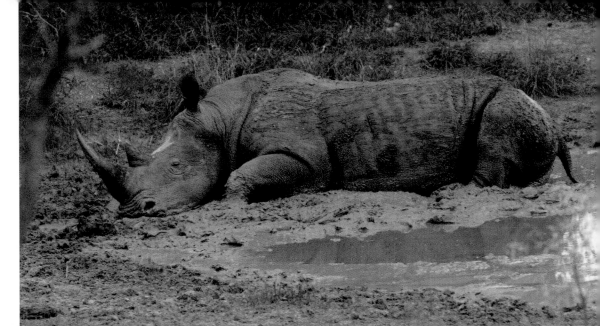

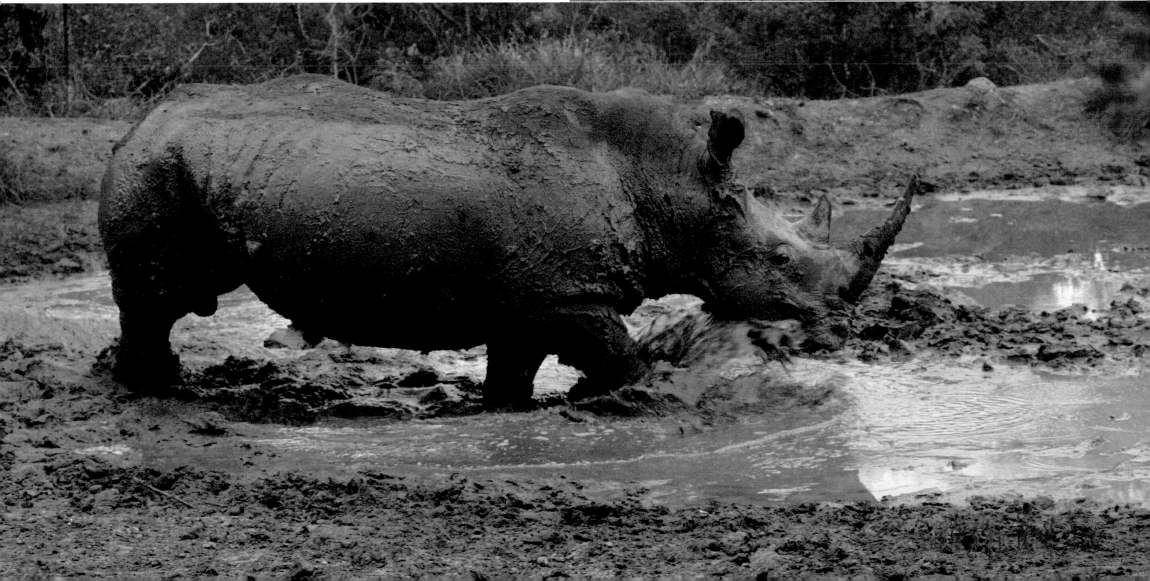

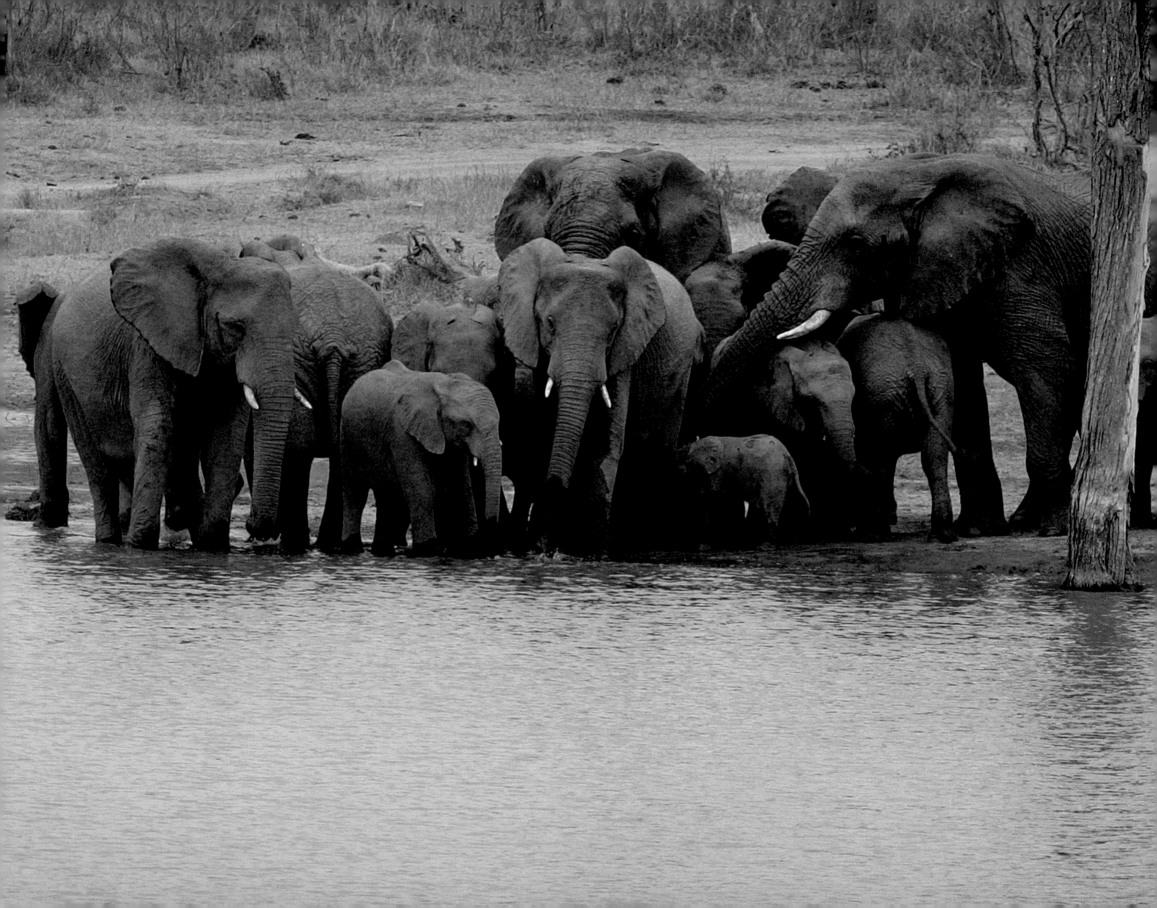

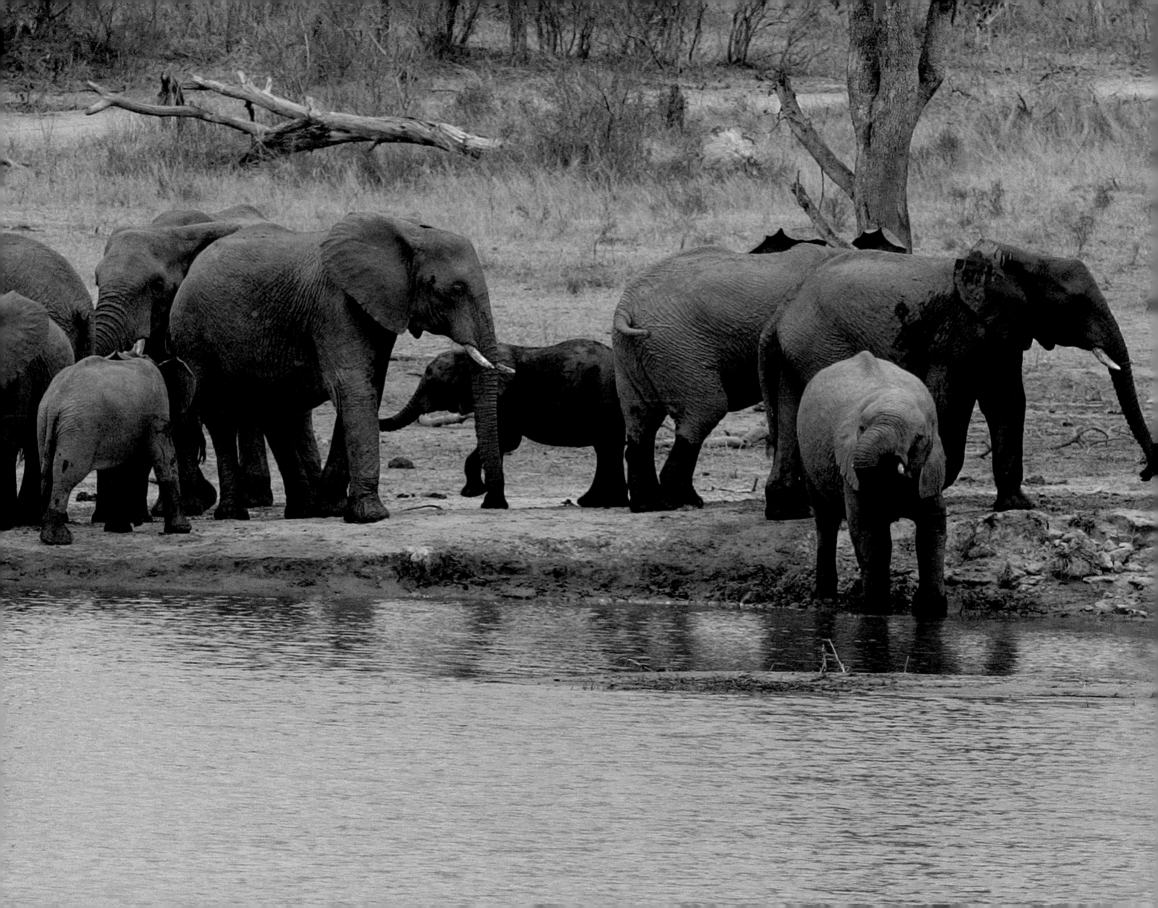

Elephant Plains

GAME LODGE

Located along a dry riverbed in the Sabi Sand Game Reserve, Elephant Plains Game Lodge is one of several family-owned and -run safari lodges in this prestigious private game reserve in Mpumalanga.

Upon arrival you will be warmly welcomed. The homely atmosphere at Elephant Plains will work its magic in taking the edge off the stress that brought you to these plains and hilly woodlands in the first place.

A typical day at Elephant Plains starts with coffee or tea and fresh rusks at the crack of dawn. By now slightly more alert, you will be whisked off in an open Land Rover. No doubt, all your senses will be awakened at the thrill of your first sight of game: perhaps lions still feasting on a kill or a leopard stalking its prey.

By 9 a.m. it is your turn to feast on a spectacular buffet breakfast. Then it is time to recharge the camera batteries in preparation for the afternoon game drive just before sunset. You might imagine there is a whole day of rest in between game drives, but when there are so many activities to fit in – a guided morning walk, a massage at the health spa, a swim in one of two pools, a buffet lunch and afternoon tea and cakes – the day does not seem long enough.

Halfway through the evening game drive the vehicle stops at a viewpoint where you partake of sundowner drinks and snacks while watching the African sun perform its daily ritual. Then the spotlight comes on and in its glare the eyes of night creatures shine – bushbabies, owls, lions and other predators of the darkness.

Elephant Plains is a favourite destination for South Africans and international visitors alike. The experience that brings them back time and again is summed up by one guest: 'Big Five many times over, tracking and knowledge excellent, great service, wonderful with kids, best friends.'

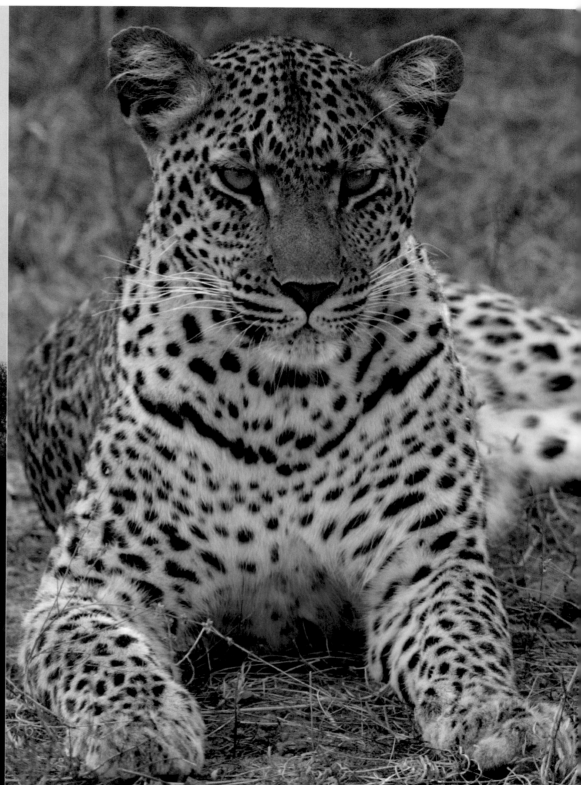

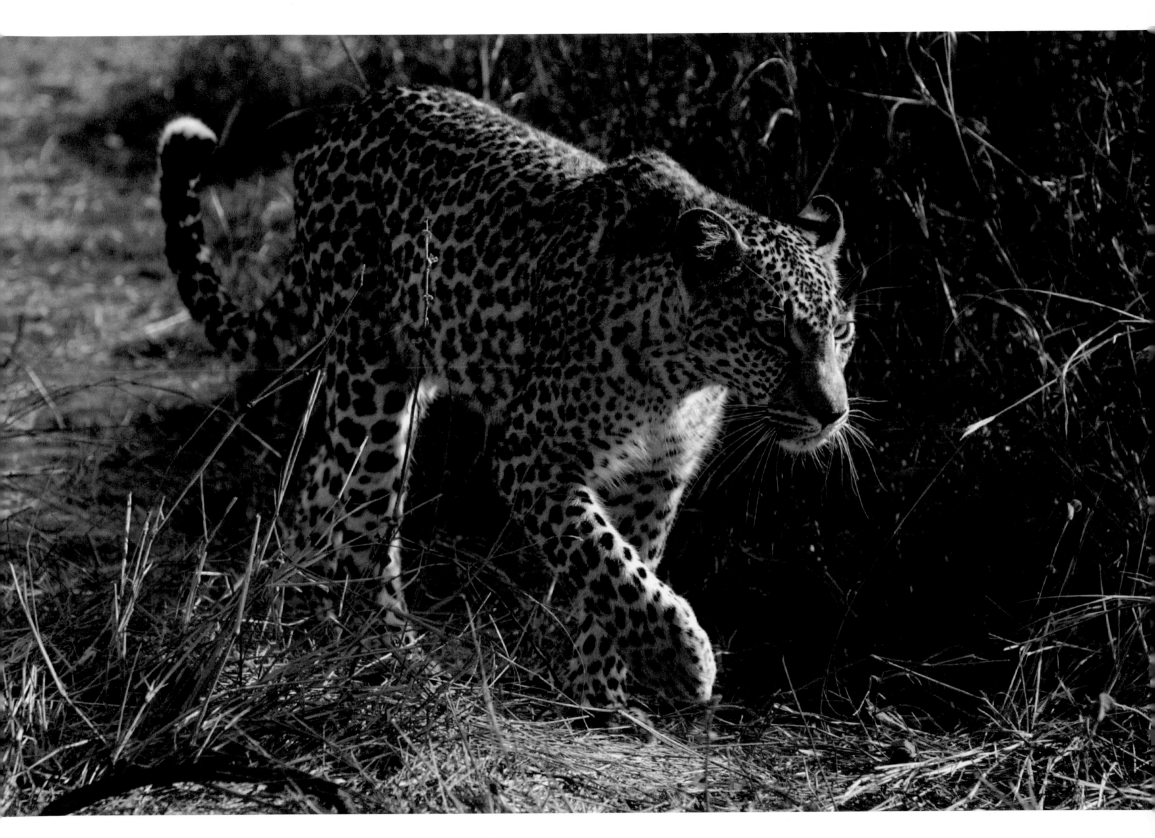

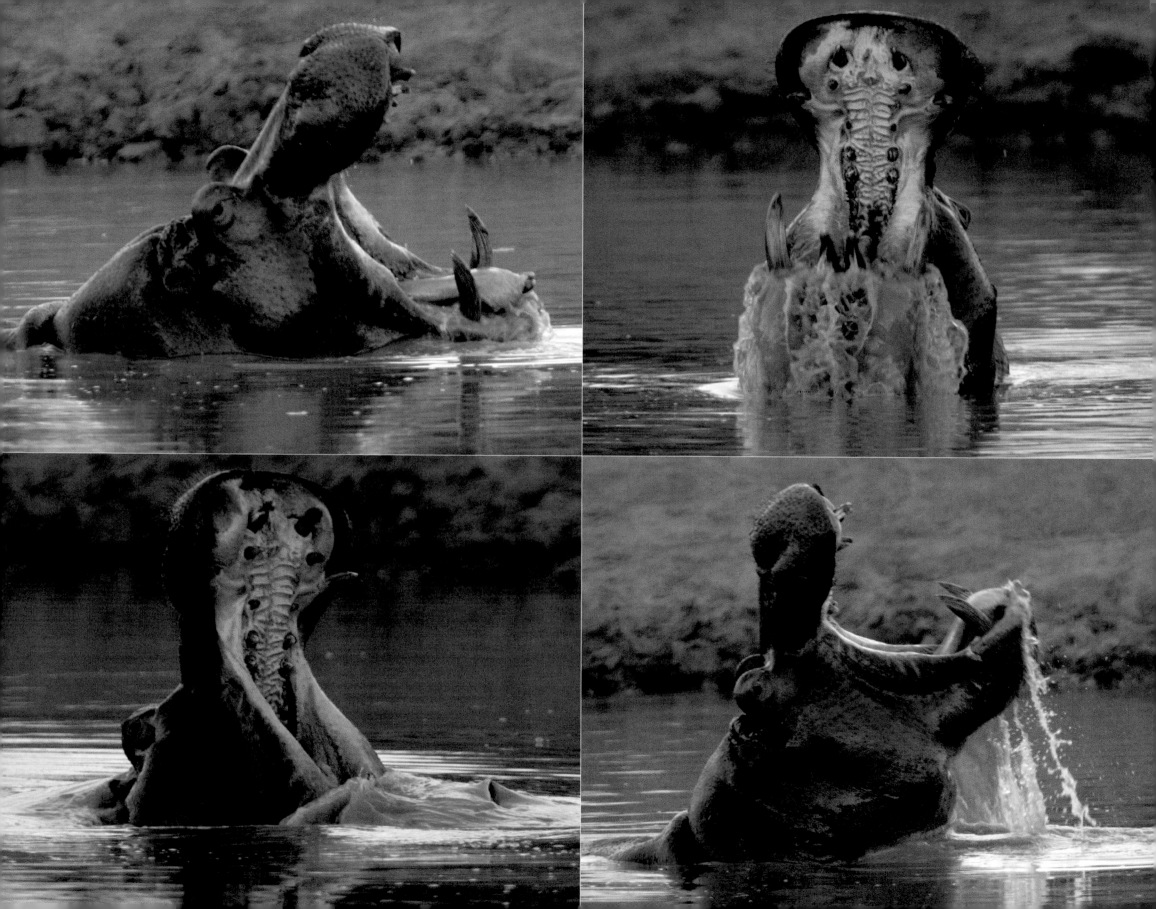

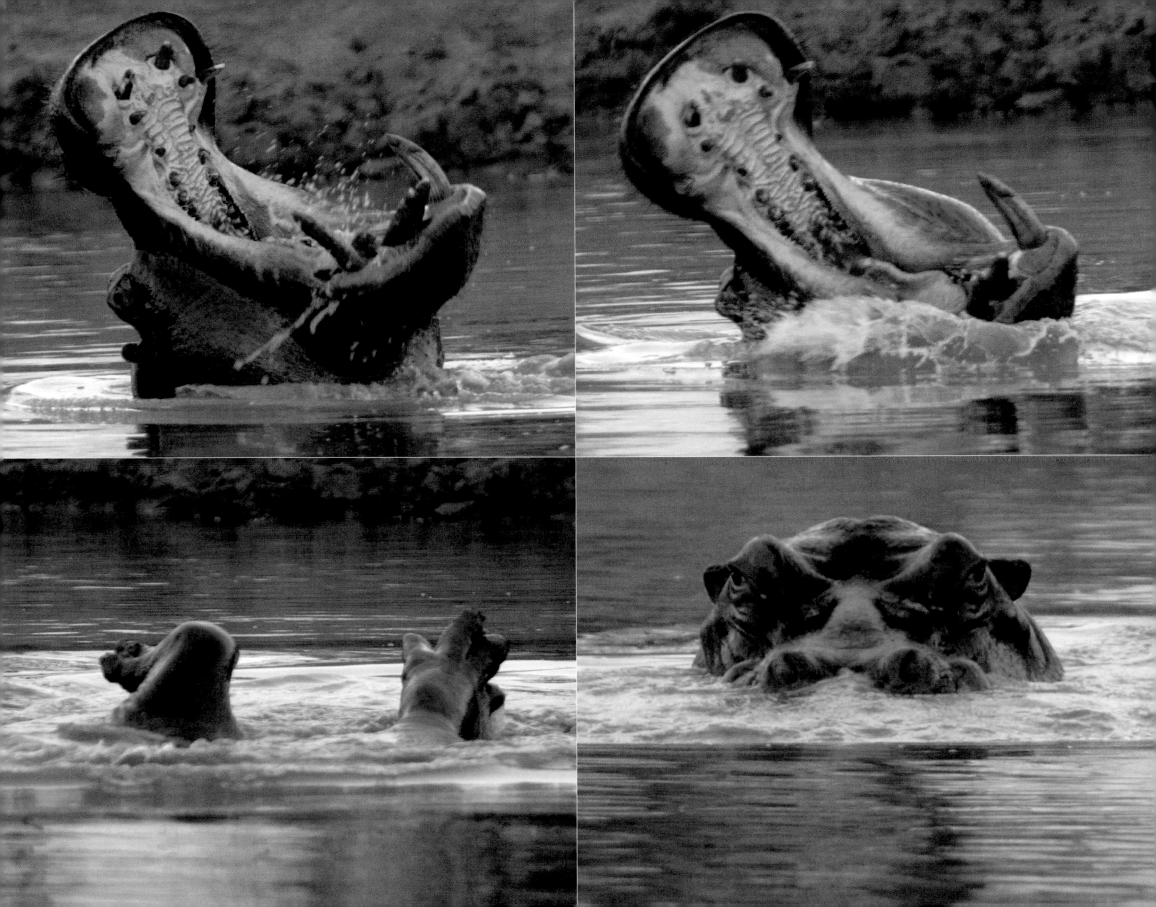

Idube

PRIVATE GAME RESERVE

Idube has been described as 'a little gem in the Sabi Sand Game Reserve'. Perhaps this is because it is family-owned, and with that comes the personal service and homely comforts that help create a special feeling of wellbeing. One lovely touch at Idube is a suspended walkway that leads to a sunken hide next to the wall of Sadulu dam, where you can watch elephants bathe or lions come down to drink.

But you do not even have to go that far to see animals. Warthog and nyala have become so habituated to lodge life that they graze on the neatly trimmed lawn, while you eat a lunch of more exotic ingredients. Eating alfresco under the knobthorn and jackalberry trees is the preferred way to enjoy meals and, with an average daily climate of between 25°C and 30°C, most days are good for feasting in the open air.

Learning what is edible in the bush is revealed during the morning nature walks. The guide is a member of the local Shangaan community and has grown up using natural, home-made remedies. He will tell you that chewing leadwood leaves is good for curing headaches, while the leaves of jackalberry and sicklebush trees are good for healing wounds. He will also advise you never to cook meat over wood from the tamboti tree as its smoke is poisonous, but you can burn elephant dung without fear, as this keeps insects away.

There is no fear of insects inside the chalets as beds are draped with mosquito nets and the doors have mosquito screens, enabling you to leave the doors open to hear the sounds of an African night. There is nothing quite like the low roar of a lion to remind you of where you are.

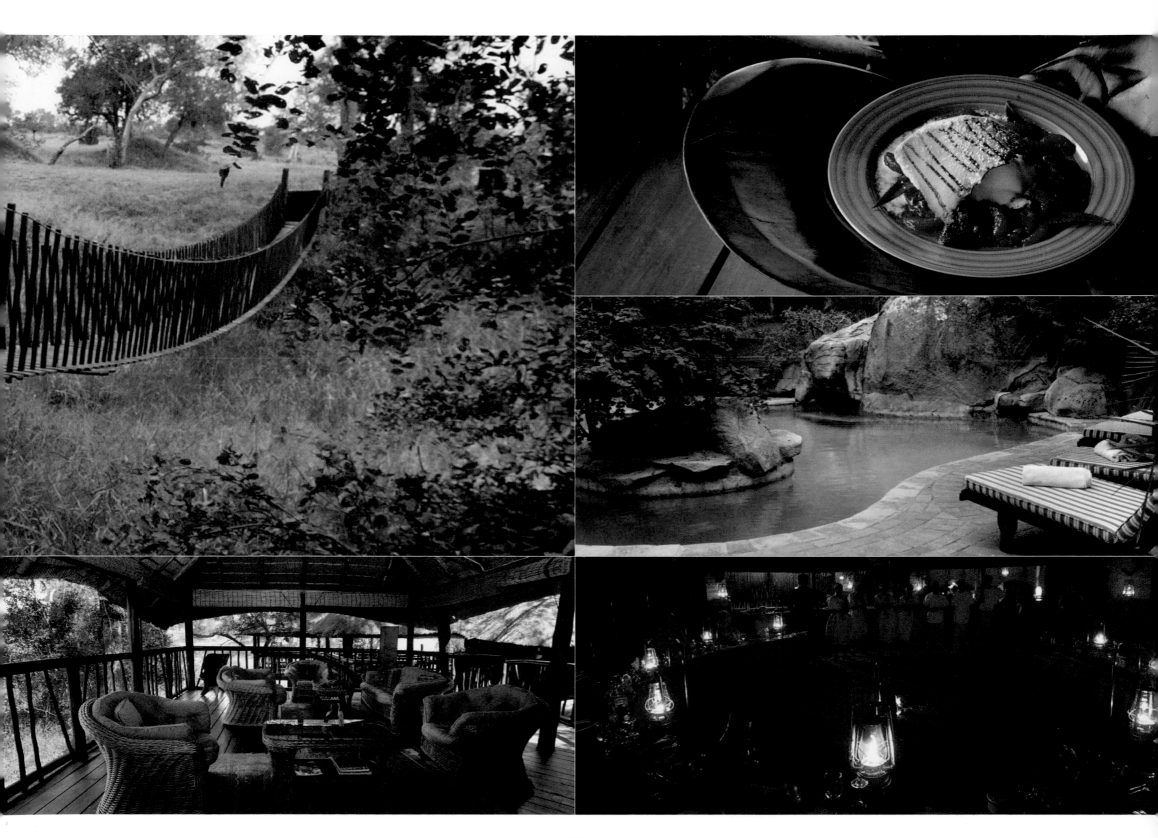

"I love to watch owls; those wizened, winged predators of the night. The owl, a symbol of ancient Athens, was featured on its silver coins (circa 440 BCE). Owls of the species shown on the coins, Athena noctua, *are still found in Greece today.*

Owls are very cute. With their large eyes, razor-sharp beaks and powerful talons, they are also quite formidable birds of prey. They are quick to respond to even the faintest rustle, turning their heads some 70 degrees in the direction of the noise. Seen through the eyes of a fieldmouse, though, owls are hardly cute."

Kirkman's Kamp

Steeped in history, this 1927 farmhouse was once home to Harry Kirkman – a ranch manager whose job it was to protect the farm owner's cattle from predators. He spent much of his time alone in the bush, with occasional sorties to neighbouring farms for supper around the open fire, swapping stories of lion attacks and the hardships of living in the wild.

Kirkman's Kamp in the southern corner of Sabi Sand Game Reserve in Mpumalanga remains true to Harry's era, with leather club chairs that are as comfortable now as when Harry might have sat in them. His old rifle is mounted on the wall and so is the skull of the only lion to have sunk its teeth into Kirkman during his long stint as a lion hunter.

In typical 1920s South African style, the homestead has a wrap-around covered veranda giving shade throughout the day as the sun crosses the sky. Across the velvety lawns are eighteen guest cottages. Afternoon tea on the lawn is in best colonial tradition, with a tiered cake stand displaying brandy snaps, petit fours and scones with jam and cream, all washed down with fragrant Earl Grey tea or iced coffee. Pre-dinner drinks and dinner are taken at the main house.

Beyond the verdant lawns lies real African bush and no amount of colonialism can keep it at bay. Long gone are the rifles and the cattle ranches; now a safari in Sabi Sand Game Reserve is all about shooting the images of Africa's big game to mount as trophies in photo frames.

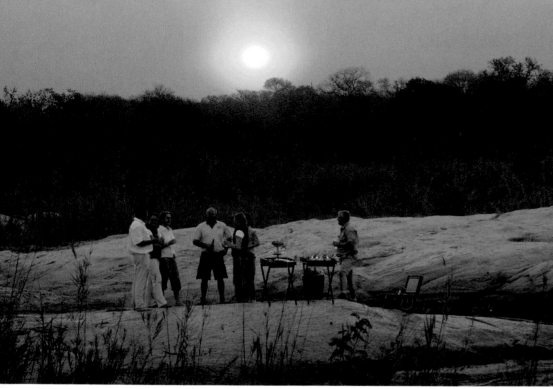
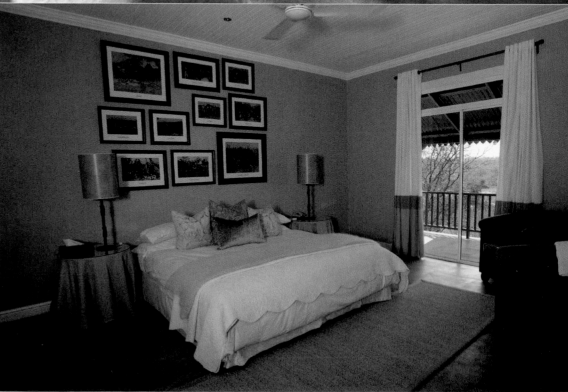

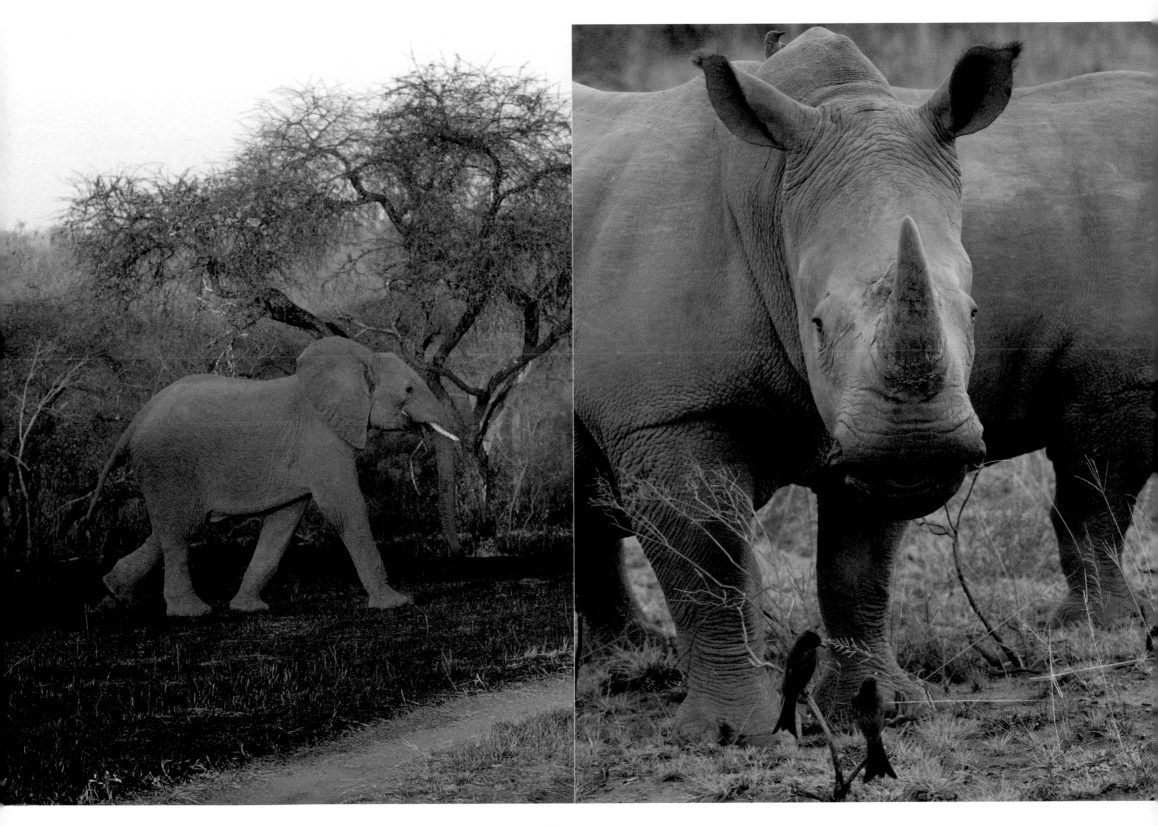

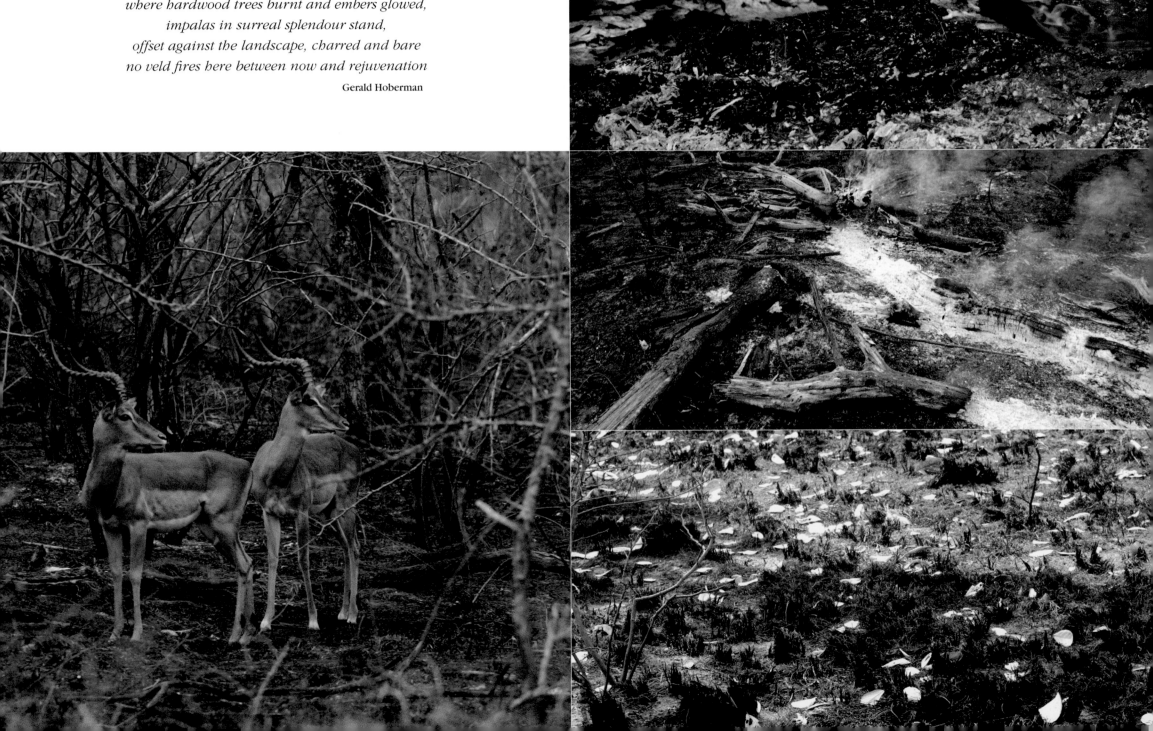

VELD FIREBREAK

Scorched earth,
boulders smolder,
pungent ash,
delicate arboreal tracery, ghostly grey,
where hardwood trees burnt and embers glowed,
impalas in surreal splendour stand,
offset against the landscape, charred and bare
no veld fires here between now and rejuvenation

Gerald Hoberman

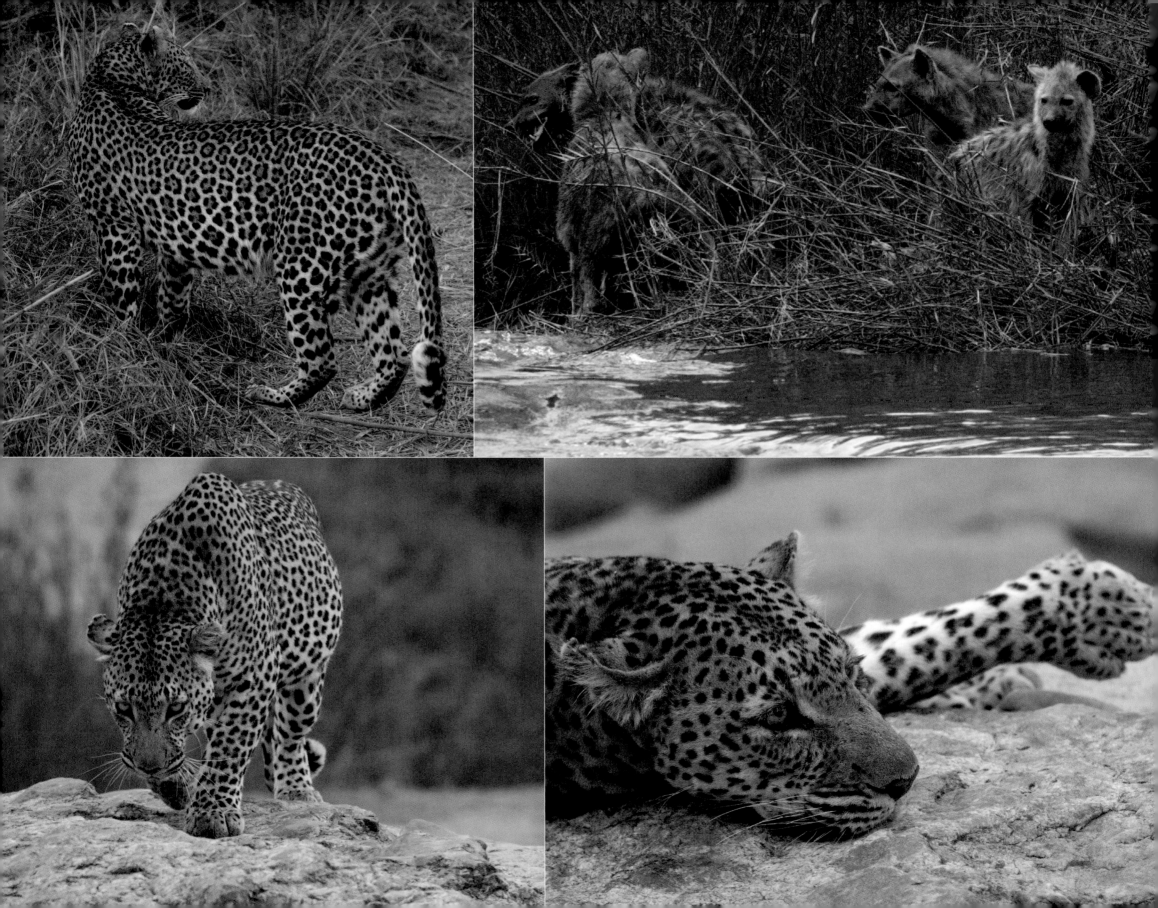

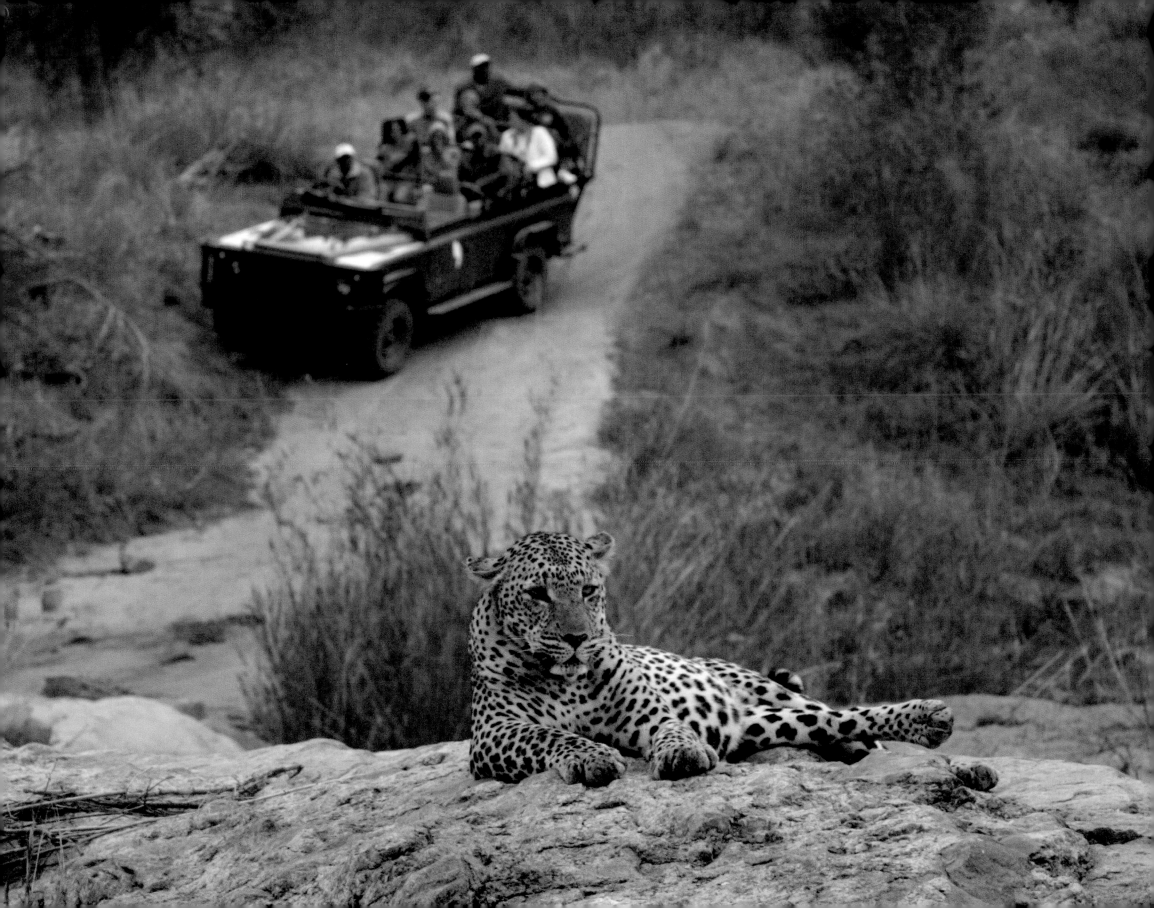

Leopard Hills
PRIVATE GAME RESERVE

Elevated on a hill above a natural waterhole, close to the perennial Sand River, Leopard Hills has an enviable position in the Sabi Sand Game Reserve in the province of Mpumalanga. There is nothing but wilderness in each direction, inhabited, of course, by the big game animals that make this ecosystem adjacent to the Kruger National Park so famous.

Named after the shy, exquisite predator that everyone wants to glimpse at least once in the wild, Leopard Hills keeps a log that speaks of almost daily leopard sightings. Add to this the presence of lion, buffalo, elephant and rhino in the reserve, and you are almost guaranteed to encounter the Big Five during your stay.

Well satisfied by the game-watching aspect of Leopard Hills, you can now turn your attention to other luxuries, of which food is most definitely a top priority. At Leopard Hills four-course dinners are the norm. Vegetarian dishes stand their ground as a serious option, but meat, like tender beef fillet or loin of springbok, is at the heart of the fine South African cuisine served at this lodge.

The opulent decor, too, has Africa at its heart and features Zanzibari carved doors, river stones embedded in the floors and high, thatched ceilings. However appealing the interiors, it is the views across the game reserve and beyond that beckon. These can be enjoyed from one of eight luxurious glass-fronted suites, each with its own sundeck and heated rock plunge pool.

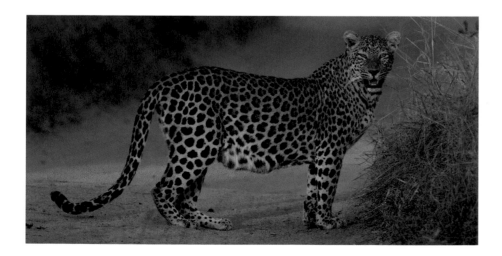

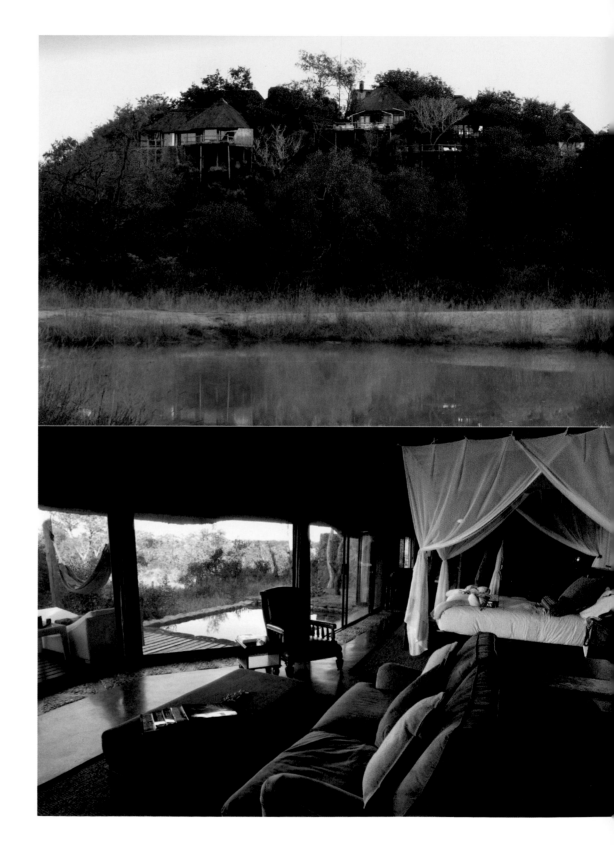

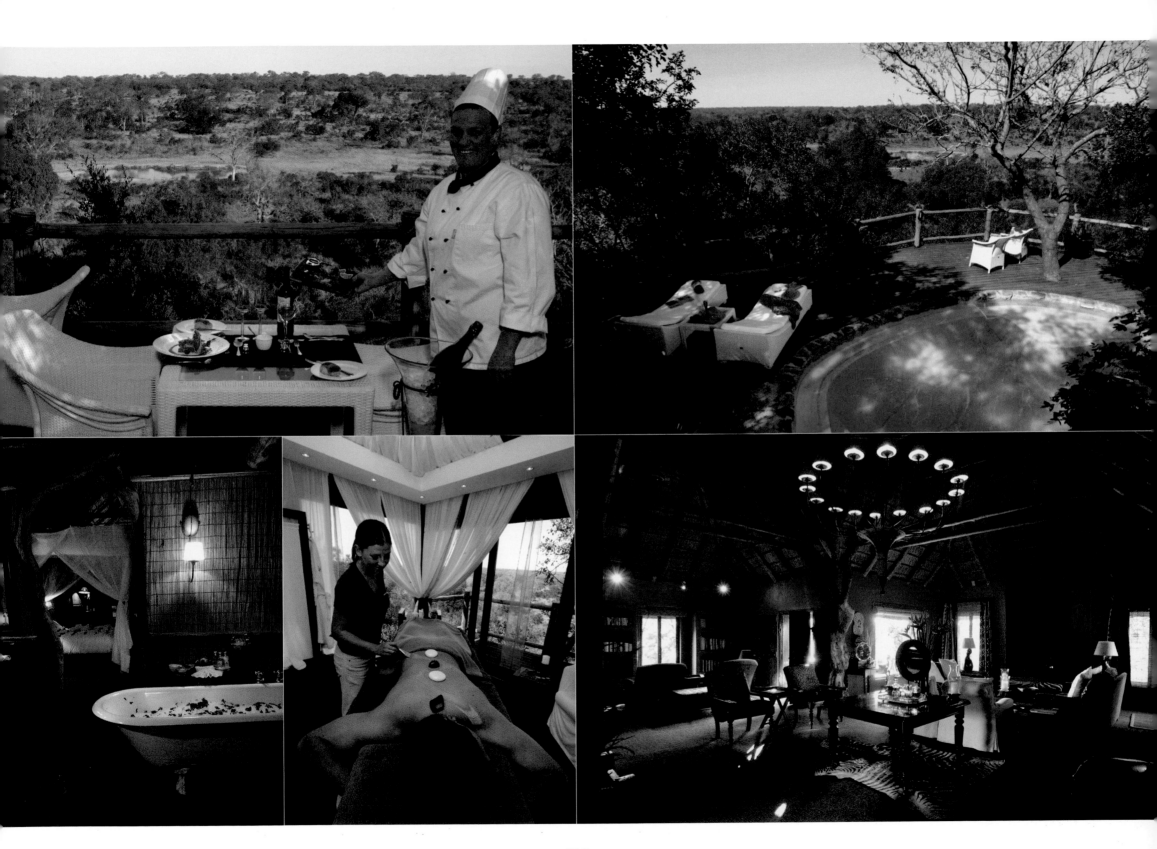

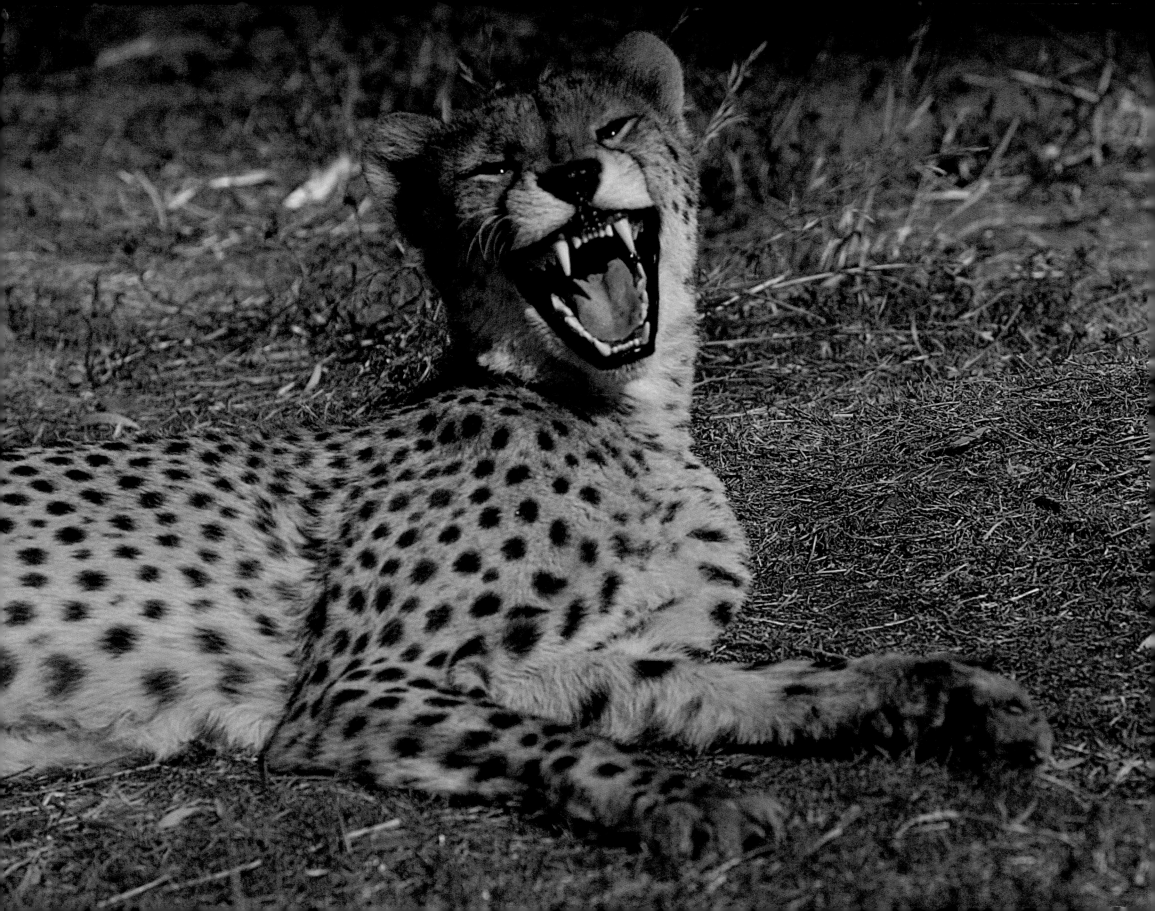

Londolozi

GAME RESERVE

The words 'Londolozi' and 'leopards' are said in the same breath, as there is a high expectation that when you visit Londolozi in Mpumalanga you will see leopards. Over the past three decades, a special relationship has developed between wild leopards and the rangers and trackers of Londolozi in the Sabi Sand Game Reserve. Documentaries, films and books celebrating this relationship have made Londolozi world famous.

For over eighty years, the Varty family has been associated with Londolozi, even if family members were not always personally running it. But now the family is back, welcoming visitors through the front door. Dave Varty says, 'Guests get a much better experience if the owners are at the front door.' This philosophy transfers to the whole guest experience at all of the five Londolozi camps: Tree Camp, featuring lanterns, leadwoods and fine linens; Pioneer Camp, hidden deep in a 500-year-old riverine ebony forest; Varty Camp, a return to the original family bushveld experience; Private Granite Suites, a private river affair pinned to granite bedrock over the Sand River; and Founders Camp, situated along the banks of the Sand River.

Each camp has its own personality, like each member of the Varty family, but one common goal is the intention to redefine the essence of safari; to find the right balance between simplicity, elegance, style and service, without compromising the core reason the Vartys and their guests are there – to celebrate African wildlife. But even deeper than that, the Vartys see their role as guardians of the future for the wild animals and local communities.

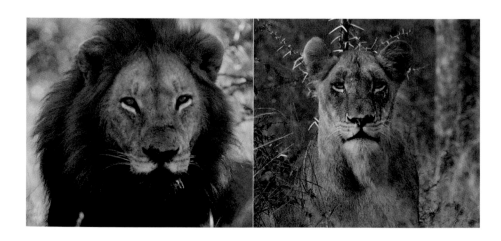

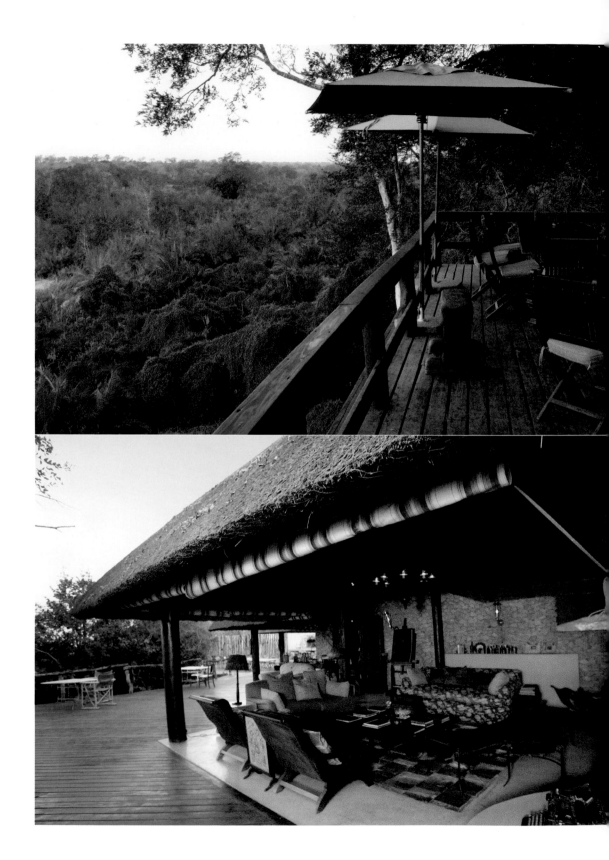

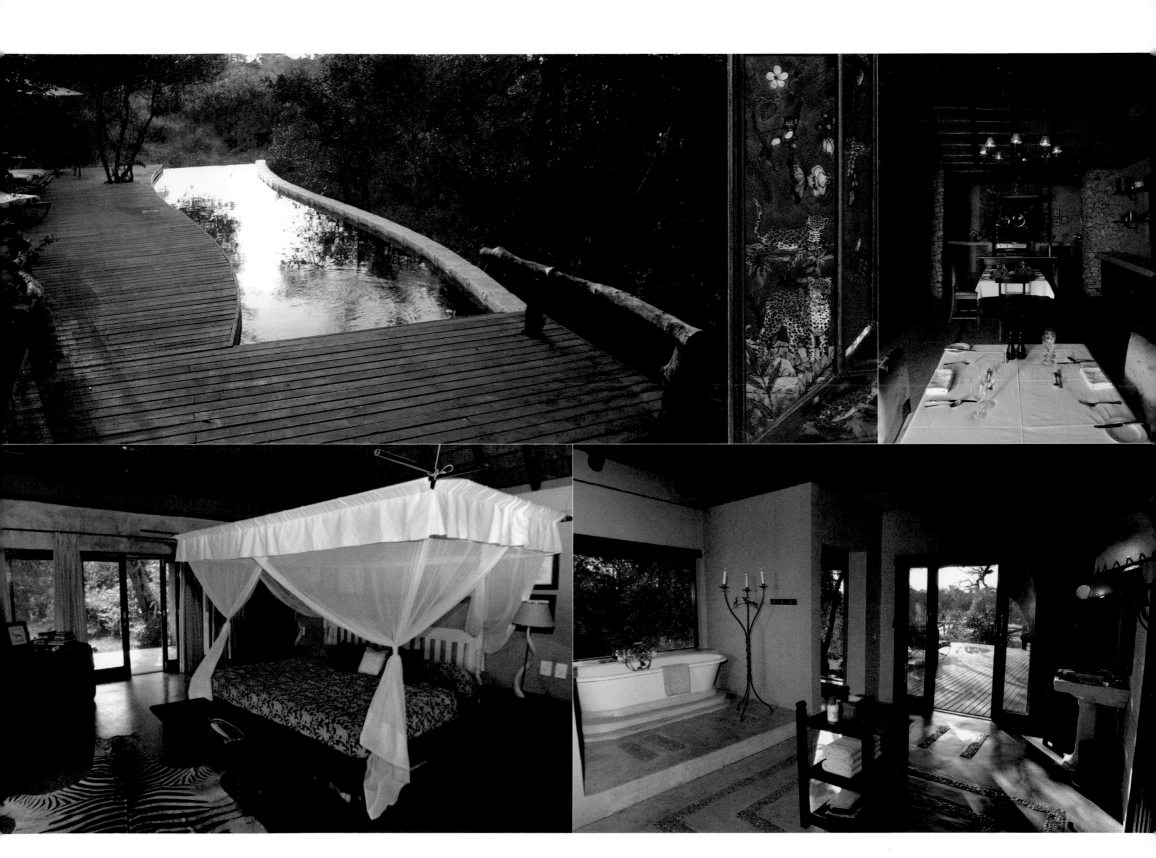

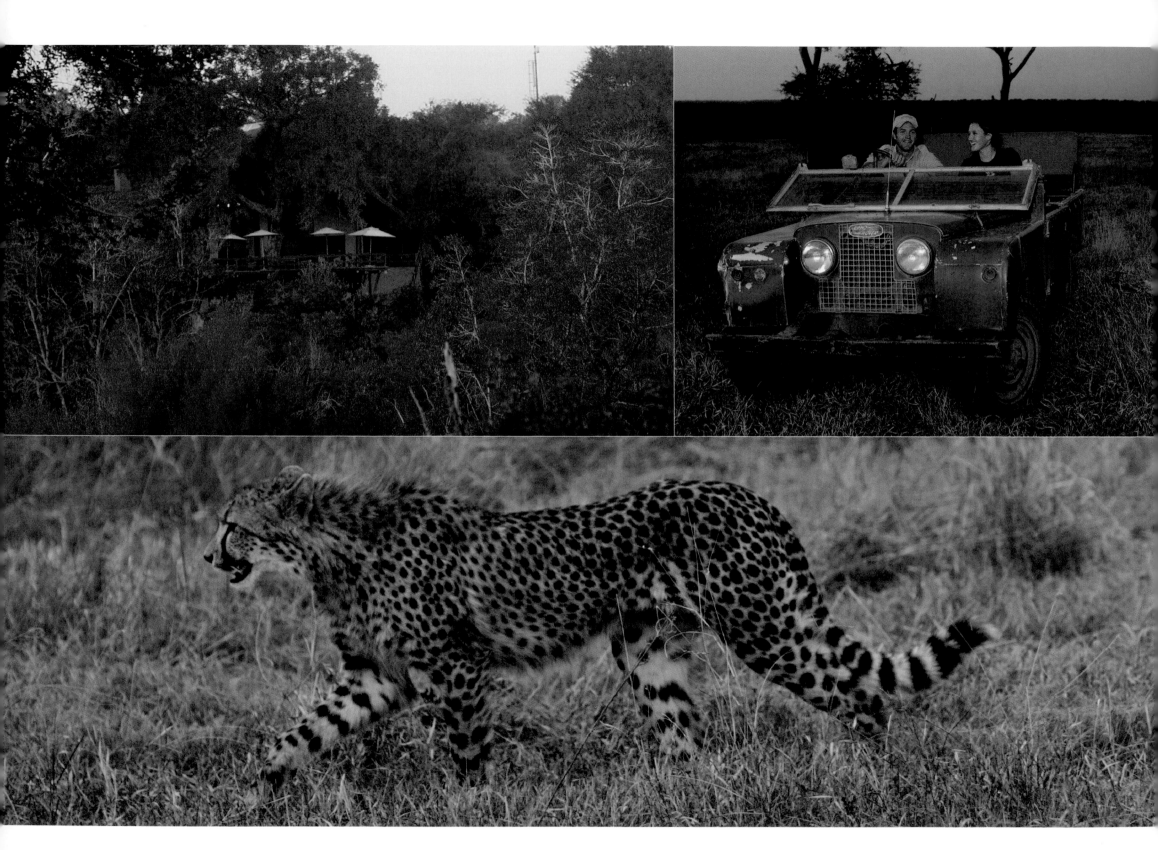

"The feline grace of the cheetah was never in my experience so magnificently displayed as on this occasion. Several cats had assembled on the apex of a mound before going off on a hunt. Their sleek, slender, black-spotted bodies and the distinctive black 'teardrop' markings on their faces were a sight to behold. When they moved off in formation, it was like poetry in motion. Their long, lithe limbs make them the fastest animal on earth over a short distance, and their long tails act as a rudder and brake when bringing down their fleeing quarry.

We drove along the track, following the cheetahs as they walked through the grass and onto the open savanna plain, which is suited to the cheetah's chase. One of the cheetahs yawned, baring its teeth and tongue in its cavernous mouth. It stretched its long, spotted body rearwards, as if to show it was enjoying the sunshine.

The ranger drove off the track and through the bush. We then got back on the path, ahead of the cheetahs. I was able to position my camera at a low angle to capture the action at close quarters as the cheetahs advanced expeditiously towards us. It was an awesome sight! They appeared to be unconcerned by our presence."

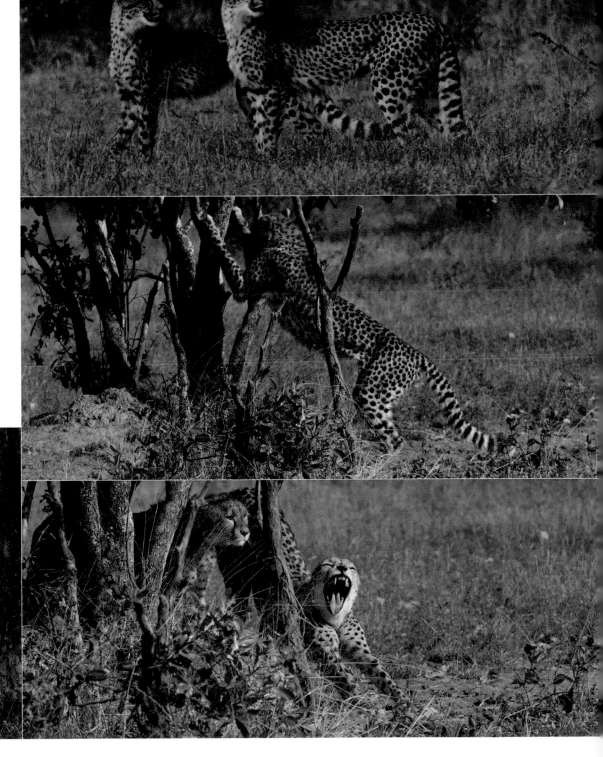

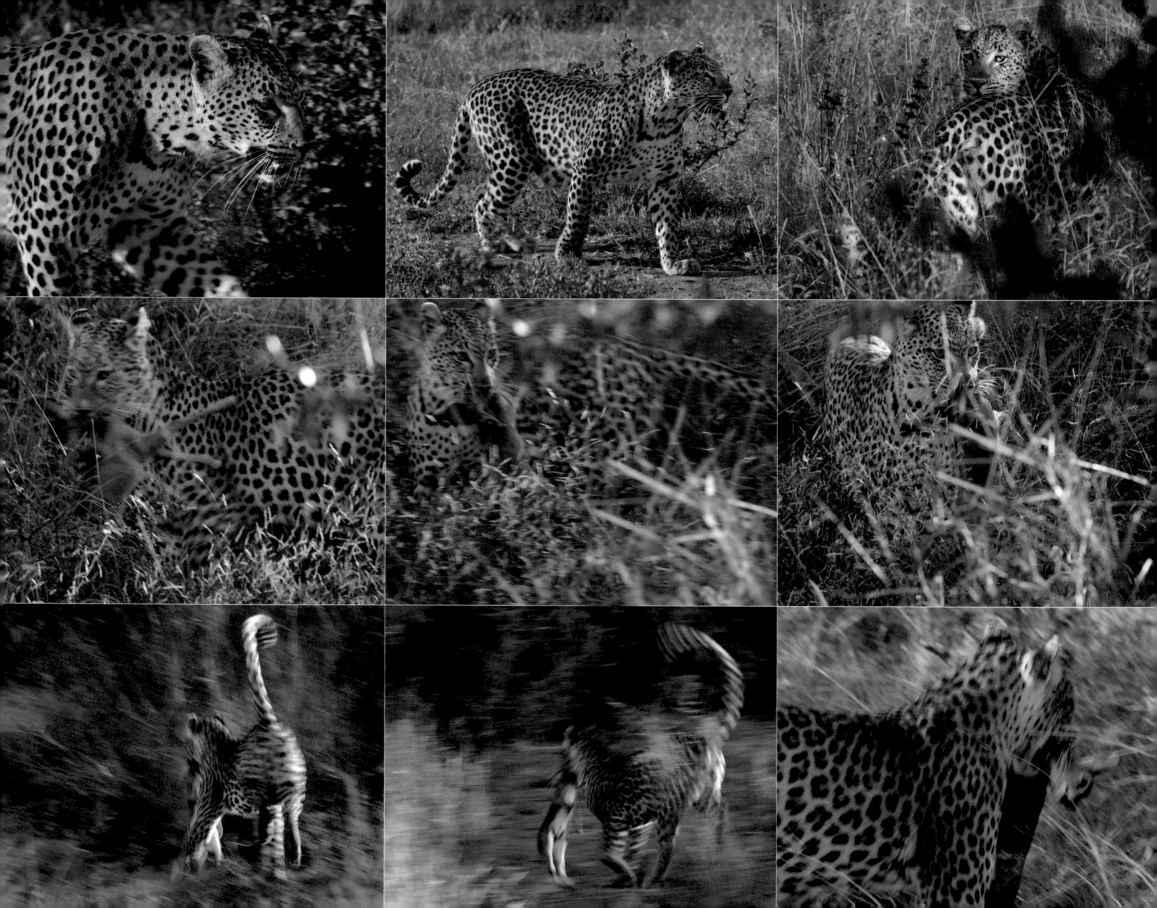

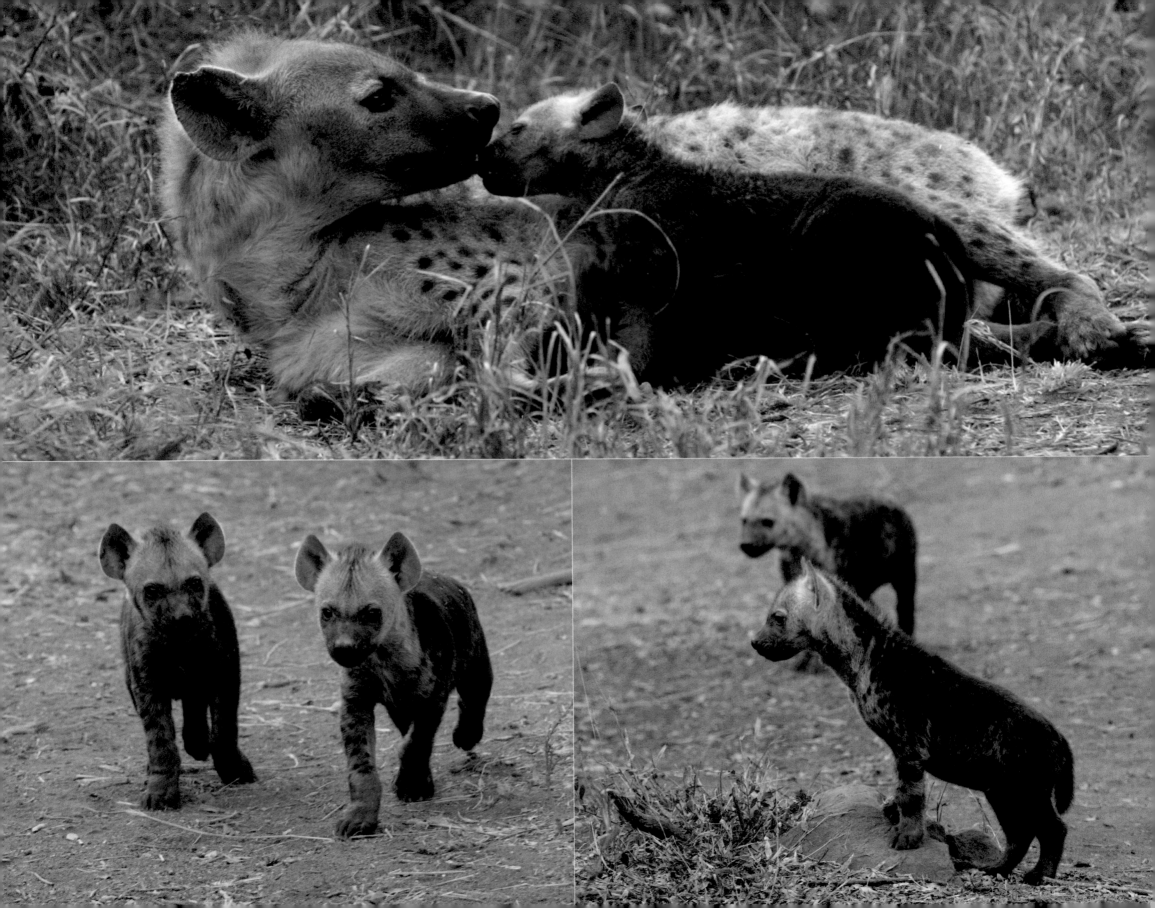

Nkorho

BUSH LODGE

When the *djembe* drum sounds at Nkorho Bush Lodge, you know it is dinner time. The rhythm of Africa vibrates in your very soul and places you firmly here in the bush of the Sabi Sand Game Reserve in north-eastern South Africa.

Arrive a stranger and leave as a friend is Nkorho's motto, and to that end you are allocated a ranger to look after you during your stay. It is he or she who makes sure your favourite beverage is on the vehicle, ready for when you stop for sundowner drinks on the late-afternoon game drive. It is your ranger who says it is safe to get out of the vehicle to stretch your legs and tuck into snacks while watching the sun go down. Your ranger becomes your best friend and protector, the person who carries the rifle on the morning game walk to ensure your safety. Less obvious than the ranger but equally important is the tracker. This is the person who sniffs the air, listens to the telltale noises of the bush and reads the spoor to locate the animals you so desire to see.

A good day of game viewing can build quite an appetite and there is nothing better than to arrive home to Nkorho's famous 'bush cuisine'. The bush element comes from both the fare on offer, such as tender fillet of venison, and the dining ambience created by an open fire around which yarns are spun and adventure stories swopped. All this, while knowing that wild animals are just a heartbeat away.

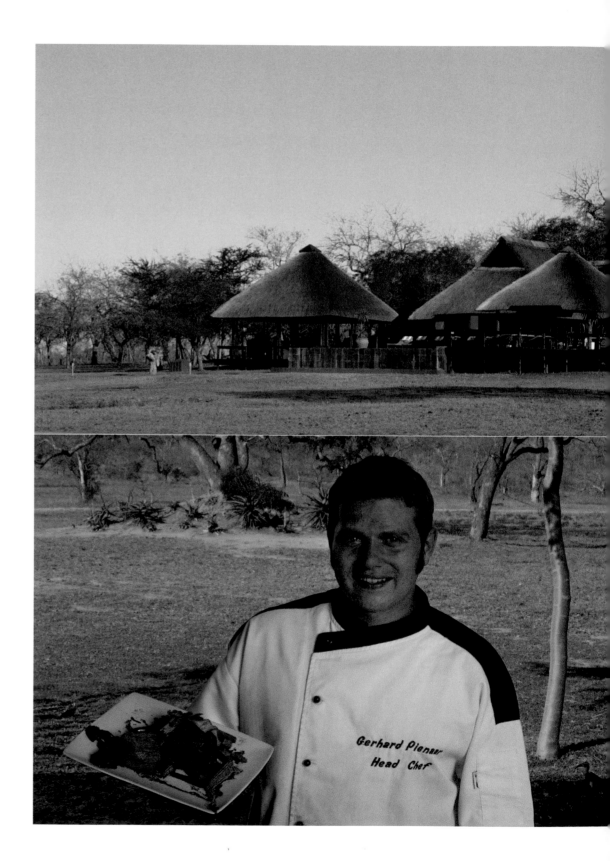

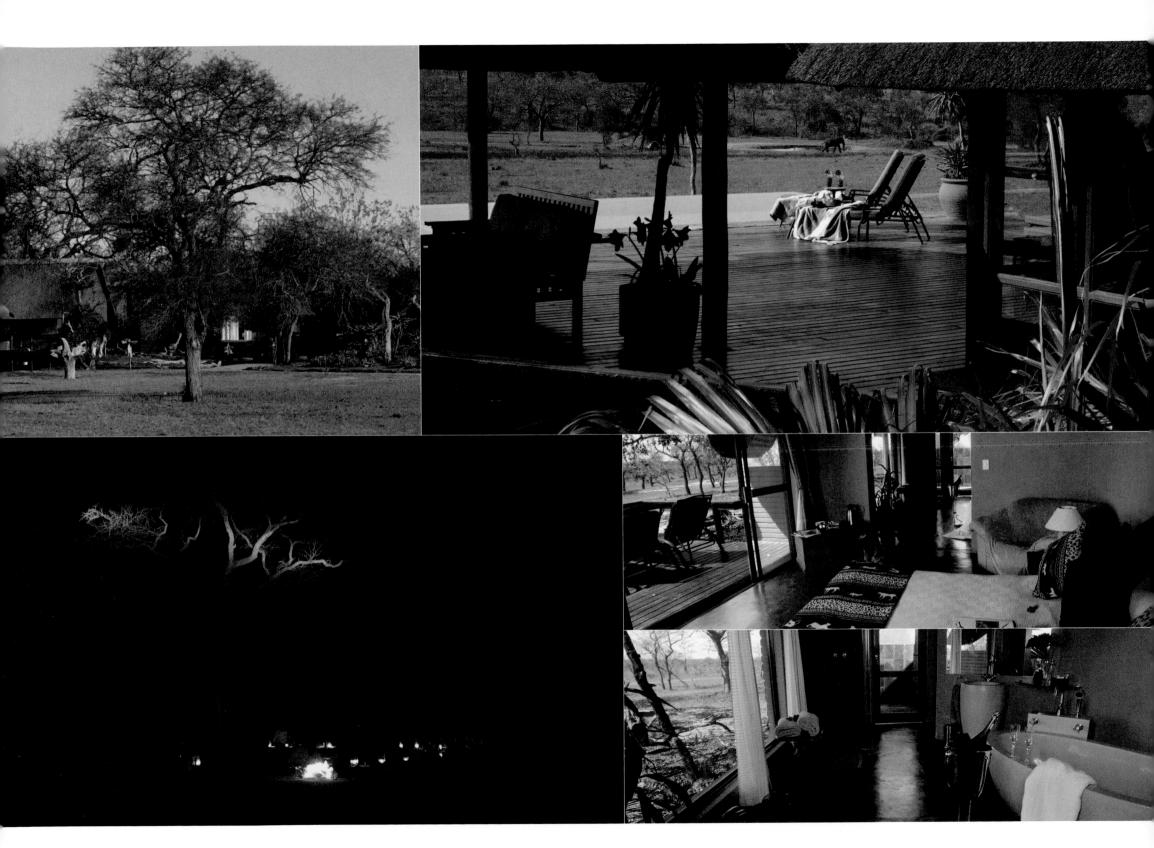

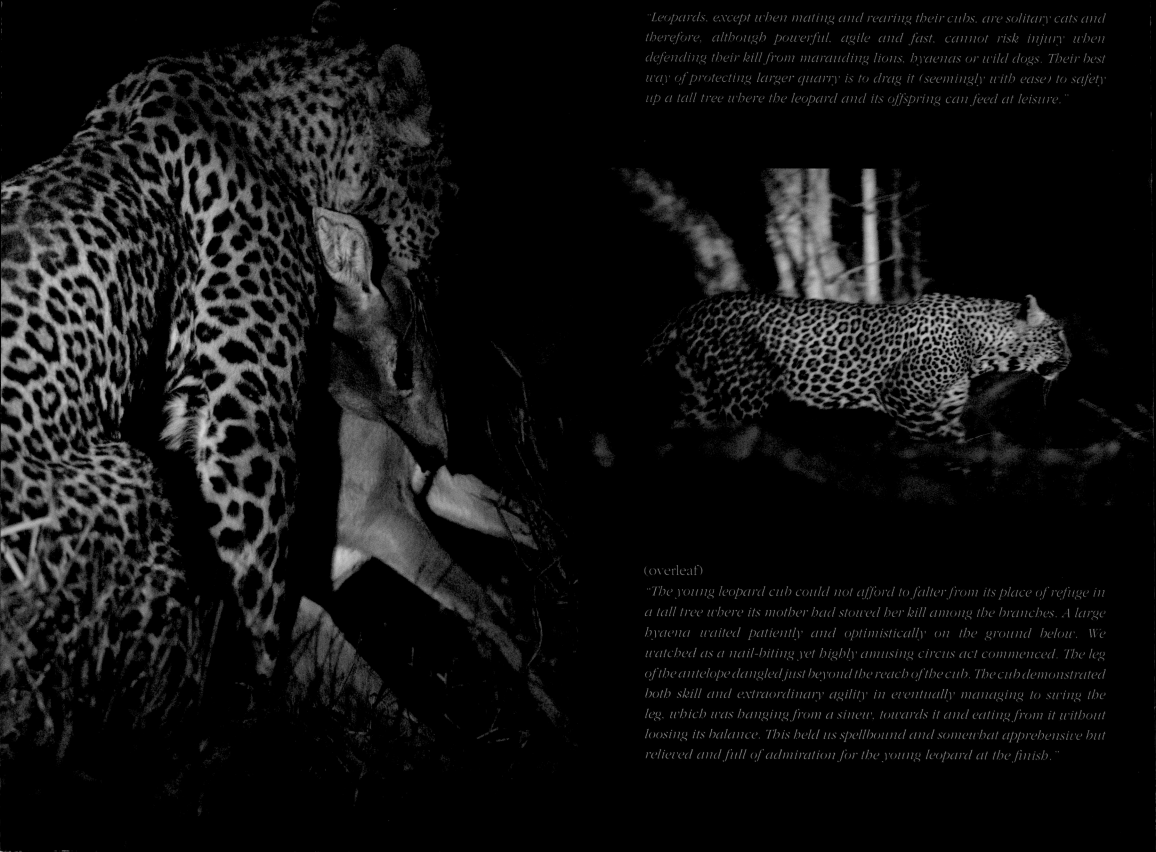

"Leopards, except when mating and rearing their cubs, are solitary cats and therefore, although powerful, agile and fast, cannot risk injury when defending their kill from marauding lions, hyaenas or wild dogs. Their best way of protecting larger quarry is to drag it (seemingly with ease) to safety up a tall tree where the leopard and its offspring can feed at leisure."

(overleaf)

"The young leopard cub could not afford to falter from its place of refuge in a tall tree where its mother had stowed her kill among the branches. A large hyaena waited patiently and optimistically on the ground below. We watched as a nail-biting yet highly amusing circus act commenced. The leg of the antelope dangled just beyond the reach of the cub. The cub demonstrated both skill and extraordinary agility in eventually managing to swing the leg, which was hanging from a sinew, towards it and eating from it without loosing its balance. This held us spellbound and somewhat apprehensive but relieved and full of admiration for the young leopard at the finish."

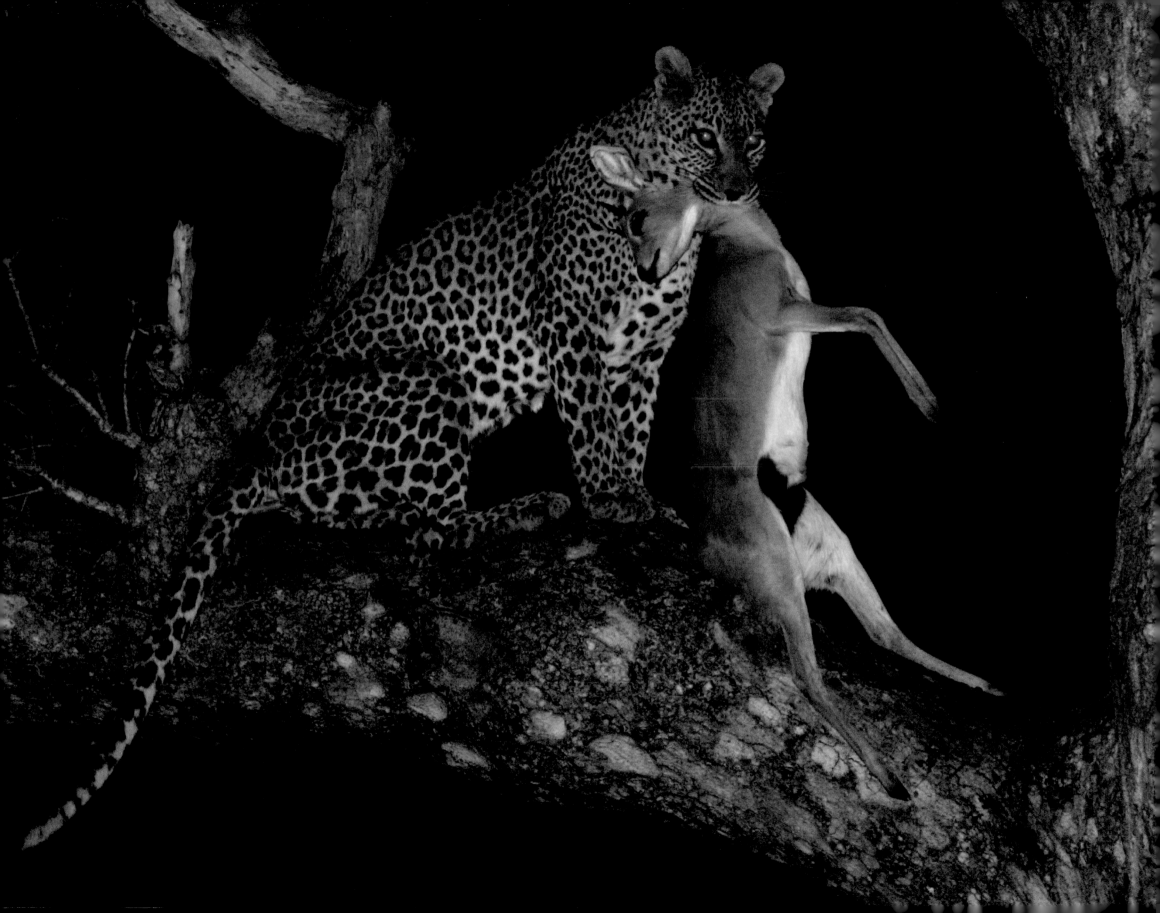

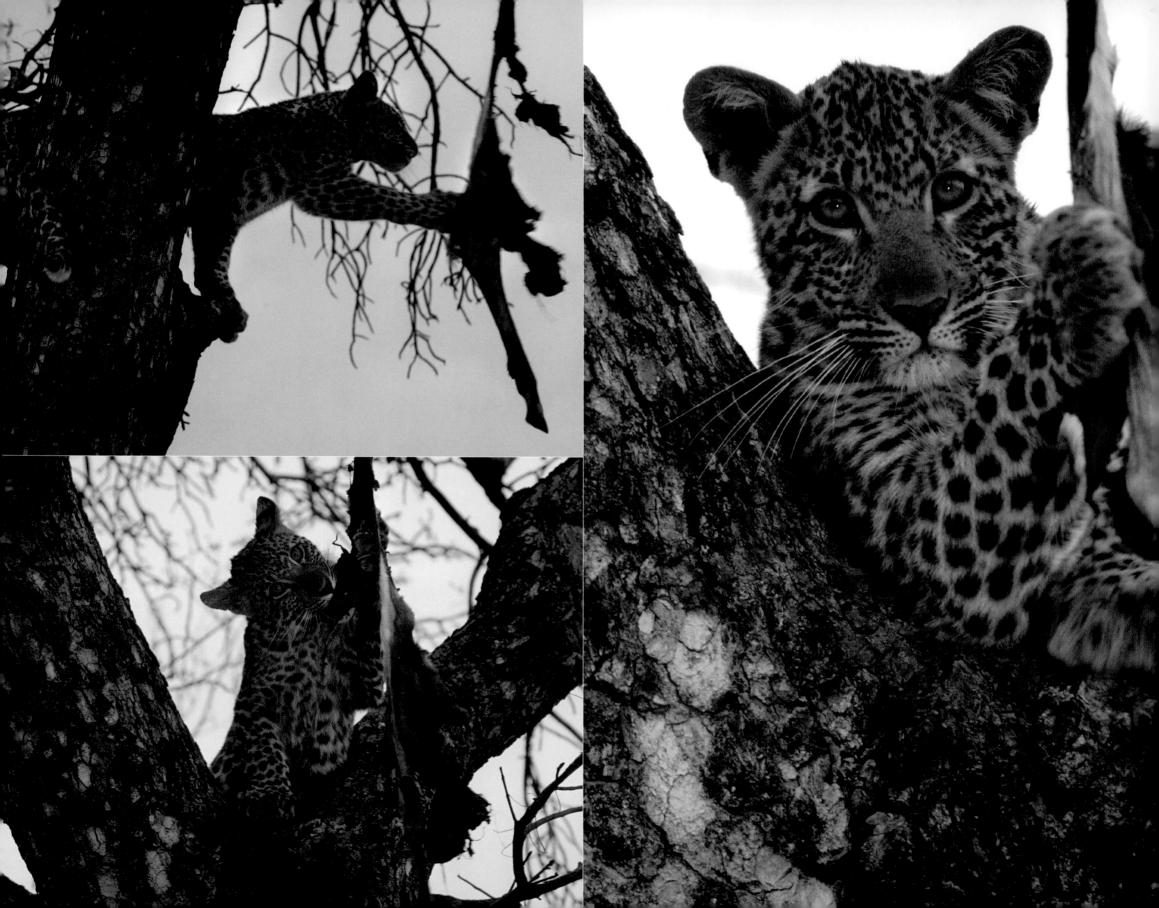

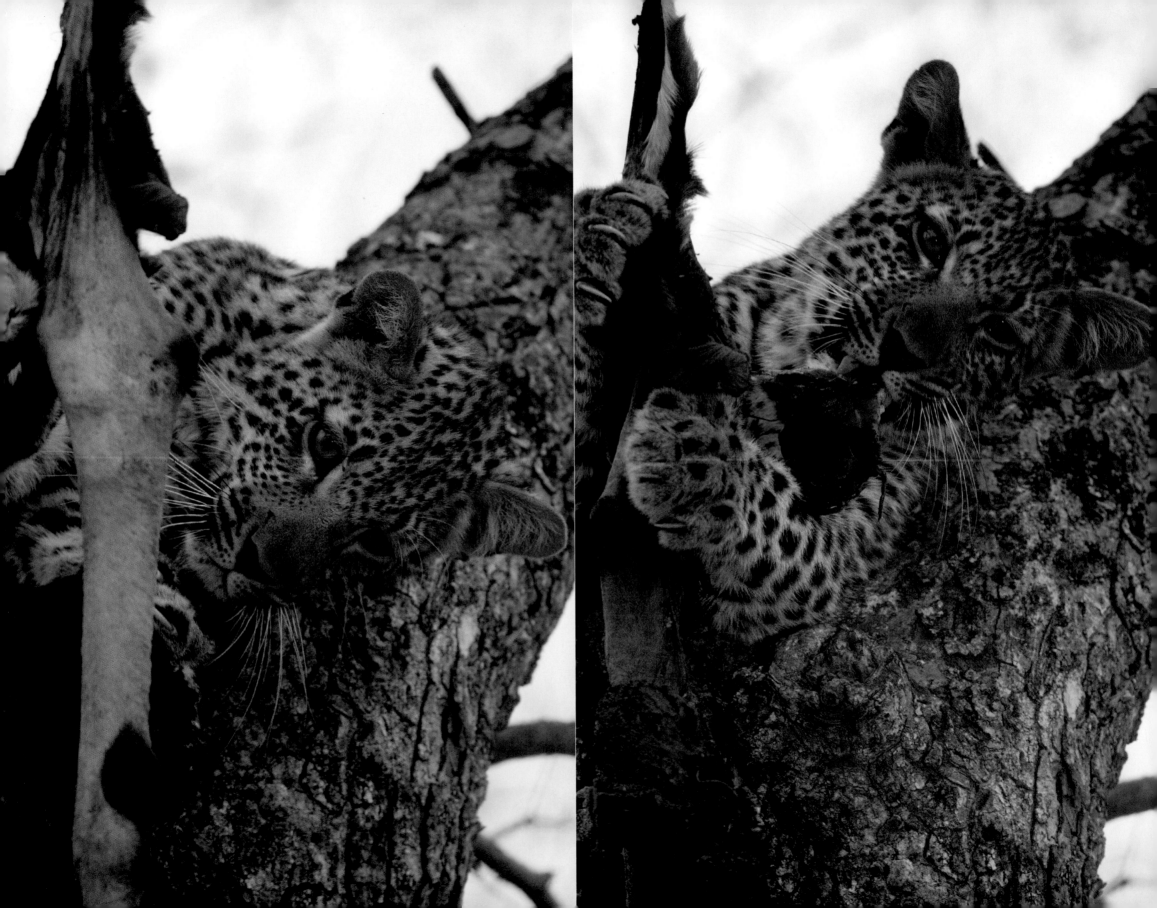

Notten's

BUSH CAMP

A cool, relaxed atmosphere prevails at Notten's Bush Camp in the renowned Sabi Sand Game Reserve in Mpumalanga. The 65 000-hectare reserve is one of the most well-known reserves in South Africa.

This exclusive safari lodge is owned and run by the Notten family. It all began in 1963, when the family bought a portion of the Sabi Sand Game Reserve to use as a tranquil retreat for family members and friends. It was not until 1986 that paying guests were invited to share their hideaway.

Now in the hands of third-generation Nottens, Notten's Bush Camp is the epitome of luxury and elegance. African textures are used throughout the lodge to striking effect. Wood and wicker, clay and cotton, reed and stone are stylishly integrated in each private suite. Each open-plan bedroom has its own private game-viewing deck from where you can look out over the endless African horizon and watch the antics of wild animals and birds.

The purposeful absence of electricity contributes to an ambience of peace and tranquillity. Candles and lanterns create a magical mood, which is exactly the impression the Notten family would like you to take away with you.

Only a few people at a time get to enjoy the boundless hospitality offered at Notten's, which is why those who truly value exclusivity return time and again to this part of Africa.

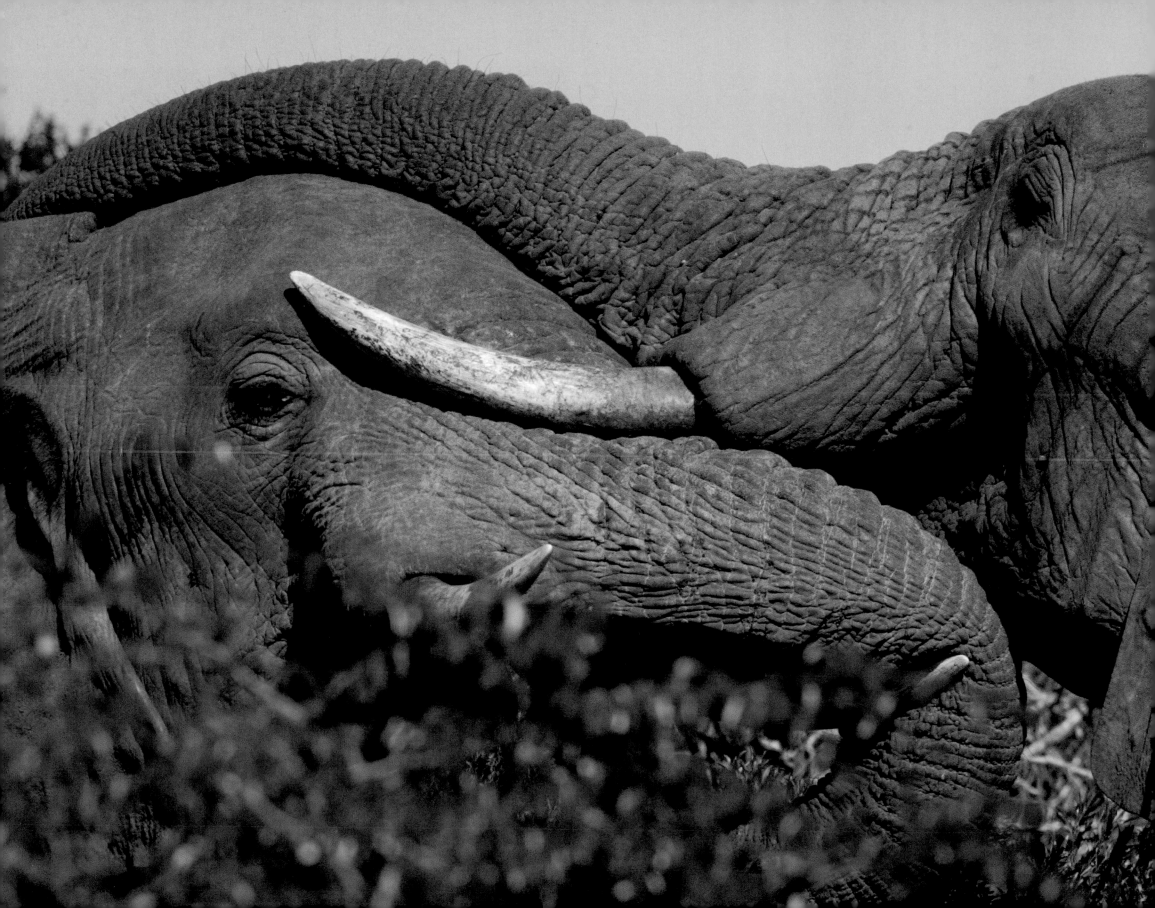

Savanna

PRIVATE GAME RESERVE

Savanna Private Game Reserve has an enviable corner of land in the western part of the Sabi Sand Game Reserve in Mpumalanga. Since there are no boundaries between the reserve and the Kruger National Park next door, animals have a vast expanse of wilderness in which to roam.

A waterhole just beyond Savanna Lodge attracts lots of game, and with no fences around the suites, it is not uncommon for guests to find an elephant wandering past their rooms.

The Sabi Sand Game Reserve is known as the 'Land of the Leopard' and a visit here without sighting a leopard is an unlikely occurrence. Savanna's rangers and trackers make sure of that and are pretty confident that most guests will go home with photographs of the reserve's resident female leopards, Mkwela and Shangwa, as well as images of its lion population. Game drives are thus a highlight in this part of the lowveld, and with a maximum of only six guests per vehicle, the service is intimate and personal.

Guests often congregate in the main entertainment area and boma or at the swimming pool – except those people in the two thatched Savanna Suites and three of the seven tented suites, who have their own private bijou splash pool. In the tented suites, Savanna has cleverly mixed two safari styles to create a unique architectural genre, defined by solid walls, glass doors that open up the entire front of the suite and a ceiling covered with drapes under a canvas roof. Neither solid lodge nor canvas tent, the suites represent an atmospheric combination of the best in safari accommodation.

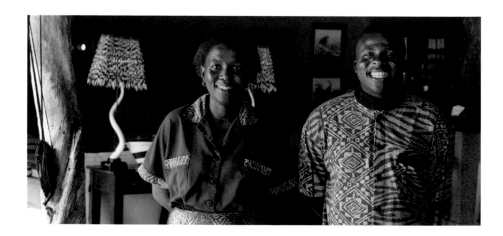

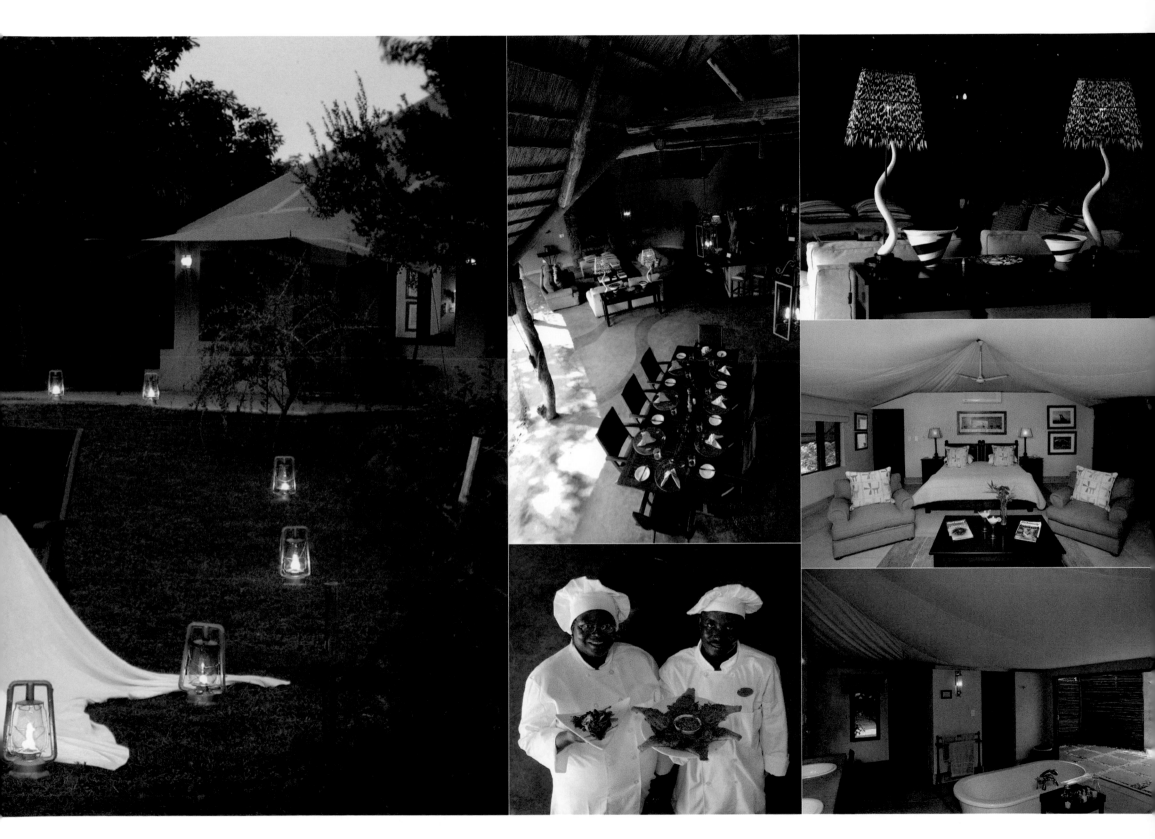

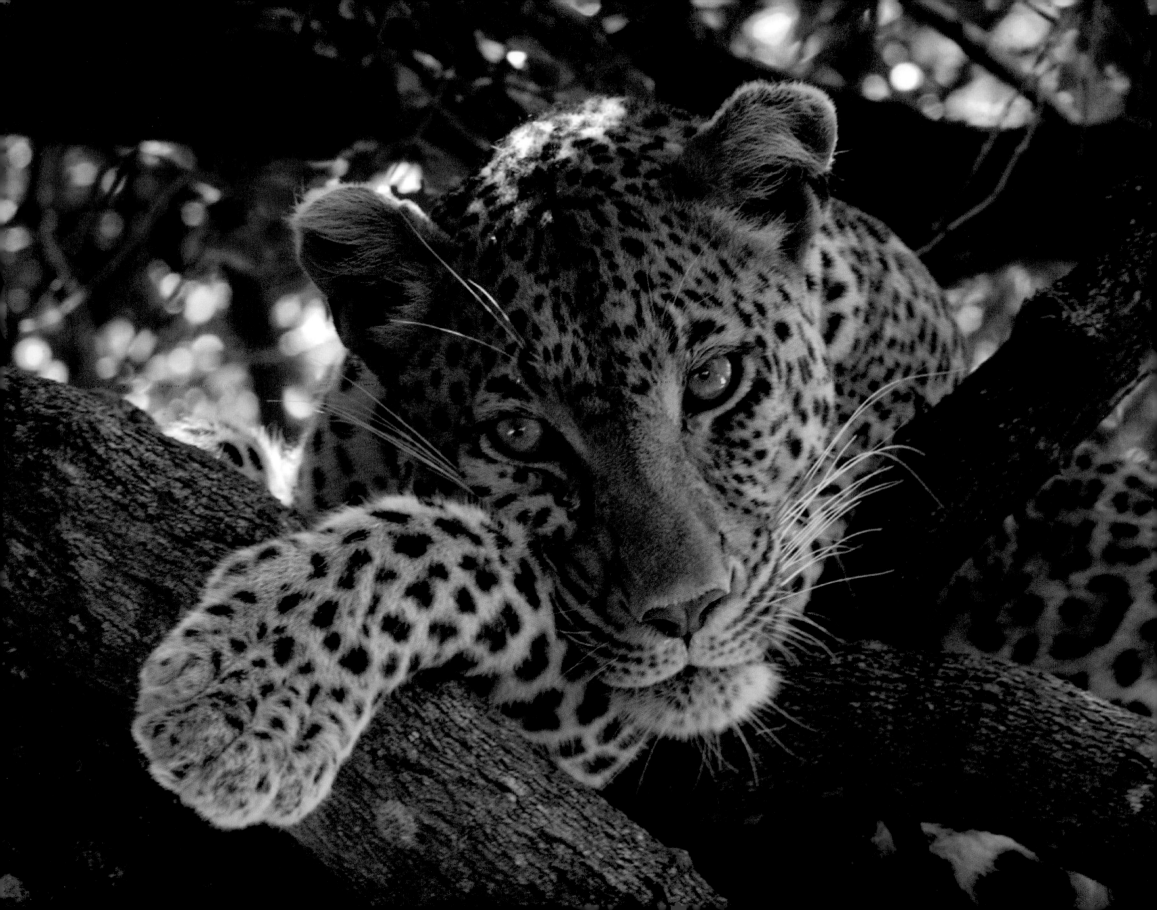

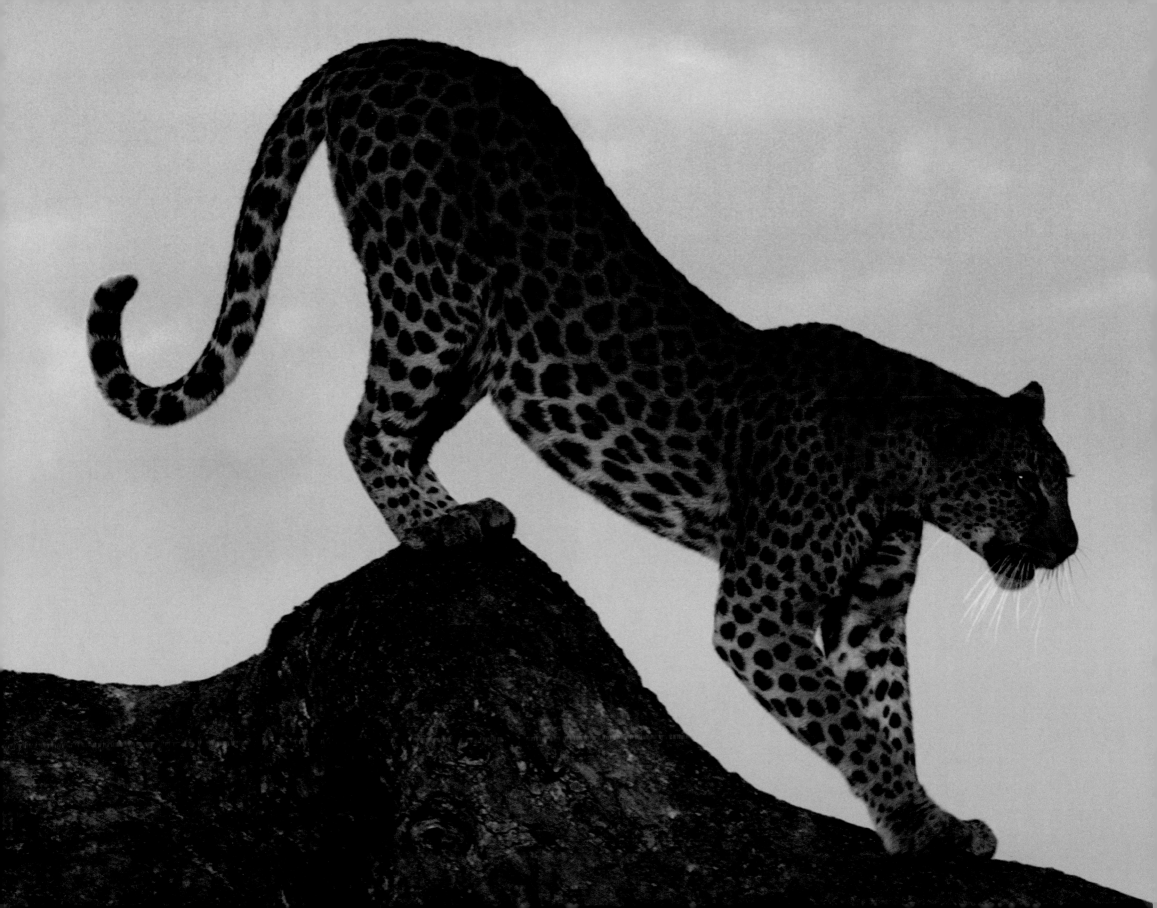

Simbambili

GAME LODGE

A warm personal touch, high levels of comfort and world-class cuisine are memorable aspects of a stay at Simbambili Game Lodge in Mpumalanga. The superb game viewing almost goes without saying, since Simbambili is located in the Sabi Sand Game Reserve in the north-western corner of the Kruger National Park, an area abundant with game. But what makes a Simbambili safari stand out is the informative and entertaining way in which its rangers impart their knowledge.

Simbambili's rangers do not just rattle off facts. They embellish information with the unexpected, such as the fact that a giraffe has the same number of neck vertebrae (seven) as a human and that this is also the same number of neck vertebrae as a mouse and a whale. If the guides manage to inform and enthuse, then they have done their job well. At Simbambili, they enlighten and amuse – making them the 'giraffe' among game rangers, standing head and shoulders above the rest.

There can surely be no greater compliment for a chef than to have his dinner guests ask for his recipes. This happens regularly at Simbambili, but such is the chef's ability to diversify that he sometimes cannot name the exact ingredients or measurements used in a particular recipe. On a whim he may add a new spice or other ingredient to a long-time favourite and so a new dish is born. Perhaps that is how he came about his sweet potato dish laced with honey, brown sugar, sweet chilli and cinnamon.

Three more special Simbambili touches deserve a mention, all of which have to do with making private time at this lodge that bit more unforgettable: a candlelit foam bath, a splash pool set into the outdoor deck of your suite, and a double daybed in your own shaded relaxation area from where you can experience the magical sounds and colours of the African bush.

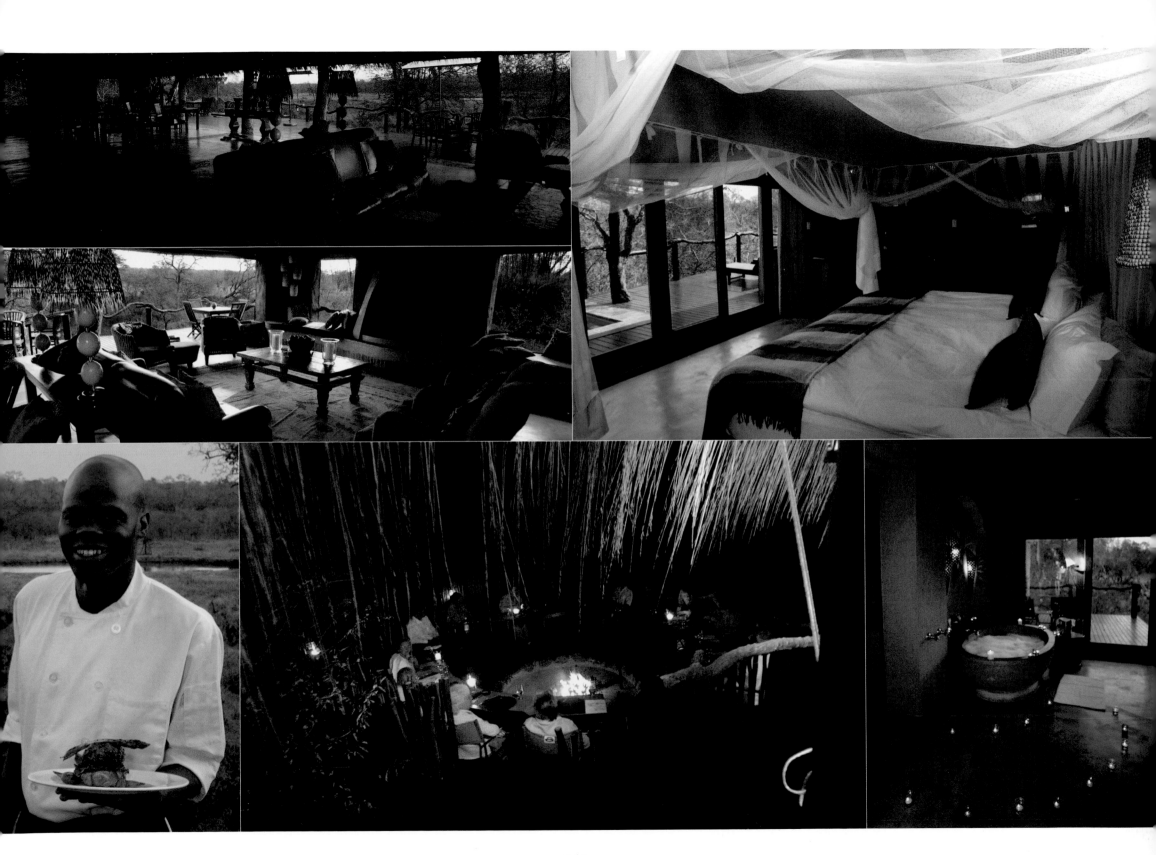

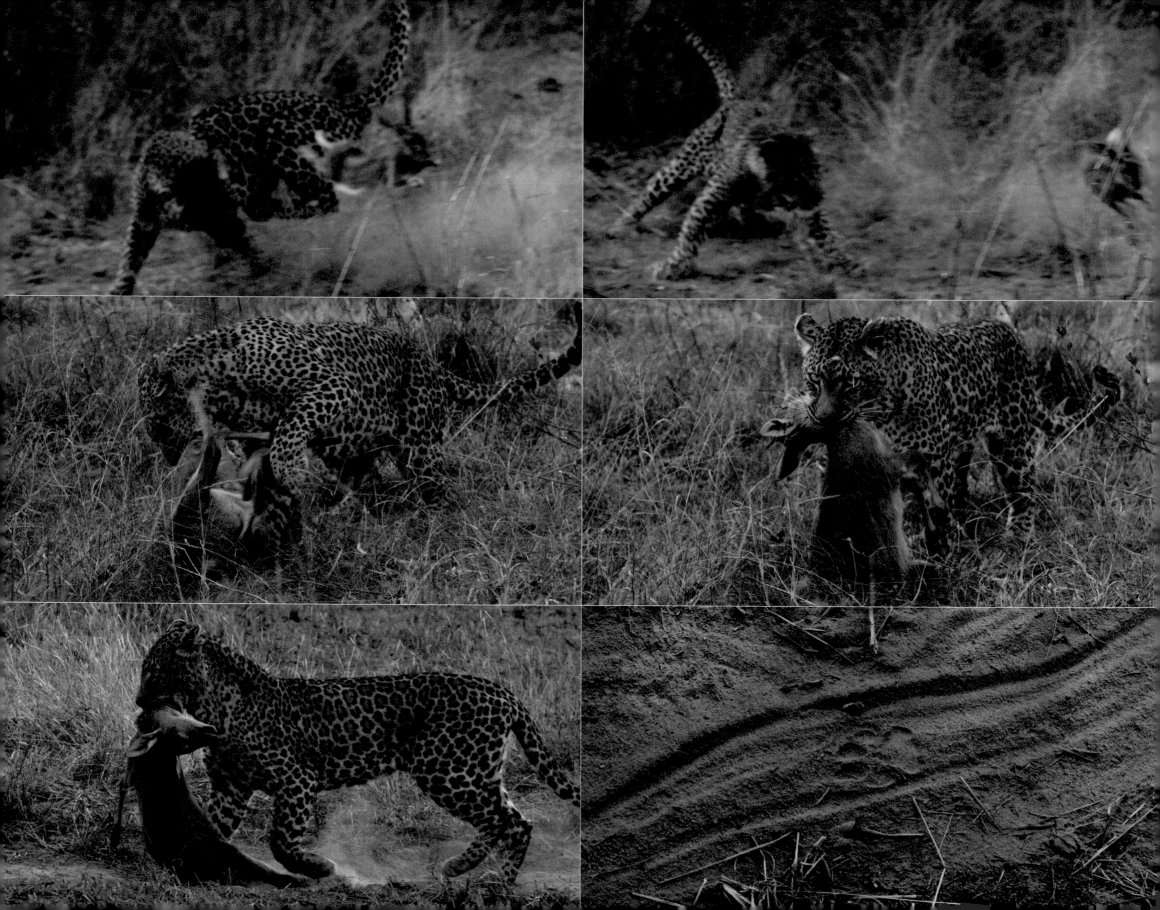

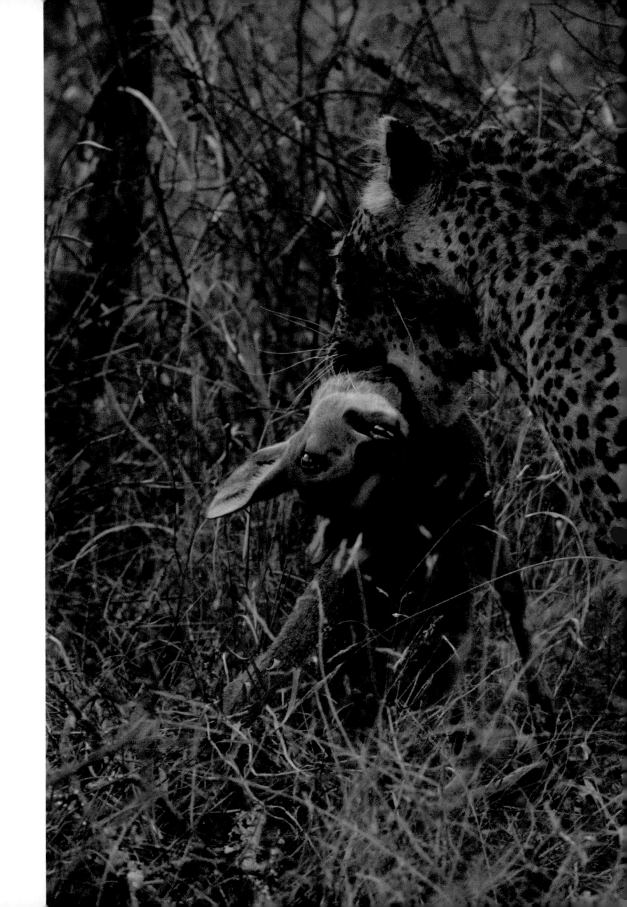

"As a prelude to the pounce, the leopard's tail went straight up into the air. In a frenzied flash of fur it sideswiped a frantically fleeing scrub hare, tossing it into the air with its powerful paw before anchoring itself, using its tail like a rudder to stabilise the skid. Miraculously, amidst a shower of grass and grit, the hare hit the ground running and escaped. At the same time, the leopard's attention was diverted to a meatier young antelope, which it summarily ran down at astonishing speed, gripping it by the throat in its powerful jaws. The animal gave a pathetic, heartbreaking cry of distress. Struggling and kicking, it tenaciously clung to its young life for what seemed to be several minutes before succumbing to the feline's stranglehold with a last conclusive shudder at the coup de grâce. *With lightning speed, I fired eight frames per second as the drama of the leopard's skirmishes, first with the scrub hare and then with the antelope, unfolded before my eyes. Adrenaline-fuelled awe at nature's profundity and a dormant primeval hunting instinct welled up inside me as I photographed the frantic action with steely resolve and tenacious determination.*

The leopard gripped the lifeless antelope in its powerful jaws and dragged its limp body for several hundred metres to a concealed spot – the base of a marula tree. After a few minutes of heavy panting, the leopard regained its composure and proceeded to remove a patch of fur from its prey before gorging on its moist, nutrient-rich organs and entrails. After a hasty feed, the leopard dragged the carcass away and covered it with grass. It then 'scent-marked' the spot to mask the smell of its quarry and to safeguard it from other hungry predators."

(overleaf)
"I am awed anew every time I see a leopard in the glow of the magic sunlight during the first two hours of dawn and the last two hours of dusk, when the sun is low on the horizon and the shadows are long. Its buff coat, marked by dark rosettes, transforms splendidly into scintillating hues of burnished gold and appears iridescent at these times of the day. An inspiration of feline symmetry, the leopard is a masterpiece of creation, both in function and in form. Images of it are found on ancient artefacts and the walls of Egyptian tombs, and in primitive rock paintings, contemporary art, sculpture, carvings, photographs and heraldry."

245

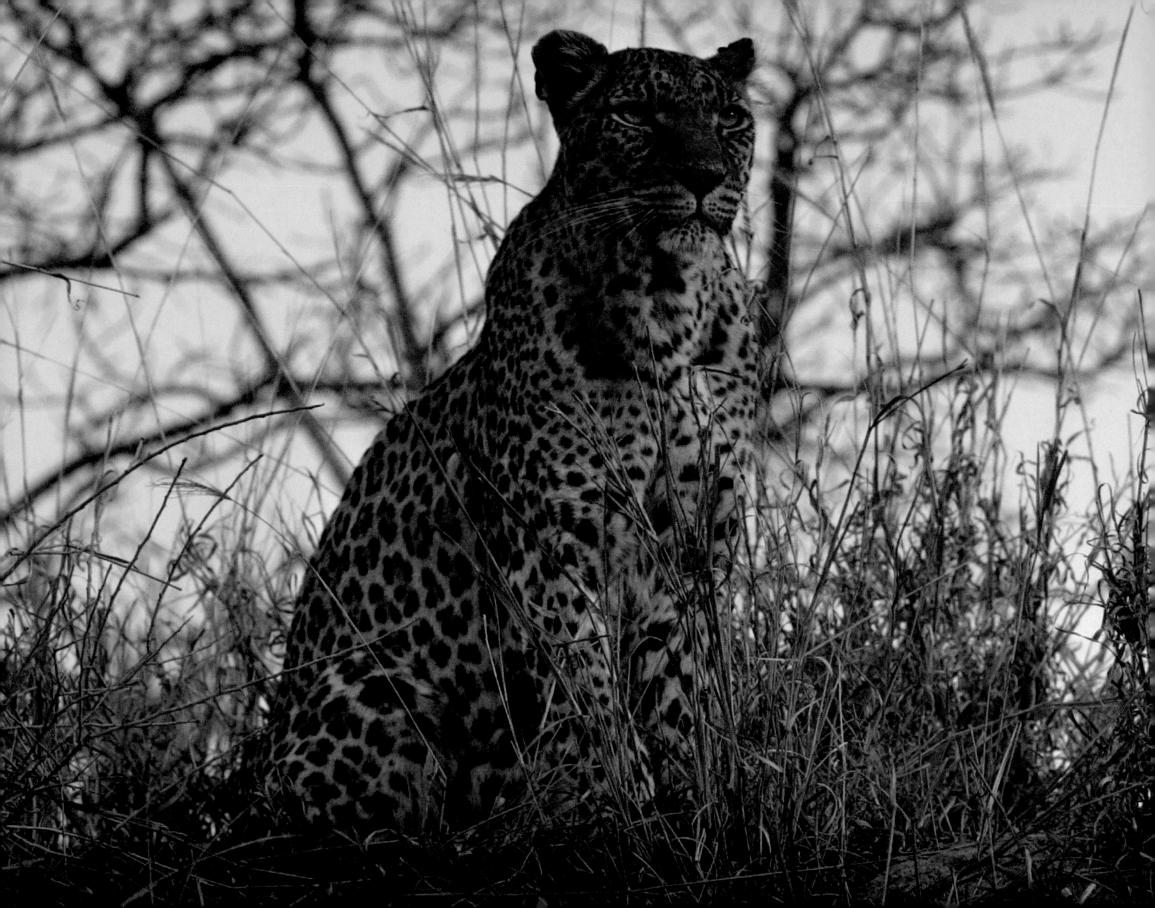

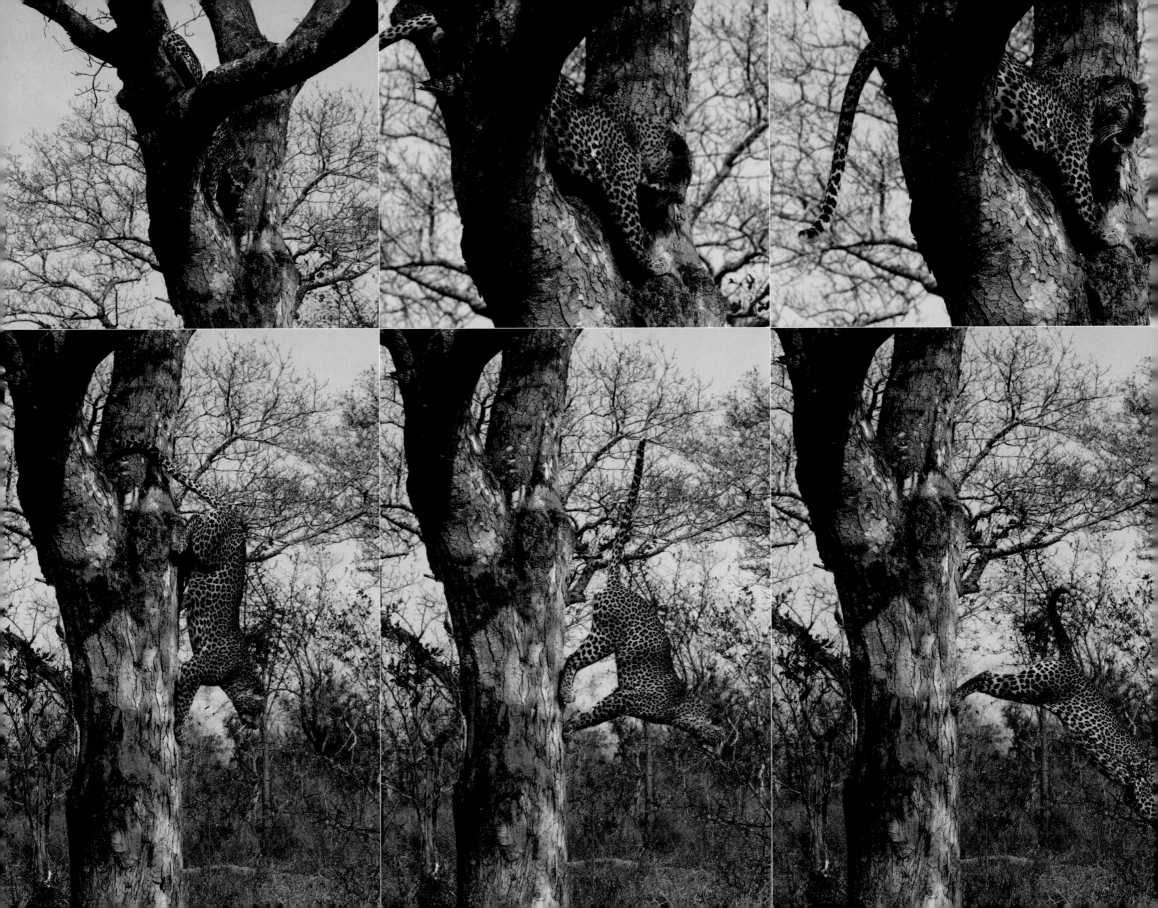

Ulusaba

PRIVATE GAME RESERVE

Ulusaba Private Game Reserve is Sir Richard Branson's personal safari retreat in the heart of the Sabi Sand Game Reserve, adjacent to the Kruger National Park, in Mpumalanga. He is, however, magnanimous enough to share his two lodges with paying guests. You can stay in luxury and comfort at Rock Lodge, on the summit of a koppie (rocky hill), or at Safari Lodge, along the banks of the dry Mabrak riverbed.

The rocky hills in this game-rich territory have a long history of having been used as strategic defences against attack, which is why the reserve kept the local name *Ulusaba*, meaning 'Place of little fear'. Even though these hills are not nearly as tall as the Drakensberg mountain range far in the distance, their vantage points give spectacular panoramic views over miles of African bush and roaming wildlife.

The high, vaulted, thatched roofs and mahogany-stained wooden floors leading onto wide decks invite a leisurely pace. But Ulusaba offers far too many activities to remain long in the deep lounge chairs or the copper bathtub. Game drives and bush walks in the reserve take precedence over most other activities, but anybody who fancies a spot of tennis by floodlight is in luck. Dedicated fitness enthusiasts can continue their daily routine in the gym-with-a-view or the rim-flow pool.

At Rock Lodge, children, too, are kept entertained. The Cub's Club organises various child-friendly activities. A backpack of goodies helps keep the kids busy, but most popular are the educational safaris with a ranger who shows them how to track animals and how to survive in the bush.

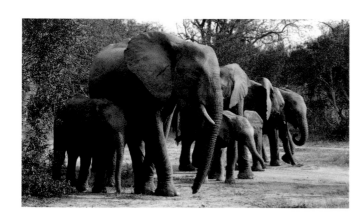

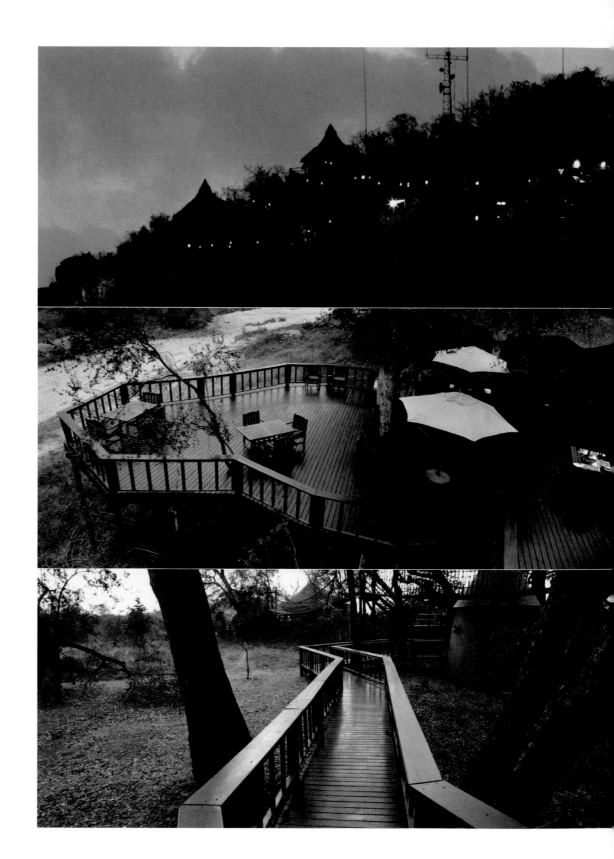

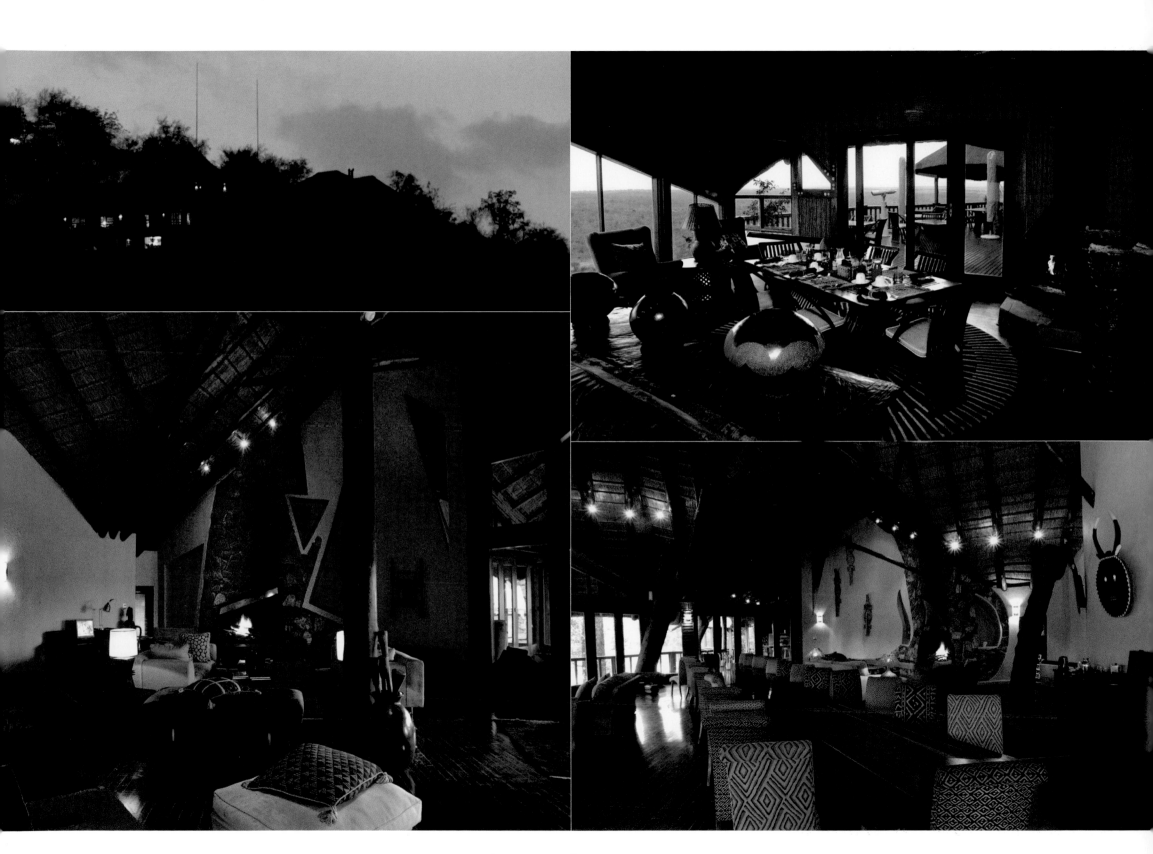

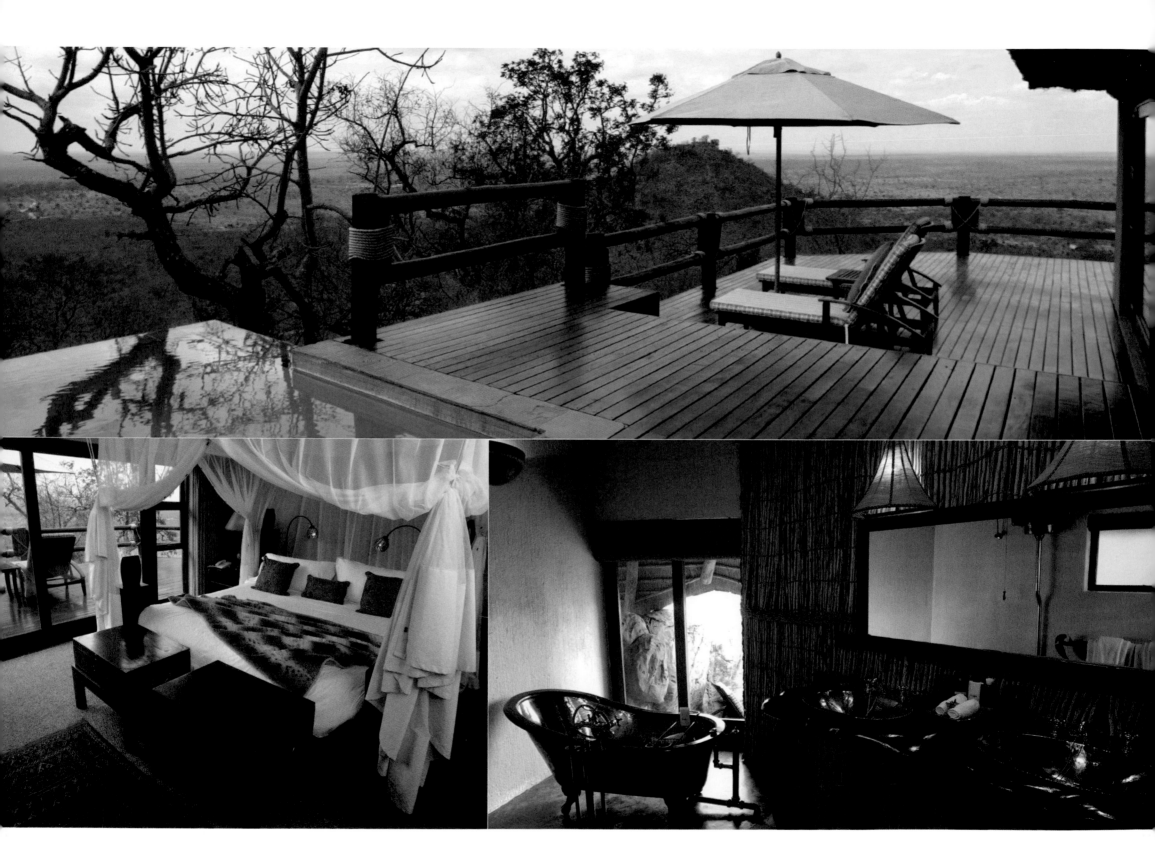

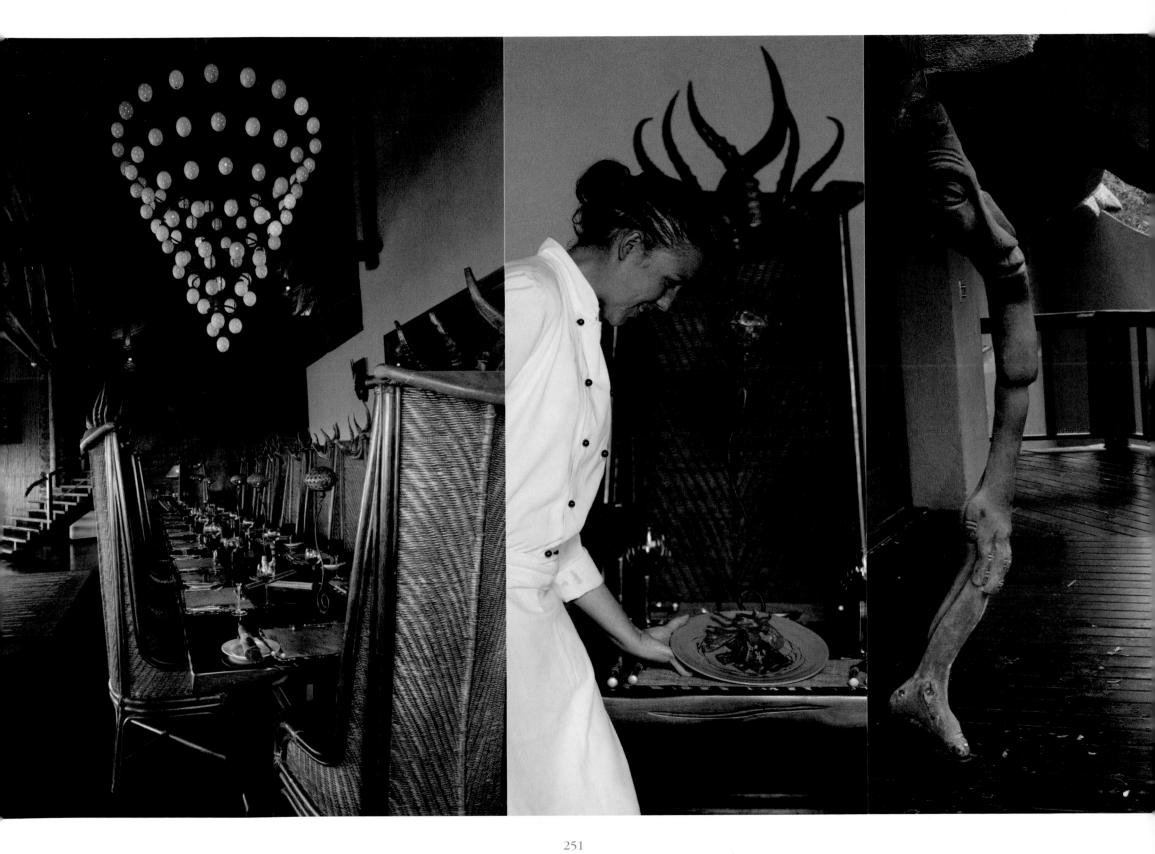

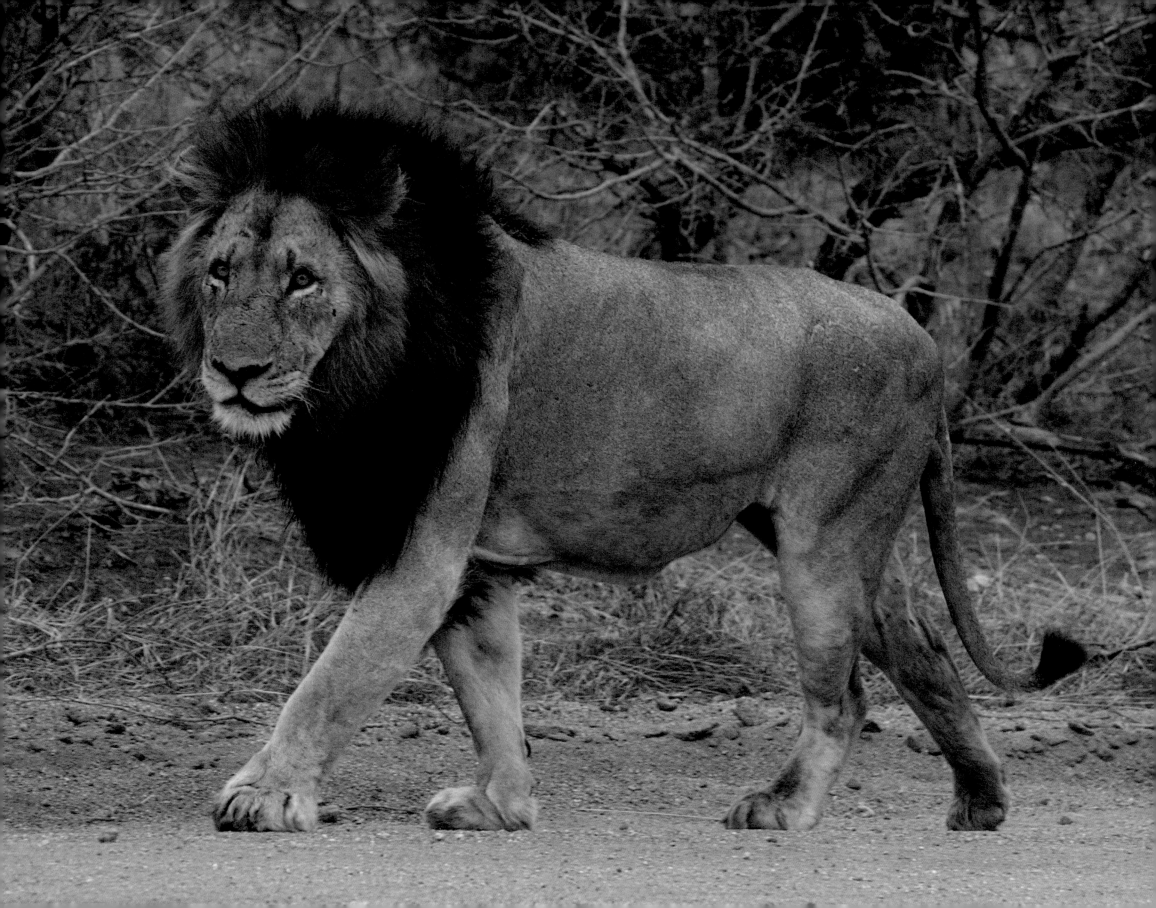

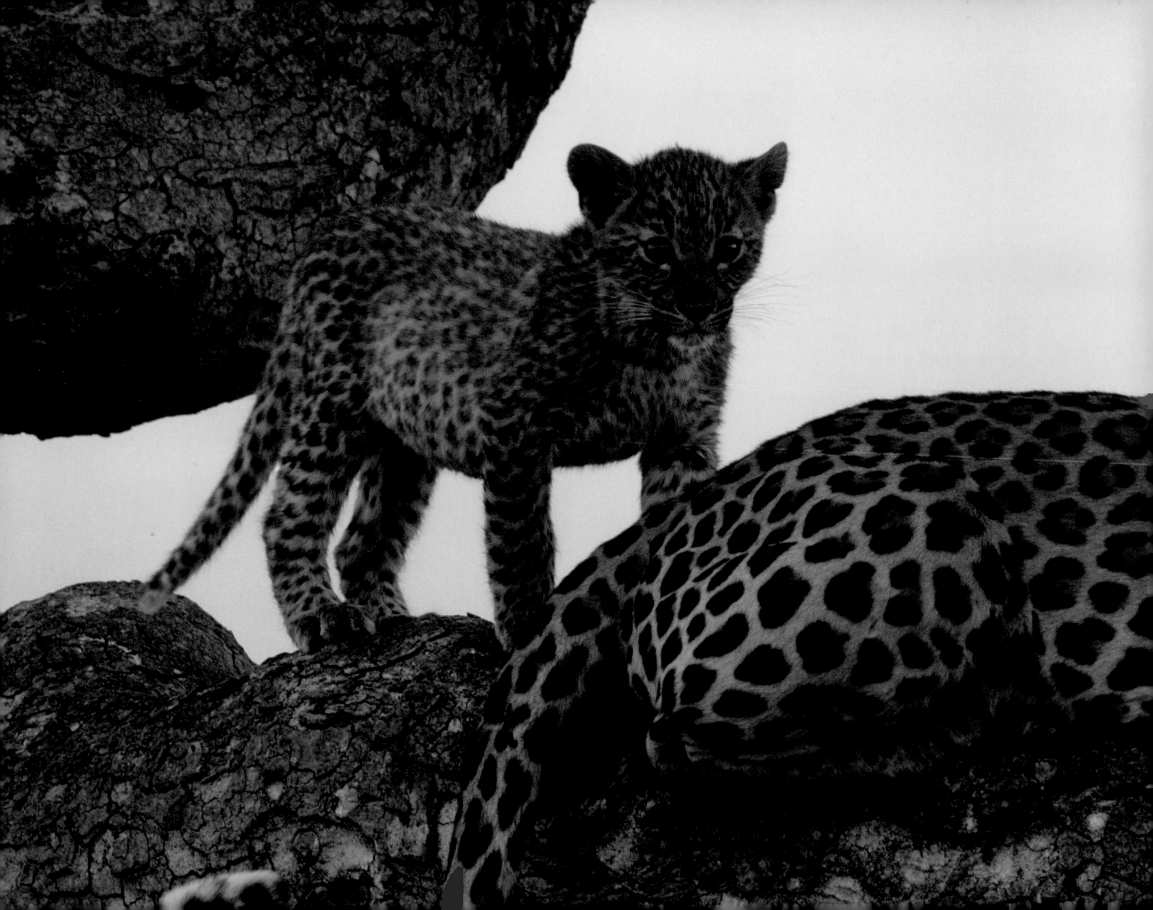

Leadwood Lodge

Traversing the Sabi Sand Game Reserve, the Sand River lives up to its name: its course weaves around great banks of sand, shaped into dunes by the wind and the flow of the river. On its well-watered banks large leadwood trees spread their boughs wide, and in their shade sits a lodge named after these noble giants.

The view from Leadwood Lodge's wooden decks changes with the seasons and the flow of the river, which is strongest during the hot rainy months of September to March. The Sabi Sand Game Reserve grows lush and thick at this time, which signals the impalas to drop their babies within a few days of each other to lessen the chances of them being taken by predators. In contrast, the bush dies down during the cooler dry season from April to August and animals are more easily visible through the undergrowth.

Any time is a good time to go to Leadwood Lodge in Mpumalanga, because with only four air-conditioned suites you are guaranteed privacy and exclusivity. Through clever design, four different levels have been created in the main lodge with intimate spaces for game watching or for reading a good book. But it is the tactile combination of materials in Leadwood Lodge that makes it architecturally and decoratively interesting: crushed stone, raw cement, dark meranti wood, rough granite and glass. Boldly used, each substance makes its own statement, yet combines in an atmosphere of self-assurance.

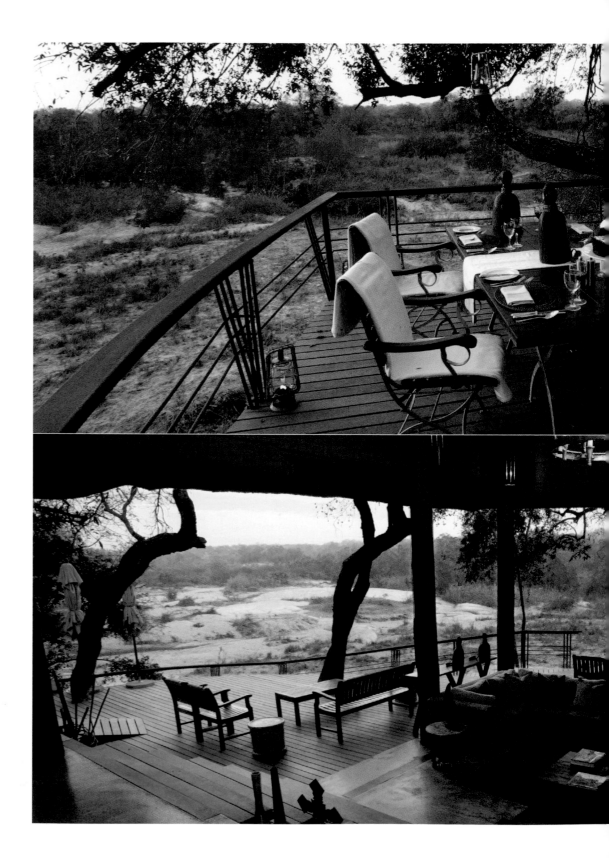

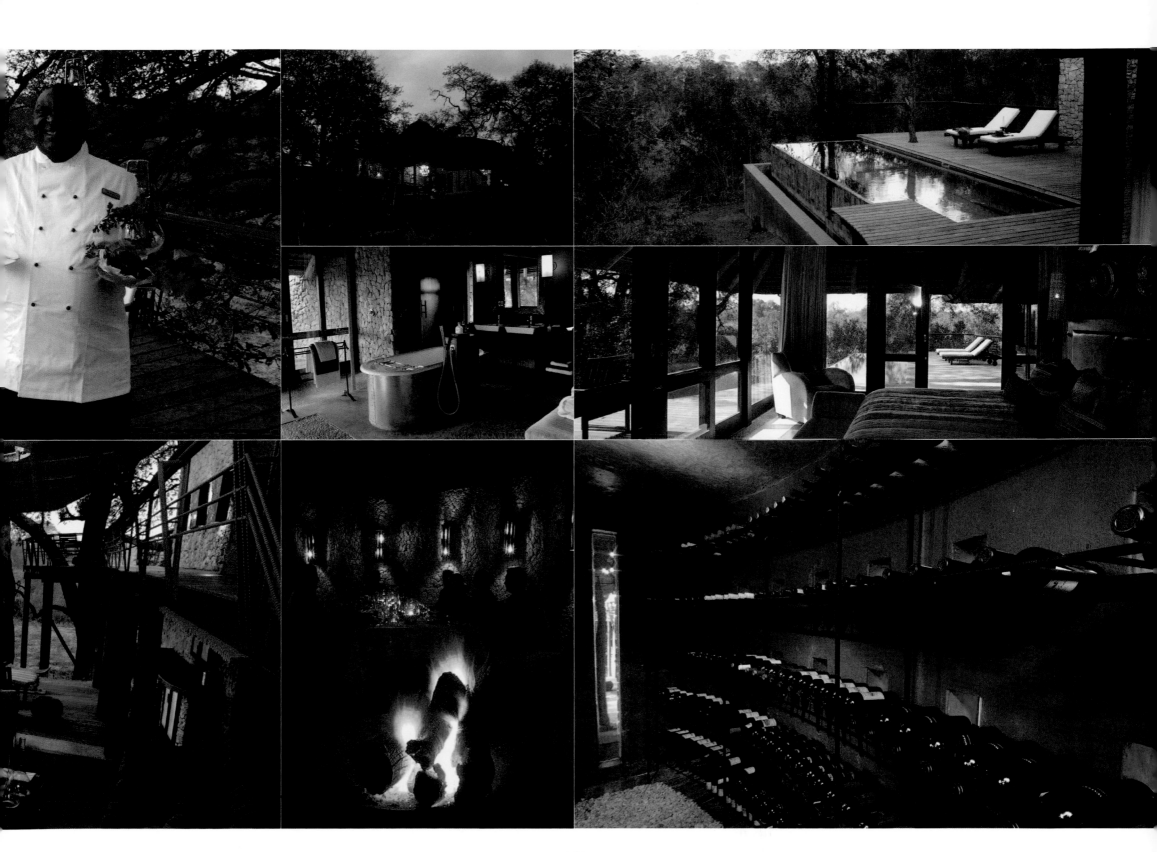

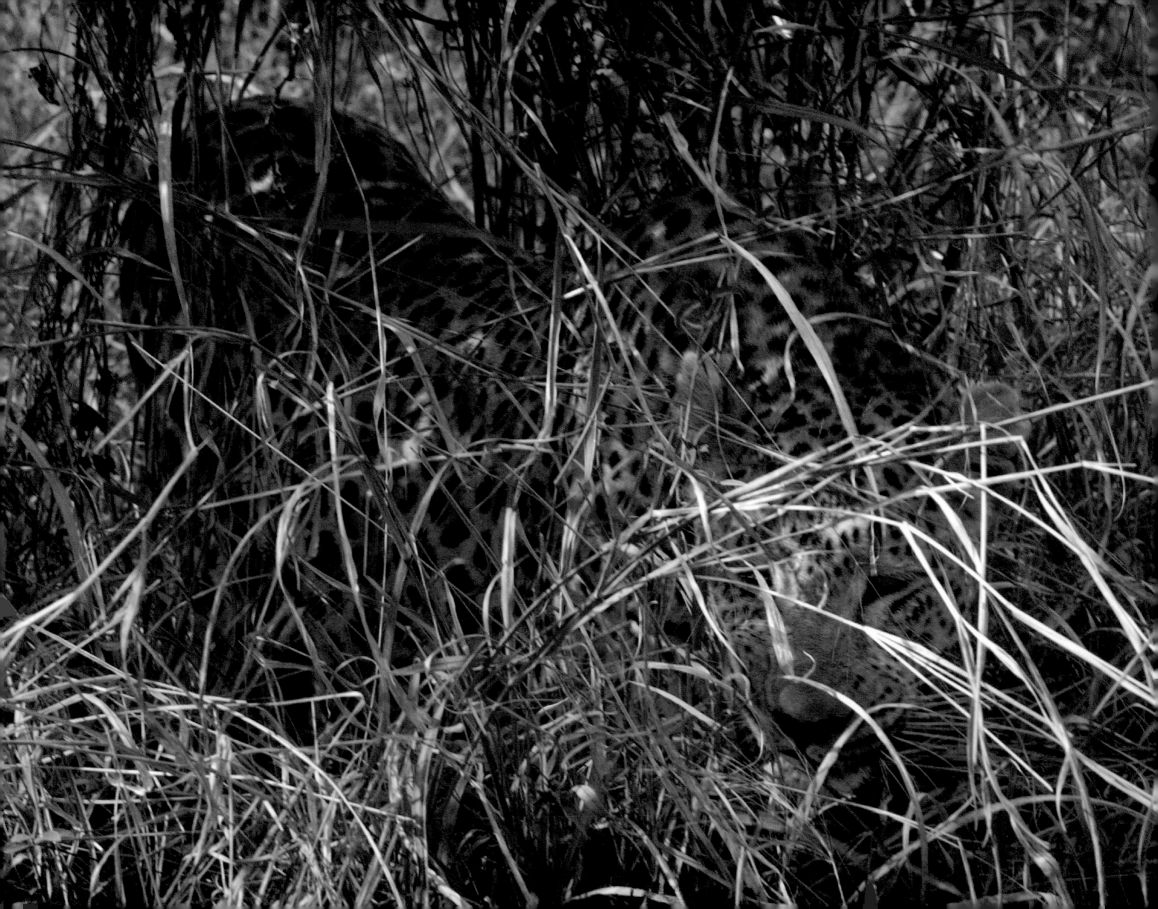

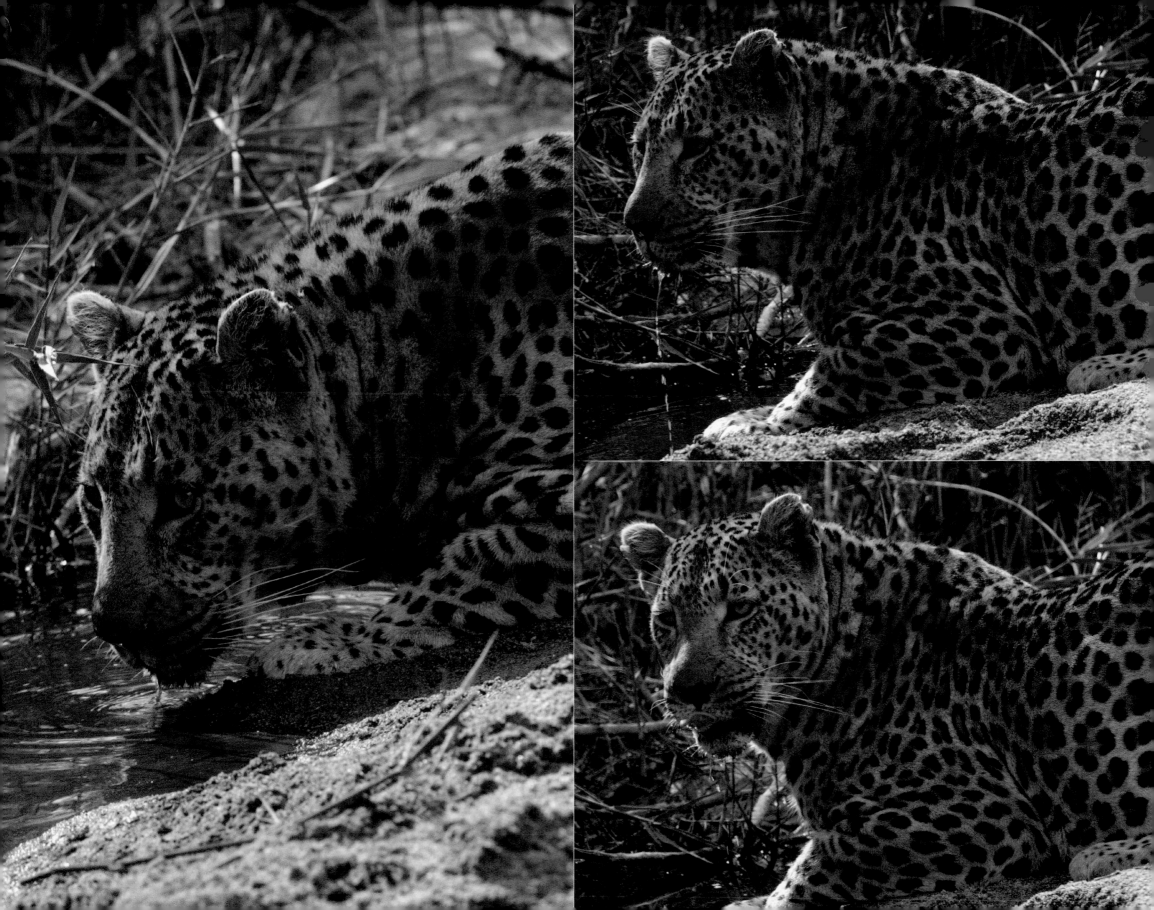

River Lodge

Shaded by tall ebony trees, the eight luxury suites of River Lodge, in the western corner of the Sabi Sand Game Reserve in Mpumalanga, are spread out along the bank of the Sand River. River Lodge is so close to the river that, while you are wallowing in your private plunge pool, the hippos are doing the very same thing just a few metres away. Elephants, too, seem to enjoy the water and they can be seen and heard splashing around and trumpeting with great excitement.

The communal lounge of River Lodge is equally well positioned for observing animals, and its deep sofas are perfect for whiling away the time between guided game drives and other activities.

As is common in the Sabi Sand area, game drives at River Lodge are undertaken in open vehicles. These safari vehicles are usually fitted with a 'jump seat', which is reserved for the tracker. The tracker is a master at reading the signs of the bush: spoor, dung, scratches on trees and even flat patches of grass hold information that the tracker is adept at analysing and interpreting. It is the tracker, informed by the clues he or she has deciphered, who directs the ranger to drive in the right direction to find the animals.

While you are out game viewing, the kitchen is busy preparing a pan-African feast, with a melange of dishes and ingredients from across the continent. Long, lazy lunches are eaten under the shade of a giant sausage tree, whose grey-green dangling fruit resemble enormous salami. The tree is regarded by some as holy, and any event occurring in the shade of it is therefore considered important.

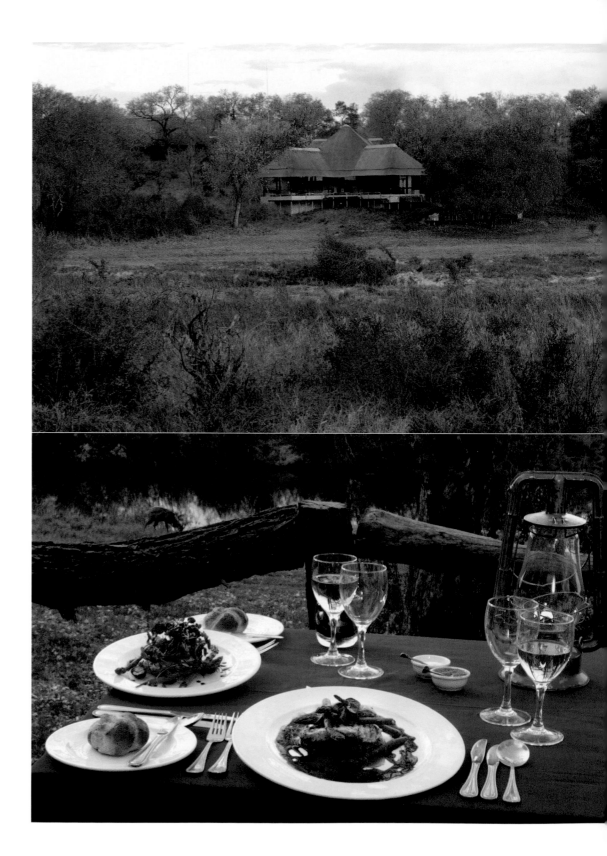

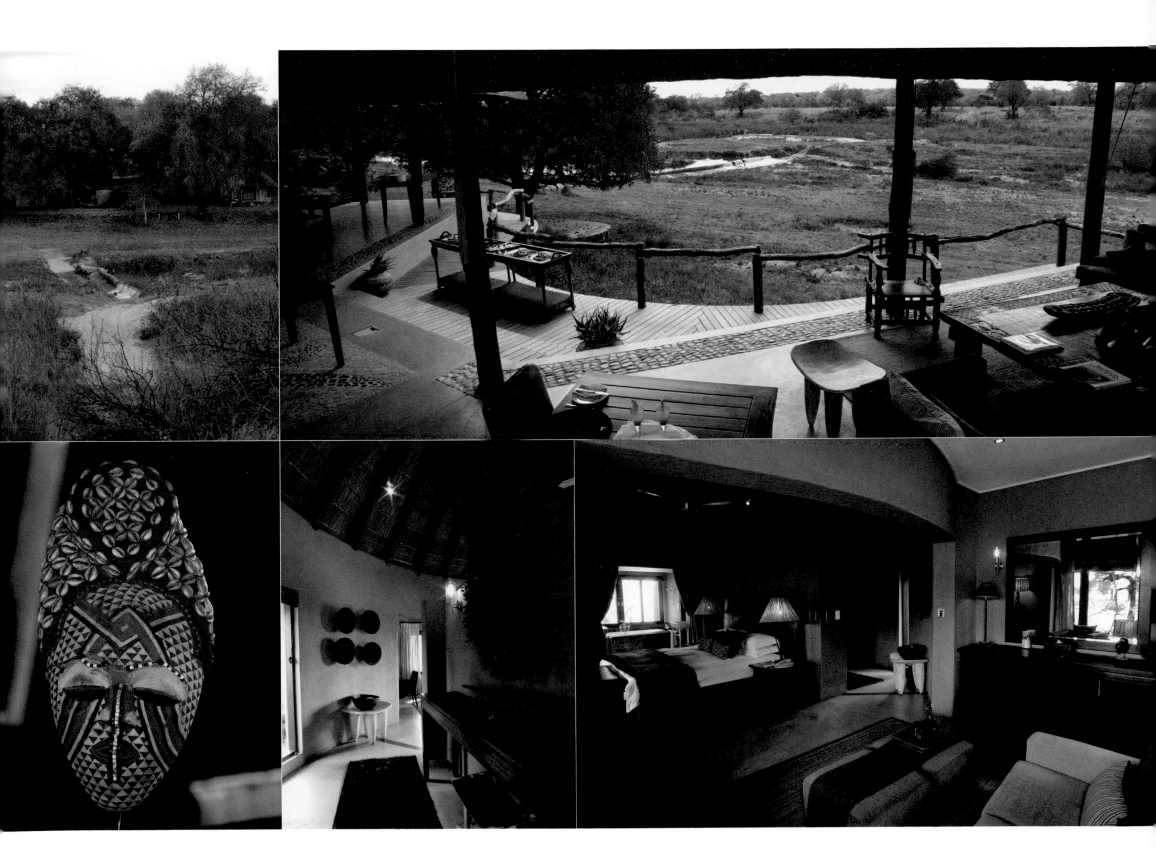

Mateya

SAFARI LODGE

Mateya Safari Lodge, in North West province, draws inspiration from Queen Mateya's legendary ruined settlement. The story starts with a terrible drought in the queen's territory in the northern parts of South Africa, which saddened her so much that she decided to go in search of Modjadji, the Rain Queen. After much travelling, Queen Mateya set up camp in the area now known as Madikwe, a wild land on the fringe of the Kalahari. After many months, she found the Rain Queen and presented her with an exquisite jewel-encrusted necklace, specially made by Queen Mateya's highly skilled smiths. The Rain Queen must have been impressed as rains started to flow in the land of Mateya. Unfortunately, according to legend, Queen Mateya never made it back to her people.

Standing upon stone supports on a rocky outcrop of the Gabbro hills in Madikwe Game Reserve, Mateya Safari Lodge commands an expansive view of the surrounding grass plains. There is certainly something regal about the place. This is immediately apparent in the bronze bust of Queen Mateya, sculpted by Donald Greig, that greets you at the entrance and the stately, ancient Zanzibari elephant doors that open onto the elegant interior of the lodge. Mateya's reign as one of the most sophisticated *grande dames* of safari lodges in South Africa is assured by its inclusion of all things fine. This goes for table silver, haute cuisine, five enormous suites, marble bathrooms, walk-in dressing rooms, fine Egyptian cotton linen, mahogany furniture, tailor-made game drives and walks and, most notably, Mateya's art collection.

Mateya's owner, Susan White Mathis, is a patron of African arts. Since the time she fell in love with Africa from her native Georgia, USA, she has collected one of the world's finest private collections of African books, art and artefacts. Bronzes by Robert Glen, Donald Greig and Dylan Lewis represent many animal species, while woodcarvings come in the form of royal palace doors and expertly crafted figureheads. In fact, such is Mathis's passion that the spaces were built to accommodate the art, not the other way round. This explains why the large wildlife and landscape paintings by Paul Augustinus have ample hanging space and why Robert Glen's huge bronze of a lion hunting an impala, entitled *Near Miss*, holds centre stage in the living room.

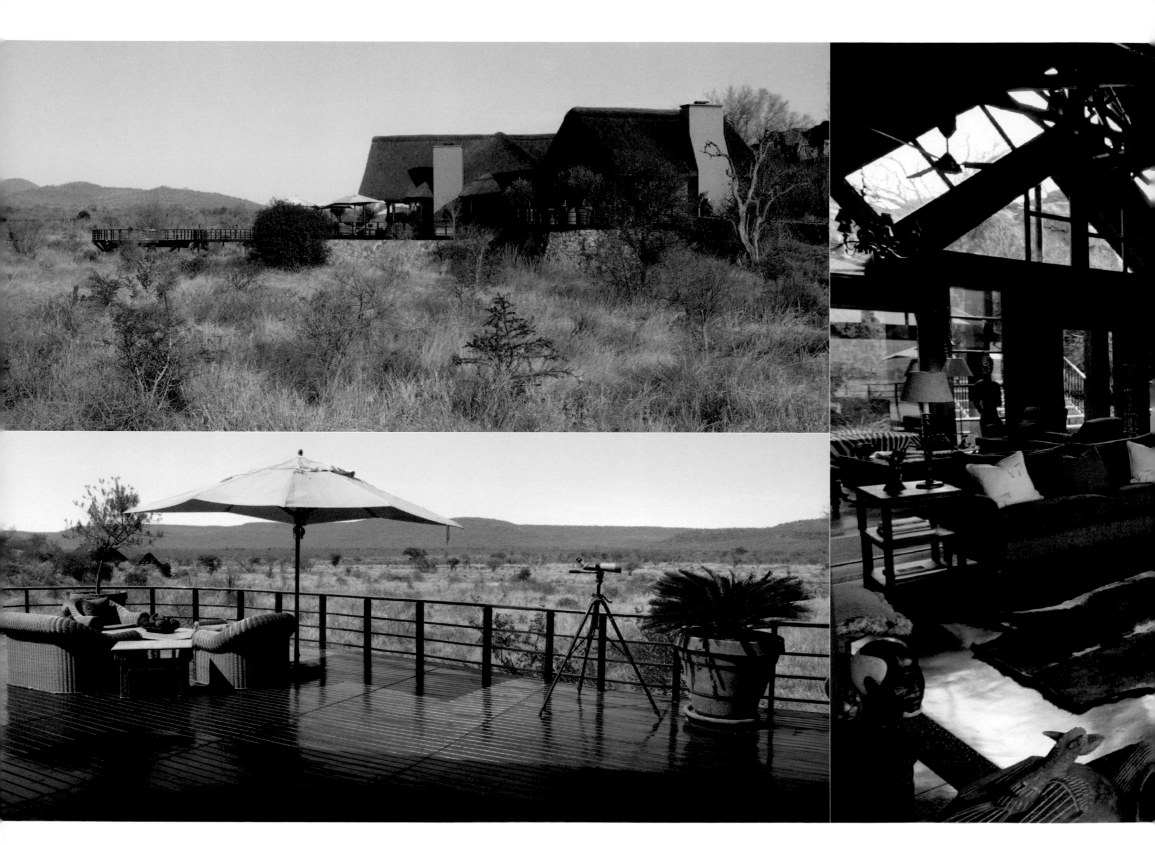

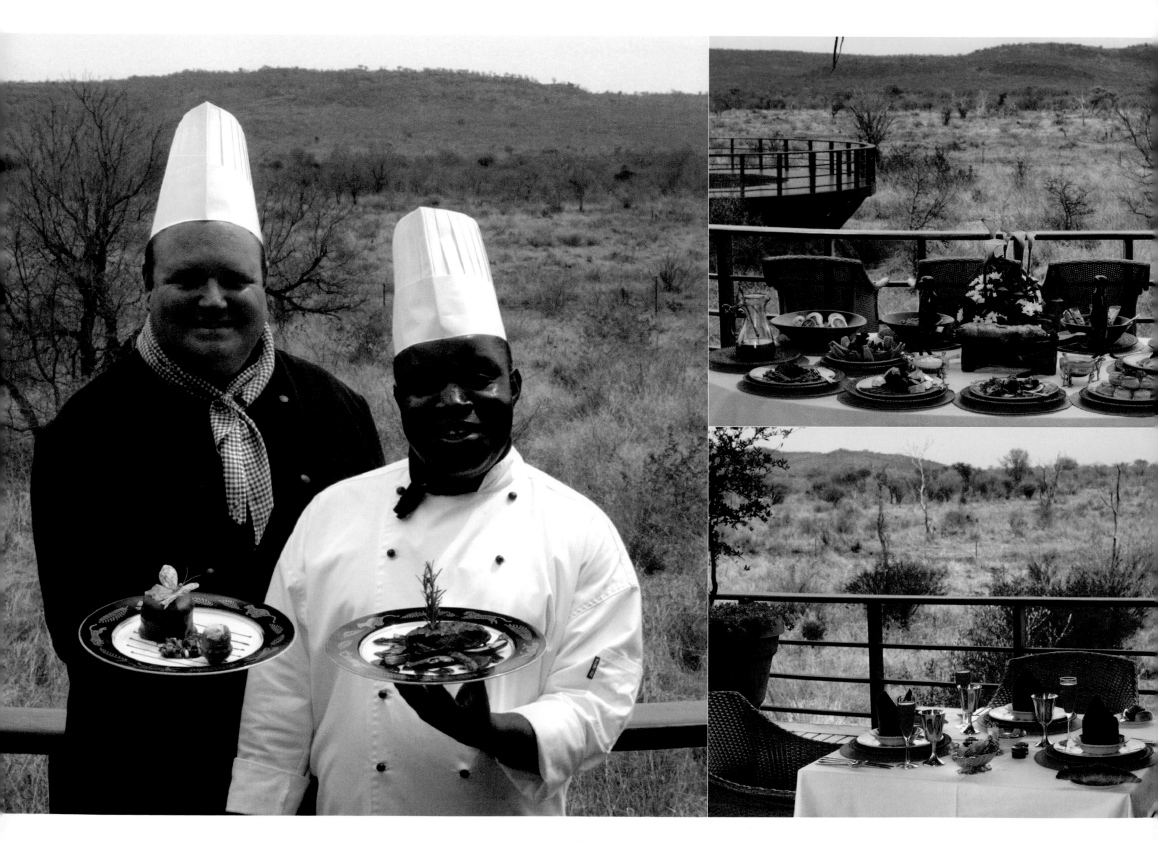

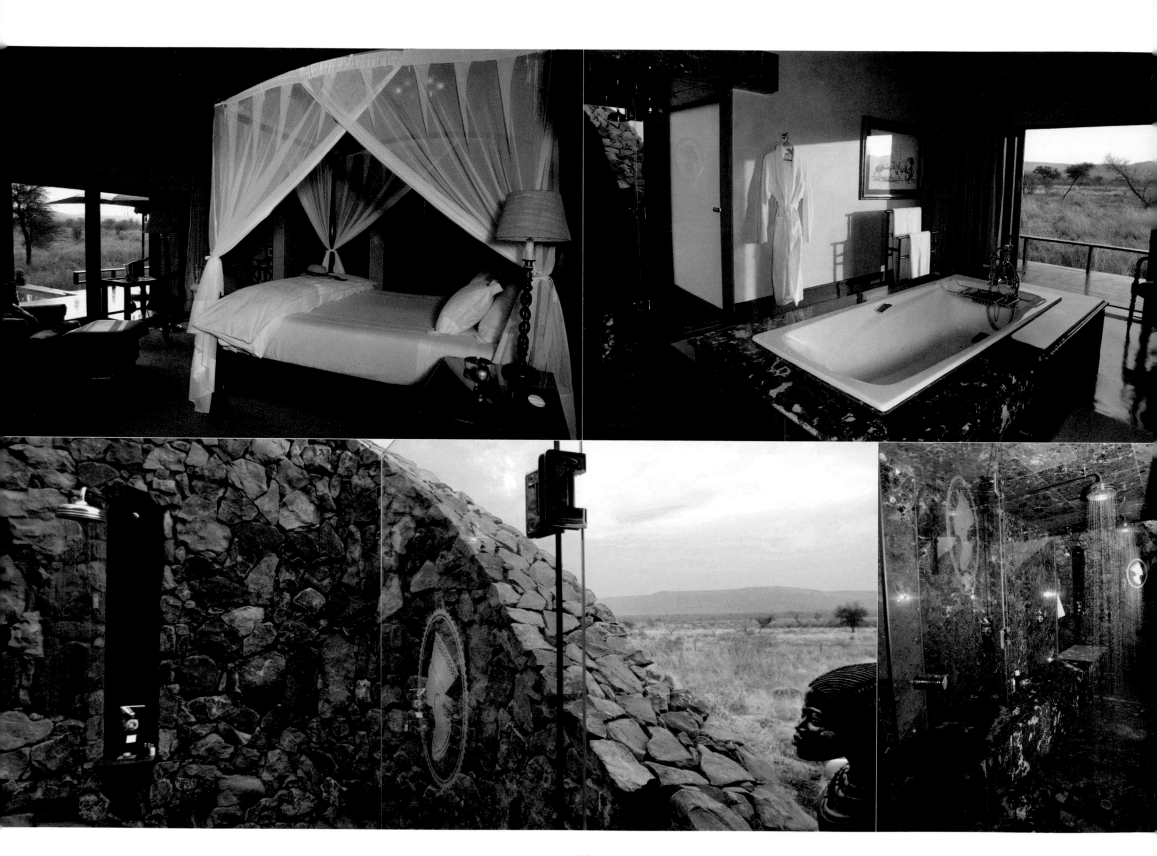

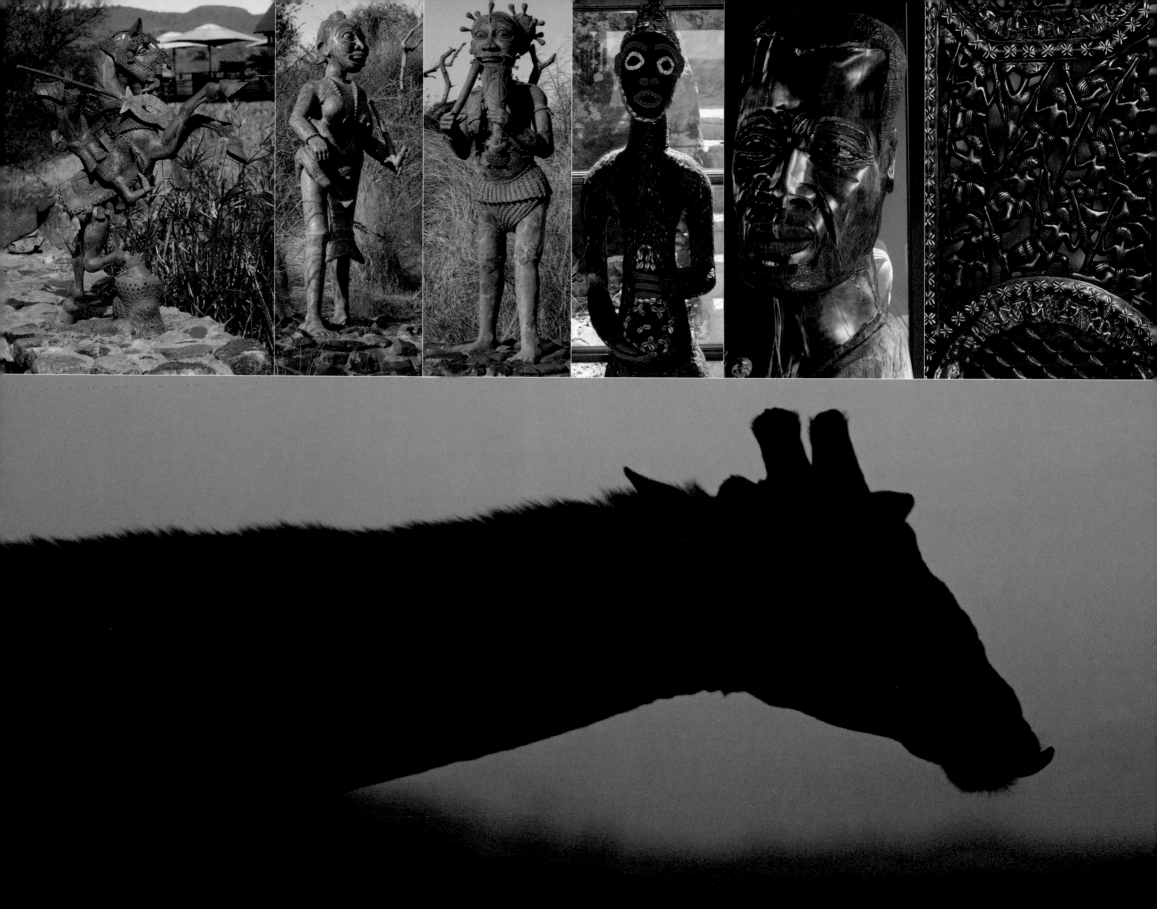

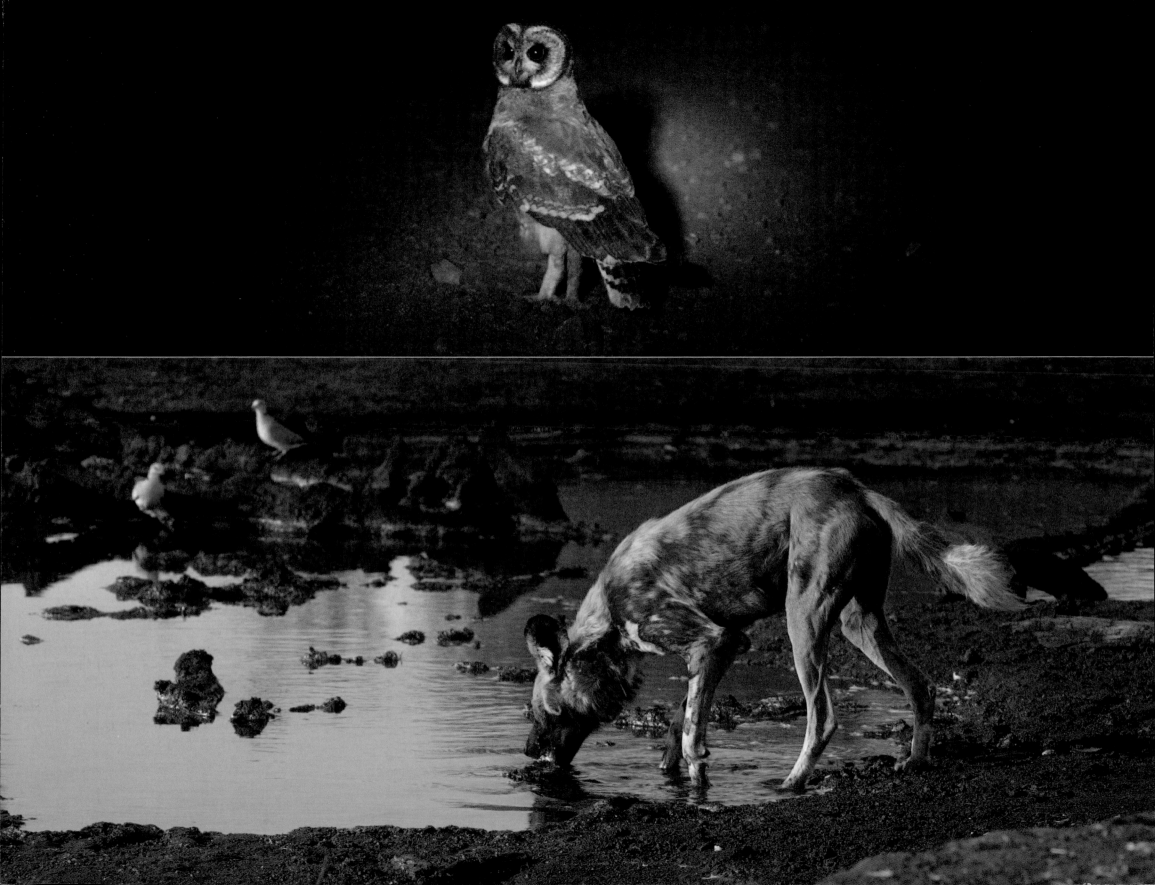

Donald Greig
AT MATEYA

As a young boy growing up in South Africa, Donald Greig formed a lasting love for its animals and wilderness areas. In adulthood, he calls upon his knowledge of animal behaviour and anatomy to create the representational bronze sculptures for which he has become so famous.

Each piece preserves a moment in the life of the animal while at the same time representing its spirit. These qualities are embodied in the grand and elegant pose of the life-size kudu bulls standing at the entrance to Mateya Safari Lodge. While Greig has captured the antelope's regal stature, he has also managed to imbue it with a sense of constant alertness. The same alertness is seen in his bronze meerkat family, although it is rendered in a slightly more comical way, thereby capturing the essential feature that makes these animals so appealing. The buffalo head on a Mateya mantelpiece reflects a mixture of ferocity and condescension. It is a look that has made hunters quiver in their boots.

Greig's talent for sculpture was fully realised when he studied at the Lorenzo de Medici School of Art in Florence, Italy, and later when he spent time at some world-famous Italian foundries to learn the age-old processes of bronze casting. Greig's work is now processed at the Bronze Age Foundry in Simon's Town on the outskirts of Cape Town.

Greig has exhibited in Europe and the USA and his commissions have included trophies for sporting events, a pair of life-size hippos for Sir John Aspinall's Port Lympne Zoo in the United Kingdom and sculptures of bulls and bears for the South African securities exchange, JSE Ltd. But Mateya Safari Lodge is where his largest private collection can be seen, and some of his gift-size sculptures can be purchased there as a memento of a visit to the bush.

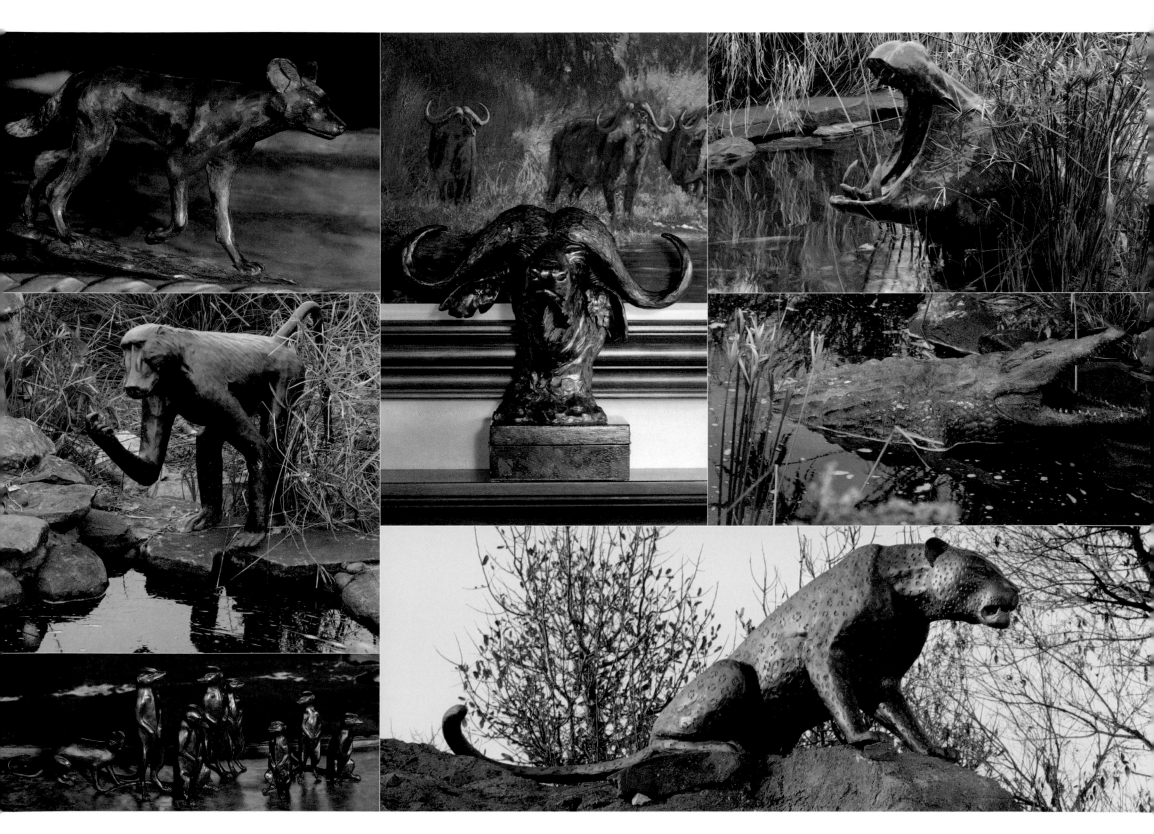

Jaci's Tree Lodge

Jaci and Jan van Heteren have two lodges in the Madikwe Game Reserve in North West province: Jaci's Tree Lodge and Jaci's Safari Lodge. Between them, the privately owned luxury lodges have picked up a raft of awards, including the AA Accommodation Awards for Best Game Lodge, 101 Best Hotels in the World, awarded by *Tatler Travel Guide*, and five-star ratings by the Tourism Grading Council of South Africa.

Being in the Madikwe Game Reserve has distinct advantages. The malaria-free reserve is described as a 'top ten territory', with wild dog, black and white rhino, hippo, lion, leopard, spotted and brown hyaena, cheetah, giraffe, buffalo and elephant found in this wildlife sanctuary. As if this is not enough, there is also a variety of plains game like wildebeest, kudu and zebra, and over 340 species of bird.

Built in a riverine forest of tamboti and leadwood trees, the eight tree houses of Jaci's Tree Lodge stand on stilts up to six metres above the ground. This gives guests a unique vantage point from which to observe the wildlife and at least some of the many species of bird recorded in Madikwe. The tree houses consist of open-plan rooms with en-suite bathrooms. Outdoor jungle showers add to the fun for children.

The safari-chic decor of the tree houses is echoed in the main lounge. Resembling the shades of Madikwe's most colourful birds, such as the lilac-breasted roller and the southern carmine bee-eater, the muted purples, pinks, oranges and reds create a confident contemporary feel in this rustic bush setting.

The food, too, is contemporary, and head chef Stewart Hunter is responsible for the exceptional gourmet dishes created in his kitchen. Some menu favourites include his starter of salmon mousse topped with prawns and a main dish of fillet of beef stuffed with cream cheese, basil and tangy pepperdew on a butternut mash.

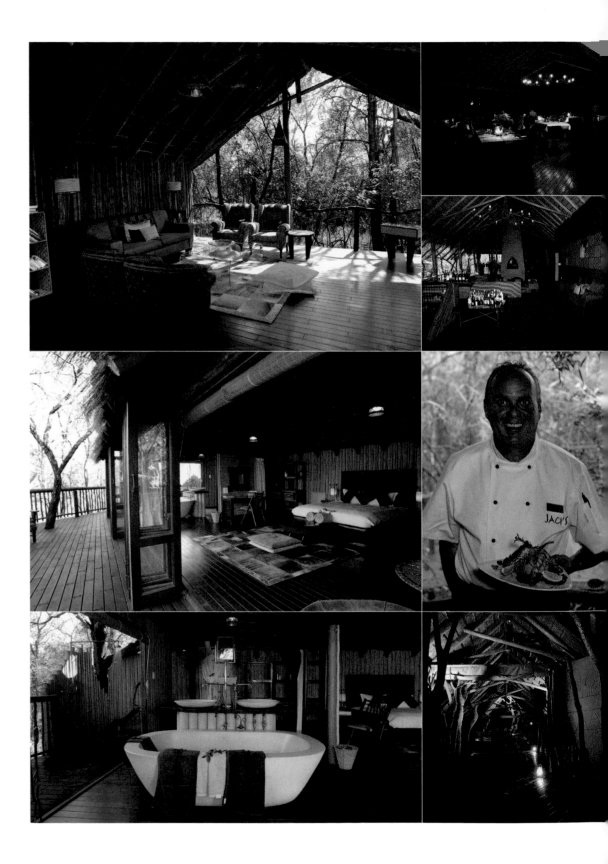

Jaci's Safari Lodge

If you want to feel like you own a patch of Africa, reserve the two-bedroom Nare Suite at Jaci's Safari Lodge in the malaria-free Madikwe Game Reserve. Think private dining on your wooden terrace on the edge of the Kalahari while watching animals at the waterhole just metres away. Think African heat relieved by a dip in the mini-pool. Conjure up the image of a bedroom with a thatched roof and low stone walls to which canvas panels, which zip open to let the outside in, are attached. Inside is a luxurious four-poster bed and a stone bath that looks inviting enough for two. Top this off with private game drives guided by a professional and you have your spot in Africa. The other eight rooms at Jaci's Safari Lodge have many of the same qualities as the Nare Suite, but with differing degrees of exclusivity.

The fascinating history of the lodge is documented in a portfolio of pictures found in the lounge, along with anecdotes of happenings during its construction. Since opening in 2000, Jaci's Safari Lodge and its sister lodge, Jaci's Tree Lodge, have progressed to become two of the most popular destinations in Madikwe Game Reserve – not only for the memorable and varied game sightings, which include endangered wild dog, cheetah and black rhino, but also because of the generosity and hospitality of the staff.

Jaci's staff have a vested interest in guests' wellbeing, because twenty-five per cent of Jaci's is actually owned by them through Jaci's Staff Trust. The opportunity to become a shareholder comes after having been employed at Jaci's for five years. The pride staff take in their ownership is evidenced by the way they look after their guests. It is what makes a stay at Jaci's so memorable.

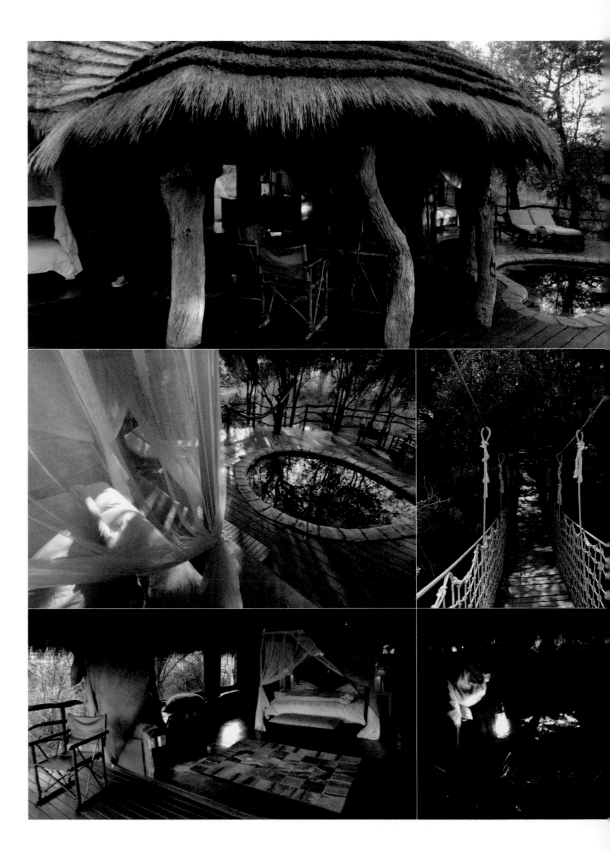

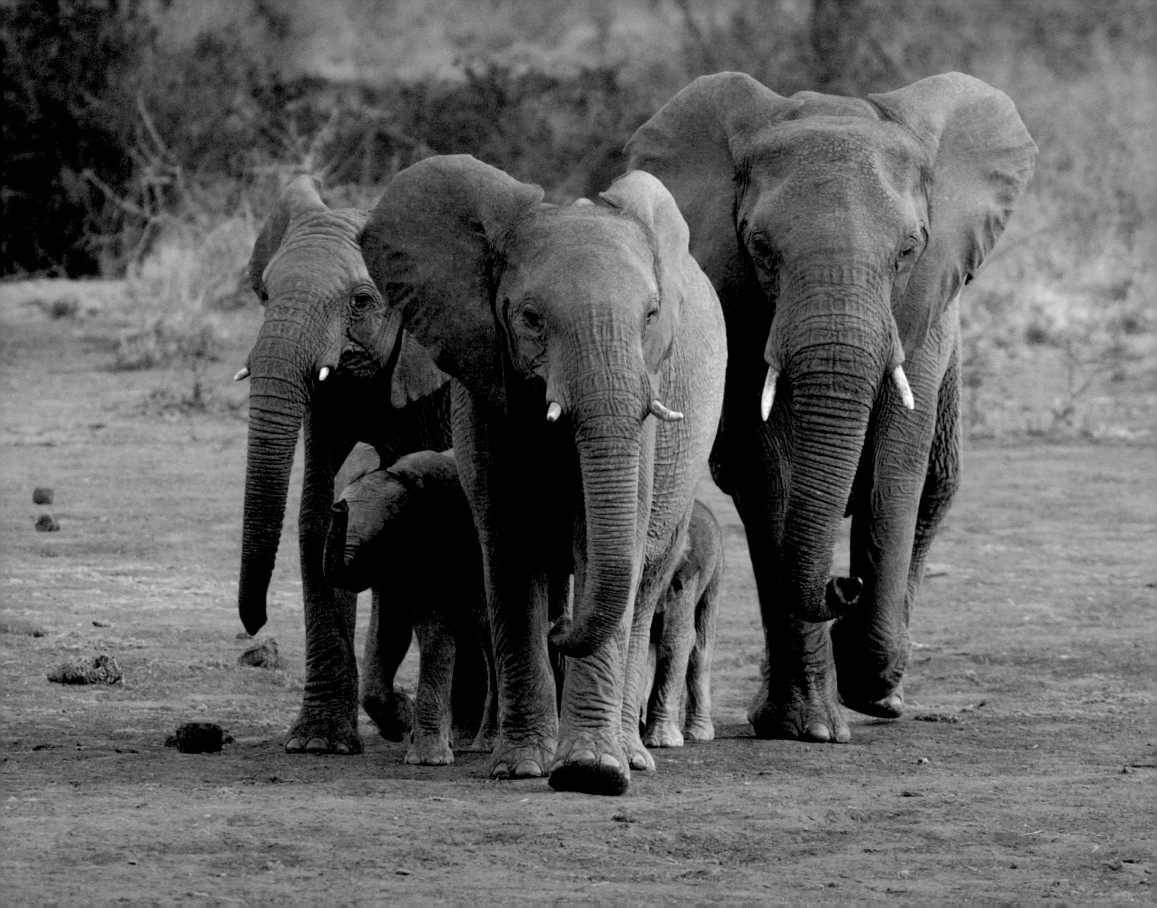

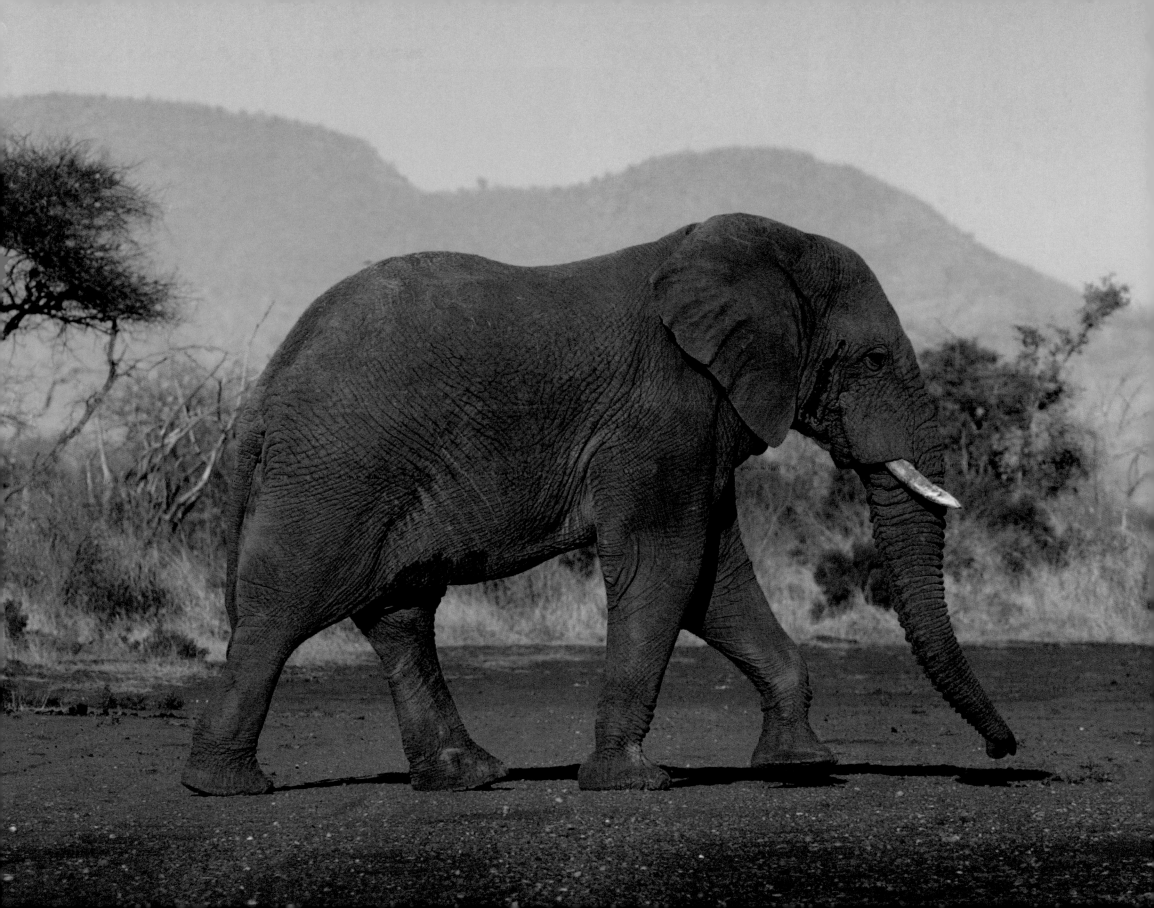

Impodimo
GAME LODGE

Like a flash of abstract artworks in black, white and brown, a pack of wild dogs makes an excited entrance in the precincts of Impodimo Game Lodge. It is a rare pleasure to be able to see this endangered species here in the Madikwe Game Reserve in a corner of North West province right on the Botswana border. On dark, moonless nights the lights of Gaborone – Botswana's capital city – can be seen flickering in the distance.

In addition to the wild dogs, Impodimo reports regular sightings of elephants. You do not necessarily need to go on a game drive to observe them as they are sometimes seen taking a mudbath at the lodge's waterhole. They do, however, prefer to drink out of something a little cleaner. They boldly stroll up to the exposed retaining wall of the rim-flow swimming pool and squeeze around it four at a time so that they can reach their trunks into the clear water. Impatience gets the better of those waiting behind, who vent their frustration with a few ear-piercing trumpets.

With nature adding its helping hand, Impodimo manages to succeed in its intention to create a never-to-be-forgotten experience. But this cannot simply be ascribed to the willing wildlife. The staff play an essential supporting role, with visitors declaring in the guestbook how 'wonderful' they are. As dedicated and professional are the highly skilled Shangaan trackers, who have the ability to find whatever animal you are looking for.

Guests also rave about the food and the surprise bush braai, which is a lantern-lit barbecue dinner in the middle of a clearing far from the lodge. Unbeknown to you, you are led to a feast containing dishes like marmalade-and-sage barbecued pork, stuffed chicken roasted over coals and ostrich *potjie* (casserole cooked in a three-legged cast-iron pot over an open fire).

Returning to the lodge, you will find that the bed in your glass-fronted suite has been turned down and that, on cold nights, the fire has been lit. The warm African decor, with fabrics in nature's own colours, complements the design of the lodge. Eye-catching features in this multilevel thatch-covered space are floors inlaid with stone and a screen created from branches that separates the mezzanine lounge and dining area below.

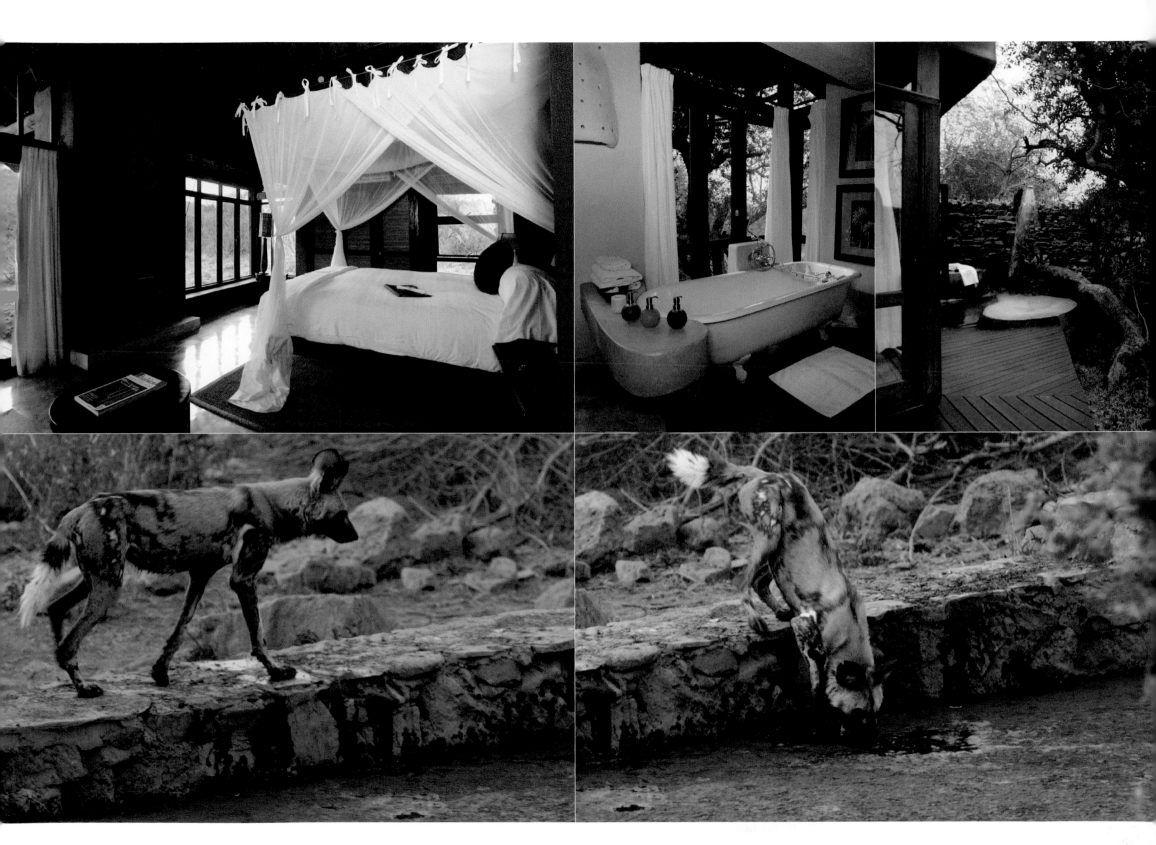

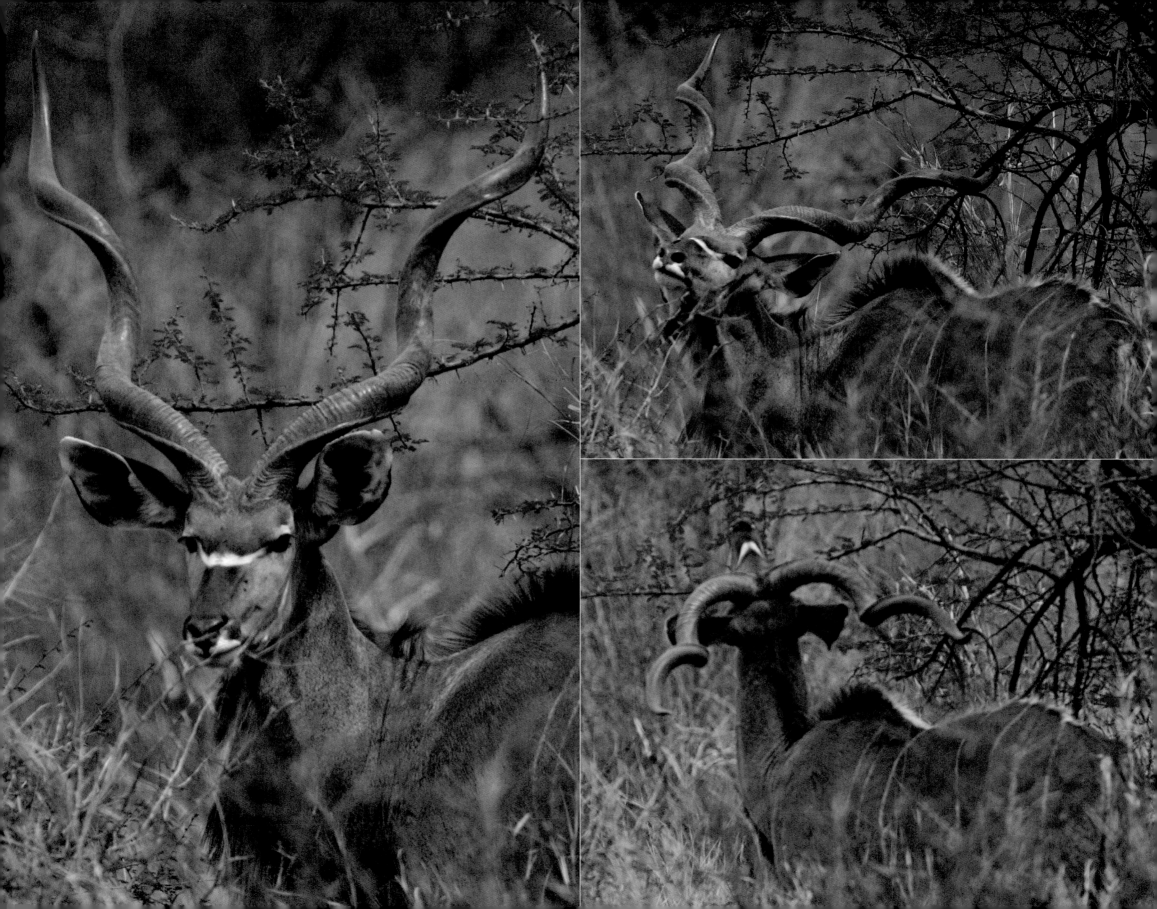

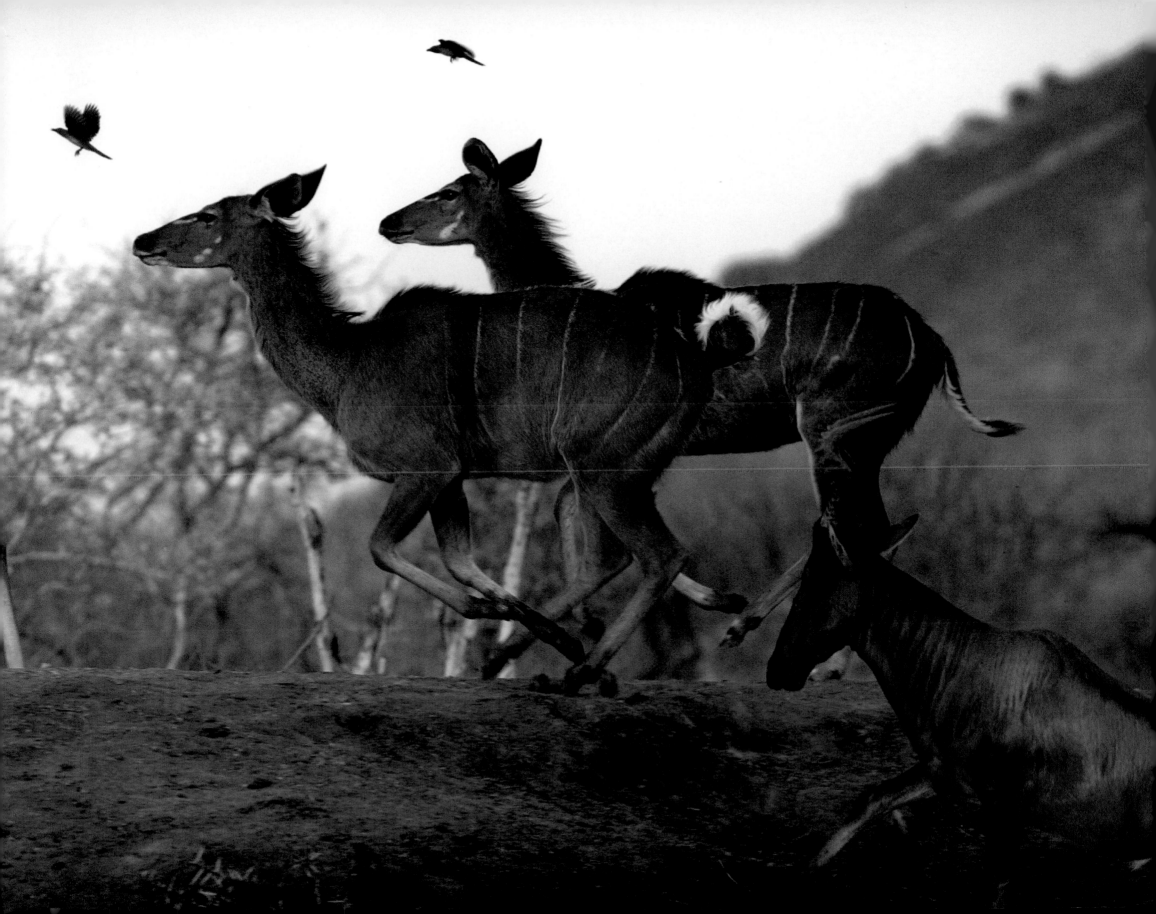

Madikwe

SAFARI LODGE

Built on a grassy slope between two hills, Madikwe Safari Lodge in North West province appears from below like an African citadel, with its curvaceous thatch-and-ochre walls leading to various buildings that seem to disappear into the hillside.

The twenty suites that make up Madikwe's three intimate safari camps are organic yet sophisticated in style. The guest areas and suites have a range of intriguing details, including carved wooden figures that function as door handles and woven copper screens that accentuate the amber-hued interiors. Beanbags and scatter cushions in the covered outdoor sitting areas help to create a homely atmosphere. As darkness falls, dozens of lanterns are lit, adding a touch of old-style romance to the evening.

The staff excel at making guests feel truly pampered. Returning from dinner, you are most likely to find burning candles arranged around the fireplace or, if it is a cold night, a fire blazing in the hearth. A tray of marshmallows for toasting over the coals and liqueur serve as a reminder that it is often the small things that bring true delight.

While relaxing on the wooden deck of your suite, you may be pleasantly surprised by elephants wandering so close that you could almost reach out and touch one. CC Africa's Madikwe Safari Lodge overlooks the vast plains of the game-abundant Madikwe Game Reserve, and the five distinct habitats that characterise this junction between bushveld and desert are home to the Big Five, as well as cheetah, wild dog, zebra and several antelope species.

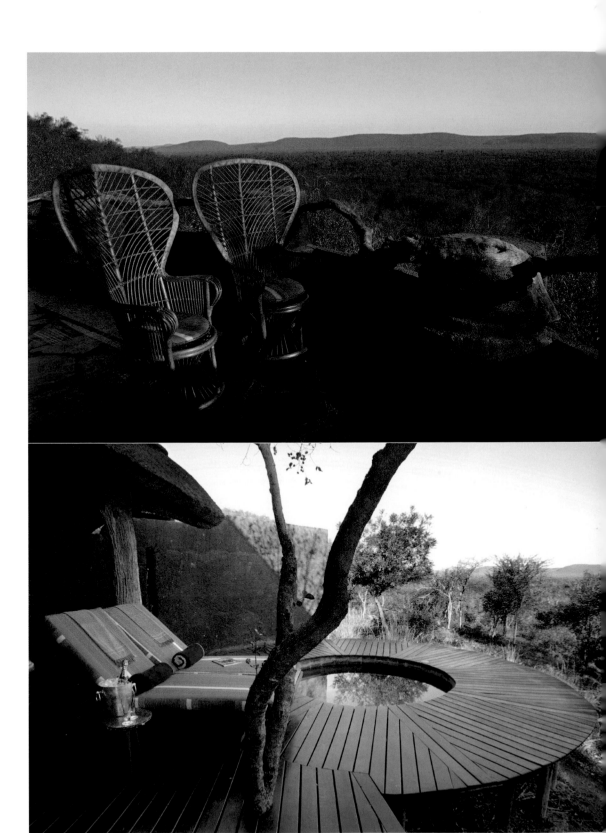

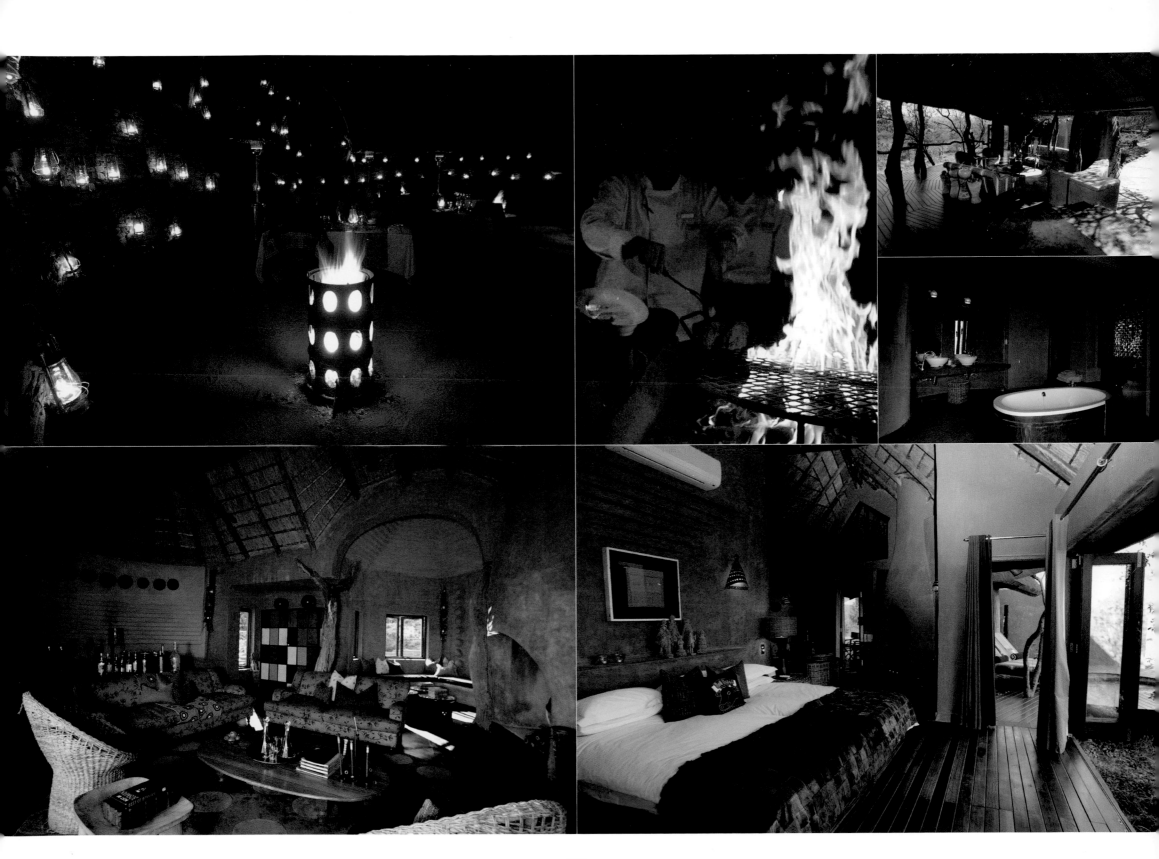

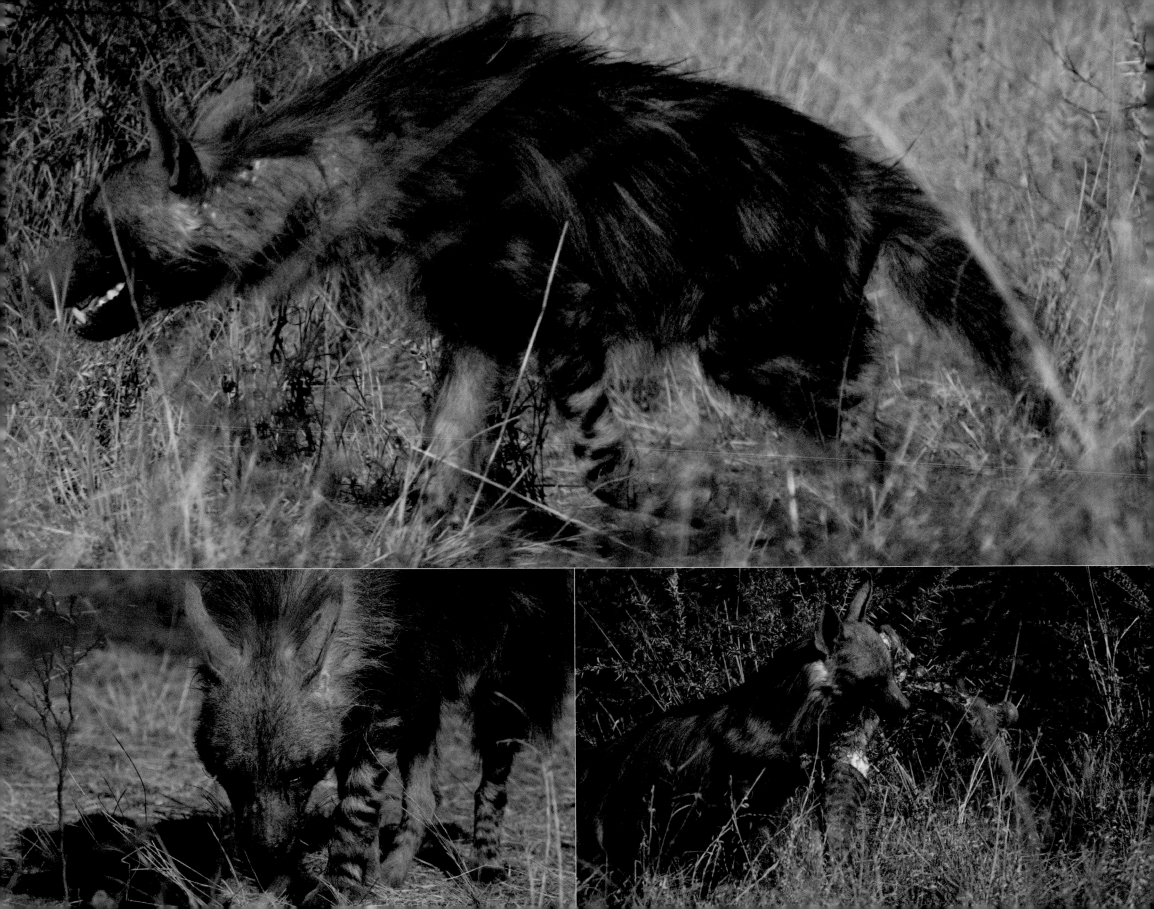

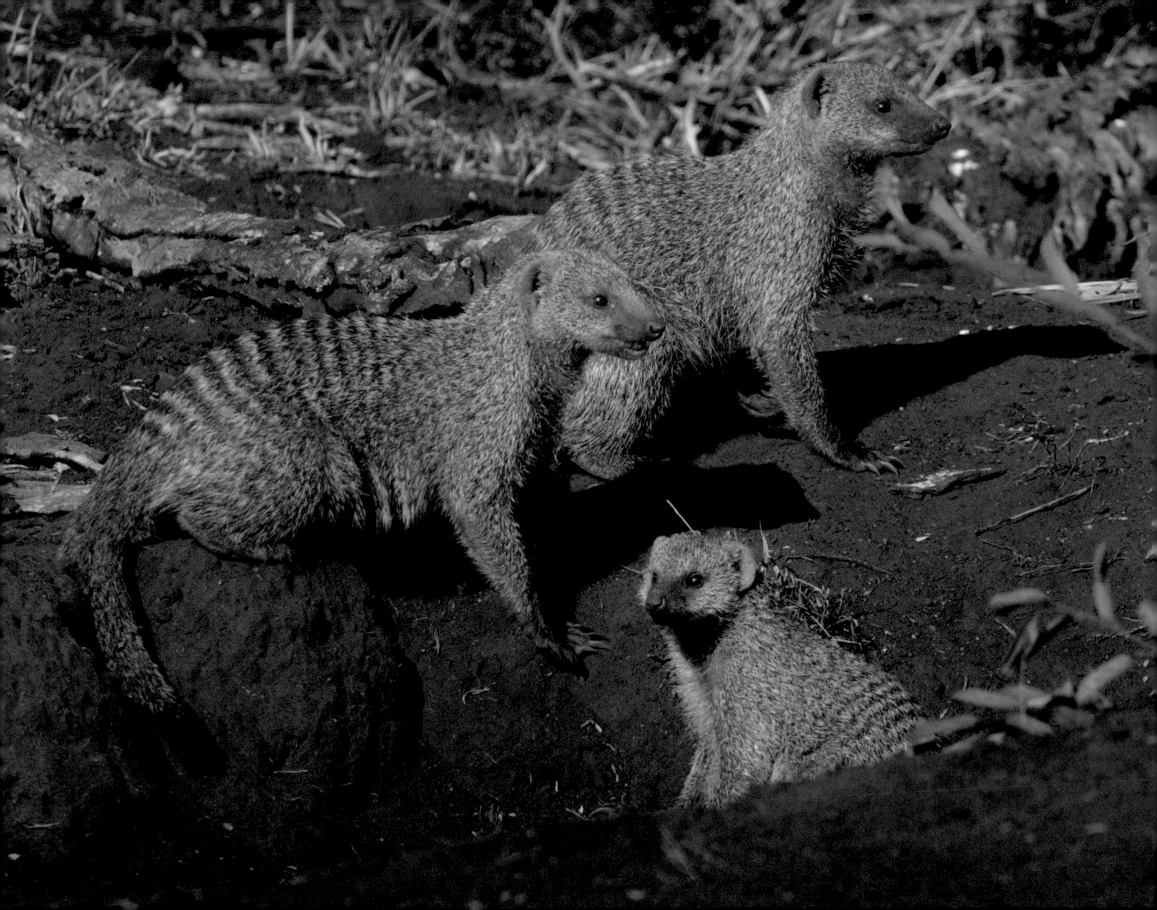

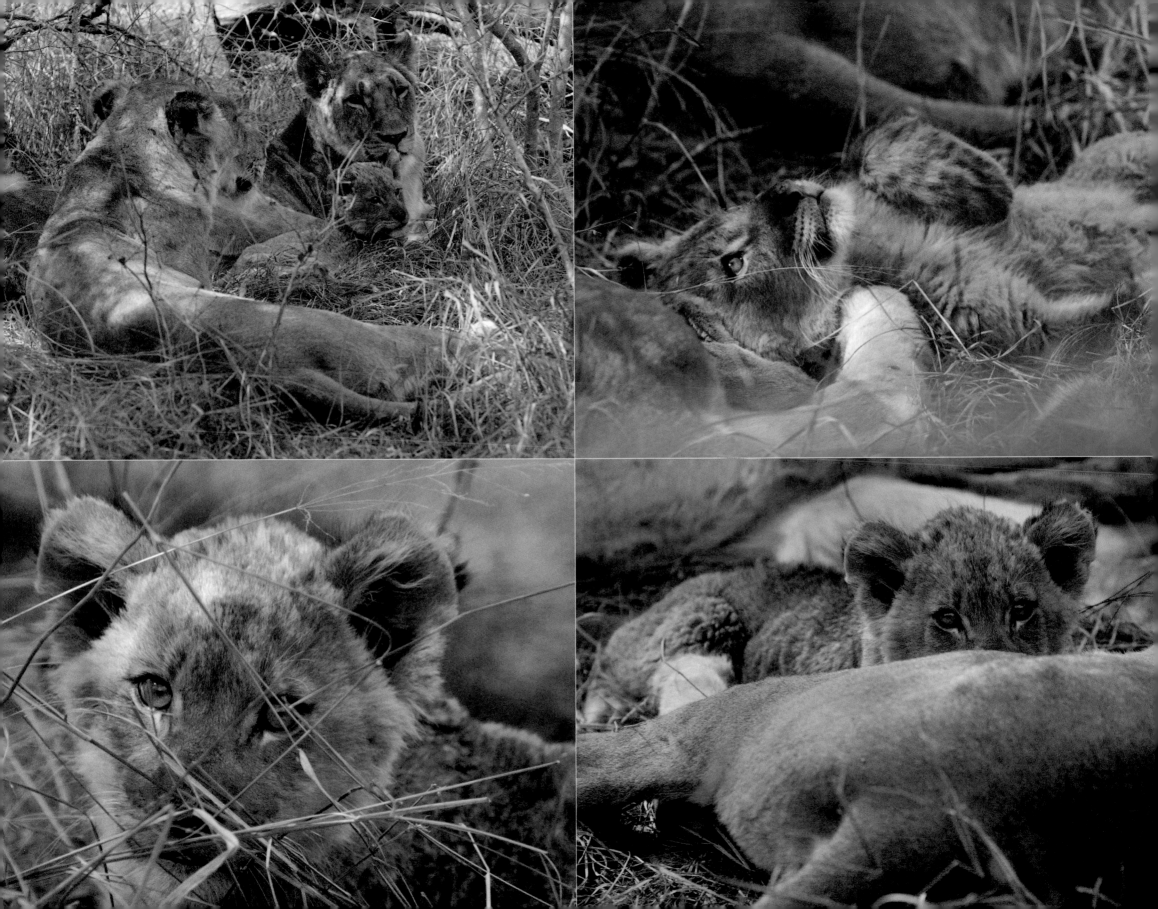

Makanyane

SAFARI LODGE

On a piece of land between the Groot Marico River and one of its lazy tributaries lies Makanyane Safari Lodge. The privately owned, 1 800-hectare property is tucked into the north-eastern corner of Madikwe Game Reserve in North West province. The size of the terrain allows rangers to take guests for exclusive game drives without the possibility of seeing another vehicle and to take them on game walks across the grass plains, where zebra, wildebeest and rhino graze.

Elephant abound in this area and are particularly fond of eating the branches, leaves and fruit of the trees that give shade to each of the eight suites. Makanyane is unfenced and it is not uncommon for elephant to wander past the glass front of your bedroom or bathroom, filling up the entire view. Even though the river is just metres away, one elephant heard the sound of tinkling water, ambled towards it and reached his trunk over the wall into the outdoor shower where a guest was having her morning wash. Both were equally startled.

Another Makanyane treat is to spend a night in the lodge's tree house – a simple double-storey wooden construction adjacent to a waterhole and accessible only to roosting birds. It has all the amenities of a good camp-out: a soft mattress, snacks prepared by the talented Makanyane chef, a spotlight, an emergency radio, a hammock to swing in and solitude. From the time the ranger drops you off until you are fetched in the morning, it is just you, the animals and the stars.

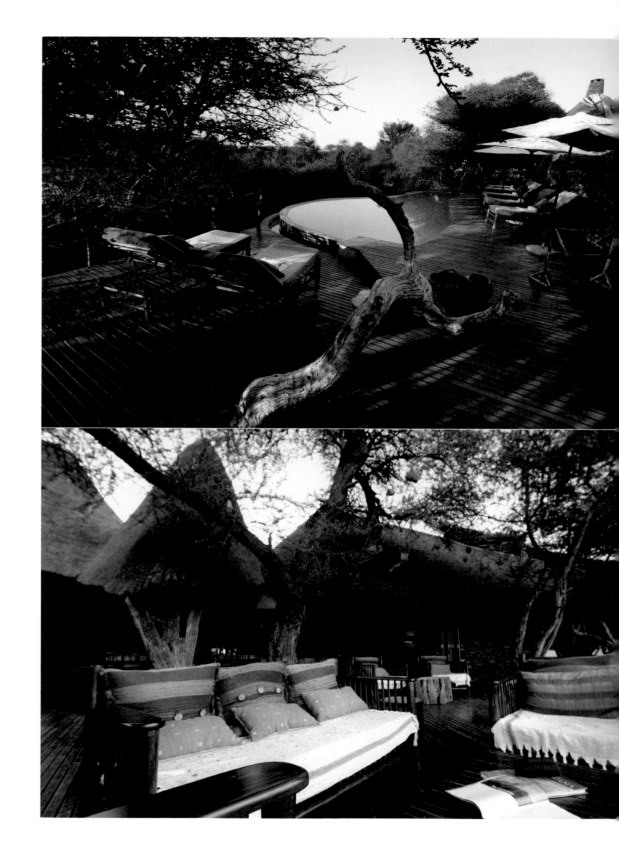

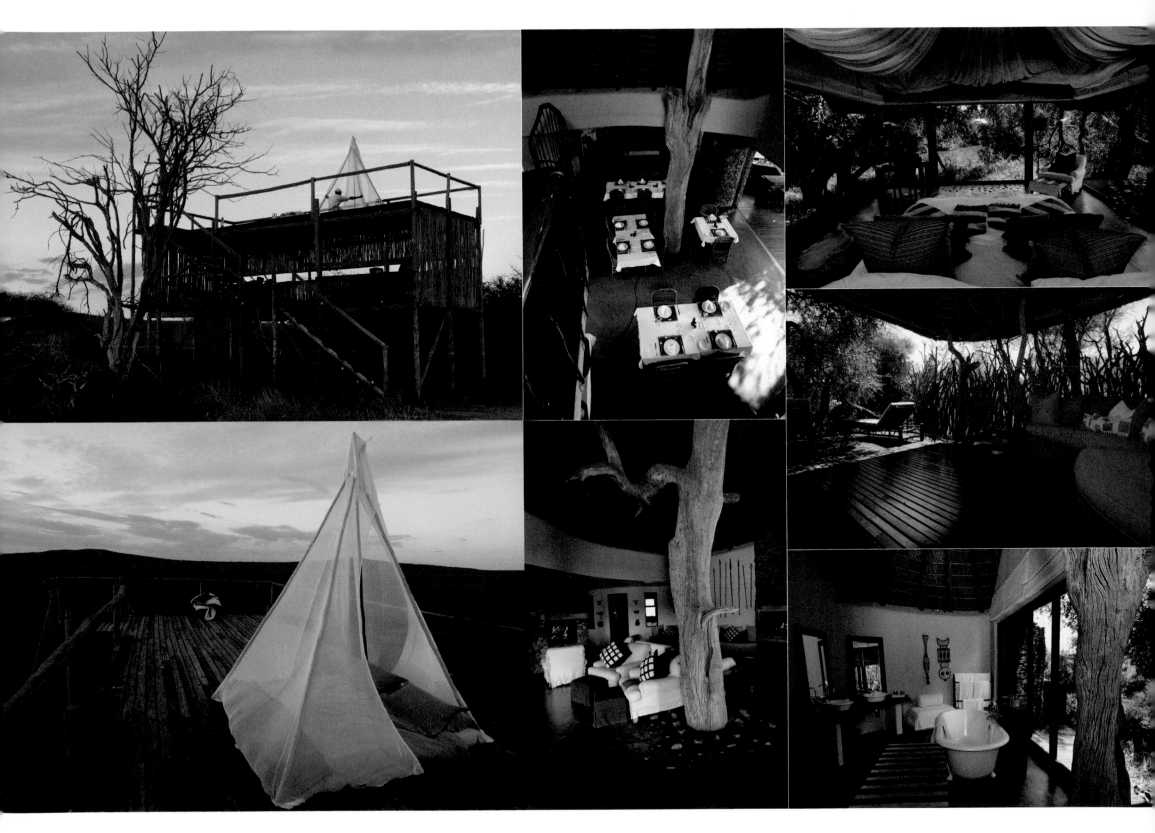

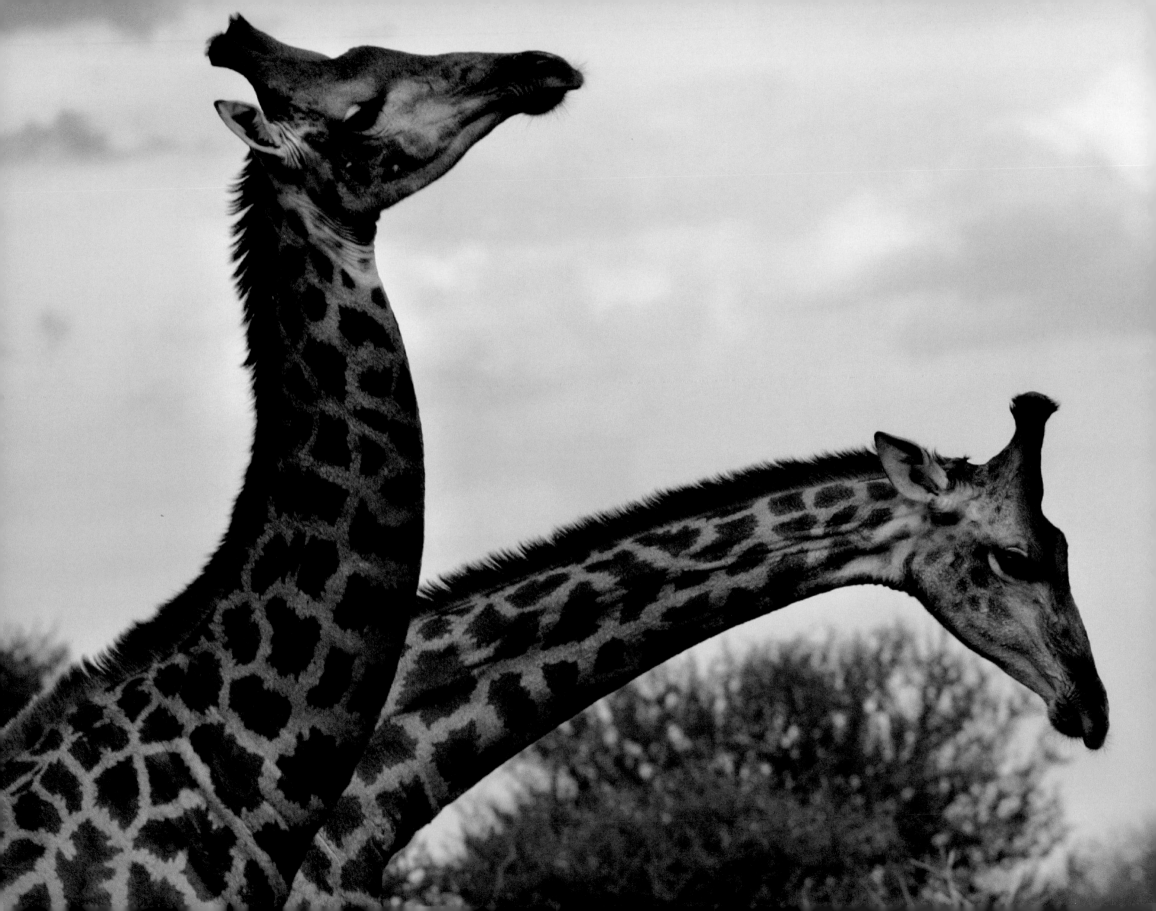

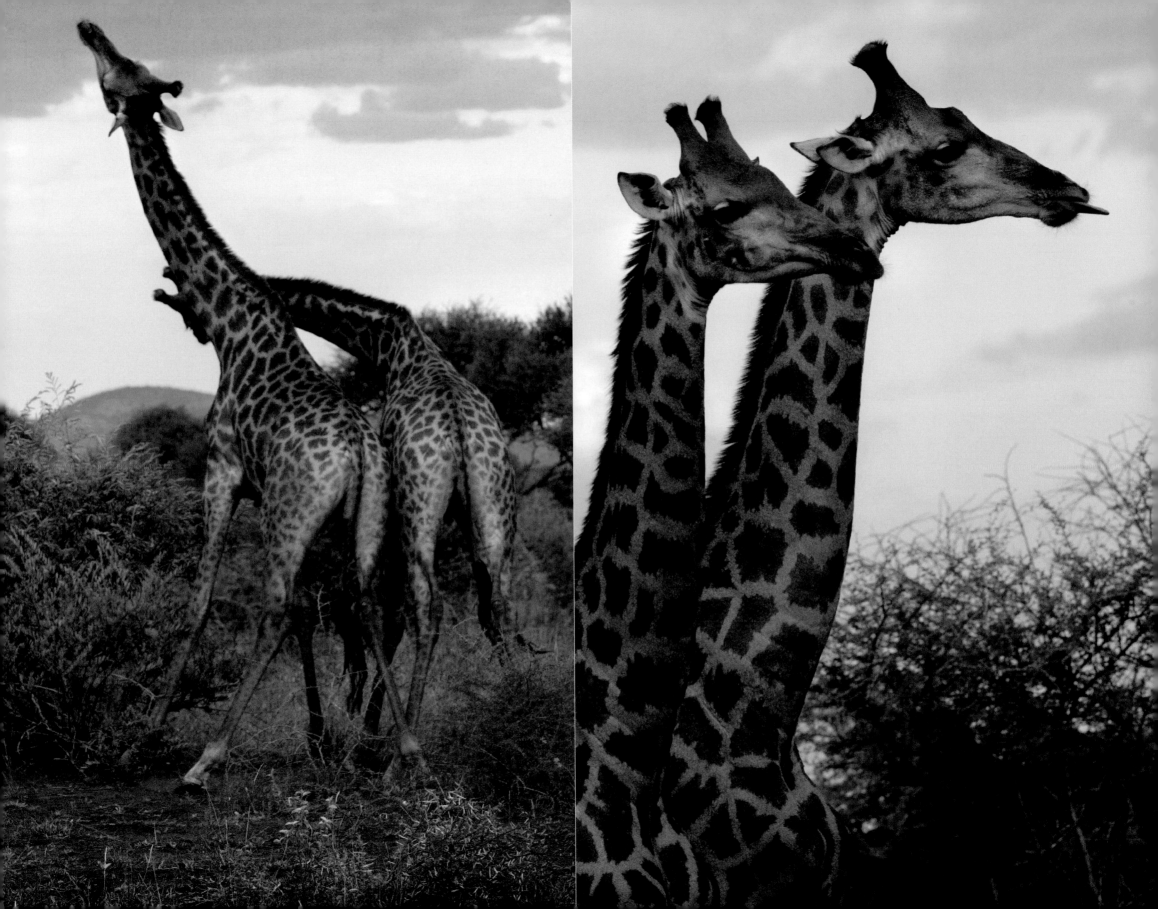

Madikwe Hills

PRIVATE GAME LODGE

Operation Phoenix in 1991 introduced 8 200 animals of twenty-seven species into the newly formed Madikwe Game Reserve, turning this area of degraded cattle farms into a reserve filled with Africa's big game. Madikwe has thrived and boasts of having cheetah and wild dog on top of the traditional Big Five.

Many of these animals can be seen without even moving from your bed or private dip pool in your suite at Madikwe Hills Private Game Lodge, as there are several waterholes around the lodge. Elephants have turned the waterhole in front of the dining terrace into a giant mudbath and regularly entertain guests with their antics.

All of this activity is seen from above, since the lodge and rooms are cleverly concealed among the rocks of a steeply inclined hillside. Stone in many forms is used to good effect throughout the lodge. In places, natural granite boulders intrude politely into the rooms, creating a synergy between the refined interior and the rugged outdoors. This gives Madikwe Hills a feeling of solidity and of connectedness with its natural surroundings.

Madikwe Hills is arguably one of the most sophisticated safari lodges in the reserve. Top-class cuisine comes out of the kitchen of executive chef Marita Pelser, whose passion for food is evident in the rich flavours and immaculate presentation of her culinary creations. Another elaborate touch at Madikwe Hills is the freshly drawn, candlelit bubble bath, complete with rose petals floating on the surface, that awaits you when you return from your final evening game drive. It is this exquisite attention to detail that puts Madikwe Hills in a class of its own.

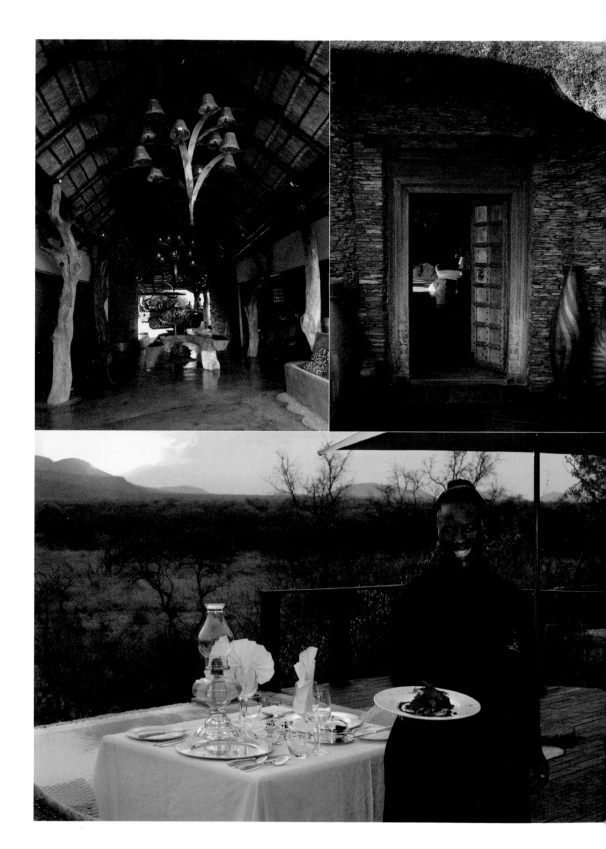

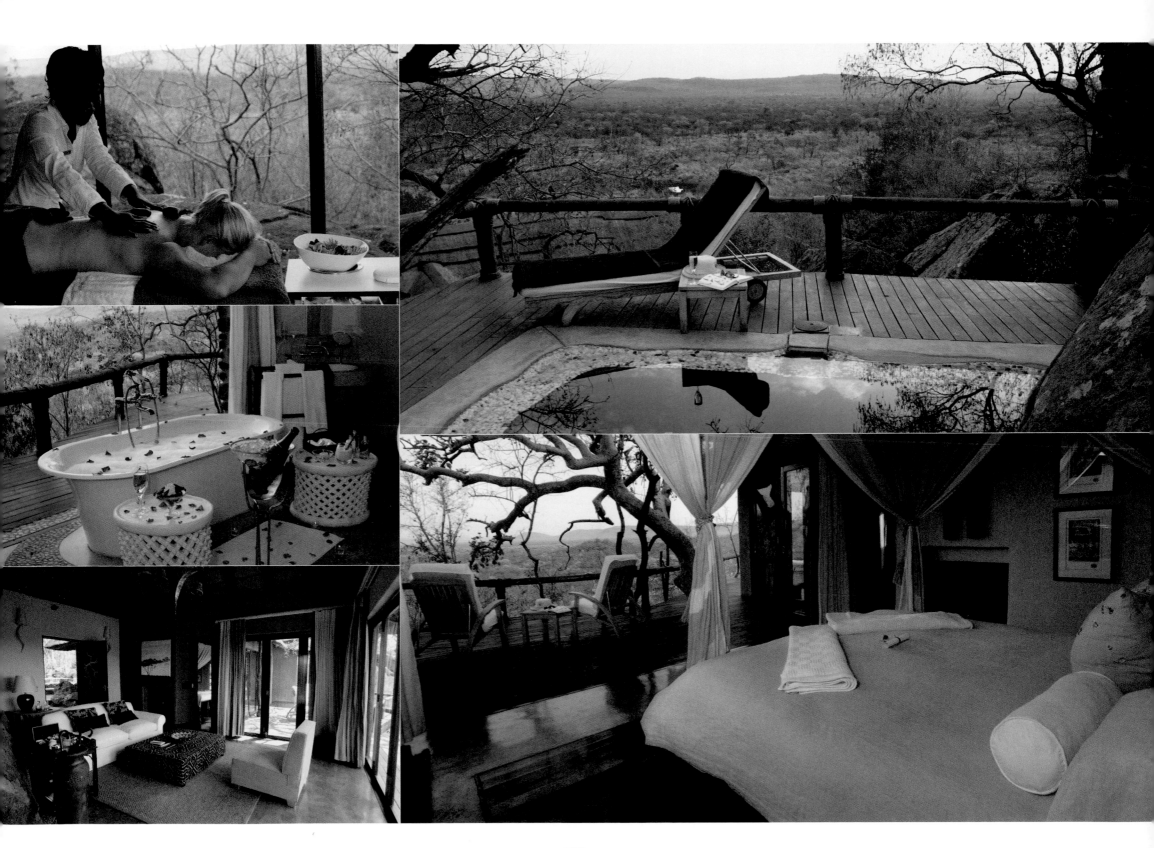

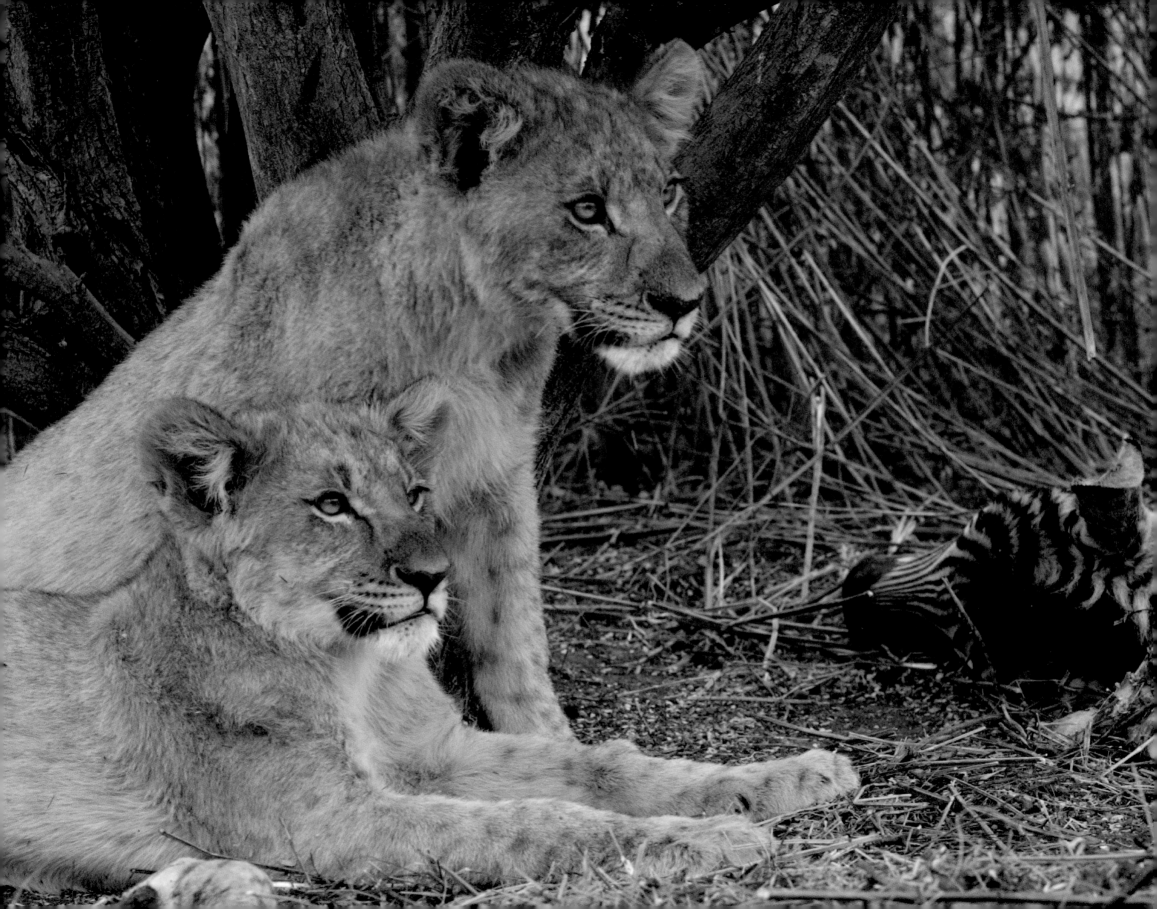

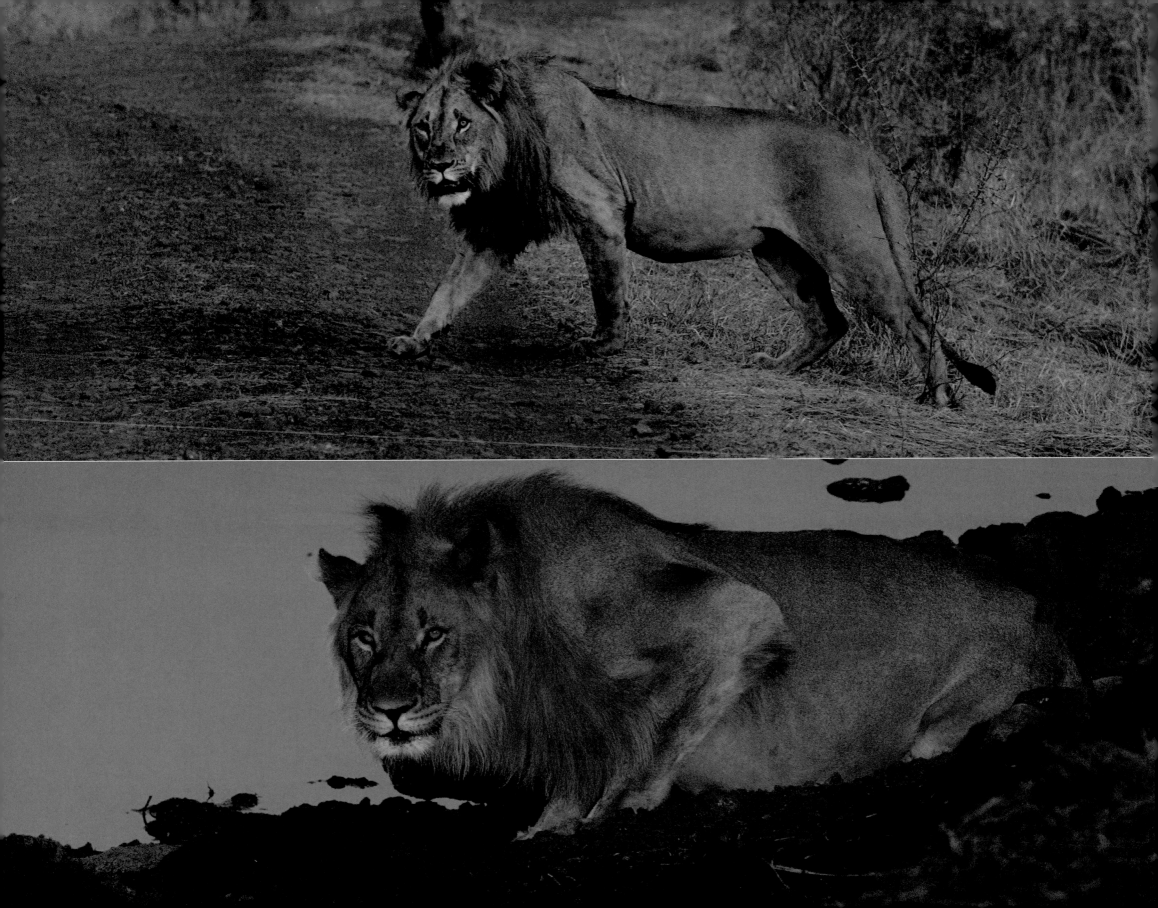

Rhulani

SAFARI LODGE

Where other safari lodges have named themselves after animals, Rhulani Safari Lodge in Madikwe Game Reserve has chosen a word that is both instructive and conceptual. *Rhulani* means 'to relax' in the Shona language. With this in mind, a private plunge pool takes pride of place on the teak deck of each chalet, aimed at enticing guests into the required state of relaxation. And to make sure there is always an opportunity to take the heat out of a sweltering Madikwe day, a sculpted-rock swimming pool has been incorporated into the wooden deck that flows seamlessly alongside the main lodge building.

The pool's curved edges mirror those of the game waterhole immediately opposite, where elephants often congregate. Sometimes, instead of drinking from the muddy waterhole, the pachyderms take their fill from the plunge pools, regardless of whether guests are in them – although a safer place would be watching the event from inside the glass-doored chalets.

Surprise visits from the local wildlife are possible because, unlike most other safari lodges in Madikwe Game Reserve, Rhulani is not fenced. This allows nature to come closer than you ever thought possible and means that rangers need to escort you to your chalet at night.

Rhulani's aim to nourish your soul and lift your spirits is applied in many ways. Even delegates in the lodge's conference centre find that they succumb to the tranquillity and harmony of Rhulani. For them, it makes it a little easier to solve complex business problems right here in the heart of the African bushveld.

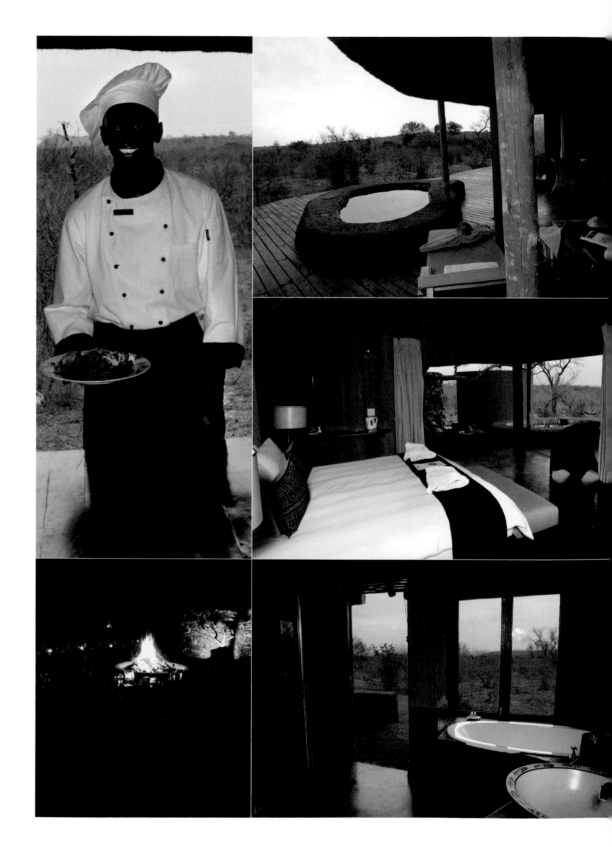

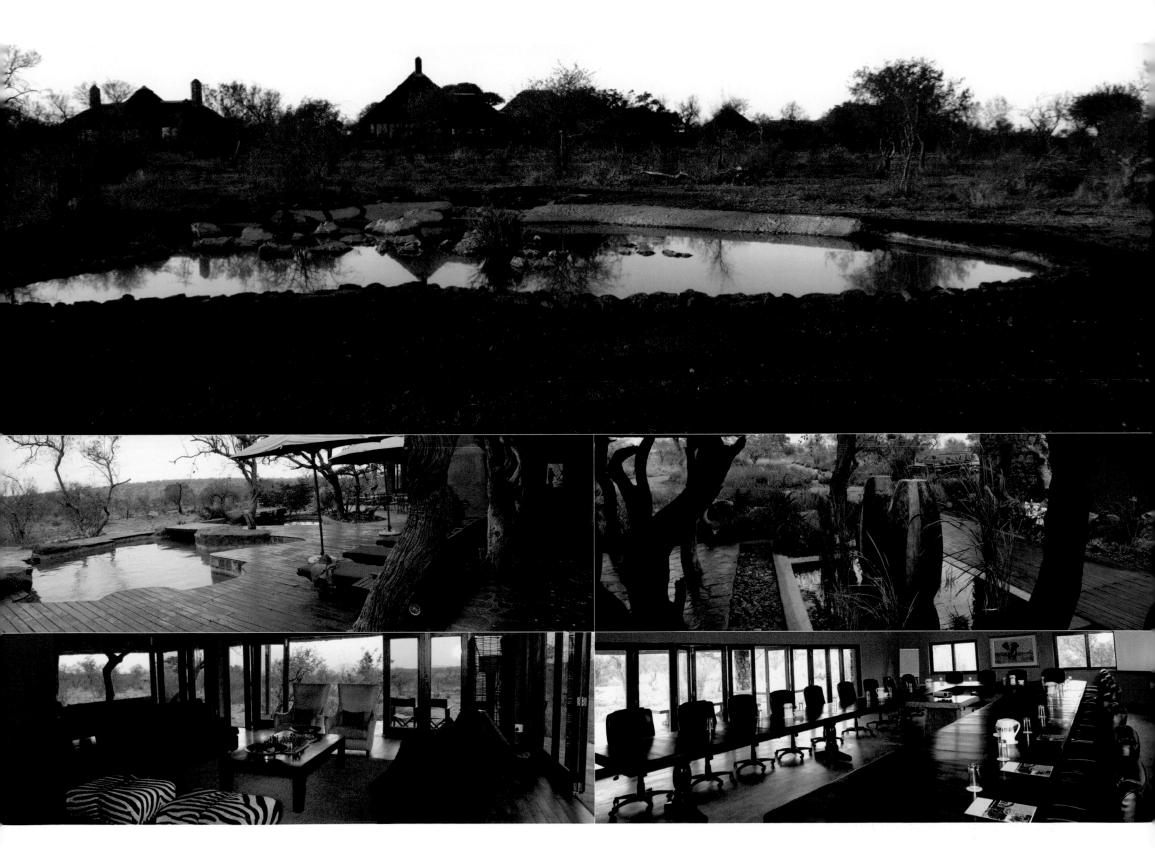

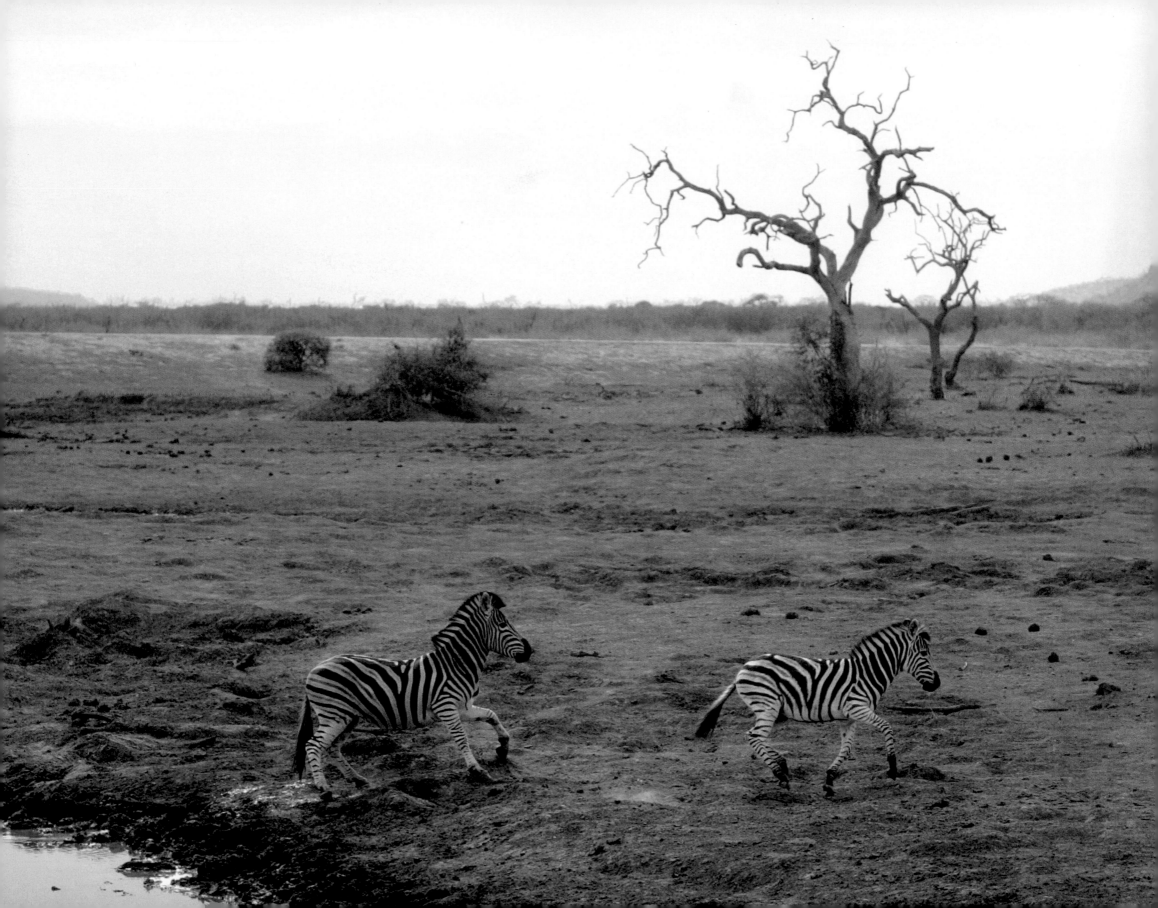

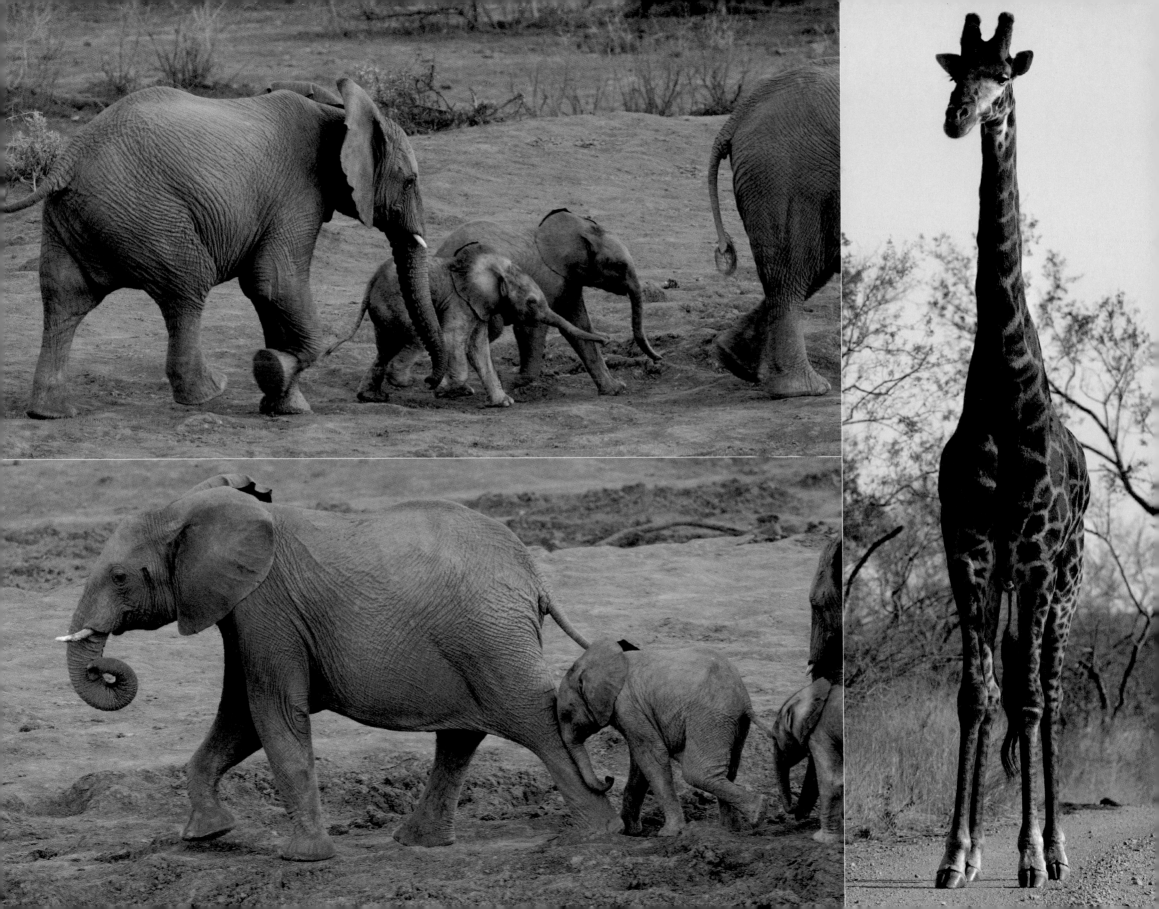

Tau

GAME LODGE

Even though Tau Game Lodge in the malaria-free Madikwe Game Reserve is large enough to accommodate up to sixty people, there is a tranquillity about the place. This could be attributed to the long, meandering waterhole, on whose banks the safari lodge's thirty rustic cottages are situated. Each little waterfront balcony gives a slightly different view of the constantly changing scene in front of it, and the variety of creatures that pay a visit to the waterhole is entertaining enough to consider missing a game drive.

Bird lovers and photographers are spoilt for choice. Spoonbills, African jacanas, herons and egrets come within easy reach of camera lenses, as do herds of golden impala, bathing elephants and mud-wallowing warthogs. Lions slink in for a drink, causing a great stir among the other animals, including the elephants, who acknowledge the arrival of the big cats by trumpeting loudly. Tau is not called 'Place of the Lion' for nothing.

The Madikwe bushveld in North West province may seem an unlikely place to find a state-of-the-art conference facility, but tucked away at the rear of the lodge is an amazing wood-and-thatch building so technologically advanced that temperature, lighting and audio-visual equipment are controlled by the touch of a screen.

To cater for all the safari guests, wedding parties and conference delegates, the Tau kitchen has to run like clockwork. This is the job of executive chef Johan Kemp and his colleague, chef Petrus Khoali, whose inspired food creations include tender ostrich fillet kebabs and red onion with a mixed berry salsa and a starter duo of smoked salmon and springbok carpaccio.

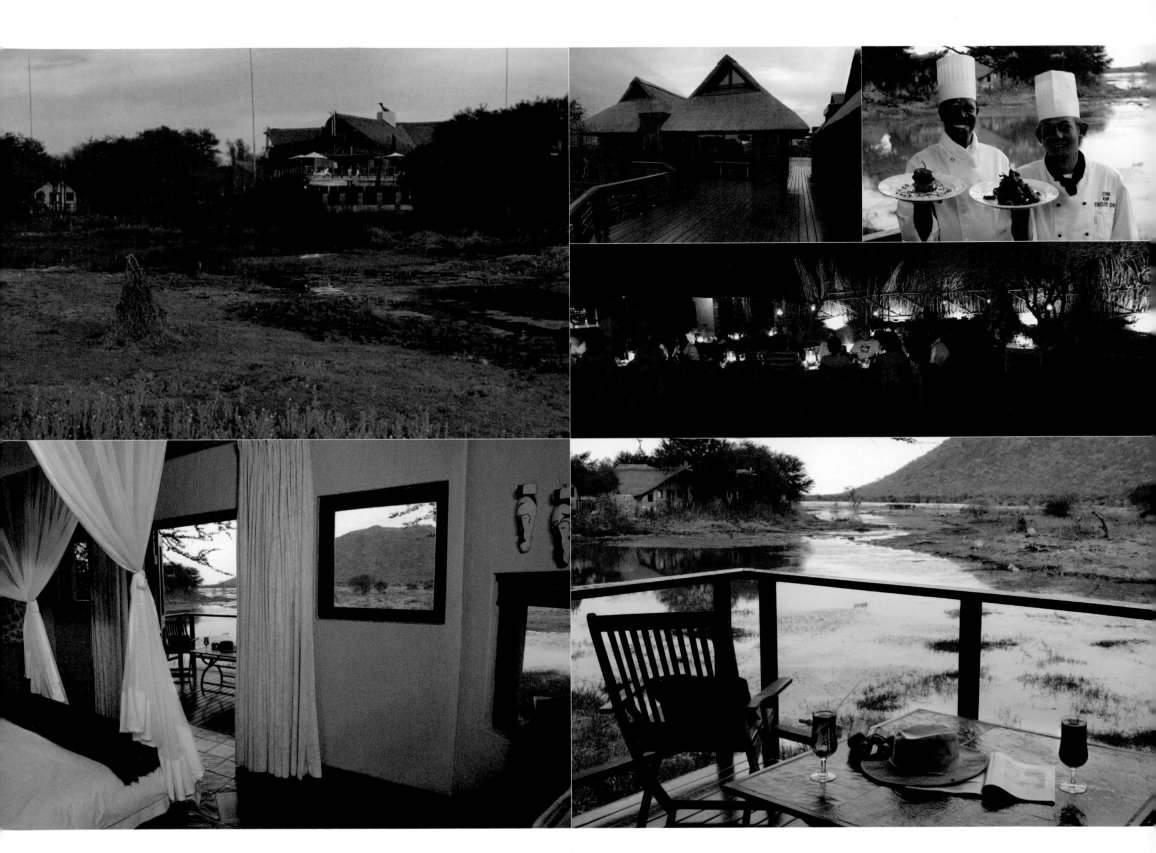

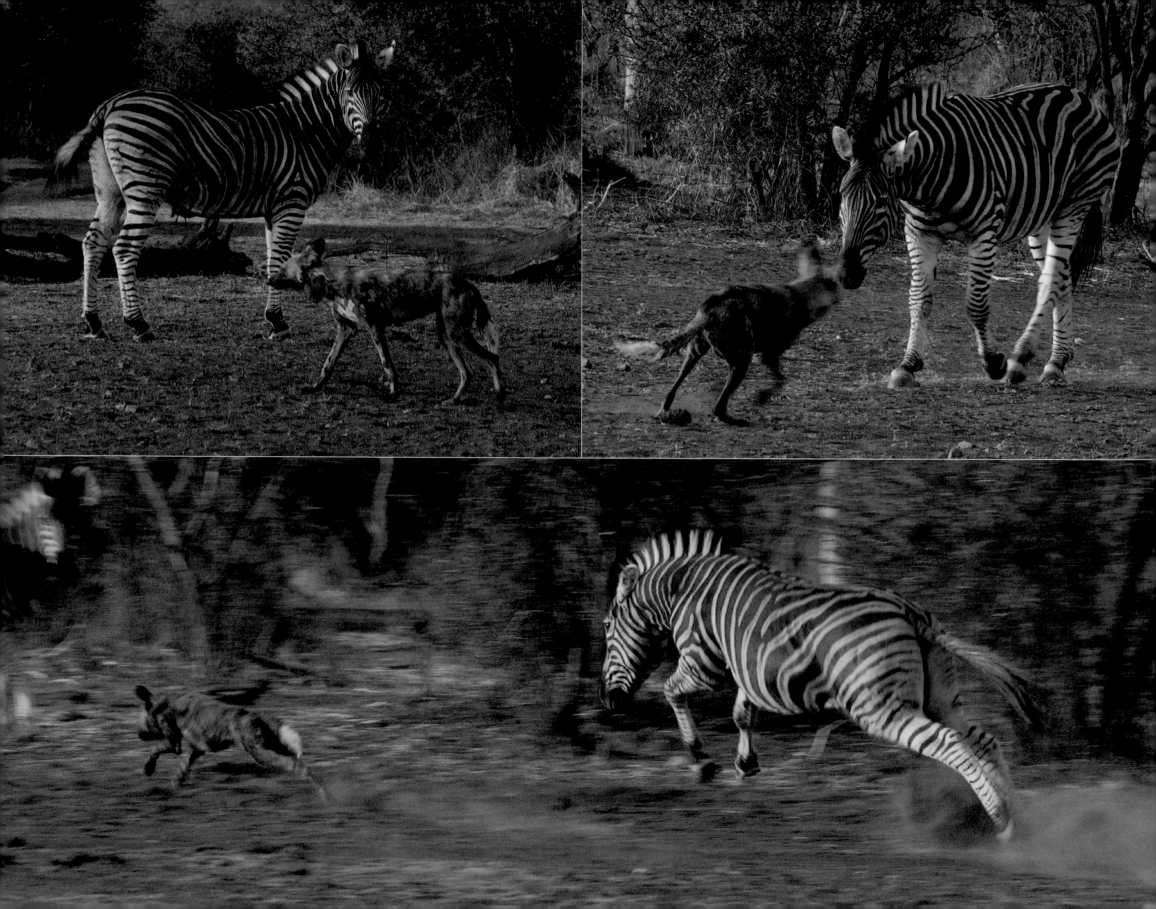

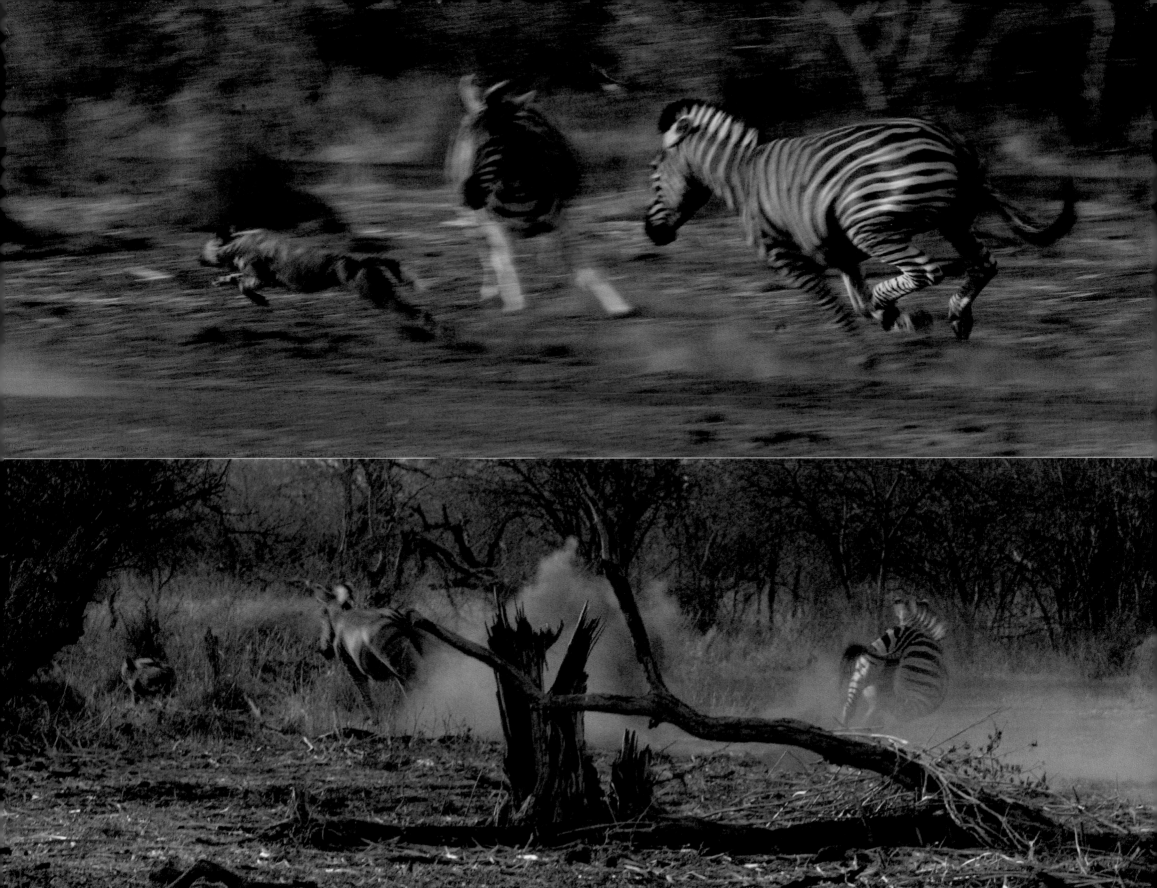

Tuningi
SAFARI LODGE

The recipe for a successful holiday is when each member of the family has a uniquely enjoyable time. This is what Tuningi Safari Lodge in Madikwe Game Reserve in North West province manages to do with apparent ease. Here, five-star bush luxury is combined with all the comforts of a child-friendly environment, without compromising either style or service.

The lodge's exclusive villas have been designed to reflect the sense of spaciousness evoked by the surrounding environment. Generously proportioned suites, high vaulted thatched ceilings, retractable doors and windows, and wooden decks from where you can view the wildlife create an organic flow between sumptuous interiors and the wild outdoors.

Guests can expect to be pampered, and a certain intimacy arises from warm relationships with staff and from sharing experiences with a maximum of only sixteen other guests. Seeing children enjoying their animal-tracking lessons or roasting marshmallows over a fire adds to the sense of wellbeing.

Meals follow the rhythm of the bush and begin with a hearty mid-morning brunch after the early-morning game drive. This is followed by a period of rest, only to be interrupted by mid-afternoon high tea served with delectable finger food and enticing gateaux. Switch to fine dining at dinner time or a surprise barbecue in the circular wooden boma, with tables arranged around a central blazing fire under the protective canopy of an ancient *Ficus tuningii* – the giant fig tree after which the lodge is named.

It takes only a few hours of relaxation at Tuningi for you to be convinced that this desirous place should be your second home. In the words of one guest: 'My trip was a 10 on all levels. Some moments I actually thought I'd died and gone to heaven! Now back in California in body and mind but with some of my soul left behind...'

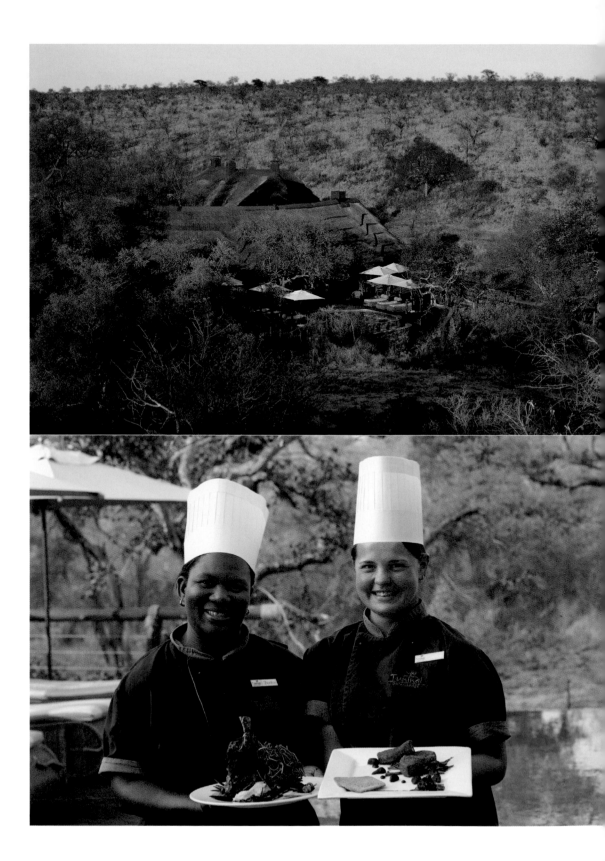

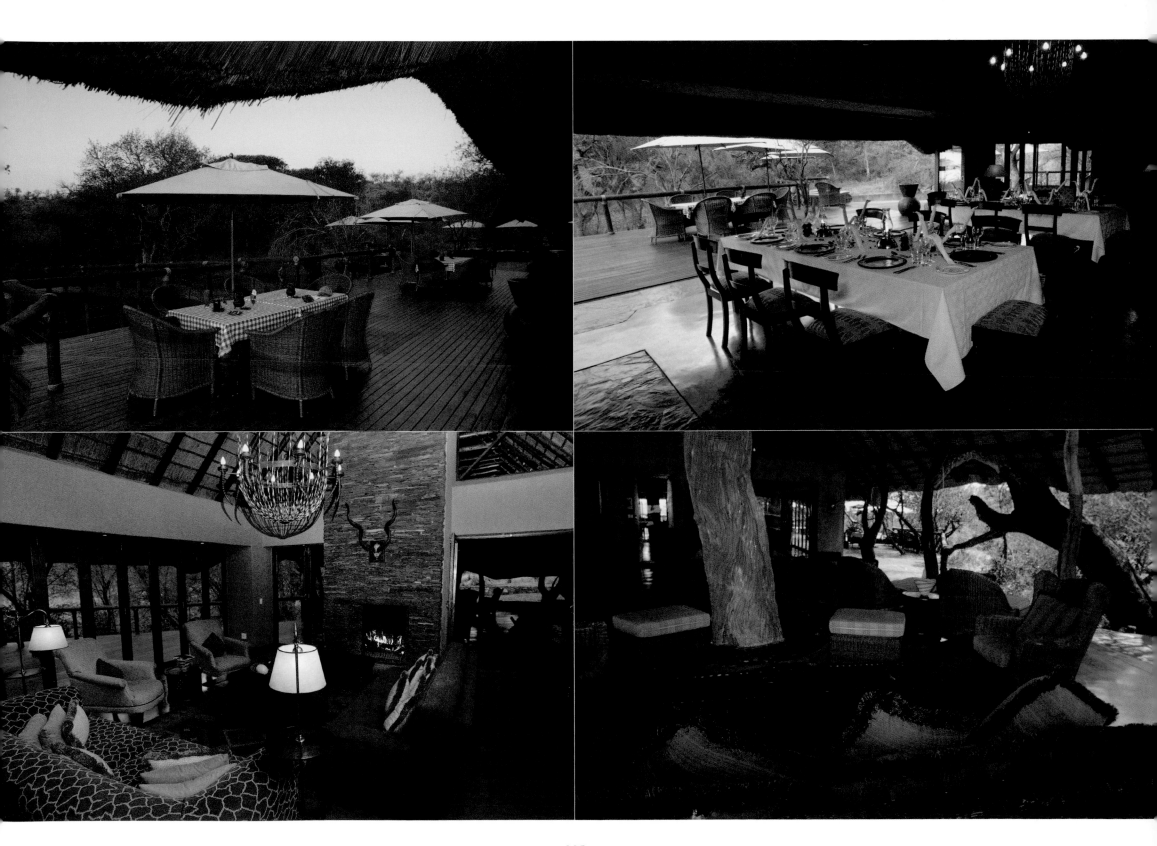

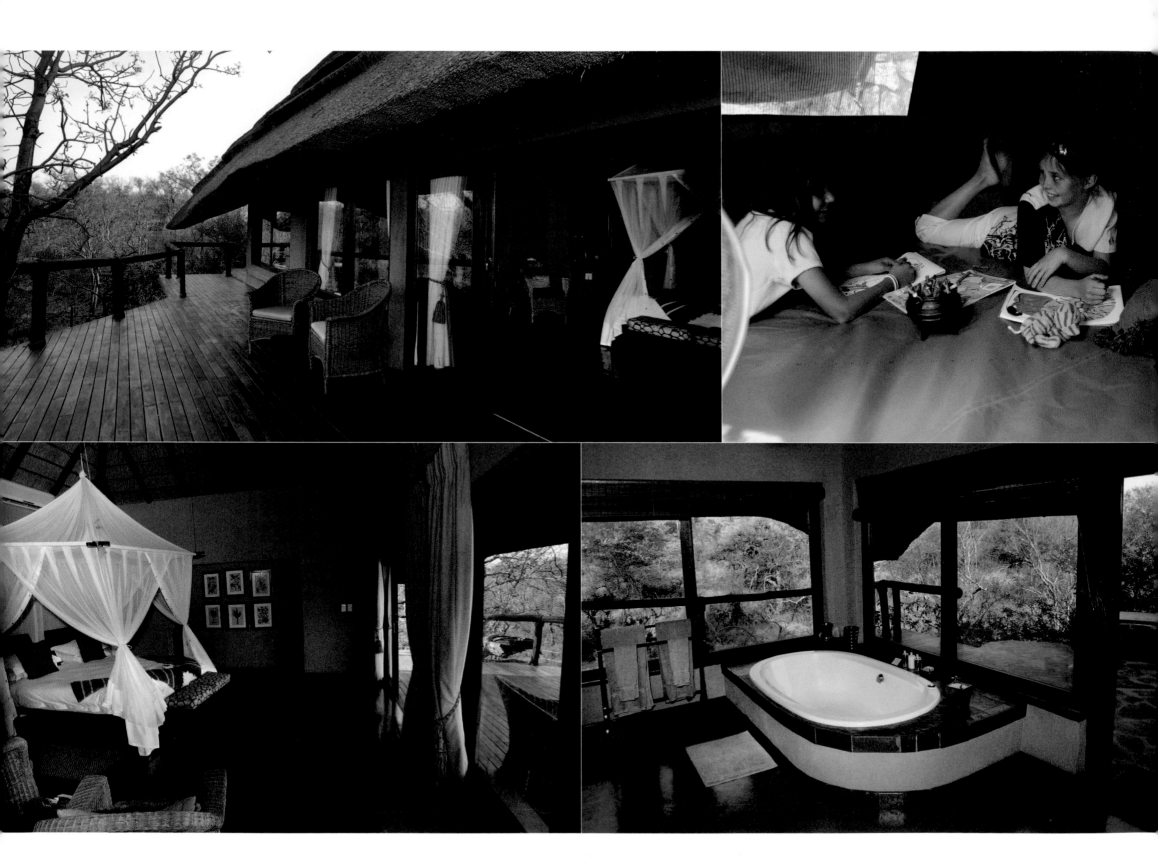

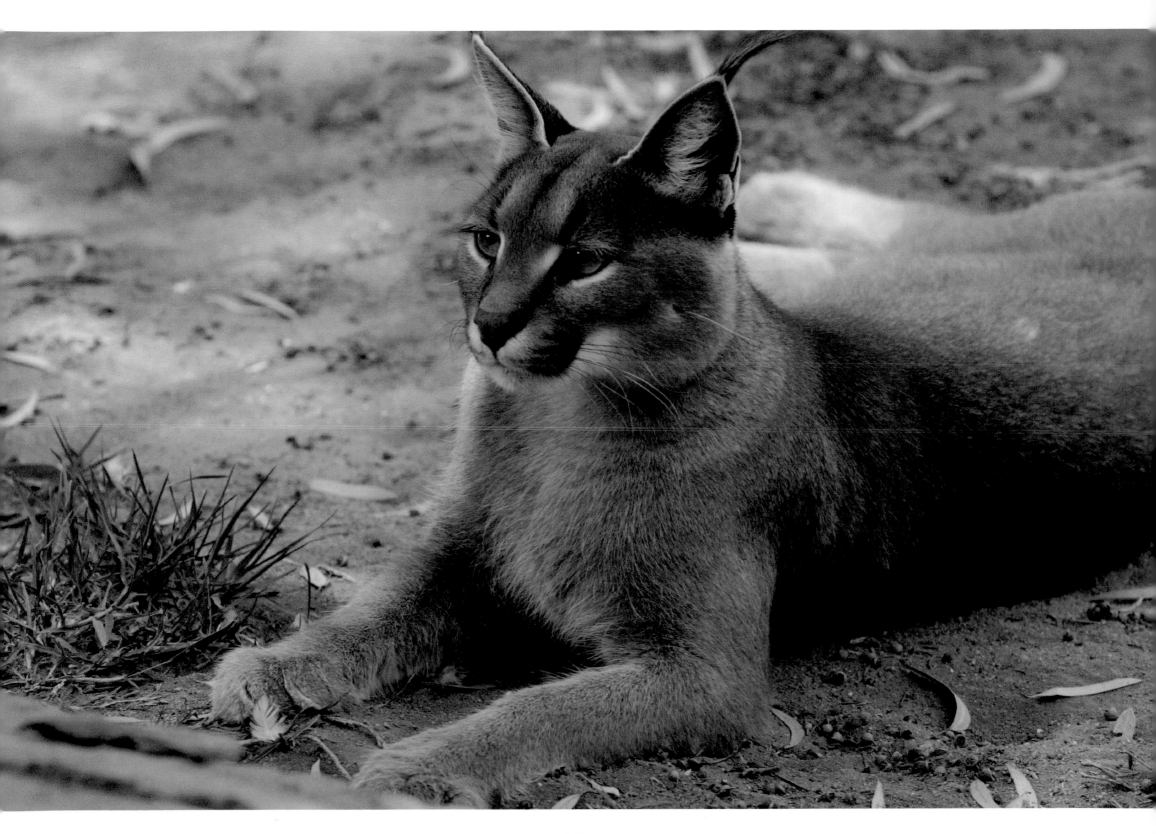

Ivory Tree
GAME LODGE

In the north-eastern region of the Pilanesberg National Park in North West province is an ancient amphitheatre flanked by volcanic spires and rolling savanna grasslands. This fertile basin of riverine woodlands is the location of Ivory Tree Game Lodge.

Sixty thatched chalets, each with its own wave-motif shower open to the sky, are tucked among the trees and granite outcrops of this landscape. The chalets have spectacular views of the surrounding foothills and thigh-high grasslands. Open grass clearings in the park are grazed by a variety of animals, including zebra, wildebeest and white rhino. Every animal has its place in the ecosystem and predators like lion, leopard, cheetah and wild dog help keep antelope numbers in balance.

Besides relaxing on your daybed on the thatch-covered veranda of your chalet, there are myriad exciting activities to keep you occupied at Ivory Tree: a bird expert will guide you on a birding safari, a frog specialist will help you search for the eighteen species of frog and toad in the park, and an astronomer will unravel the secrets of the southern hemisphere night sky. If sighting game is what you are after, stick close to your assigned guide who will take you on a game drive in a specially adapted open game vehicle, and let him or her interpret the awesome sights and sounds of the African bush for you.

For those who want something more challenging, Ivory Tree's 'Amazing Race' will contribute to making the holiday an unforgettable experience. Accompanied by a guide and equipped with GPS hand units, a fictional budget and resources to buy information, teams of seven to ten guests per Land Rover have to navigate themselves through the African bush. Teams usually have a time limit of three hours in which to accomplish all the tasks set for them, although tailor-made games could last for several days. This highly popular activity affords guests the opportunity to experience the thrill of the African bushveld up close while having a great deal of fun in the process.

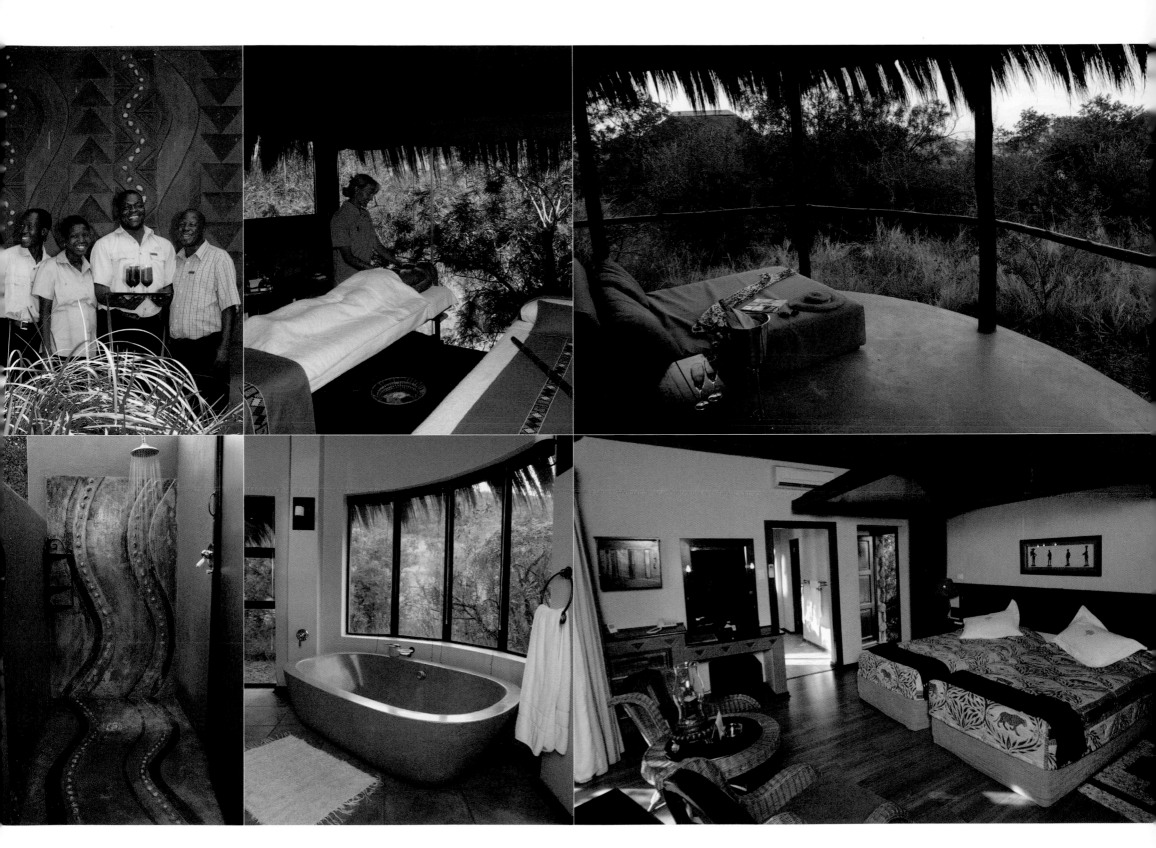

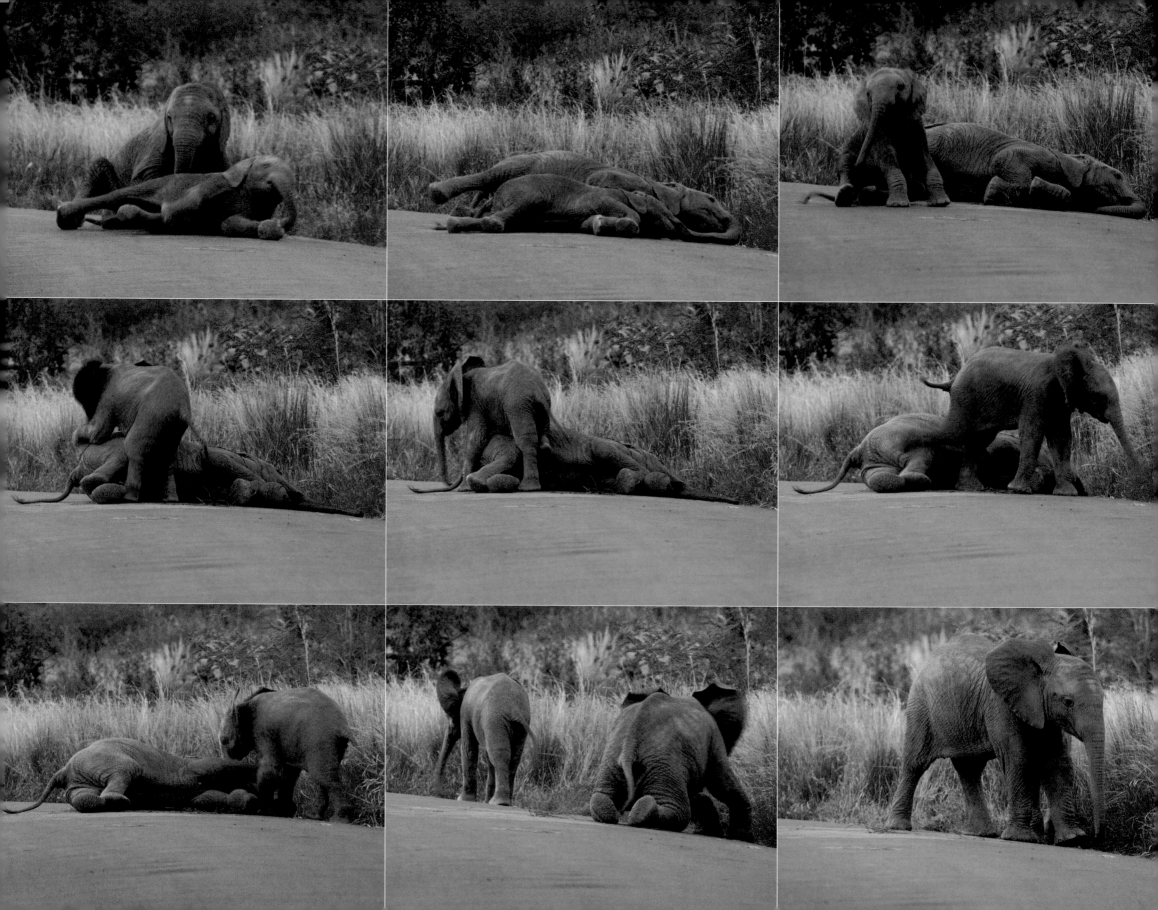

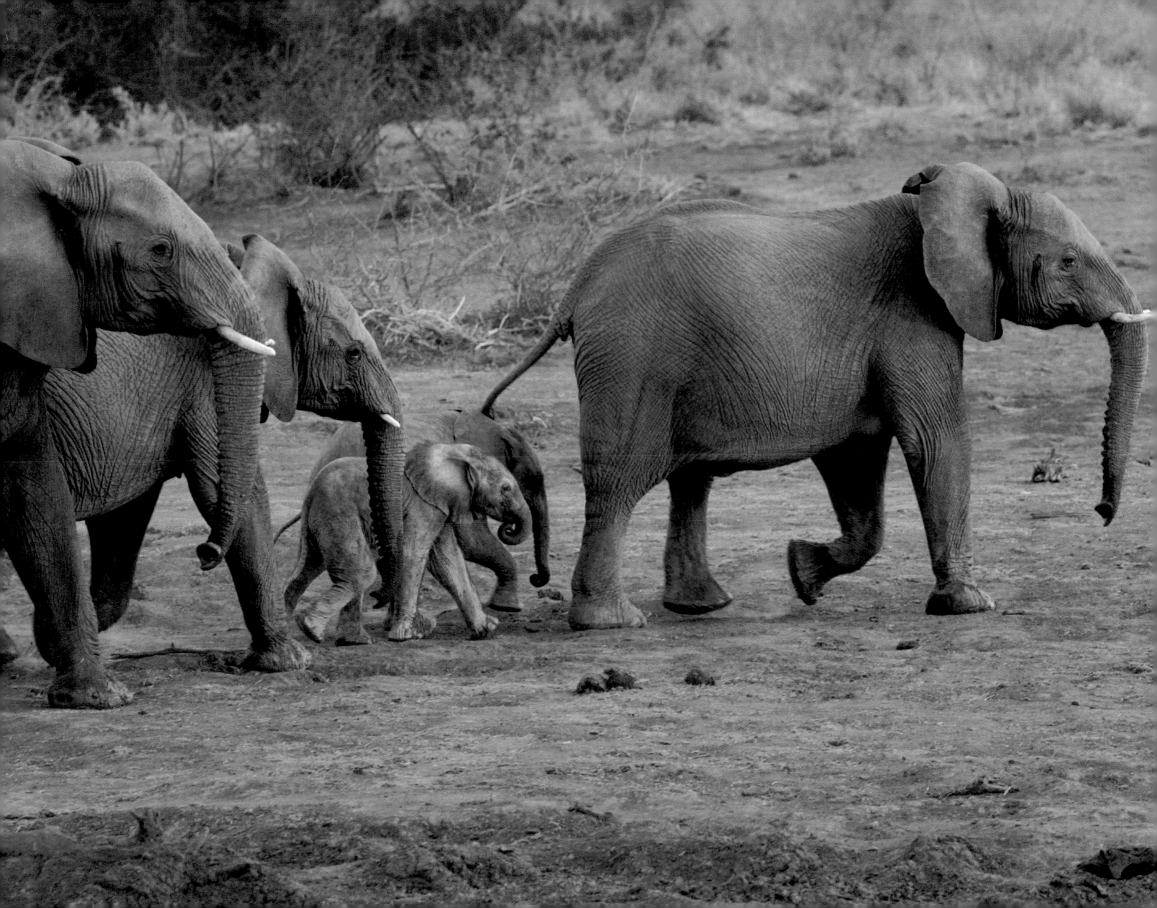

Tswalu

KALAHARI RESERVE

The Kalahari is a rich, red sea of undulating sand topped with grasses, shrubs and trees – not at all the empty pale desert you might have expected. There are even mountains in this remote corner of the Northern Cape, which is so far from anywhere that maps show few roads and even fewer signs of human habitation. In this vast open space you will find Tswalu Kalahari Reserve.

Tswalu is the largest private game reserve in southern Africa. Since this 100 000-hectare reserve was first established, animals like black rhino, buffalo, lion, cheetah, sable and roan antelope have been reintroduced.

This is truly one of the wildest parts of South Africa and, considering the region's limited rainfall and extreme temperatures, may seem like a difficult place to live. Yet the San (Bushmen) have inhabited the Kalahari for thousands of years. Even visitors who have come and gone feel its ancient soils and wild open spaces calling them back.

The Kalahari has a unique appeal and there is no reserve that better takes advantage of this allure than Tswalu. Tswalu's two lodges – Motse, with eight bungalows in a village setting, and Tarkuni House, a separate, freestanding luxury home that sleeps eight – are the epitome of style and elegance. Local natural materials were used to create these rustic yet elegant dwellings. Curved stone walls and thatched roofs form an organic whole, blending with the surrounding landscape.

Tarkuni House, a forty-five-minute drive from Motse, is set amid rolling hills. Tarkuni is ideal for small groups or families of up to eight people. With a nearby waterhole and its own swimming pool, private game-viewing vehicle and dedicated chef, Tarkuni has all the comforts a visitor would need.

Game drives, bush-walking trails and horseback safaris are but some of the activities guests can enjoy during the day. At night, cloudless skies are ideal for stargazing. Soon the clear skies, ochre sands and majestic mountains of Tswalu will cast their spell on you. Do not even try to resist.

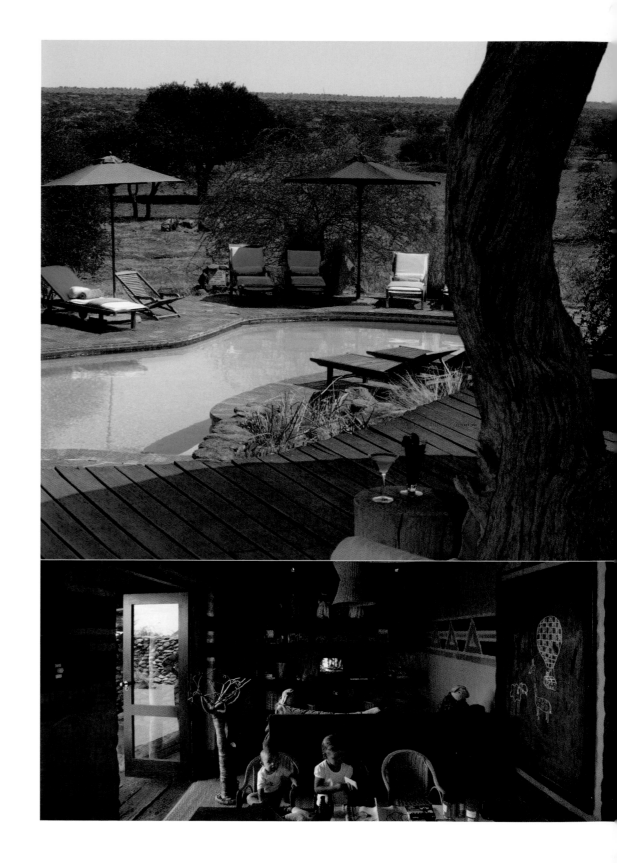

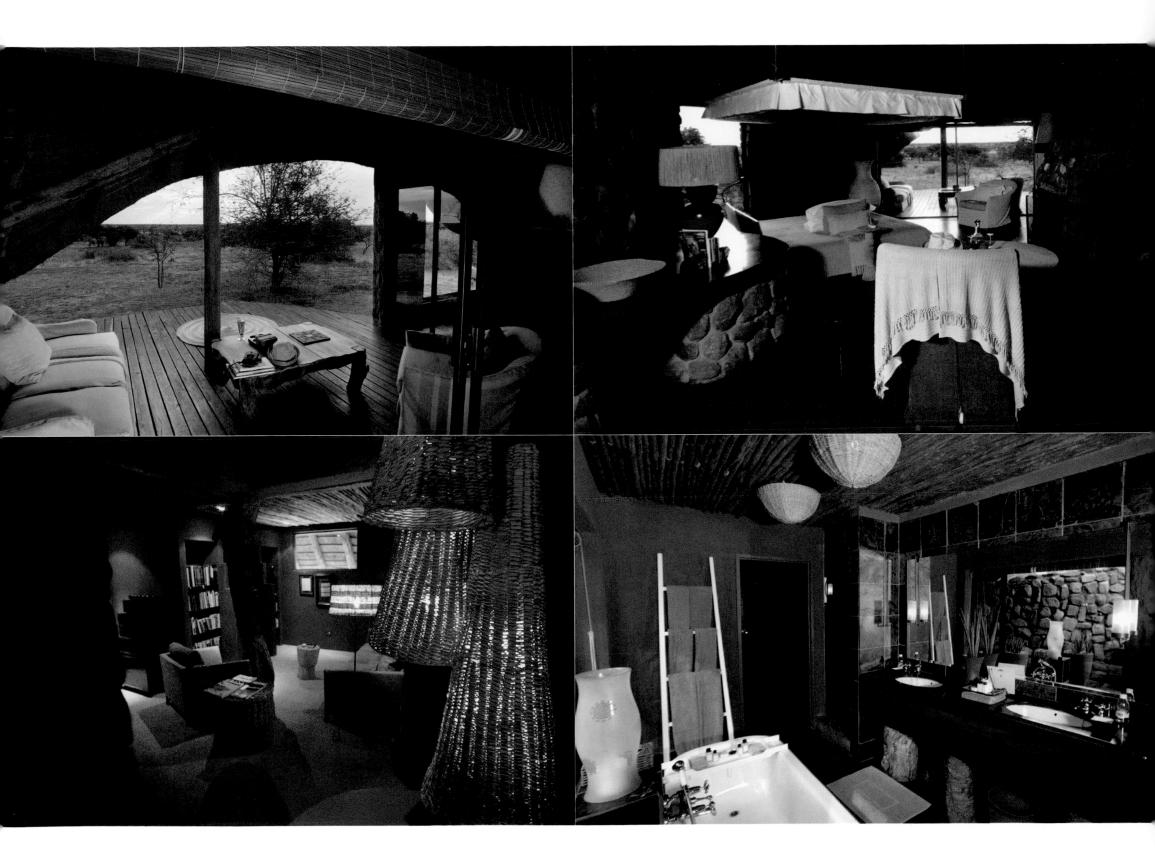

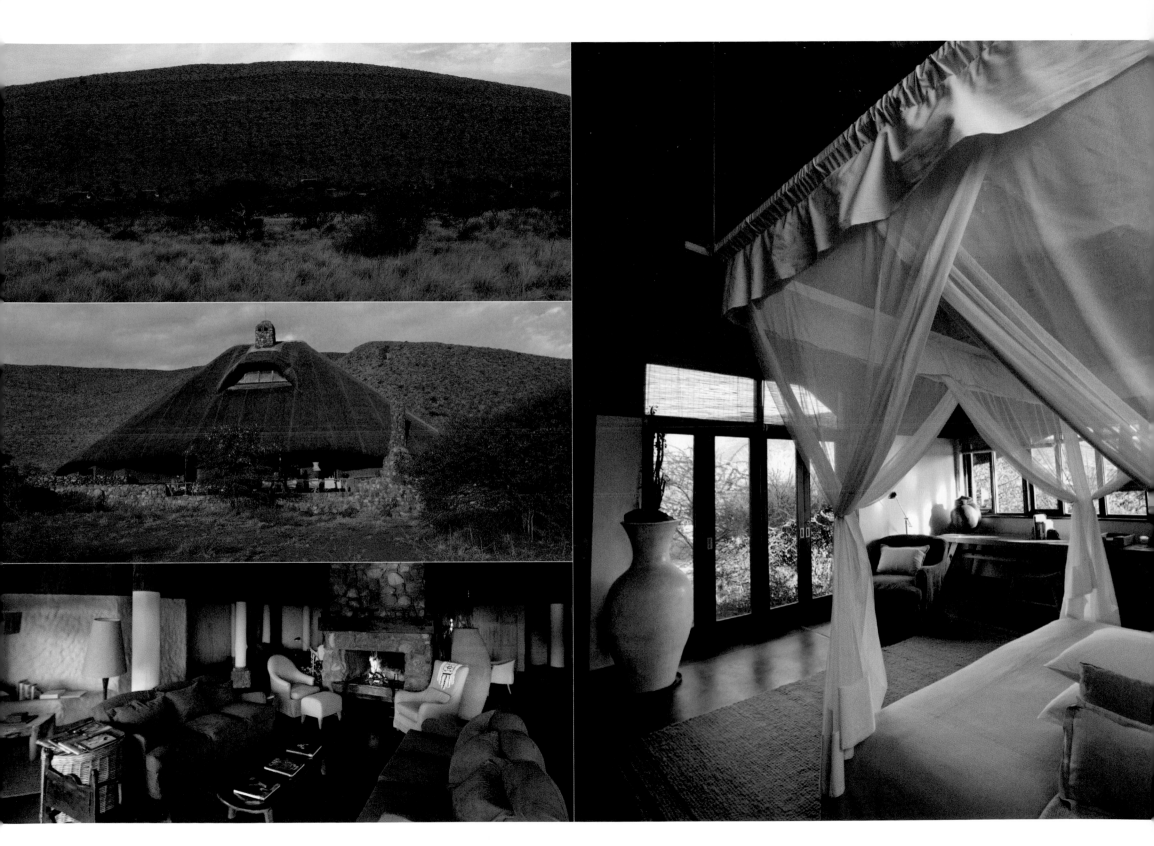

Aquila

PRIVATE GAME RESERVE

At Aquila Private Game Reserve, just under two hours' drive from Cape Town, the Karoo scrubland rises into majestic peaks, with beautiful golden escarpments dipping into sandy valleys mottled with small dark-green aromatic bushes. Aquila is full of the game that used to roam this dry interior. Here you will find the greatest quantity and variety of wild animals in the Western Cape, including the Big Five and a range of plains animals.

It is also an area of great habitat diversity: the distinct biomes of succulent Karoo, fynbos and renosterveld, the world's rarest biome, can be found at Aquila. This ecology is explained fully by the passionate rangers who make your stay so special. Let them show you the reserve in a Land Rover or get on a horse or quad bike and feel the freedom of riding with animals.

The Karoo colour palate of greys, ochres, browns and sand is mirrored in Aquila's luxury cabins, which are constructed of hefty local stone and faded poplar logs topped with a darkening thatch. They blend perfectly into the hillside. The thick, stone walls are tempered by soft cushions and a fluffy white duvet on a gigantic log four-poster. This Flintstones-with-style ambience is further enhanced by carpets on the stone floor and a flaming fire on cold nights.

Strolling to the main lodge, you may bump into smaller wild animals; the cute meerkat family is the most photogenic. Lunch and dinner are buffet style with superb salad bars, vegetable in sauces, rich stews and great slabs of roasted meat, including local venison like springbok or cholesterol-free ostrich. Forget about watching your waistline at Aquila.

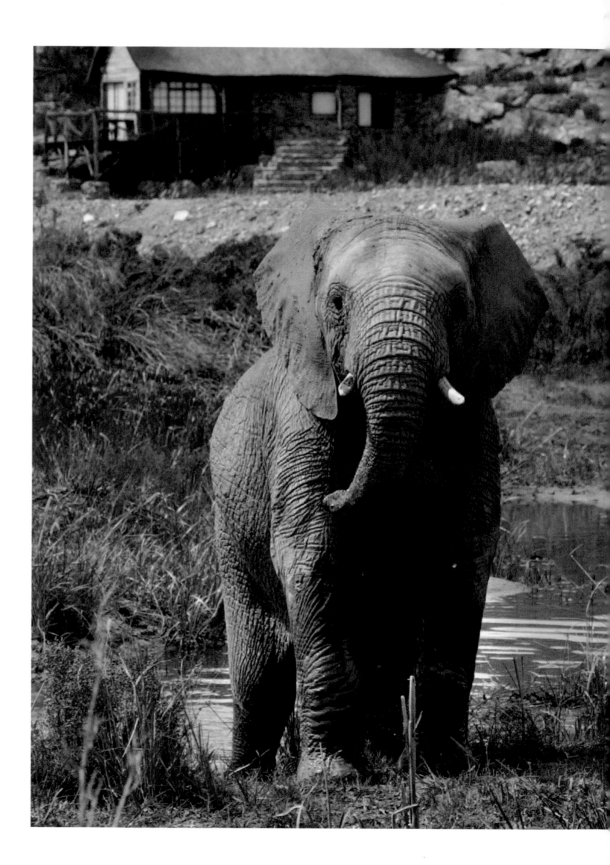

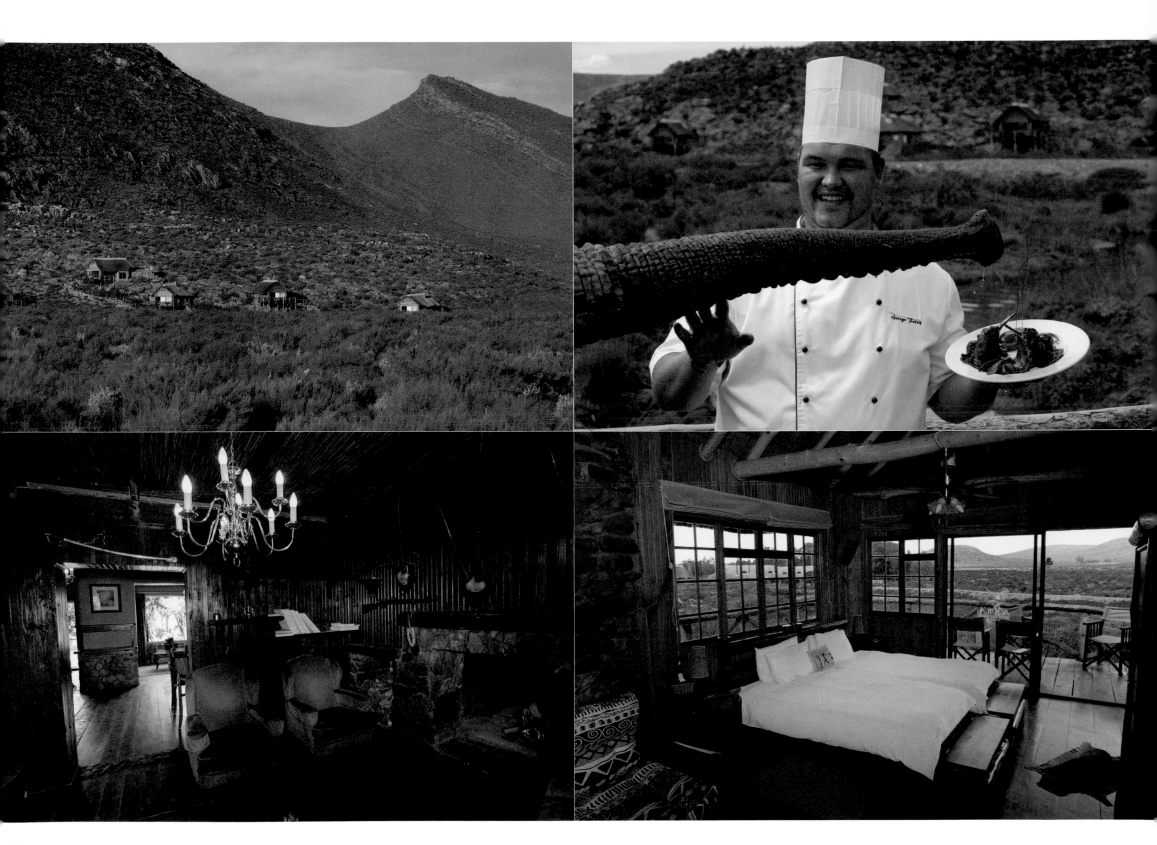

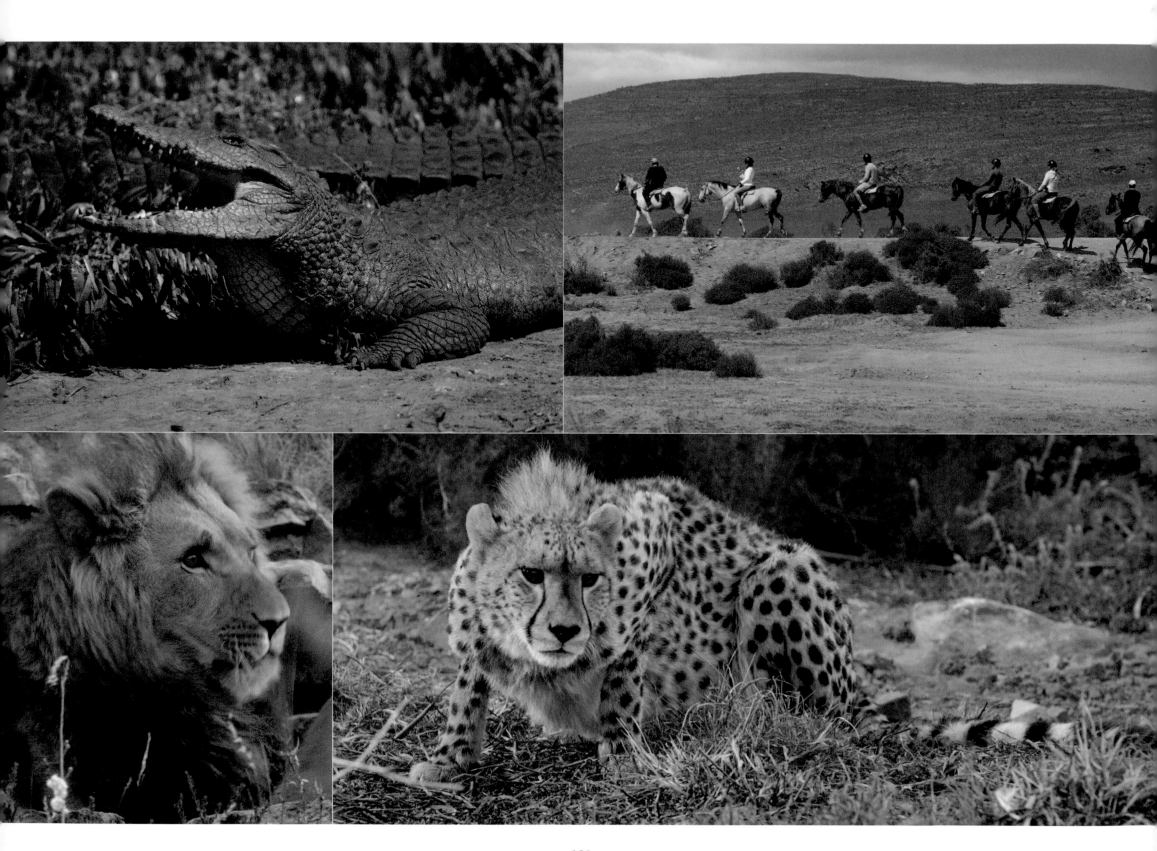

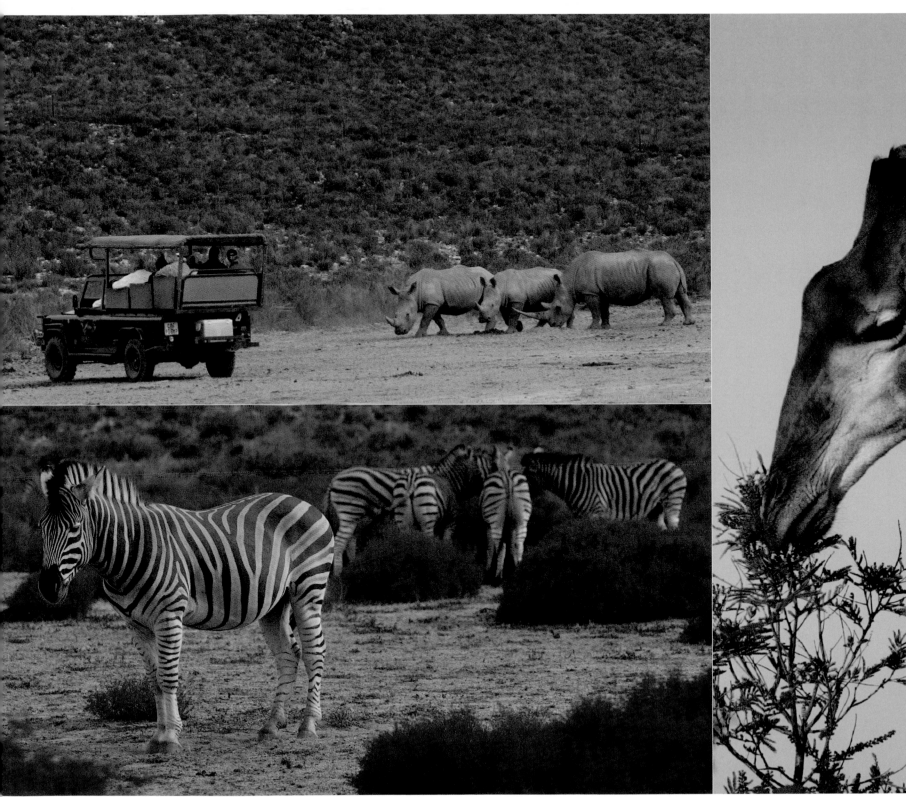

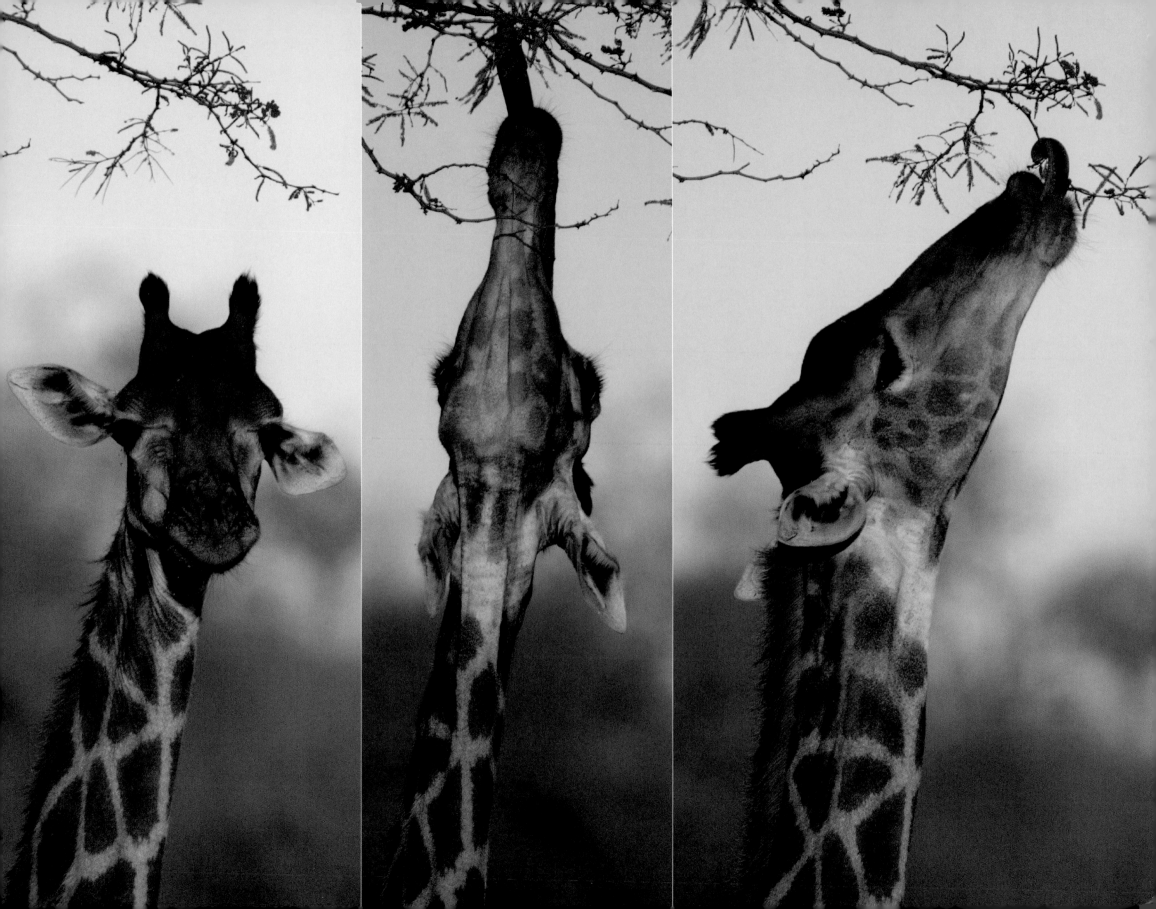

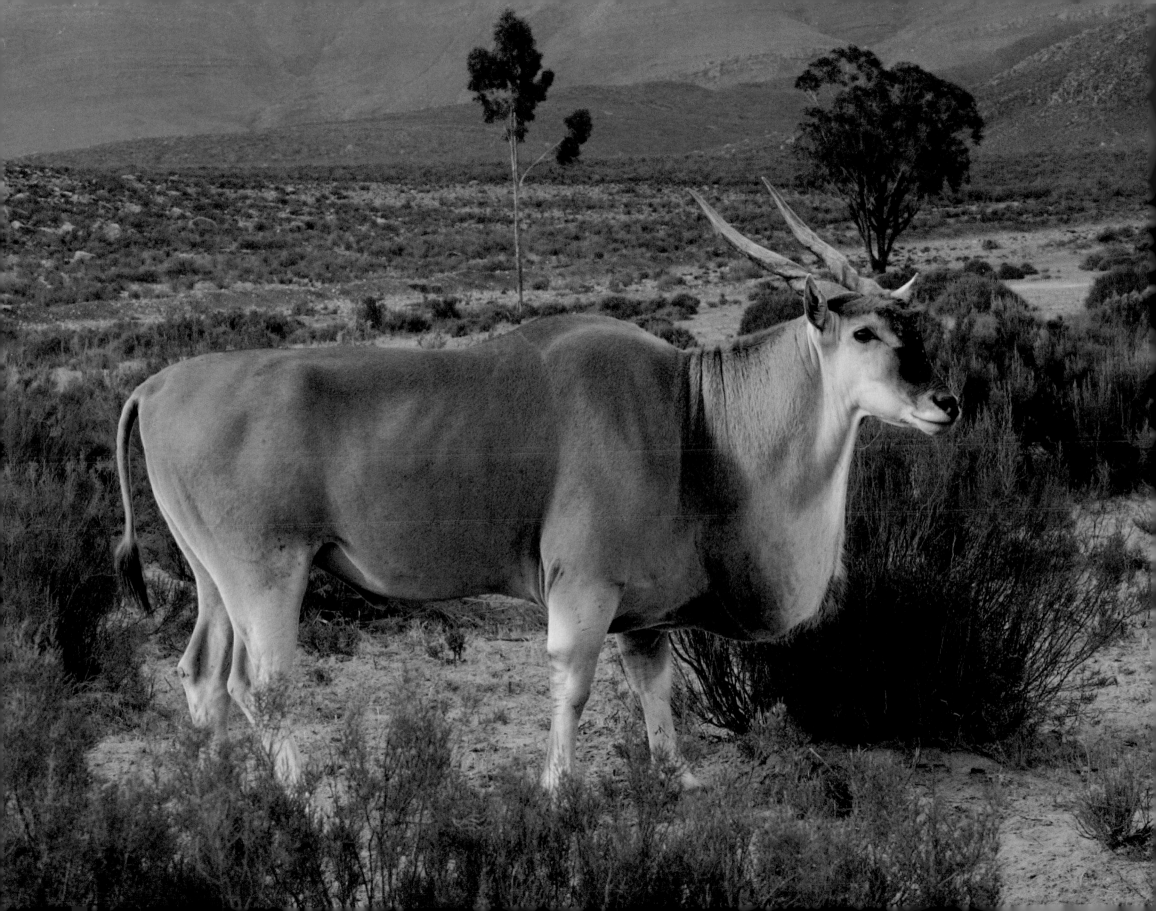

Sanbona

WILDLIFE RESERVE

According to legend, white lions are messengers of the gods. It seems that the gods looked favourably upon the white lions introduced to Sanbona Wildlife Reserve and blessed them with a triplet of white cubs. This lion family is free to roam and hunt in a 5 000-hectare section of the reserve. This alone is rare and special, and so is the very land on which they hunt.

A mere three hours' drive from Cape Town in the Western Cape, Sanbona Wildlife Reserve lies at the foot of the Warmwaterberg in the Little Karoo, a semi-arid region where plants and animals have evolved over millennia to create a diverse and unique environment. Seemingly inert, the plains and hillsides burst into life between August and November with a show of brilliantly coloured flowers triggered by spring rains.

There is a palpable feeling of history at Sanbona, not only from the occasional tumbledown cottage curiously sited in the middle of nowhere or the Georgian lines and interior decor of the manor house or the African proverbs on your pillow at night, but also because the rocks themselves hold the history of the San (Bushmen) whose ancient art adorns hidden overhangs.

There are seven rock-art sites throughout Sanbona dating back to more than 3 500 years. These sites can be visited on game drives, but you may well be distracted by the elephant and buffalo that wander the reserve's 54 000 hectares. Semi-habituated cheetah can be tracked on foot for a thrilling close-up encounter. Conversely, you may become enraptured by the little creatures and plants that thrive in this parched land, or even find fossils from a long-distant past when these hills and plains were part of the seabed.

At the end of a long Karoo day, there is one very special pre-dinner pleasure that makes you realise Sanbona is no ordinary place: a steaming hot bath ready for you with rose petals floating on its bubbly surface.

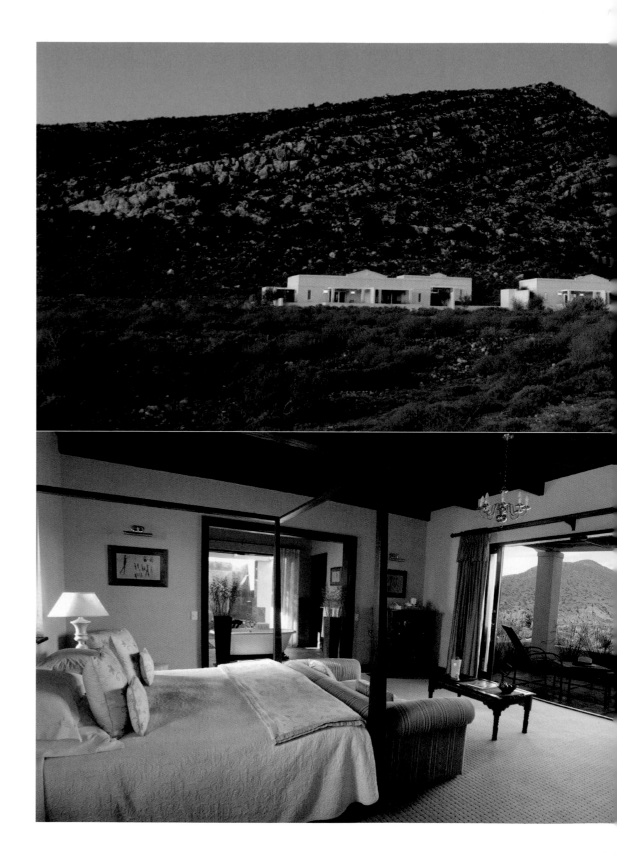

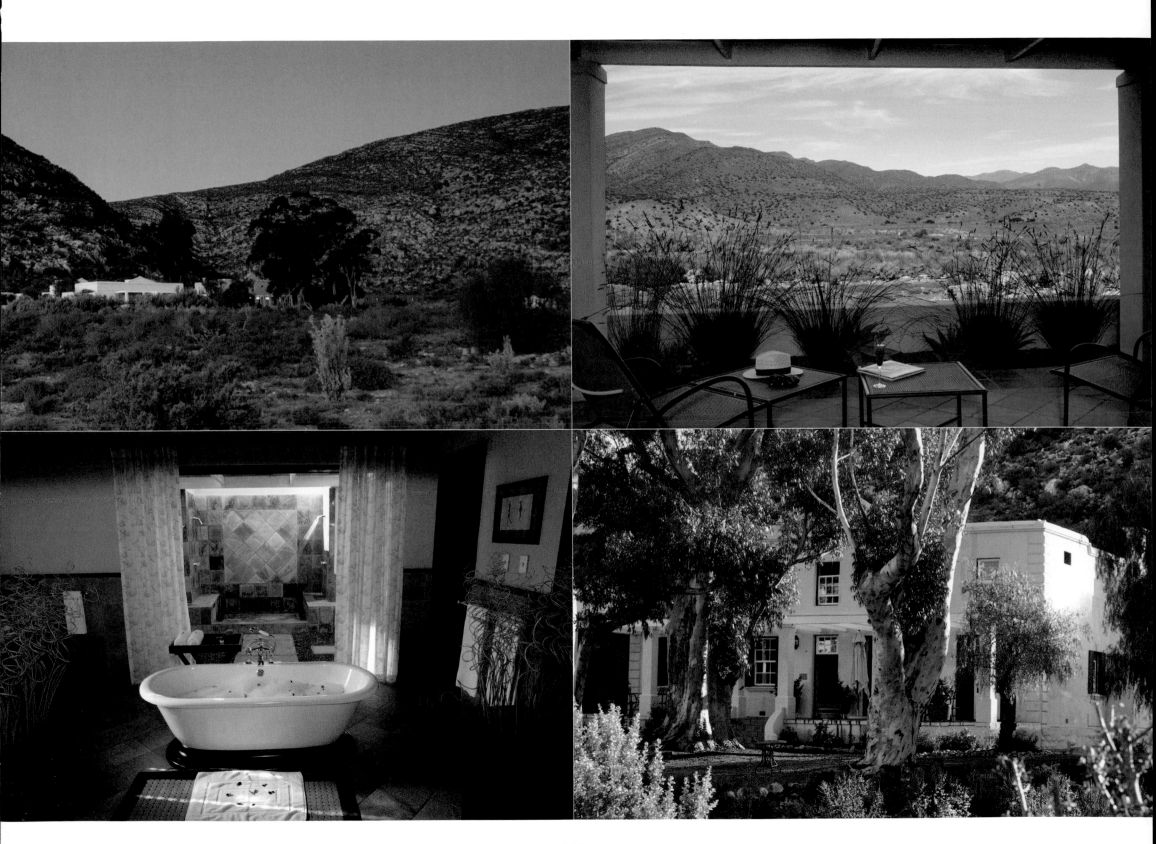

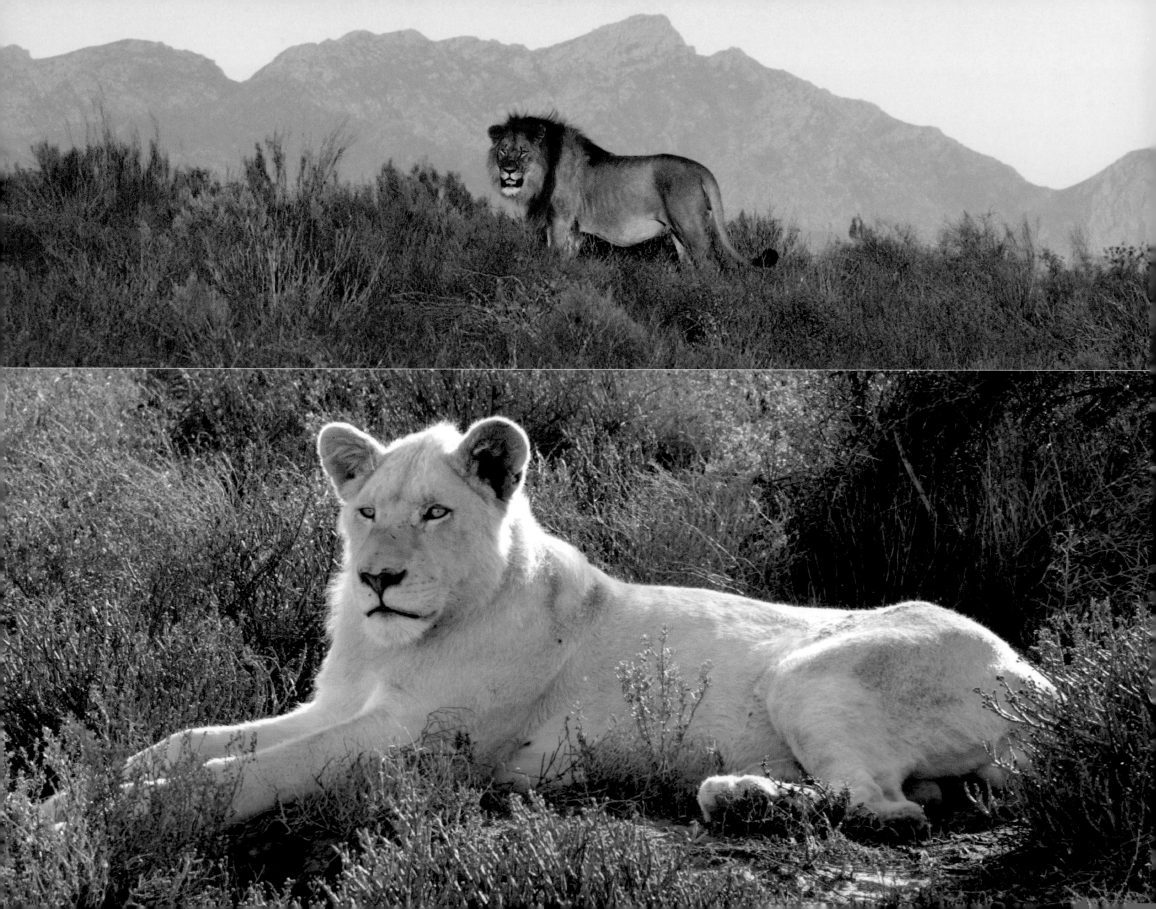

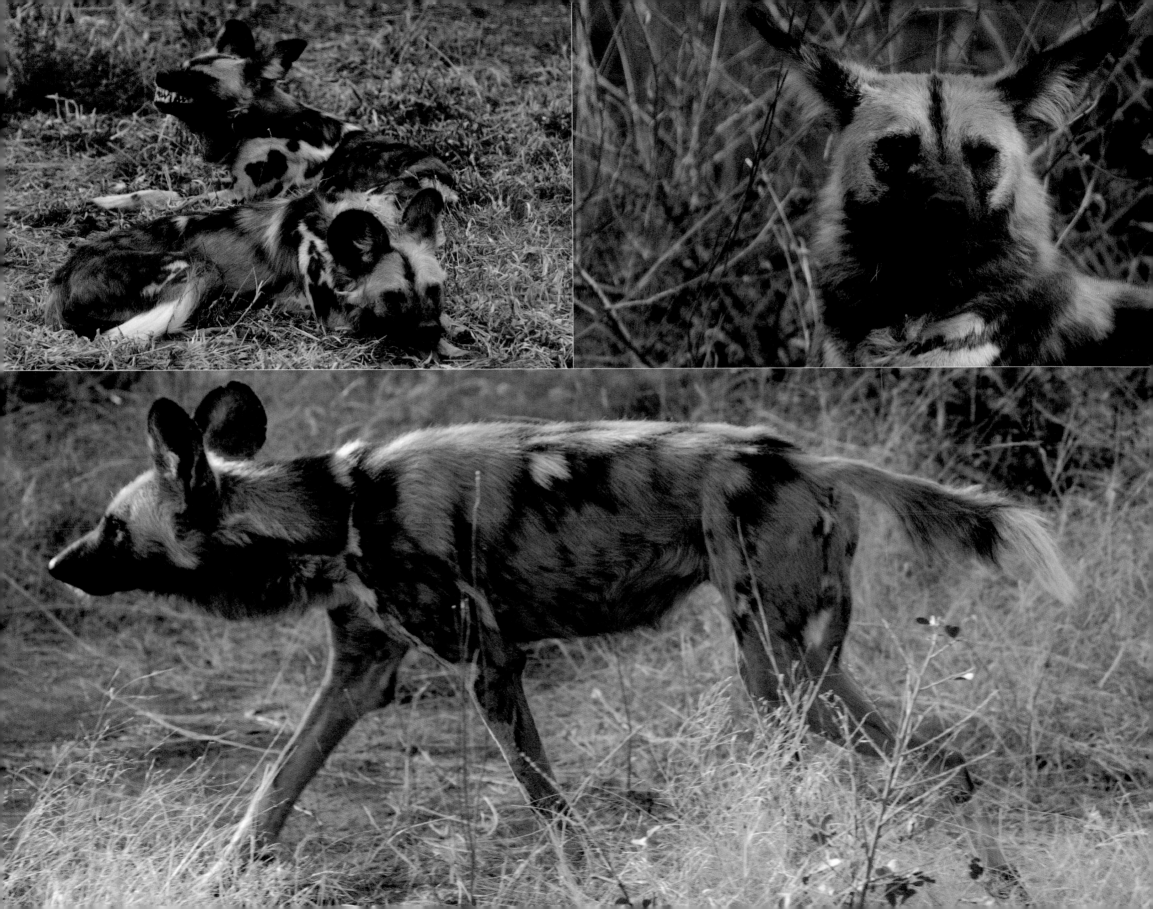

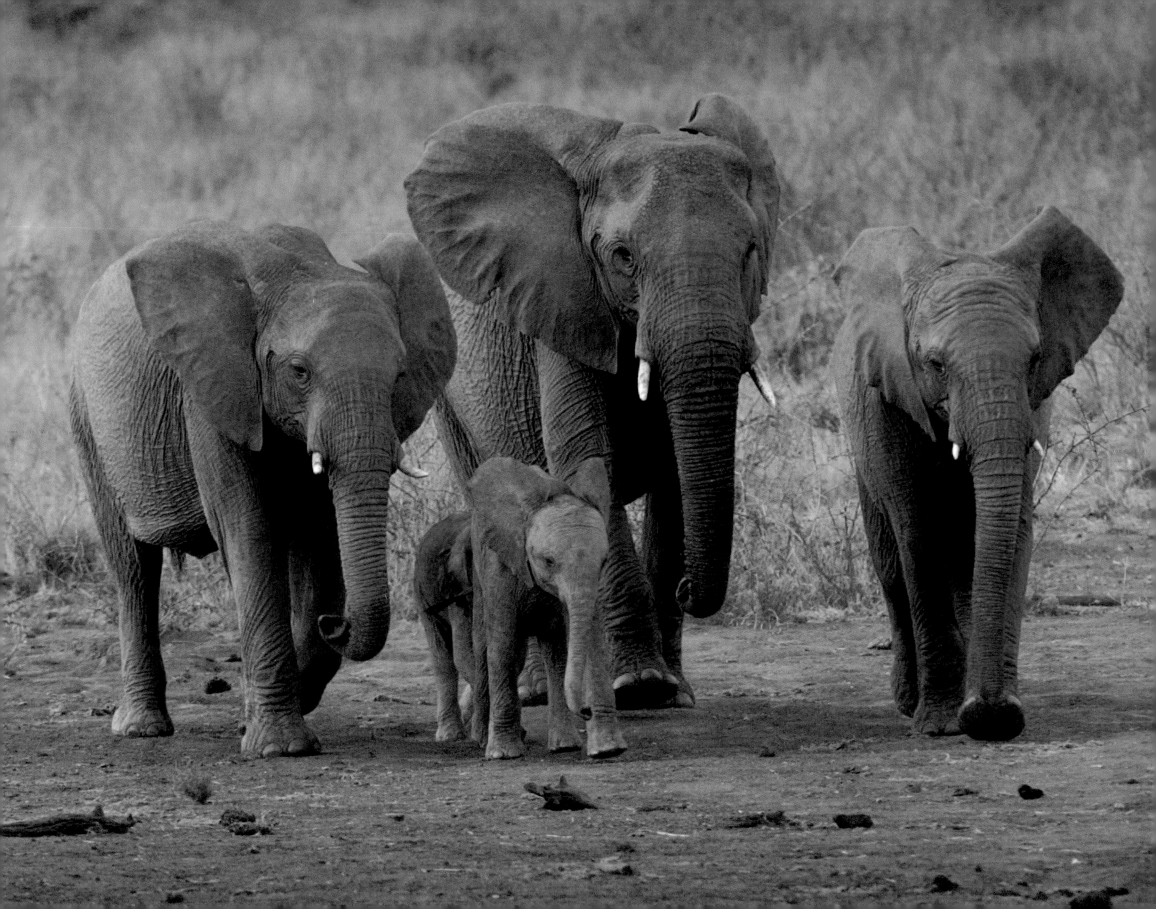

Species Description List

NOTES:

Order: The animal and bird species are listed in the order in which they appear in the book.

Weight: Weight is given in grams or kilograms. The weight range includes the range for females and for males.

Height: The height given for animals is generally taken to mean shoulder height, and is given in centimetres and metres. The height measurements include the range for females and for males. In the case of the species of bird, height is measured from the tip of the beak to the tip of the tail, and is given in centimetres.

Length: The length given is generally taken to mean head and body length, and is given in centimetres and metres. The length measurements include the range for females and for males.

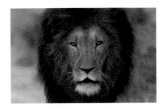

Lion, *Panthera leo*
Weight: 120–260 kg
Height: Up to 1.25 m
Habitat: Savanna and plains zones, depending on availability of prey
Social system: Very social, live and hunt in prides, which number from a few individuals to up to 40 lions
Activity: Nocturnal, but may hunt during the day
Diet: Hoofed mammals and smaller animals, including birds, reptiles and insects; carrion
Reproduction: Year-round; 2–3 cubs per litter

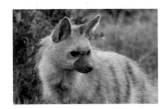

Aardwolf, *Proteles cristatus*
Weight:: 8–12 kg
Height: 40–50 cm
Habitat: Open savanna woodland, grassland
Social system: Normally occur singly, but also live in pairs or small family groups
Activity: Nocturnal
Diet: Principally termites (of the genus *Trinervitermes*), as well as other insects, carrion, mice and birds
Reproduction: October–February; 2–4 young per litter

Cheetah, *Acinonyx jubatus*
Weight: 35–65 kg,
Height: 70–90 cm
Habitat: Savanna woodland and open plains
Social system: Solitary
Activity: Diurnal
Diet: Medium-sized antelope, small mammals, young of large mammals
Reproduction: Year-round; 3–4 cubs per litter

Gemsbok, *Oryx gazella*
Weight: 120–240 kg
Height: 1.15–1.25 m
Habitat: Dry savanna, arid semi-desert zones
Social system: Gregarious, occur in herds of up to 12 individuals
Activity: Diurnal and nocturnal
Diet: Grazers/browsers; grasses, foliage, tubers, bulbs, roots
Reproduction: Year-round; 1 calf

Burchell's zebra, *Equus burchelli*
Weight: 220–250 kg
Height: 1.2–1.4 m
Habitat: Open savanna, near water
Social system: Gregarious, live in small family groups
Activity: Diurnal and nocturnal
Diet: Grazers
Reproduction: Year-round; 1 foal

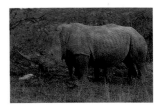

White rhinoceros, *Ceratotherium simum*
Weight: 1 600–2 300 kg
Height: 1.7–1.8 m
Habitat: Open plains with areas of short grass, near water and thick bush (for cover)
Social system: Small groups; males are territorial
Activity: Diurnal and nocturnal
Diet: Grazers
Reproduction: Year-round; 1 calf

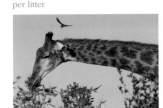

Giraffe, *Giraffa camelopardalis*
Weight: 700–1 300 kg
Height: 2.7–3.3 m (shoulder height) 4.3–5.2 m (total height)
Habitat: Closed savanna
Social system: Loose, open herds
Activity: Predominantly diurnal, but may move and feed at night
Diet: Browsers; prefer the leaves of *Acacia* trees
Reproduction: Year-round; 1 calf

Puff adder, *Bitis arietans*
Length: Up to 1.2 m; individuals measuring 1.8 m have been recorded
Habitat: All habitats, especially rocky grasslands, except true deserts and dense forests; bask in sunny spots
Diet: Rats, mice, birds, small mammals
Reproduction: Eggs develop within the body of the female; young free themselves from eggs minutes after eggs have been laid

Green water snake, *Philothamnus hoplogaster*
Length: 50–70 cm
Habitat: Open grassy vleis
Diet: Frogs, tadpoles, small fish
Reproduction: 8 eggs

South African bushbaby, *Galago moholi*
Weight: 140–230 g
Length: 8.8–2.1 cm
Habitat: Open woodlands, savanna grasslands
Social system: Solitary, small family groups
Activity: Nocturnal
Diet: Grasshoppers, moths, butterflies, fruits, seeds, flowers, sap, nuts
Reproduction: During summer; 1–2 young

Village weaver, *Ploceus cucullatus*
Height: 14–16 cm
Habitat: Savanna, reedbeds, grassland
Social system: Gregarious, occur in flocks; nest in colonies in reedbeds and in trees overhanging water
Diet: Seeds, insects, nectar
Reproduction: 2–3 eggs

Southern masked-weaver, *Ploceus velatus*
Height: 11–14.5 cm
Habitat: Savanna, grassland
Social system: Nest in colonies in trees overhanging water; also nest in thornveld and suburbia
Diet: Seeds, insects, flowers, shoots, berries, fruit
Reproduction: 2–3 eggs

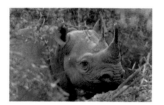

Black rhinoceros, *Diceros bicornis*
Weight: 800–1 300 kg
Height: 1.4–1.6 m
Habitat: Near water in a wide range of habitats, including woodland and thickets
Social system: Solitary
Activity: Diurnal and nocturnal
Diet: Browsers; feed on a wide range of plants
Reproduction: Year-round; 1 calf

Wild dog, *Lycaon pictus*
Weight: 20–30 kg
Height: 60–75 cm
Habitat: Open savanna woodland and plains, where prey is available
Social system: Large packs, with an average of 10 per pack; packs of up to 60 individuals have been recorded
Activity: Diurnal, but may hunt at moonlight
Diet: Small to large mammals, particularly antelope
Reproduction: Mainly during the dry season (March–July); average of 10 pups per litter

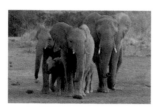

Elephant, *Loxodonta africana*
Weight: 3 000–6 000 kg
Height: 2.5–3.3 m
Habitat: Anywhere near water and a good supply of food
Social system: Herds of related individuals led by a matriarch; mature males are solitary
Activity: Diurnal and nocturnal
Diet: Grazers/browsers; grasses, shrubs, branches, fruits, bark
Reproduction: Year-round; 1 calf

Bennett's woodpecker,
Campethera bennettii
Height: 18–20 cm
Habitat: Broad-leaved woodland, savanna
Social system: Pairs, family groups
Diet: Mainly ants and termites
Reproduction: 2–3 eggs

Grey-headed kingfisher,
Halcyon leucocephala
Height: 20–21 cm
Habitat: Broad-leaved woodland, near water
Social system: Solitary or in pairs; long-distance migrant to southern Africa
Diet: Insects, lizards
Reproduction: 3–4 eggs

Little bee-eater, *Merops pusillus*
Height: 14–17 cm
Habitat: Woodland, savanna, reedbeds, forest fringes
Social system: Pairs
Diet: Small insects, butterflies, aphids
Reproduction: 4–6 eggs

Black-backed jackal, *Canis mesomelas*
Weight: 7–10 kg
Height: 38–48 cm
Habitat: Dry areas, open terrain, woodland
Social system: Solitary or in pairs; forage in small family groups
Activity: Diurnal and nocturnal
Diet: Rodents, insects, carrion, reptiles, small mammals, birds
Reproduction: July–October; 3–6 pups per litter

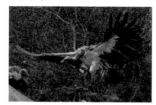

White-backed vulture, *Gyps africanus*
Height: 95 cm
Habitat: Savanna
Social system: Gregarious, nest in trees in small colonies
Diet: Carrion
Reproduction: 1 egg

Hooded vulture,
Necrosyrtes monachus
Height: 65–75 cm
Habitat: Where carrion is available
Social system: Pairs; may roost in trees in groups
Diet: Carrion, termites, lizards
Reproduction: 1 egg

Marabou stork,
Leptoptilos crumeniferus
Height: 150–155 cm
Habitat: Savanna
Social system: Single, but usually occur in colonies
Diet: Carrion, fish, birds, locusts
Reproduction: 1–4 eggs

Spotted hyaena, *Crocuta crocuta*
Weight: 55–75 kg
Height: 70–80 cm
Habitat: Savanna plains, where there is an abundance of prey
Social system: Large clans, with up to 80 individuals per clan having been recorded
Activity: Nocturnal, but may be seen during the day
Diet: Scavengers; hunt predominantly hoofed mammals
Reproduction: Year-round; 1–4 pups per litter

African buffalo, *Syncerus caffer*
Weight: 425–800 kg
Height: 1.4–1.6 m
Habitat: Open savanna, near water
Social system: Gregarious, with herds of up to 500 animals; solitary old bulls
Activity: Considered nocturnal, but feed night and day
Diet: Grazers
Reproduction: March–May; 1 calf

Verreaux's (Giant) eagle-owl,
Bubo lacteus
Height: 58–66 cm
Habitat: Savanna, woodland, riverine areas, thornveld
Social system: Pairs
Diet: Mammals, birds
Reproduction: 2 eggs

Chacma baboon,
Papio hamadrayas ursinus
Weight: 14–44 kg
Height: 60–72.5 cm
Habitat: Savanna, arid zones, near water and shelter
Social system: Gregarious, with up to 100 individuals in a troop
Activity: Diurnal
Diet: Grasses, tubers, roots, leaves, seeds, flowers, fruits, insects, shellfish, birds' eggs, young of antelope
Reproduction: Year-round; 1 young

Spotted eagle-owl, *Bubo africanus*
Height: 43–50 cm
Habitat: Open savanna, woodland, desert
Social system: Solitary or in pairs
Diet: Insects, birds, small mammals
Reproduction: 2–4 eggs

European roller, *Coracias garrulus*
Height: 30–31 cm
Habitat: Open savanna woodland
Social system: Usually solitary, but seen perching with other European rollers; migrant to southern Africa
Diet: Grasshoppers, locusts

Blue pansy butterfly, *Junonia oenone*
Wingspan: 40–50 mm
Habitat: Forest edges, parks, hilltops; settle on rocks and bare ground
Diet: Larval food plants (for caterpillars); nectar (for adult butterflies)
Reproduction: Eggs laid singly on host plant

Nile crocodile, *Crocodylus niloticus*
Weight: Up to 500 kg; individuals weighing 900 kg have been recorded
Length: Up to 6 m
Habitat: Rivers, large lakes, freshwater swamps
Social system: Communal, with communities ranging from a few to several hundred crocodiles
Diet: Insects and small aquatic invertebrates when young; fish, large mammals
Reproduction: November–December; 16–80 eggs laid in a riverbank nest; young carried to the water once eggs have hatched

Purple roller, *Coracias naevius*
Height: 33–38 cm
Habitat: Open woodland, dry thornveld
Social system: Solitary or in pairs
Diet: Insects, lizards, mice, small reptiles, young birds
Reproduction: 2–4 eggs

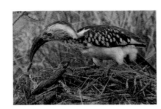

Red-billed hornbill, *Tockus erythrorhynchus*
Height: 40–51 cm
Habitat: Savanna, thornveld
Social system: Gregarious, occur in groups of up to 12
Diet: Insects, termites, fallen fruit
Reproduction: 3–6 eggs

White-headed vulture, *Aegypius occipitalis*
Height: 78–84 cm
Habitat: Savanna, thornveld
Social system: Solitary
Diet: Carrion, small mammals
Reproduction: 1 egg

Banded mongoose, *Mungos mungo*
Weight: 1–1.6 kg
Height: 33–41 cm
Habitat: Closed savanna, underbush
Social system: Occur in packs of up to 35 individuals
Activity: Diurnal
Diet: Insects, termites, birds and their eggs, small reptiles, millipedes, fruits
Reproduction: October–February; 2–6 young per litter

Basal stinging ant, Subfamily *Ponerinae*
Length: Up to 2 cm
Habitat: Warm, moist environments
Social system: Live in small colonies, compared with the much larger colonies of other species
Diet: Mostly termites as well as insects; larvae are fed on bits of insects
Reproduction: Small underground colonies, with one reproductive pair

Millipede (Songololo), Class *Diplopoda*
Length: Up to 20 cm
Habitat: Cool, moist environments
Diet: Plants, rotten leaves
Reproduction: Eggs laid in the soil

Foam nest frog, *Chiromantis xerampelina*
Length: 50–90 mm
Habitat: Tree branches overhanging water
Diet: Tadpoles, algae, rotting vegetation
Reproduction: Eggs deposited into a foam nest; hatched tadpoles drop into water

Bateleur, *Terathopius ecaudatus*
Height: 55–70 cm
Habitat: Savanna
Social system: Solitary or in pairs
Diet: Carrion, birds, small mammals
Reproduction: 1 egg

Tawny eagle, *Aquila rapax*
Height: 66–73 cm
Habitat: Semi-desert areas, thornveld, dry woodland, savanna
Social system: Pairs
Diet: Mammals, birds, reptiles, carrion
Reproduction: 1–3 eggs

Vervet monkey, *Cercopithecus aethiops*
Weight: 4–9 kg
Length: 45–49 cm
Habitat: Savanna woodland, riverine vegetation
Social system: Gregarious, live in troops of up to 20 monkeys
Activity: Diurnal
Diet: Wild fruits, leaves, seeds, seed pods, flowers, lizards, birds' eggs, birds, insects
Reproduction: Usually December–February; 1 young

Waterbuck, *Kobus ellipsiprymnus*
Weight: 230–270 kg
Height: 1.2–1.7 m
Habitat: Rocky hills, floodplain, grassland, near water
Social system: Gregarious, occur in herds of up to 30 individuals
Activity: Diurnal and nocturnal
Diet: Predominantly grazers, but also feed on herbs and leaves
Reproduction: Year-round; 1 calf

Kudu, *Tragelaphus strepsiceros*
Weight: 120–260 kg
Height: 1.25–1.4 m
Habitat: Savanna woodland, scrub, rocky terrain
Social system: Gregarious, occur in herds of up to 15 individuals
Activity: Diurnal and nocturnal
Diet: Browsers; leaves, fruits, tubers, seed pods, but may also eat grass
Reproduction: February–March; 1 calf

Warthog, *Phacochoerus aethiopicus*
Weight: 45–100 kg
Height: 60–70 cm
Habitat: Open savanna, grassland
Social system: Family groups
Activity: Diurnal
Diet: Graze on short grass; feed on rhizomes, sedges, herbs, wild fruits, shrubs
Reproduction: September–December; 3–4 piglets

Coqui francolin, *Peliperdix coqui*
Height: 21–26 cm
Habitat: Woodland, savanna, open areas bordering savanna
Social system: In breeding pairs; occur in coveys
Diet: Termites, spiders, ants, seeds, fruits
Reproduction: 2–8 eggs

Blue wildebeest, *Connochaetes taurinus*
Weight: 168–270 kg
Height: 1.15–1.45 m
Habitat: Open plains with short grass
Social system: Gregarious, occur in large herds
Activity: Diurnal and nocturnal
Diet: Grazers; short green grass
Reproduction: November–January; 1 calf

Bushbuck, *Tragelaphus scriptus*
Weight: 25–60 kg
Height: 65–100 cm
Habitat: Forest, dense undergrowth, near water
Social system: Solitary, but may sleep in small groups
Activity: Nocturnal, but also active during the day
Diet: Grazers/browsers; green grass, herbs, leaves, fruits, flowers
Reproduction: Year-round; 1 calf

Red hartebeest, *Alcelaphus buselaphus caama*
Weight: 105–156 kg
Height: 1.25 m
Habitat: Open plains
Social system: Gregarious, occur in small herds of up to 20 individuals; form large aggregations as well
Activity: Diurnal and nocturnal
Diet: Grazers
Reproduction: October–November; 1 calf

Blesbok, *Damaliscus dorcas phillipsi*
Weight: 55–80 kg
Height: 85–100 cm
Habitat: Grassland, near water
Social system: Gregarious, occur in bachelor herds and female herds with territorial male; aggregations of several 100 individuals
Activity: Mainly diurnal
Diet: Grazers
Reproduction: November–January; 1 calf

Black wildebeest,
Connochaetes gnou

Weight: 110–180 kg
Height: 1–1.2 m
Habitat: Open plains, arid shrubland
Social system: Gregarious, occur in large herds
Activity: Diurnal and nocturnal
Diet: Predominantly grazers; feed on short green grass and shrubs
Reproduction: December–January; 1 calf

Water (Nile) monitor,
Varanus niloticus

Length: 1–2.1 m
Habitat: Vegetation, near water
Diet: Insects, frogs, crabs, fish, birds, eggs
Reproduction: August–September; 20–60 eggs

White-faced duck,
Dendrocygna viduata

Height: 43–48 cm
Habitat: Freshwater areas
Social system: Pairs, family groups
Diet: Tubers, seed pods, mollusks, insect larvae
Reproduction: 4–9 eggs

Egyptian goose,
Alopochen aegyptiaca

Height: 63–73 cm
Habitat: Any freshwater habitat
Social system: Pairs; gregarious when not breeding
Diet: Grass, herbs, sedges
Reproduction: 5–11 eggs

Golden orb-web spider,
Nephila senegalensis

Length: Up to 3.5 cm
Habitat: Open habitat, scrub, forest edges
Social system: Male and female occur together on same web
Diet: Insects, captured in web
Reproduction: Eggs laid in egg sac attached to web

Southern white-faced scops-owl,
Ptilopsus granti

Height: 25–28 cm
Habitat: Dry, broad-leaved woodland, thornveld
Social system: Solitary or in pairs
Diet: Small mammals, birds, reptiles, insects
Reproduction: 1–4 eggs

Flap-necked chameleon,
Chamaeleo dilepis

Length: 20–24 cm
Habitat: Savanna, bushland
Diet: Insects
Reproduction: 25–50 eggs laid in tunnels dug by females

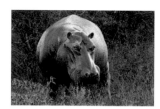

Hippopotamus,
Hippopotamus amphibius

Weight: 995–2 000 kg
Height: 1.3–1.6 m
Habitat: Open water with food supply within range
Social system: Gregarious, with 10–15 hippos in a herd
Activity: Nocturnal, but can be seen resting during the day
Diet: Grazers; prefer short grass
Reproduction: Year-round; 1 calf

Leopard, *Panthera pardus*

Weight: 28–65 kg
Height: 57–70 cm
Habitat: Rainforest to desert, where game exist
Social system: Solitary
Activity: Nocturnal, but may be seen during the day
Diet: Any prey, from insects to large antelope
Reproduction: Year-round; 2–3 cubs per litter

Pearl-spotted owlet,
Glaucidium perlatum

Height: 18–19 cm
Habitat: Thornveld, woodland
Social system: Solitary or in pairs
Diet: Insects, birds, small mammals, amphibians
Reproduction: 2–4 eggs

Striped fieldmouse,
Rhabdomys pumilio

Weight: 37–54 g
Length: 85–100 mm
Habitat: Wide variety of habitats, with cover of grass
Social system: Ranges from solitary to pairs, family groups and complex social groups
Activity: Predominantly diurnal
Diet: Grass, insects, seed pods, proteas
Reproduction: September–April; 2–9 young per litter

Impala, *Aepyceros melampus*

Weight: 40–65 kg
Height: 70–92 cm
Habitat: Open woodland, near grassland and water
Social system: Gregarious, occur in bachelor herds, adult male herds and breeding herds; herd numbers range from 6 to 100 or more
Activity: Predominantly diurnal, but feed at night as well
Diet: Grazers/browsers; grasses, leaves, seed pods, shoots
Reproduction: September–October; 1 fawn

Leopard tortoise,
Geochelone pardalis babcocki

Weight: 8–12 kg
Length: 30–70 cm
Habitat: Thornveld, grassland
Diet: Plants, fruits, grass, fungi, leaves
Reproduction: Up to 30 eggs per batch laid in the ground

Marsh owl, *Asio capensis*

Height: 32–38 cm
Habitat: Marshes, damp grassland
Social system: Pairs; occur in flocks
Diet: Small mammals, insects, lizards, frogs, birds
Reproduction: 2–6 eggs

Brown hyaena, *Hyaena brunnea*

Weight: 37–49 kg
Height: 64–87 cm
Habitat: Open woodland savanna, semi-desert, open scrub
Social system: Clans of between 4 and 14 members
Activity: Predominantly nocturnal
Diet: Scavengers; may hunt small mammals, birds and reptiles and feed on fruit and insects
Reproduction: August–November; 1–4 young per litter

Caracal, *Felis caracal*

Weight: 8–18 kg
Height: 40–50 cm
Habitat: Woody bush, mountains, rocky hills
Social system: Solitary
Activity: Mainly nocturnal, but also active during the day
Diet: Antelope, small mammals, rodents, birds
Reproduction: Year-round; 2–4 kittens per litter

Cape ground squirrel, *Xerus inauris*

Weight: 0.1–1 kg
Height: 45 cm
Habitat: Grassy plains, shrubby terrain
Social system: Occur in colonies
Activity: Diurnal
Diet: Leaves, roots, bulbs, grasses, termites
Reproduction: Year-round; 2–6 young per litter

Eland,
Tragelaphus (Taurotragus) oryx

Weight: 450–700 kg
Height: 1.5–1.7 m
Habitat: Open savanna, arid zones, woodland
Social system: Gregarious, occur in small herds; seasonal aggregations of up to 500 individuals
Activity: Diurnal and nocturnal
Diet: Grazers/browsers; leaves, herbs, seeds, fruits, grass
Reproduction: Year-round; 1 calf

Select Bibliography

Alderton, D. 1991. *Crocodiles and alligators of the world.* London: Blandford Publishing.

Estes, R.D. 1993. *The safari companion: A guide to watching African mammals.* Johannesburg: Russel Friedman Books.

Ginn, P.J., McIlleron, W.G. and Milstein, P. le S. 1990. *The complete book of southern African birds.* Cape Town: Struik Winchester.

Hoberman, G. and Theron, R. 2002. *Wildlife.* Second edition. Cape Town: The Gerald & Marc Hoberman Collection.

Hockey, P., Dean, W. and Ryan, P. (eds). 2005. *Roberts birds of southern Africa.* Seventh edition. Cape Town: John Voelcker Bird Book Fund.

Kruger National Park and Jacana Education. 1995. *Kruger National Park: Find it.* Johannesburg: Jacana.

Sinclair, I., Hockey, P. and Tarboton, W. 2002. *Birds of southern Africa: The region's most comprehensively illustrated guide.* Third edition. Cape Town: Struik Publishers.

Smithers, R. 1983. *The mammals of the southern African subregion.* Pretoria: University of Pretoria.

Index

Safari Lodge Websites

Aquila Private Game Reserve www.aquilasafari.com
Camp Jabulani www.campjabulani.com
Chitwa Chitwa Private Game Lodge www.sabisandslodges.co.za
Clifftop Exclusive Safari Hideaway www.clifftoplodge.com
Donald Greig www.donaldgreig.com
Elephant Plains Game Lodge www.elephantplains.co.za
Garonga Safari Camp www.garonga.com
Hayward's Luxury Safaris www.haywardsafaris.com
Idube Private Game Reserve www.idube.co.za
Impodimo Game Lodge www.impodimo.com
Intsomi Forest Lodge www.intsomi.com
Itaga Luxury Private Game Lodge www.itaga.co.za
Ivory Tree Game Lodge www.ivorytreegamelodge.com
Jaci's Safari Lodge www.madikwe.com
Jaci's Tree Lodge www.madikwe.com
Jock Safari Lodge www.jocksafarilodge.com
Kapama Buffalo Camp www.kapama.co.za
Kapama Lodge www.kapama.co.za
Kapama River Lodge www.kapama.co.za
Kings Camp Private Game Reserve www.kingscamp.com
Kirkman's Kamp www.ccafrica.com
Kuname River Lodge www.kuname.co.za
Kwandwe Ecca Lodge www.ccafrica.com
Kwandwe Great Fish River Lodge www.ccafrica.com
Kwandwe Uplands Homestead www.ccafrica.com

Leadwood Lodge www.ccafrica.com
Leopard Hills Private Game Reserve www.leopardhills.com
Lion Sands Ivory Lodge www.lionsands.com
Lion Sands River Lodge www.lionsands.com
Londolozi Game Reserve www.londolozi.co.za
Lukimbi Safari Lodge www.lukimbi.co.za
Madikwe Hills Private Game Lodge www.madikwehills.com
Madikwe Safari Lodge www.ccafrica.com
Makanyane Safari Lodge www.makanyane.com
Makweti Safari Lodge www.makweti.com
Mateya Safari Lodge www.mateyasafari.com
Nedile Lodge www.nedile.co.za
Ngala Safari Lodge www.ccafrica.com
Ngala Tented Camp www.ccafrica.com
Nkorho Bush Lodge www.nkorho.com
Notten's Bush Camp www.nottens.com
Phinda Forest Lodge www.ccafrica.com
Phinda Getty House www.ccafrica.com
Phinda Mountain Lodge www.ccafrica.com
Phinda Rock Lodge www.ccafrica.com
Phinda Vlei Lodge www.ccafrica.com
Phinda Walking Safaris Camp www.ccafrica.com
Phinda Zuka Lodge www.ccafrica.com
Rhulani Safari Lodge www.rhulani.co.za
River Lodge www.ccafrica.com

Royal Malewane www.royalmalewane.com
Sabi Sabi Earth Lodge www.sabisabi.com
Sanbona Wildlife Reserve www.sanbona.com
Savanna Private Game Reserve www.savannalodge.com
Sediba Letlapa Lodge www.sediba.co.za
Sediba Letlapala Lodge www.sediba.co.za
Shamwari Bayethe Tented Lodge www.shamwari.com
Shamwari Eagles Crag Lodge www.shamwari.com
Shamwari Lobengula Lodge www.shamwari.com
Shibula Lodge www.shibulalodge.co.za
Simbambili Game Lodge www.simbambiligamelodge.co.za
Singita Boulders Lodge www.singita.com
Singita Ebony Lodge www.singita.com
Singita Lebombo Lodge www.singita.com
Singita Sweni Lodge www.singita.com
Tanda Tula Safari Camp http://timbavati.krugerpark.co.za
Tau Game Lodge www.taugamelodge.co.za
Thanda Private Game Reserve www.thanda.co.za
Tinga Legends Lodge www.tinga.co.za
Tinga Narina Lodge www.tinga.co.za
Tswalu Kalahari Reserve www.tswalu.com
Tuningi Safari Lodge www.tuningi.co.za
Ulusaba Private Game Reserve www.ulusaba.com